# CINEMA 4D 11 Workshop

Arndt von Koenigsmarck

ELSEVIER

AMSTERDAM • BOSTON • HEIDELBERG • LONDON
NEW YORK • OXFORD • PARIS • SAN DIEGO
SAN FRANCISCO • SINGAPORE • SYDNEY • TOKYO
Focal Press is an imprint of Elsevier

Focal Press is an imprint of Elsevier
30 Corporate Drive, Suite 400, Burlington, MA 01803, USA
Linacre House, Jordan Hill, Oxford OX2 8DP, UK

Translation: Frank Wagenknecht

Recognizing the importance of preserving what has been written, Elsevier prints its books on acid-free paper whenever possible.

**Library of Congress Cataloging-in-Publication Data**
Application submitted.

**British Library Cataloguing-in-Publication Data**
A catalogue record for this book is available from the British Library.

ISBN: 978-0-240-81195-6

For information on all Focal Press publications
visit our website at www.books.elsevier.com

09  10  11  12  13  5  4  3  2  1

Printed in the United States of America

Working together to grow
libraries in developing countries

www.elsevier.com  |  www.bookaid.org  |  www.sabre.org

ELSEVIER     BOOK AID
International     Sabre Foundation

# Contents

Please visit http://www.elsevierdirect.com/companions/9780240811956 to download the project files used in this book, as well as an online-only bonus chapter on 'Getting Started' using CINEMA 4d.

# Short Projects

Typical complex projects can take several days to complete. To give you as much practical knowledge as possible and not focus on certain themes, I would like to show you some typical projects in this chapter. Along the way you will become familiar with other modeling tools and techniques not mentioned before.

The projects were chosen to demonstrate a complete production cycle from modeling to texturing and lighting, right up to the final rendering. The first example shows the use of primitives for modeling a flashlight. The second workshop demonstrates the use of the HyperNURBS object and the realistic creation of a carabiner. The third example goes more in an artistic direction and shows the construction of an antique glass vase. Have fun and good luck!

## Modeling with Parametric Objects—A Flashlight

Many technical shapes and objects for daily use can be built from simple shapes. Shapes such as a cylinder, sphere, or cube are offered by CINEMA 4D in a ready-to-use format as so-called primitives and can be easily modified in the viewports by value fields or virtual handlers. These objects also have the advantage that they can be rounded or further subdivided, for example, when a still image needs more details or when a curve has to have more definition.

We will start this workshop with an empty scene. Delete all objects in your scene or open a new scene at FILE>NEW. Several scenes can be opened in CINEMA 4D. You can switch between these scenes in the WINDOW menu of CINEMA 4D.

## The Head of the Flashlight

First add a CONE object and change the upper radius to 90, the lower radius to 125, and the height to 320 units, as shown in Figure 1.1. I took these measurements from a real flashlight. The units of these values generally don't matter to CINEMA 4D. The object will have the same size regardless of whether you use millimeter, centimeter, or kilometer as units. The numerical value is what is important. For example, if you measure 32 mm on a real object, then this measurement can become 320 units in CINEMA 4D. The purpose for this is to have enough decimal places so adjustments can be made later if necessary. I used the same principle in this example. All measurements were done in millimeters and then multiplied by 10.

I increased the number of segments around the cone circumference to 72 so there will be more detail in a close-up later on. You can work with a lower number of segments if you want to use multiple flashlights in your scene and need to watch the number of polygons. There will be a deformation in the next step; therefore, additional points are needed on the surface of the cone. In that case the subdivision along the height is set to 8.

The cone also has small roundings at its caps. Hardly any real object has perfectly sharp edges. This should be kept in mind during modeling. The highlights alone that will be captured by the rounded edge can improve the quality of an image tremendously.

The head of the flashlight is supposed to be bent in a soft curve between the different radii of the caps. This can be accomplished

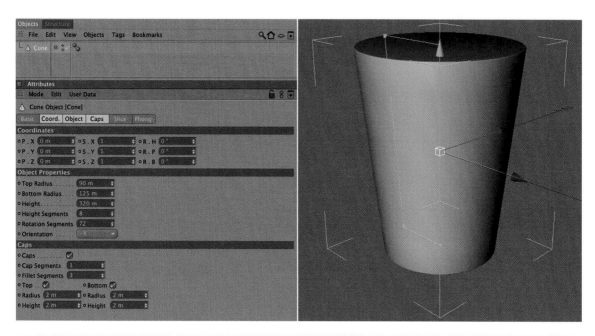

— Figure 1.1: A cone object will create the head of the flashlight.

quickly with a BULGE deformer. Subordinate the deformer under the cone, as shown in Figure 1.2. Make sure that the Y axis of the deformer points vertically up or down because the constriction or bulging of this deformer is always calculated vertically to the Y axis. This should automatically be the case if you haven't changed the position or direction of the cone.

Now increase the value for STRENGTH of the BULGE object in the ATTRIBUTE MANAGER. You should be able to see now how the surface of the cone bulges outward in the middle. Increase the Y part of the deformer size to 320 units and the strength to about 12% in order to get a result like that shown in Figure 1.2. If the bulge of the cone appears too angled, then increase the number of segments along the height of the cone in its dialog box, as shown in Figure 1.1.

**THE FOCUS RING**

Above the head of the flashlight is the separately rotating focus ring, which turns the flashlight on or off and regulates the focus of the light beam for different distances. As the name indicates, it is a simple ring that is available as a primitive. I would like to use a spline with a NURBS object, though. Add a RECTANGLE spline and place it in the front viewport (XY viewport), above the right edge of the upper cone cap, as shown in Figure 1.3.

I gave the rectangle a width of 30 and a height of 100 units. Zoom in to make sure the lower edge of the spline is level with the cone. You can see also the numerical value of the position in Figure 1.3.

Instead of using the built-in ROUNDING option of the RECTANGLE spline, we convert the spline with MAKE EDITABLE in the FUNCTIONS menu or by using the (C) key. The parameters of the spline in the ATTRIBUTE MANAGER are lost but we can now edit the points of the spline directly in USE POINT TOOL mode.

Use the LIVE or FRAME SELECTION to select either the upper or lower two points of the rectangle. Then right click into an empty area in the viewport and use CHAMFER from the

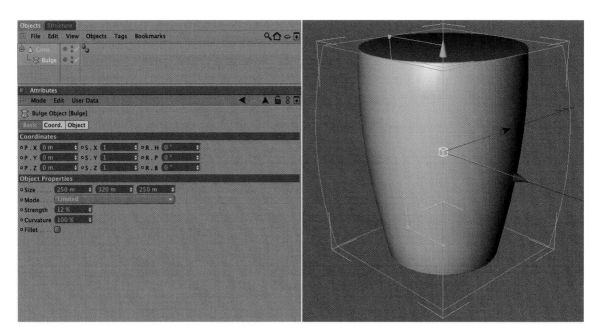

— Figure 1.2: Bending the cone.

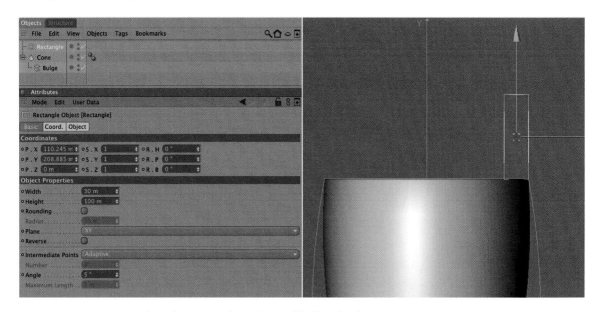

— Figure 1.3: A rectangle spline is used as the profile for the focus ring.

context menu. This command can also be found in the STRUCTURE menu under the EDIT SPLINE entry. While holding the mouse button, drag the mouse to the left or right to round the spline points, or enter a value in

the ATTRIBUTE MANAGER after selecting the tool.

In this case, that should be enough to create an optically pleasing result. When you are done with the two points, select the

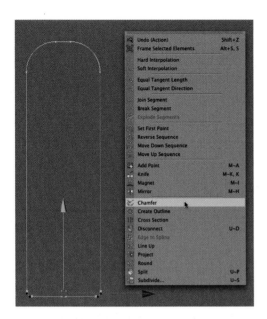

— Figure 1.4: Individual rounding of the spline corner.

other two points and do the same, but with a different radius. Try to match the radius in Figure 1.4.

### The Lathe NURBS Object

This completes the desired profile of the focus ring. To develop a three-dimensional shape, we will use a LATHE NURBS object and subordinate the rounded rectangle spline under it. Instantly an object is generated, as can be seen in Figure 1.5.

The Lathe NURBS rotates the subordinated spline around its Y axis. If your result looks different, check the location of the Lathe NURBS object and then control the position of the spline. The rectangle spline should be visible in the XY viewport and positioned directly above the upper edge of the cone.

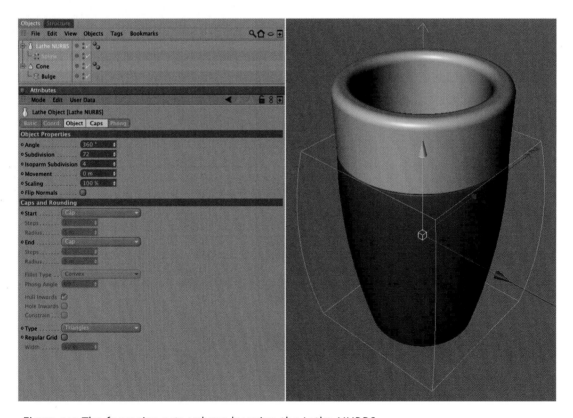

— Figure 1.5: The focus ring gets volume by using the Lathe NURBS.

Increase the number of SUBDIVISION in the Lathe NURBS object to the same value as was used for the circumference elements of the cone. In my case it was 72 SUBDIVISION. Otherwise there are no settings to be made.

## The Handle of the Flashlight

This completes the outer shape of the flashlight head, and we now can concentrate on the handle. It can be made out of a cylinder object, the HEIGHT of which should be 940 and the RADIUS 85 units. Here I use 72 segments again around the circumference and a small rounding at the caps. Be sure that the cylinder is aligned along the Y ORIENTATION. Use the ORIENTATION menu within the cylin-

der settings in the ATTRIBUTE MANAGER or rotate the cylinder manually by 90° so it is positioned vertically under the model of the upper part of the flashlight.

Move the cylinder down along the Y axis until the upper cap is level with the head piece of the flashlight. Figure 1.6 shows the desired result.

## The Bottom Cap of the Flashlight

The screw-on bottom of the flashlight is more difficult because there is an additional hole that can be used for a wrist strap. First we will take care of the outer shape of the bottom cap and again use a rectangle spline, as shown in Figure 1.7. Change its size to a height of 90 and a radius of 170 units, and

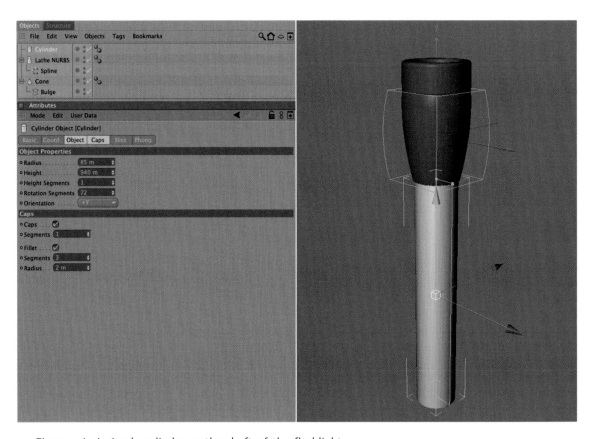

— Figure 1.6: A simple cylinder as the shaft of the flashlight.

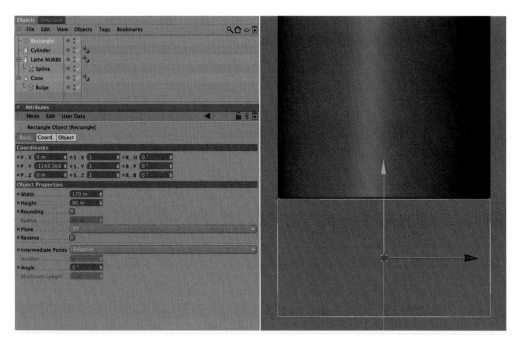

— Figure 1.7: Another rectangle spline as the base for the bottom cap of the flashlight.

place it as level as possible under the cylinder of the handle.

In order to gain direct access to the rectangle, you need to convert the spline with the (C) key as well as select the two points on the left side of the rectangle in the USE POINT TOOL mode. Switch the mode in the COORDINATE MANAGER to WORLD and set the X position value to 0. This should move the two selected points to the world Y axis.

Now select the lower of the recently moved points and right click in an empty spot in the viewport. In the context menu choose SET FIRST POINT. Then deactivate the CLOSE SPLINE option of the former rectangle spline in the ATTRIBUTE MANAGER, as shown in Figure 1.8. In case you can't see this option, click on the converted spline again in the OBJECT MANAGER to select it.

The reason for this action is that the spline can now be used with the Lathe NURBS to create a massive cap. Because the two points are positioned on the world Y axis, a closed cap is automatically created when the spline

is rotated. Of course we could have used a cylinder for this part, but with the spline it is easier to create round corners, especially when different radii are used. We already did that with the focus ring of the flashlight.

As mentioned, we will now create a new LATHE NURBS object and place the open spline as its child, as shown in Figure 1.9. If the location of the spline wasn't changed, then a cylindrical object should appear immediately. Then select the left points of the spline one by one and use the CHAMFER function to round the corners with different radii, as shown in Figure 1.9. This function can be found in the context menu after a right click into the empty viewport. If you have problems seeing the points on the spline, then deactivate the Lathe NURBS for a moment by clicking on the green checkmark behind the name in the OBJECT MANAGER. Another click on the checkmark activates the Lathe NURBS again. The ENABLED option in the BASIC settings of the Lathe NURBS in the ATTRIBUTE MANAGER has the same purpose.

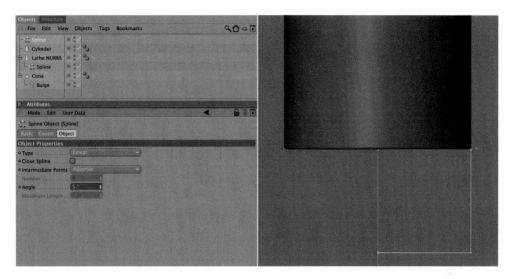

— Figure 1.8: The opened rectangle spline.

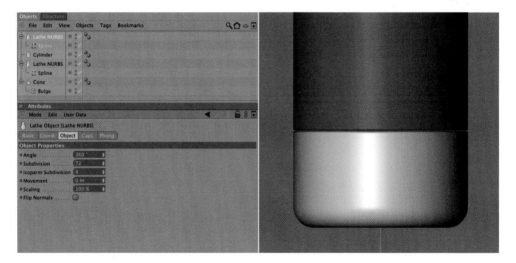

— Figure 1.9: The Lathe NURBS rotates the spline and creates a closed volume.

## USING SYMMETRY

Two parts should now be subtracted from the bottom cap to make space for a pass-through wrist strap. So first we need to create a new cylinder and give it a RADIUS of about 84 units. The HEIGHT is not so important for the next few steps. It should just be large enough so the cylinder protrudes past the lateral boundary of the bottom cap.

The cylinder should be located parallel to the world X axis. Therefore, pay attention to the +X or −X setting in the ORIENTATION menu of the cylinder. The sign doesn't matter for our purposes. Place the cylinder in the XY viewport so that it doesn't quite reach the Y axis. This can be seen in Figure 1.10 in the upper right image. Take a look at only the left of the two cylinders in this image. The right cylinder will automatically be generated in the next step by mirroring.

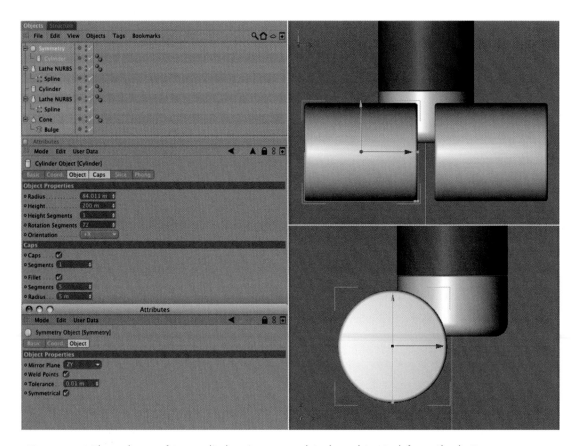

— Figure 1.10: The volume of two cylinders is supposed to be subtracted from the bottom cap.

In the ZY viewport, which is the side view of the scene, the cylinder should be located slightly in front of the bottom cap of the flashlight and close to the middle axis. The image on the bottom left of Figure 1.10 shows that placement.

In order to create a symmetrical cylinder on the other side, it is possible to just make a copy of the cylinder. It would have to be placed manually, though, and adjusted every time the first cylinder is changed. It is easier to use the SYMMETRY object, which can be found in OBJECTS>MODELING or in the corresponding icon menu. Place the cylinder as a child of the SYMMETRY object. Depending on the chosen symmetry plane, a virtual copy of the cylinder appears in the scene. The axis system of the SYMMETRY object acts as the base for the mirroring. The mirror plane there-

fore has to be set to ZY in the ATTRIBUTE MANAGER so the mirrored cylinder appears to the right of the original. Correct the position of the cylinder if necessary to get the result shown in Figure 1.10. Also add a fillet to the caps in the ATTRIBUTE MANAGER so a rounding is created when the cylinder is subtracted from the bottom cap of the flashlight. A radius of 5 units should be enough. Since we work entirely parametric, this setting can be changed anytime.

## CONNECTING OBJECTS WITH THE BOOLE OBJECT

Many complex forms can be created by combining simple shapes. The BOOLE object can be helpful, especially with mechanical parts.

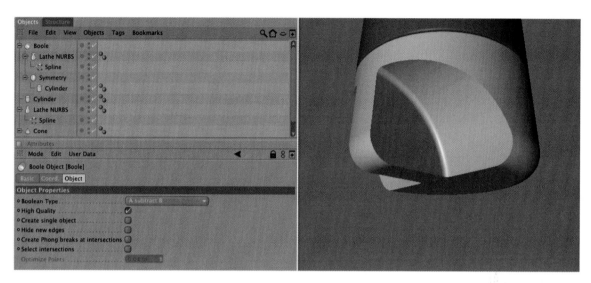

— Figure 1.11: The Boole object enables the subtraction of objects from each other.

It can be used to subtract shapes from an object or to calculate intersections between objects. In our example we created the cylinders for this purpose, which are currently stuck inside the bottom cap of the flashlight.

Therefore, we add a BOOLE object, found in the corresponding icon menu or in OB-JECTS>MODELING. It can be set to different modes in the ATTRIBUTE MANAGER in the BOOLEAN TYPE menu. A SUBTRACT B means that the second object subordinated under the BOOLE object (B) is subtracted from the first subordinated object (A).

The other options of the BOOLE object influence the quality of the calculation and are only of interest for further manipulation of the calculated object. The interconnected objects can still be edited as separate entities. With CREATE SINGLE OBJECT these objects can be merged to one single surface. HIGH QUALITY simply activates a different algorithm. Sometimes, though, the deactivation of this option can lead to a better result. HIDE NEW EDGES merges the faces created by the union of the objects into N-gons. This can result in a cleaner look and a more efficient geometry, and should be used when the BOOLE object

is to be converted into an editable polygon object.

Currently, all this is not that important to us. Just make sure that the Boolean type A SUBTRACT B is selected. Then subordinate the Lathe NURBS object and the SYMMETRY object under the BOOLE object. The order of the objects is important because the cylinders in the SYMMETRY object will be subtracted from the capsular Lathe NURBS object. Figure 1.11 shows that and the expected result. The cylinders reduce the front part of the bottom cap of the flashlight to a thin bridge in the center. If we drill a hole in this bridge, we can later pull a wrist strap through it.

In this step the position and diameter of the bore are defined by another cylinder. The length of the cylinder is also not important here, as long as it penetrates the bridge of the bottom cap all the way through. A radius of 15 units and a position as shown in Figure 1.12 should be enough.

In order to be able to subtract the cylinder from the Lathe NURBS cap for the bore, as well as the two laterally placed cylinders, we have to combine the SYMMETRY object and the new cylinder in a second BOOLE object. Set the second BOOLE object to A UNION B

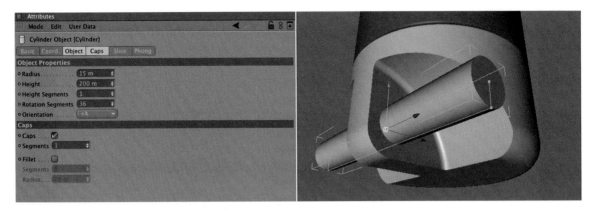

— Figure 1.12: A slim cylinder defines the bore.

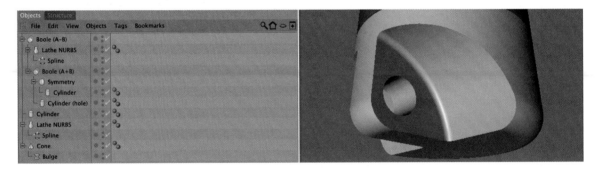

— Figure 1.13: Boole objects can be combined to create more complex shapes.

mode to get a solid unit, one volume created from the three cylinders. This unit can then be subtracted from the Lathe NURBS as we did before. Figure 1.13 shows the structure of the hierarchy between the BOOLE objects on the left and the result on the right. Since all objects remain parametric, the width of the bridge can be changed anytime by moving the cylinder in the SYMMETRY object. The bore can also be adjusted by changing the radius of the slim cylinder.

## The Knurling at the Head of the Flashlight

When adding roughness to surfaces, we have to first ask whether these need to be mod-
eled or whether it is enough to use a material property. In the case of the knurling on the head piece of the flashlight, I decided to model it with a ready-to-use STAR spline. I've set the number of points to 160 teeth and oriented the STAR spline along the XZ plane.

An inner radius of 126 and an outer radius of 127 generate flat spikes that are well suited for our purpose. Place the STAR spline as a child of a new EXTRUDE NURBS object from the OBJECTS>NURBS menu. A movement of 50 units along the Y direction should be enough.

Now move the star under the focus ring so that the knurling is positioned as shown in Figure 1.14. The figure also shows the other settings of the Extrude NURBS and the STAR spline.

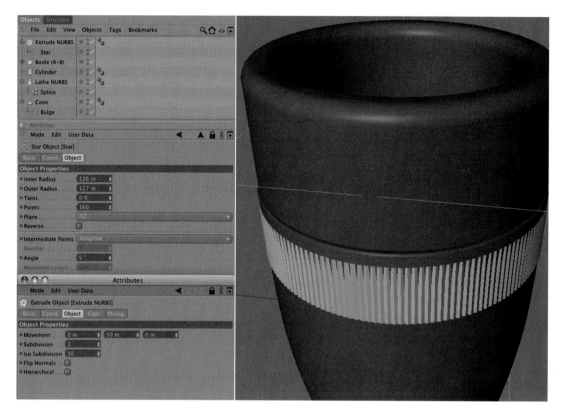

— Figure 1.14: Adding the knurl as its own object.

## CREATING A HOLE SPLINE

Everything looks fine from the outside, but there are some details missing from the inside of the flashlight head. In order to add these we need to *drill out* the recently created corrugation. We are forced, because of the shape of the knurl, to create caps through the Extrude NURBS. This, though, causes a problem inside the flashlight because the caps of the star will penetrate the reflector of the bulb, which we will model later. Consequently, the corrugation would have to be restricted to the outside casing of the flashlight.

A BOOLE object can be used to subtract a cylinder from the Extrude NURBS of the star. I would like to take this opportunity, though, to show the creation of a hole spline, which means curves with encased hollows.

Add a CIRCLE spline and subordinate it under the STAR spline in the OBJECT MANAGER. The advantage here is that we can adjust the alignment and position of the circle in the COORDINATE MANAGER. Therefore, set the COORDINATE MANAGER to OBJECT mode and reset all position and rotation values to 0. Don't forget to press the APPLY button. Then check the plane of the CIRCLE spline and, if necessary, correct it in the ATTRIBUTE MANAGER to the setting XZ. Now the star and circle are located in exactly the same plane and position.

### Connect Splines

To create a hole spline, the two splines have to be combined into a single one. Because both are still parametric they need to be converted first. Select the two splines with (Ctrl) or clicks, or by a frame selection with the

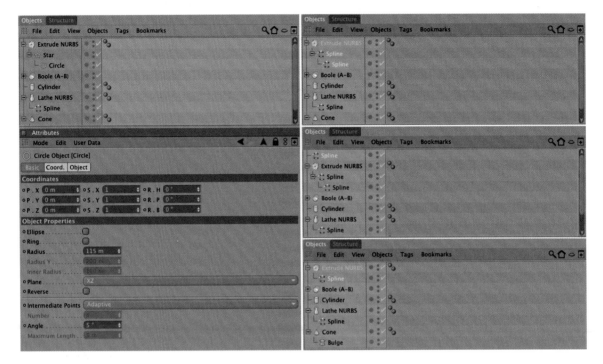

— Figure 1.15: Apply a notch to the Extrude NURBS.

mouse in the Object Manager. Then select Make Editable in the Functions menu or simply use the (C) key. The result can be seen in the upper right of Figure 1.15. The two still selected splines can now be combined into a new spline with Functions> Connect. This new spline now appears on the top of the list in the Object Manager. The two original splines still remain. The center image on the right side of Figure 1.15 shows this situation.

You can now delete the two original splines. Just use the (Delete) key or select the Delete command under Edit in the Object Manager. Of course, the two splines about to be deleted have to be selected first.

The newly connected spline can now be placed as a child of the Extrude NURBS, as shown on the bottom right of Figure 1.15.

Before the connection we dealt with two individual splines that used different interpolations. The star had a linear interpolation and the circle a cubic interpolation. After connecting the two splines, only one type of interpolation can be used for both segments. In the case of the linear interpolation, it would look like the left side of Figure 1.16. The star remains unchanged, while the circle on the inside, since its points are no longer connected in a cubic manner but in a linear one, changes to a square.

In this case you can switch to Bezier interpolation. Select the inner four points belonging to the circle and right click into the empty area of the viewport. Select Soft Interpolation in the context menu. The selected points automatically receive soft interpolated tangents. Now the circle gets its shape back almost completely, as seen in the right part of Figure 1.16.

In order to get back the outer corners of the star spline, invert the current point selection of the four inner points by selecting Selection>Invert and right clicking in the viewport. Choose Hard Interpolation in the context menu to reduce the tangents of the points to 0 lengths.

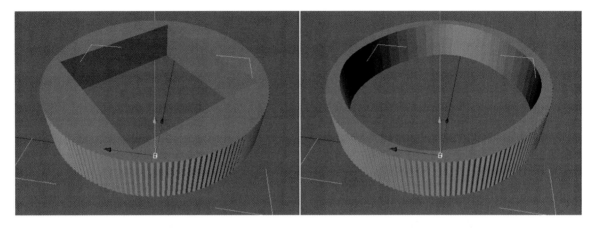

— Figure 1.16: Influencing the shape of the hole.

## The Reflector of the Flashlight

When looking through the focus ring, we see the cap of the deformed cone. This will now be changed by adding some more parts. Start with a new CIRCLE spline, which can be deformed individually along its two axes by using the ELLIPSE option in the ATTRIBUTE MANAGER. As you can see in Figure 1.17, I aligned the ellipse in the front view so it remains exactly on the world Y axis. Its lower end protrudes into the head part of the flashlight in such a way that the curve of the ellipse portrays the reflector.

I used a radius of 105 units in the X direction and 100 units in the Y direction. This is not set in stone, though. The ellipse shouldn't extend to the upper part of the focus ring. Instead it should extend into the lower part.

Similar to the bottom part of the flashlight, the reflector will be built by rotating the ellipse spline using a Lathe NURBS. But we only need the bottom part of the ellipse. Therefore, convert the CIRCLE spline by pressing the (C) key, switch into the USE POINT TOOL mode, and select the lowest point, as shown in Figure 1.18. With a right click into an empty part of the viewport, open the context menu and select SET FIRST POINT. This is necessary because the spline has to be opened,

and this opening is always located between the first and last point of the spline. Deselect the CLOSE SPLINE option of the spline in the ATTRIBUTE MANAGER and delete the two ellipse points on top and on the left. What remains is the lower right quarter part of the ellipse, as shown on the right side of Figure 1.18.

Now we will shape the part of the spline that protrudes from the flashlight without changing the remaining shape of the spline. Therefore, we need to add a point to the spline. Activate the MOVE tool in USE POINT TOOL mode and hold the (Ctrl) key while clicking on the spline. This creates a new point at the spot where we clicked without changing the course of the spline.

Click the mouse in the area of the spline just before where it reaches the inner wall of the focus ring. The left part of Figure 1.19 shows the location and the newly created point. Then select the point at the upper end of the spline and select HARD INTERPOLATION in the context menu. Now move this point down as far as is shown on the right side of Figure 1.19. You will have to adjust the upper tangent of the new spline point, so hold the (Shift) key in order to move the tangent arms independent of each other. The goal is to soften the transition between reflector and focus ring.

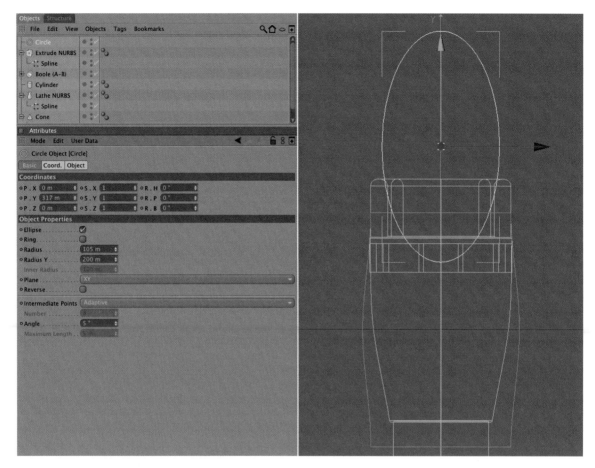

— Figure 1.17: The basic shape of the reflector in the head of the flashlight is created with the help of the Circle spline.

Add a LATHE NURBS object and subordi-nate the spline under it. For a better view of the reflector it might be helpful to make the surrounding objects invisible. Use the upper of the two gray dots behind the objects in the OBJECT MANAGER. Double clicking on the dot changes its color to red and makes the object invisible. Another click on the dot allows the object to appear again.

**THE LIGHT BULB IN THE REFLECTOR**

In order to get our flashlight to illuminate, we need a light bulb at the base of the reflector. We could just put an object at the reflector, but instead I want to cut a hole into the reflector so the light bulb can protrude through it. Generally it would be enough to move the lowest point of the reflector spline away from the Y axis, creat-ing an opening at the Lathe NURBS. The flank of the reflector would change its tilt at the same time, though, and I want to avoid this.

As a result we will use a new slim CYLIN-DER and combine it with a BOOLE object, as shown in Figure 1.20. The volume of the vertical cylinder is then subtracted from the reflector bowl and creates the desired opening. Note that the Boole object does not use the A SUBTRACT B mode this time since we aren't working with two volumes. The

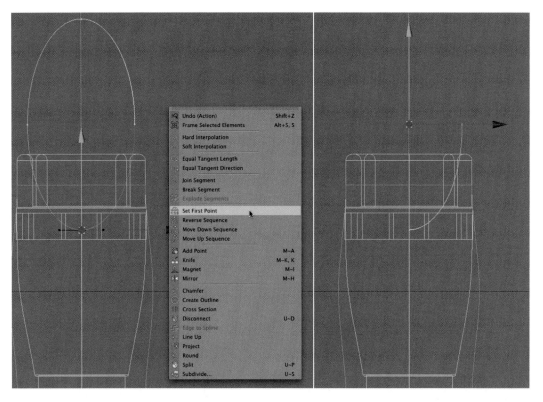

— Figure 1.18: Removing part of the ellipse.

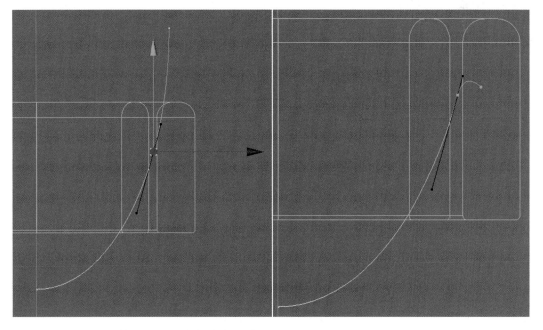

— Figure 1.19: Shaping the upper edge of the spline.

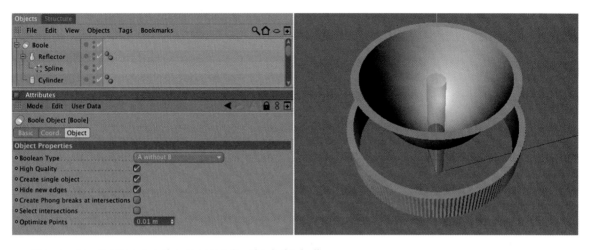

— Figure 1.20: Cutting out the opening for the light bulb.

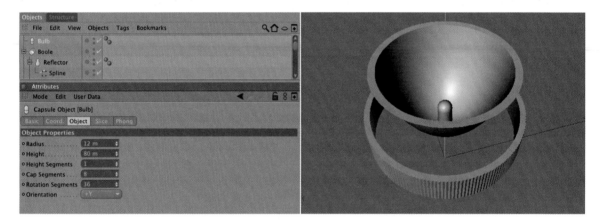

— Figure 1.21: Adding a capsule as the light bulb.

reflector is just a thin-walled bowl. To create the opening we have to use the A WITHOUT B mode. The volume of the cylinder will then be subtracted from the open bowl and creates the desired effect. Figure 1.20 shows, superimposed on the right, the cylinder and underneath the reflector with the resulting opening.

For the actual light bulb we don't need many details. I recommend using the CAPSULE object of CINEMA 4D. Its shape is close enough to the shape of a light bulb. Choose a capsule RADIUS slightly under the radius of the cylinder used to cut the hole in the reflec-

tor. Figure 1.21 shows my settings and the finished result on the right.

### THE COVER GLASS OF THE FLASHLIGHT

The only thing missing is the cover glass on top of the reflector. It is very thin and doesn't have any special facets. As a result we can use a simple flat cylinder for this part. Add a new cylinder, align it vertically, and match its radius to the upper edge of the reflector. One unit is enough for the height. Make sure that the cylinder lies

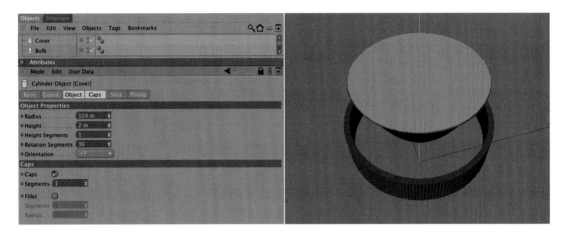

— Figure 1.22: A flat cylinder acts as the cover glass.

flush on top of the reflector, as shown in Figure 1.22.

## FINISHING THE MODEL

After making all parts of the flashlight visible again, depending on the intrusion depth of the reflector, we notice something. Even though we have faded out the knurling by building the hole spline for the reflector, the upper cap of the deformed cone is still in the way. We could convert the cone into a POLYGON object and delete the cap, but then we would lose the parametric properties of the cone. Therefore, I decided to use a BOOLE object to subtract a cylinder from the upper part of the cone.

Figure 1.23 shows the necessary hierarchical structure and the position of the cylinder on the left side. As for the size of the cylinder, it is important only that it doesn't penetrate the sides of the cone and that it

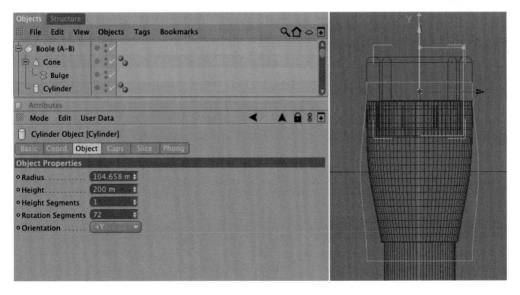

— Figure 1.23: Making space for the reflector.

leaves enough space for the lower end of the reflector and the light bulb. This completes the model and we can now focus our attention on the surface and the lighting.

## The Texturing of the Flashlight

Part of the flashlight handle has a diamond-shaped pattern, which makes it less slippery. I don't want to use additional geometry, like with the knurling beneath the focal ring. This time I will use bump, a material property. This is always recommended when the structure is so flat that it doesn't significantly change the shape of the object.

We start by creating a new material in the MATERIAL MANAGER by going to FILE > NEW MATERIAL. A double click on the gray preview sphere in the MATERIAL MANAGER opens the settings of this material in a separate MATERIAL EDITOR. These settings could also be done in the ATTRIBUTE MANAGER.

We will disregard all the color settings for now and concentrate on the roughness of the material. The BUMP channel is used for simulating this roughness. It can be activated on the left side of the MATERIAL EDITOR with a checkmark and edited by clicking in the

right side. There we will need a diamond-shaped structure. Of course, we could find an image of this structure in an image collection or create it ourselves in Photoshop. We have more flexibility, however, when we build these kinds of structures with shaders directly in CINEMA 4D.

For all structures that are constructed by straight lines, the TILES or GRADIENT shader can be used. The latter gives us more control over the width and direction of the lines. The GRADIENT can be found in the menu that opens after clicking on the triangle button in the TEXTURE area of the BUMP channel. The settings of the GRADIENT shader can be accessed by clicking on the large button in the TEXTURE area of the material channel or by clicking on the preview image of the shader.

### CONTROLLING THE GRADIENT

Figure 1.24 shows the GRADIENT shader loaded inside the BUMP channel and all the settings necessary to create a diamond-shaped pattern. Choose the gradient type 2D-DIAGONAL and adjust the color handler so the middle color of the gradient is black and the left and right sides are white.

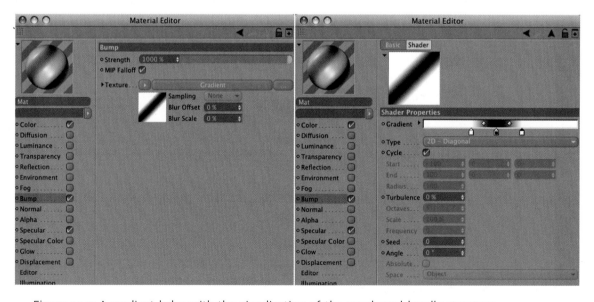

— Figure 1.24: A gradient helps with the visualization of the roughened handle structure.

The color tabs can simply be moved with the mouse. These positions can also be set numerically in the advanced settings by double clicking on the small triangle in front of the gradient, making these settings visible. New color tabs can be added with a mouse click directly under the gradient. Obsolete color tabs can be removed from the gradient by pulling them upward with the mouse. The color values of the color tabs can be edited in the advanced settings under the gradient or by opening the system color chooser and double clicking on the color tab.

The goal is to create a diagonal black line. In order to turn this line in a diamond pattern, the CYCLE option has to be activated in the shader. It allows us to tile the shader, or repeat it multiple times, on the surface.

## APPLYING THE MATERIAL

In order to increase the effect of the bump, we need to return to the level of the BUMP channel. To return, use the upward arrow in the upper right corner of the MATERIAL EDITOR or just click on the word *Bump* in the channel list on the left side. Then increase the intensity of the bump to 1000% using the STRENGTH value. Values above 100% can be entered directly in the numerical field. The slider itself can only go up to 100%.

## ADJUSTING THE TEXTURE TAG

Pull the material from the MATERIAL MANAGER onto the handle cylinder in the OBJECT MANAGER. To make the projection onto the object easier, choose a projection type similar to the shape. In the TEXTURE TAG settings, which can be seen in the ATTRIBUTE MANAGER, choose CYLINDRICAL as the PROJECTION of the material. If you can't see these settings, simply click on the small material symbol behind the cylinder in the OBJECT MANAGER. The size of the projection can be found and adjusted in the COORDINATES section of the ATTRIBUTE MANAGER.

If you prefer more visual options, then activate the USE TEXTURE TOOL mode. Make sure that the TEXTURE TAG behind the cylinder is active, which is indicated by the white frame around the symbol. This mode shows a preview of the projection in the viewports. A yellow grid indicates the size and position in 3D space. The common tools for moving, rotating, and scaling can be used to change the direction of the material projection.

In order to fit the projection to the dimensions of the object, use the FIT TO OBJECT command in the TAGS menu of the OBJECT MANAGER. In our case the corrugation is not supposed to cover the entire length of the handle, but only a part of it. We will look into that in a moment. First, we must determine the correct proportion of the bump so that the corrugation has the proper size and number on the cylinder.

The size, shape, and number of diamonds are determined by the size of the projection and controlled by the number of tiles in the TEXTURE TAG. As shown in Figure 1.25, I used 100 tiles in the X direction and 50 in the Y direction, with a Y length of the projection of 300 units. In addition, the options TILES and SEAMLESS need to be activated. The SEAMLESS option alternately mirrors the tiles and actually generates the diamond structure, since the gradient itself shows only a diagonal line. The alternate tiling of these lines to one another builds the diamond shape. By placing the INTERACTIVE RENDER REGION, which can be found in the RENDER menu in CINEMA 4D, over the cylinder in one of the viewports, we can easily follow the changes made by the number of tiles or the size of the projection. Figure 1.25 shows the desired result on the right.

## RESTRICTING THE MATERIAL

Upon a closer look, we realize that when tiling the texture, the covered area became larger than the original area of the projection. Even when the area for the corrugation is defined by the Y length of the projection, the pattern continues beyond these limits. This is always the case when the TILES option has been activated. The preview of the

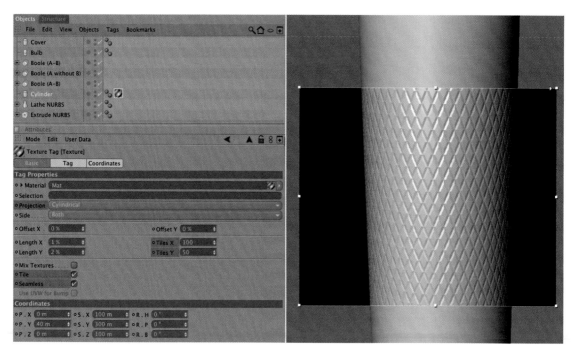

— Figure 1.25: The color gradient on the handle cylinder.

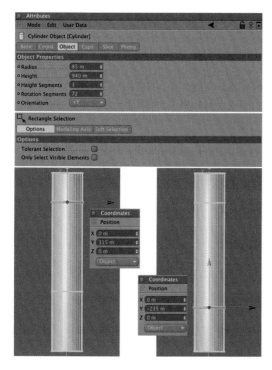

— Figure 1.26: Moving edges to define the area of corrugation on the handle.

projection in Use Texture Tool mode loses its function with regard to the area covered on the object. We can counteract this by creating a polygon selection. A scaled polygon strip on the cylinder has to be selected and a material applied to it. In the first step, increase the number of Height Segments of the cylinder to 3. This creates two additional segments along its height.

Now, we can't avoid it any longer: we need to convert the cylinder to a Polygon object so we can gain direct access to the points and faces of the cylinder. Press the (C) key and switch to the Use Point Tool mode. Use the Frame Selection to select the upper of the two subdivisions. In the Coordinate Manager enter the value 315 for the Y position of these points. Then press the (Enter) key or the Apply button to actually apply this value. The points in the lower subdivision are to be changed in the same manner and moved to the Y position of 235. Both measures were applied in the Object coordinate system of the cylinder. These steps are illustrated in Figure 1.26.

We will now switch to the USE POLYGON TOOL mode and use the RING SELECTION, in the SELECTION menu, to select the polygon strip that is between the two previously moved subdivisions. With the RING SELECTION tool activated, move the mouse over the middle polygon strip and click on it when the desired faces are highlighted. Then select SET SELECTION, also located in the SELECTION menu. This saves the information of the selected faces in a polygon selection tag, which then appears in the OBJECT MANAGER, behind the cylinder.

The selection tag becomes active when you click on it once. Its name can be changed in the ATTRIBUTE MANAGER and the saved selection can be accessed by means of sev-

eral buttons. For applying a material, though, only the name is of importance. As shown in Figure 1.27, I used the name "grooved" and entered this name into the SELECTION field of the TEXTURE TAG. An even easier way is to simply pull the selection tag from the OBJECT MANAGER directly to the SELECTION field of the TEXTURE TAG dialog in the ATTRIBUTE MANAGER. From now on, the material will be restricted to the faces saved in the selection tag.

### CREATING THE REST OF THE MATERIALS

All the remaining materials will not need visible structures and can be applied by a simple drag and drop onto the object. But first we

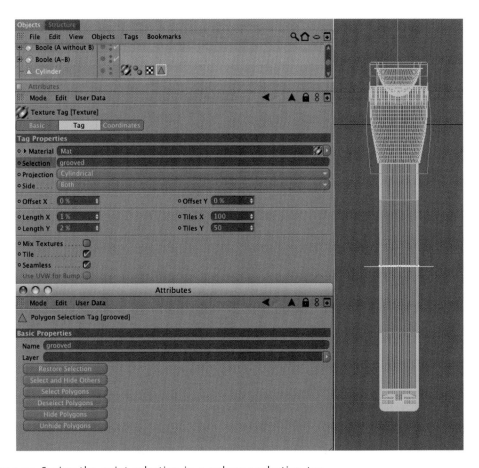

— Figure 1.27: Saving the point selection in a polygon selection tag.

need to finish the texturing of the flashlight handle. Open the material with the gradient in the BUMP channel using a double click in the MATERIAL MANAGER. Activate the COLOR channel by clicking on it in the channel list on the left. There, use a very dark and desaturated blue. Metals generally have a very dark color.

Metals get their appearance more by way of their reflective properties, which we will now apply by using the REFLECTION channel. Activate the REFLECTION channel with a checkmark and set a slightly blue color with medium brightness. In order to make the metal appear less polished, increase the value for the BLURRINESS to 20%. This increases the render time but looks more natural for a basic commodity like a flashlight. The highlight should be relatively small but intense. This setting can be made with the HEIGHT and WIDTH settings in the SPECULAR channel.

Lastly, go to the ILLUMINATION channel and switch to the OREN-NAYAR MODEL. This increases the impression of a slightly rough surface. All these settings can be seen in detail in Figure 1.28. Use the same settings for a second new material that will be used for the head and bottom of the flashlight. No bump is necessary in these areas.

**The Material of the Reflector**

The reflector is nothing more than a mirror. It often would be enough to just use a mate-rial with reflective properties and a highlight. But we have to keep in mind that there are not many objects, or even an environment, available around the flashlight. Even with high reflection values, not much would be reflected in the reflector. Consequently, we will use a trick and simulate a light reflection in the reflector by using additional material properties.

Create a new material that you could call *Reflector*, and apply a strong REFLECTION of about 95% and a small intense SPECULAR. In addition, activate the LUMINANCE channel, set it to 50%, and reduce the color brightness of the COLOR channel to about 40%. Figure 1.29 shows all settings in detail. This causes the reflector to react, in addition to the reflection, to the incoming light and be brightened through luminance. We will see if all this looks as desired at the end, after the lighting is added.

**The Glass Material**

The material for the lens is structured in a simple way. One main part, of course, is a high brightness in the TRANSPARENCY channel. The EXIT REFLECTIONS option can be turned off since this doesn't matter with such thin objects and would only use up valuable render time. A REFRACTION of 1.5 is enough for glass. In addition, I want to strengthen the reflective properties by activating the REFLEC-TION channel with a brightness of 100%. This

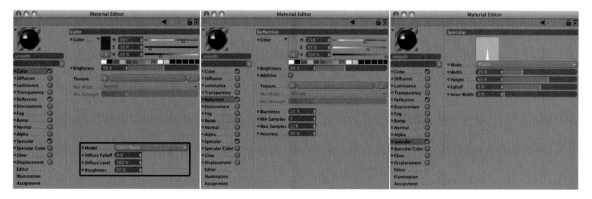

— Figure 1.28: The material of the flashlight.

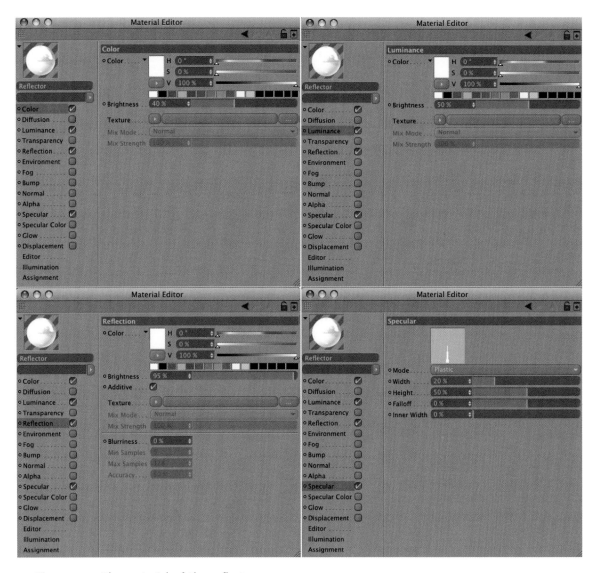

— Figure 1.29: The material of the reflector.

high value will be balanced by the strong transparency. The brightness of the color is reduced to 20%. I don't use a highlight this time, since the reflector behind delivers enough brightness. All these settings are shown in Figure 1.30.

## THE FLOOR IN THE SCENE

I want to add a floor to put the flashlight on so it doesn't just float in 3D space. This floor should simply have a white color. We will create a new material and give it a brightness of 100%, as shown in Figure 1.31. The desired overall matte look is generated by the settings in the ILLUMINATION channel. We use again the OREN-NAYAR MODEL and increase the DIFFUSE REDUCTION value to 100%. This widens and diffuses the highlighted area on the object as seen at the preview sphere of the material.

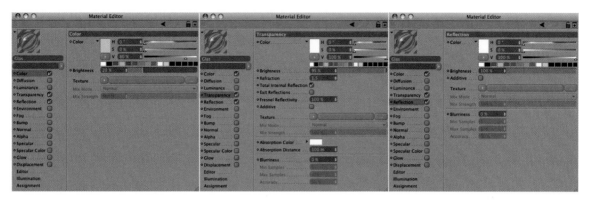

— Figure 1.30: The material for the lens of the flashlight.

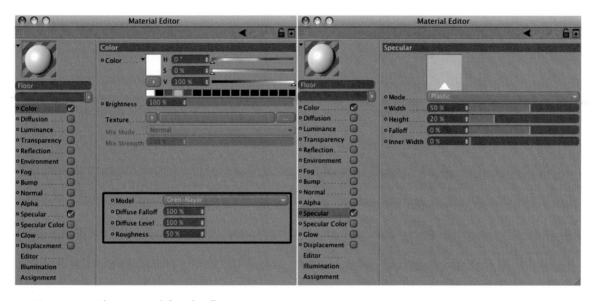

— Figure 1.31: The material for the floor.

Negative values can also be used when polished surfaces are portrayed. Then the brightness is more concentrated around the highlight and less scattered across the surface.

As the object for the floor, either a POLY-GON or PLANE object could be used. However, in some cases it is better to use the FLOOR object since it has a special property. It automatically expands up to the horizon of the scene when rendered, actually becoming infinite.

We will add this FLOOR object, which can be found in OBJECTS>SCENE, and apply the previously created material to it. Don't be fooled by the small square area in the viewport. The floor will cover the entire area of the scene after the image is rendered. The FLOOR object can also be moved and rotated just like any other object. Therefore, it can also be used for different purposes, like the roof of a very large hangar or the sky.

The parts of the flashlight should now get the appropriate materials. Simply pull the

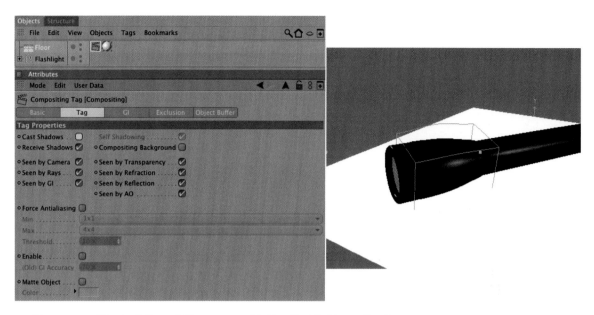

— Figure 1.32: The building of the scene with the flashlight on the floor.

materials from the MATERIAL MANAGER onto the respective object in the viewports or onto the names in the OBJECT MANAGER. Only the corrugated part of the handle that already has a material applied has to be treated differently.

Although the handle already has a material applied to it, the remaining faces have to receive a material as well. This is no problem, since an object can receive multiple materials. What is important here is the order of the materials behind the object in the OBJECT MANAGER. The material on the very top is always placed on the far right behind the object. This works just like a layer system. First pull the blue flashlight material without the BUMP channel onto the handle cylinder. The corresponding TEXTURE TAG symbol will then appear to the right of the previously applied TEXTURE TAG of the corrugated part. The flashlight material now covers the corrugated material.

As a result, we have to change the order of the TEXTURE TAGS manually. Drag and drop in the OBJECT MANAGER in such a way that the material without the bump structure is

placed on the bottom, to the left of the corrugated material. Then group all the parts of the flashlight with a Null object. The fastest way to do this is to select all objects, except the floor, with a frame selection in the OBJECT MANAGER and then press the key combination (Alt) + G. This will group the selected objects under a Null object that can then be renamed to flashlight.

Then rotate and move the flashlight so it appears to lie on the floor. This can be seen in Figure 1.32 on the right.

**The Compositing Tag**

Many properties of the objects can be controlled during the rendering with a COMPOSITING TAG. We want to try this with the FLOOR object. Right click on the FLOOR object in the OBJECT MANAGER and choose CINEMA 4D TAGS>COMPOSITING TAG from the context menu.

The COMPOSITING TAG offers many options in the ATTRIBUTE MANAGER for determining how the object should behave in the scene later on. For example, the object could be set

to invisible for the camera, yet remain visible in reflections or behind glass walls. Shadows could also be turned off, or the precision level for the global illumination or the edge smoothing could be altered. Other options adjust the calculation of individual alpha masks, like with the Multi-Pass rendering. In our case we just need to deactivate the shadows and the SEEN BY GI options. This will prevent the floor from participating in the global illumination.

## The Light Sources in the Scene

Every scene automatically contains a light that can have its position adjusted in the DISPLAY>DEFAULT LIGHT menu in every viewport. This light source is not suitable for the final lighting, though, since neither the intensity nor the shadows can be edited. Therefore, we will place other light sources into the scene. As soon as a light is added to the scene the default light turns off. In this case, I'd like to use a classic studio light setup with a main light and a fill light. Both lights should be AREA lights because these lights simulate a very realistic behavior. Real light sources also have a certain areal expansion and don't consist of just a point in space.

I place one of the AREA lights, based on the view through the camera, behind the flashlight. This light is very intense and will also appear in the reflections of the flashlight by activating the SHOW IN REFLECTION option in the DETAILS section of the light source. The VISIBILITY MULTIPLIER will increase the reflection even more. Because this light is positioned right behind the flashlight I increase its INTENSITY manually to 200%. As with many parameters controlled by sliders, values larger than 100% can be set by entering them directly into the numerical field. The option for GI ILLUMINATION remains deactivated. Such an intense light would overpower the scene in a global illumination calculation.

It is also important to be sure that the floor isn't affected by the light source; if it is,

it would appear way too bright. Pull the FLOOR object from the OBJECT MANAGER into the OBJECTS list found in the SCENE portion of the light source dialog. With the MODE menu set to EXCLUDE, the objects listed will not be affected by the light source. The icons behind the listed objects, representing single attributes like highlight, diffuse illumination, or shadows, can be used to exclude certain attributes from this restriction. For example, if we deactivate the icon for the highlight by clicking on it, the object won't be diffusely lit and won't cast any shadows, but it would still have a highlight from the light source, provided of course that the material of the floor permits a highlight.

Figure 1.33 shows the settings of this light source in detail on the left. On the right are the parameters for the second light source. It is also an AREA light but with much less intensity and without reflective properties. Here we permit global illumination by activating the GI ILLUMINATION option.

As for the positioning of the lights, just take a look at Figure 1.34. The intense and reflective light is positioned as a small strip to the left of the flashlight. The weaker fill light is opposite as a slim, vertical strip. These positions should be tested with test renderings or, even better, with the INTERACTIVE RENDER PREVIEW to adjust them to your liking.

Figure 1.35 shows the desired effect after the rendering of the current viewport. I had set the ANTI-ALIASING to BEST in the RENDER SETTINGS in order to be able to judge the effect of the bump material on the handle. I also activated the AMBIENT OCCLUSION in the RENDER SETTINGS to create shading in the area between the flashlight and the floor without a real shadow generated by a light source. I increased the MAXIMUM RAY LENGTH to 500 units, which is adjusted to the dimensions of our flashlight. A DISPERSION of 80% restricts the scattering of the samples and thereby increases the contrast of the AMBIENT OCCLUSION at the edges.

I already like the intensity of the reflection at the head of the flashlight. Only the

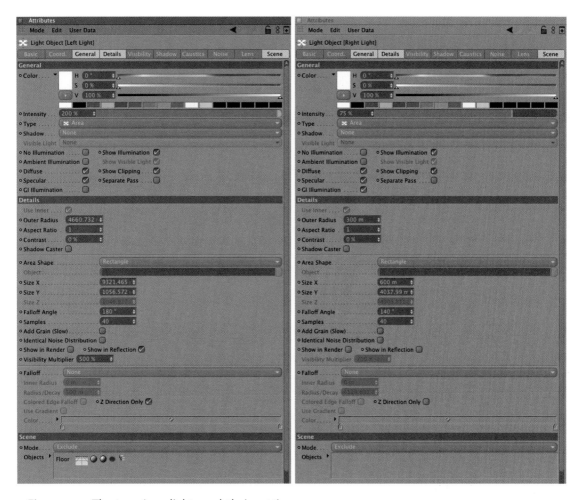

— Figure 1.33: The two Area lights and their settings.

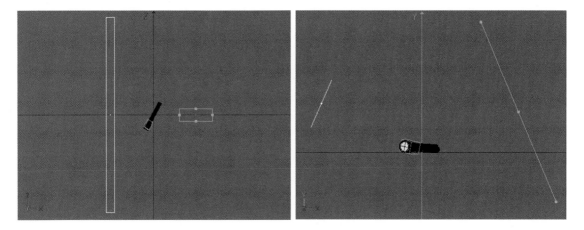

— Figure 1.34: The position and size of the two Area lights.

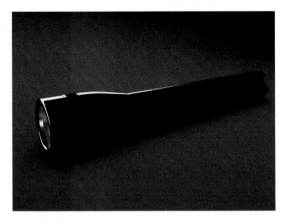

— Figure 1.35: The effect of two light sources on the flashlight.

overall brightness needs to be improved. This is the fault of the flashlight material, which mainly consists of reflective materials and reacts only slightly to diffuse illumination.

To add reflections to the upper part of the flashlight, an object has to be placed there. We are going to use a hemisphere that will

hover over the scene. Create it by adding a sphere and changing the TYPE to HEMISPHERE. Change the size and position so the two lights, and of course the flashlight, are located underneath the hemisphere, as shown in Figure 1.36.

Also apply a COMPOSITION TAG to the sphere object. We already used this tag to control the rendering of the FLOOR object. This time we will deactivate the CAST SHADOW and RECEIVE SHADOW options as well as the SEEN BY CAMERA option. Now the hemisphere can only be seen in the reflections of the flashlight and is not in the way when we look for the right camera angle.

Additionally, we need to deactivate SEEN BY AO so the hemisphere is excluded from the AMBIENT OCCLUSION and does not create a shadow on the floor. All these settings can be seen in Figure 1.36, which also shows how much the rendering was improved. Because of the reflection of the hemisphere in the metal of the flashlight, the surface shading appears much brighter and more vivid.

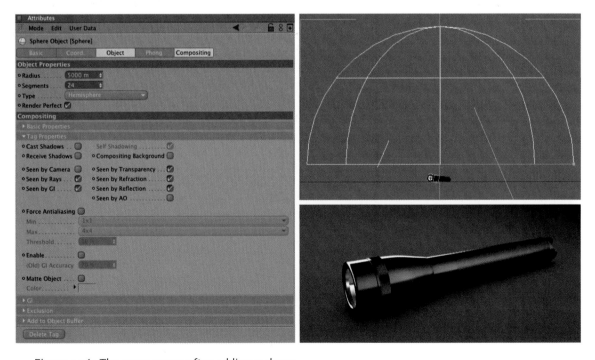

— Figure 1.36: The same scene after adding a dome.

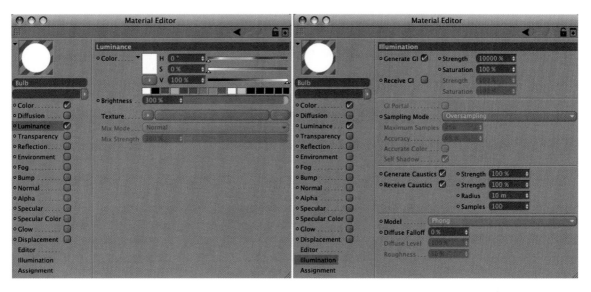

— Figure 1.37: Getting the light bulb to glow.

## Lighting with Global Illumination

To simulate the switched-on flashlight, we could place a spotlight on the reflector and adjust its opening angle to the width of the lens. We can go a step further, though, by using global illumination. Not only does this define the light bulb itself as the light source, but also the indirect light and the light reflected from the hemisphere will enhance the look of the image.

In order for the light bulb to emit light, it has to receive a material with illuminating properties. Also, the intensity for the global illumination and the SAMPLING MODE has to be defined on the ILLUMINATION page. The size of the object plays a part, too. The smaller an object, the more illuminated it has to be to create an illumination effect. Thus, in the case of the light bulb, I have to use extreme values like 10000% for the GENERATE GI STRENGTH and 300% for the SATURATION, as shown in Figure 1.37. These values are multiplied to define the actual illumination strength.

The SAMPLING MODE in illuminating materials defines how they are sampled during the global illumination calculation. Figure 1.38 shows a visual comparison of the light bulb material and the results after activating the global illumination and changing the SAMPLING MODE. It also lists the render times, showing how increasing the sample accuracy has a direct influence on the render time. We have to find a compromise between quality and render time here. Keep the SAMPLING MODE OVERSAMPLING for now and apply the material to the light bulb by pulling it onto the CAPSULE object in the OBJECT MANAGER.

### USING GI PORTALS

A GI PORTAL is an object that lets GI rays pass without using render time to do so. This is helpful when light shining through a window is supposed to illuminate a room. The window glass would then be such a GI portal. In our example this property would apply to the lens because the light bulb beneath is supposed to send its rays out into the scene.

For that purpose we open the glass material again and go to the illumination setting, as shown in Figure 1.39. As you can see,

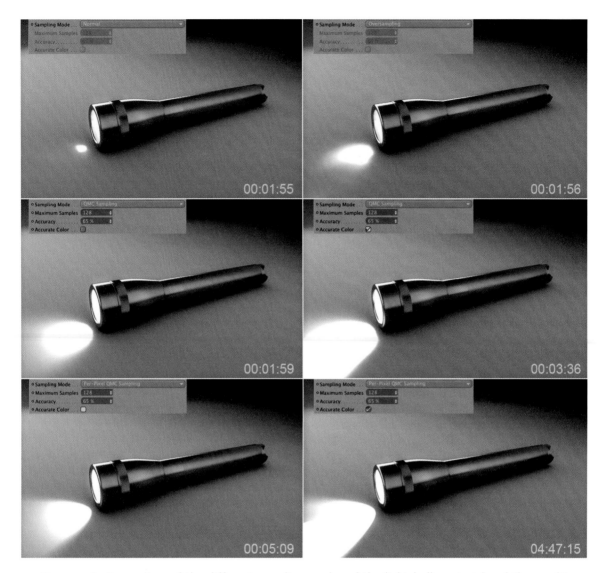

— Figure 1.38: Comparison of the different sampling modes of the light bulb material and the resulting render times.

I completely deactivated the generating and receiving GI properties. The more transparent a material is, the less it benefits from global illumination. Therefore, we can do without it here and save some render time. The GI PORTAL option also bundles the calculation rays of this object since—as the name *Portal* indicates—a passing of light through the object is expected.

The reflector material also has illuminating properties. Here the SAMPLING MODE controls the evaluation of this object during rendering by global illumination. Since this object doesn't affect the illumination of the scene as much as the light bulb, we can use the relatively fast but also softly interpolated OVERSAMPLING. Figure 1.40 shows these settings again.

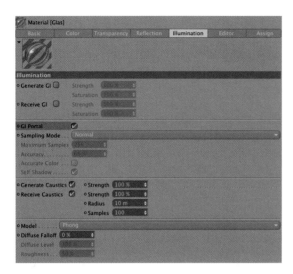

— Figure 1.39: The lens and its illumination settings.

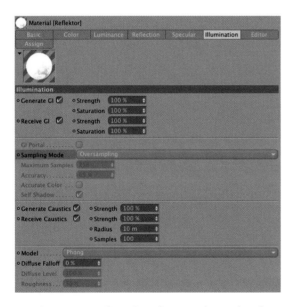

— Figure 1.40: Changing the sample mode of the reflector material.

## THE RENDER SETTINGS FOR GLOBAL ILLUMINATION

Despite the wealth of possible settings for global illumination, CINEMA 4D makes it easy for us since we only see the fine adjustments when we actually need them. First select GLOBAL ILLUMINATION from the list of effects and then decide on the GI mode for the rendering. The QMC mode is very precise but needs a lot of samples to achieve a minimum amount of noise and is therefore too slow for a high-resolution image. The IRRADIANCE CACHE, on the other hand, looks for image areas that need more samples than other parts and then interpolates between the different levels of brightness. It is quite fast and delivers an almost noise-free result. The down side is that small details get lost during the interpolation. Regardless, this mode is the best choice in most cases because calculation data can be saved and loaded, making global illumination in animations usable. Since we have a still image, we ought to choose the IR (SINGLE IMAGE) mode and leave the DIFFUSE DEPTH at 1 with a PRIMARY INTENSITY of 100%. That means the light will bounce only once from another surface. This should be enough, since we also have traditional light sources in the scene that aid with the illumination. The other settings in the IRRADIANCE CACHE section remain at their standard settings.

I also activated the GLOW effect, as shown in Figure 1.41. This effect can be found in the list of all POST effects by clicking on the EFFECTS button. It superimposes a light halo on all light places in the image and by doing so softens the image, making it look more natural. Such image manipulation can also be done in postproduction. The base parameters of the GLOW effect are the size and intensity of the effect. Both depend on the size of the rendered image and are difficult to estimate. Therefore, test renderings using the final size of the image are necessary. This is another reason to create such effects in postproduction.

You can also see the described settings of the AMBIENT OCCLUSION in Figure 1.41. I have, based on the color of the flashlight, set the color value at the right edge of the gradient to a dark blue so the simulated shadow underneath the flashlight doesn't appear too dark and is better integrated into the overall

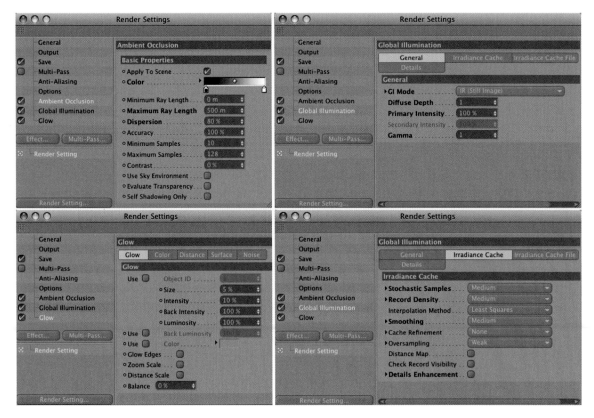

— Figure 1.41: The render settings for the flashlight scene.

image. The last thing to do is to enter the desired render resolution into the OUTPUT section and the file path in the SAVE section of the RENDER SETTINGS, and to start the rendering in the PICTURE VIEWER. The result of my rendering can be seen in Figure 1.42.

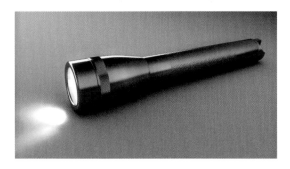

— Figure 1.42: The rendered image with global illumination and glow effect.

## Modeling with the HyperNURBS Object

So far we have only used NURBS objects as help objects that can generate POLYGON objects out of spline curves. The HyperNURBS object is different from the other NURBS objects since it needs a POLYGON object to actually do something. It is quintessential for modeling rounded objects. The HyperNURBS is able to subdivide and automatically place these subdivisions to make the object look rounded.

### A Short Example

A short example will clarify its abilities. Create a primitive cube and add two segments

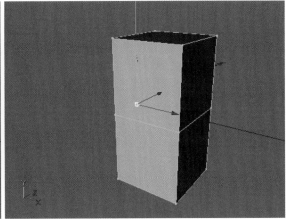

— Figure 1.43: A cube is converted and cut in half by deleting some points.

in the X direction and two in the Y direction in the ATTRIBUTE MANAGER. Then change the Z size to 100 units and convert the cube using the (C) key. Change into USE POINT TOOL mode and select all points that are located to the left of the center of the cube in the front viewport. Delete these six points by using the (Delete) key. Make sure that the mouse pointer sits over one of the viewports. Otherwise, when the pointer is located over the OBJECT MANAGER, the (Delete) or (Backspace) key then deletes the whole object and not just the selected points. Figure 1.43 shows the desired state of the object.

In the next step, select the lowest four points and scale them along the Z direction to about one-third of the original distance between them. Then move the points of the half cube as shown in Figure 1.44. Can you guess what the final shape will be?

The shape should look like a stylized heart by now. Make sure that the four points on the lower left edge of the shape remain exactly on the ZY plane. We will want to amend the left side of the heart with a SYMMETRY object. The SYMMETRY object combines points that are located exactly on the mirror plane. This is an important feature to ensure that the original and the copy will fit together seamlessly.

In a moment the HyperNURBS will automatically subdivide and smooth the roughly modeled shape. This can only be done, however, with a completely closed volume. Open edges remain sharp after the HyperNURBS rounding. Accordingly, we close the upper four points along the open side of the former cube with a square.

## MANUALLY GENERATED POLYGONS

Make sure that you are still in USE POINT TOOL mode and then select CREATE POLYGON in the STRUCTURE menu of CINEMA 4D. By clicking on a series of points, this tool allows the creation of a new polygon between them. To make a triangle, single click on the first two points and double click on the third. A quadrangle is built with three single clicked points and one double click on the fourth point.

Planes with more than four points, so-called n-gons, are also possible. Just single click on all points along the edge and create the face with a double click on the last point. The tool can be deselected by selecting another tool, such as the MOVE tool. Keep in mind that the points will be connected in the order they were clicked on. Therefore, get into the habit of clicking clockwise or counterclockwise. The left side of Figure 1.45 shows the desired result.

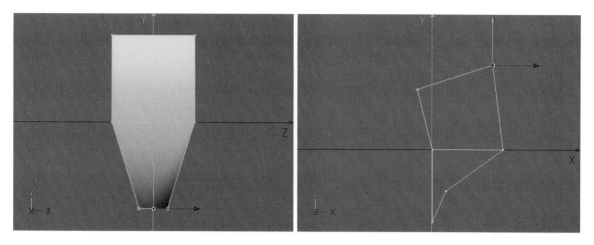

— Figure 1.44: Moving the lower points together along the Z axis and the shaping of the remaining points.

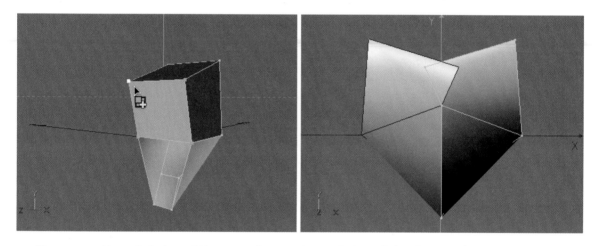

— Figure 1.45: Manual closing of the upper faces and completion of the shape with a Symmetry object.

### ALIGNING THE NORMALS

The direction in which the points were clicked also determines indirectly the alignment of the normals on the polygon. When polygons are created manually, it is often the case that the normal of the face has a different alignment from the rest of the object. This can be recognized by the different tint of these faces in the viewports. In this case, use the ALIGN NORMALS command in the FUNCTIONS menu of CINEMA 4D. Make sure that no polygons are selected

when this function is selected, or switch for a moment to USE MODEL TOOL mode. This way the command affects all the faces and not only the currently selected ones.

If you are sure that there is only one face with the wrong alignment, then it can be selected directly and changed with REVERSE NORMALS, found in the FUNCTIONS menu. Lastly, add the SYMMETRY object and subordinate the former cube in the OBJECT MANAGER. The right side of Figure 1.45 shows the result in the front viewport.

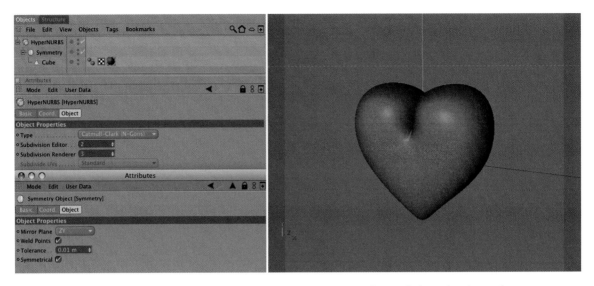

— Figure 1.46:  The HyperNURBS generates an interactive smoothing of the subordinated geometry.

## THE HYPERNURBS SMOOTHING

After subordinating the SYMMETRY object under the HYPERNURBS object (you can find it in the OBJECTS menu under NURBS), a small miracle occurs. The previously angular structure is now smooth and rounded, as you can see in Figure 1.46. This effect can be set separately in the ATTRIBUTE MANAGER for display in the viewport and renderer. The higher the SUBDIVISION value, the more faces are generated and used to smooth the object.

Be careful! Every increase of just 1 unit results in a quadrupling of the faces and also increases the memory use. The subdivision for the editor is generally much smaller than for the renderer, since we need the best possible quality for the final rendering. In the editor it is more important to be able to work efficiently with the object. This would be more difficult to do with the display of so many faces in the editor.

If you have difficulty getting used to working with the HyperNURBS object, take a look at the difference between a linear and a B-spline. The principle is identical, as can be seen in Figure 1.47. The B-spline uses

— Figure 1.47: Two identical splines, one with a linear interpolation and the other with a B-spline interpolation.

the straight segments between the tangents of a rounded curve. The curve doesn't pass through the points but instead has a soft curvature. This principle can be compared to HyperNURBS smoothing except it isn't a curve being rounded but instead a three-dimensional surface.

Also keep in mind that the structure of the added and rounded faces looks different with triangular faces than it does with quadrangular-shaped ones. Therefore, you should

work with only quadrangular faces on POLY-
GON objects whenever possible. Otherwise,
the triangles could cause some visual irregu-
larities on rounded surfaces. This rule can be
ignored when an area is supposed to be
exactly within a plane. In this case only, tri-
angles and n-gons don't cause any problems
and can be used without influencing the
roundings on the object.

## Modeling a Carabiner

For this example we will use a photo of a
small carabiner (as shown in Figure 1.48) as
our template. This ensures that we keep the
approximate dimensions and it helps with
placing the geometries more exactly.

You can load images in any of the isomet-
ric viewports: the front, side, or top view. In
this case, use the EDIT menu in the front
viewport and select CONFIGURE.

In the settings of the ATTRIBUTE MANAGER
you can also find a BACK tab. A click on the
button with the three dots opens a window
where you can load any type of bitmap.
Depending on the size and orientation of the
image you can now rotate, scale, and move it
to a different location within the viewport.
Because of the orientation of the image we
have to rotate it by –90°, as shown in

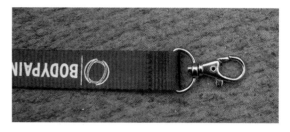

— Figure 1.48:  The carabiner to be modeled, at
the end of a keychain.

Figure 1.49. The settings for the size and
position of the image in the front viewport
depend on your individual preferences. By
and large you don't have to change anything
here.

### MODELING THE UPPER LOOP

We will start the modeling at the fixed top
curve of the carabiner and then continue
downward. In a second step we will model
the gate, and last is the mounting for the
key ring. Again, we will use as many basic
objects as possible to reduce the manual
modeling. You will also learn about some
new polygon tools such as the knife and the
extrusion tools.

The easiest way to start is with a bent cyl-
inder at the upper part of the carabiner. Add

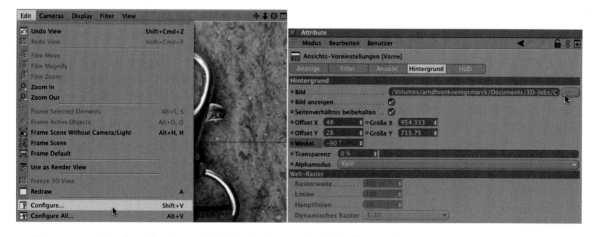

— Figure 1.49: Loading the image into the background of the front viewport.

a CYLINDER primitive and set the RADIUS to 10 and the HEIGHT to 250 units. These values depend on the scale of your background image. Adjust your radius so it approximately matches the thickness of the gate in your image. When in doubt increase the radius since the geometry will shrink a bit when the HyperNURBS smoothing is applied. Eight segments are enough for the circumference. The smoothing will be done later with a HyperNURBS object. Because the cylinder is supposed to be bent we will need additional segments along its height. I prefer to work with 10 segments. The cylinder should also stand vertically, so use the +Y direction in the settings of the cylinder in the ATTRIBUTE MANAGER.

Since we have to split the carabiner into two halves at the base—the movable gate has to be added there—it makes sense to rotate the cylinder around the vertical axis so one face of its circumference is placed vertical to the symmetry axis. For a better understanding, take a look at Figure 1.50. Rotating

— Figure 1.50: A slim cylinder is the start object.

the vertical cylinder by 22.5° places a face, when seen from above, left, and right, onto the world X axis. When these faces are deleted, the cylinder will be divided into two pieces where we need to insert the gate. Lastly, deactivate the option for the creation of caps at the cylinder. What is left is a thin-walled pipe.

## Bending the Cylinder

Rotate the cylinder in the front view so it is slightly tilted to the right. Use the outer edge of the carabiner as a guide that runs from the lower base at the right side of the carabiner in the direction of the gate. The area over the gate then transforms into a curve. This bend can be created with a BEND deformer, which is a child of the cylinder. Correct its local H rotation in the COORDINATE MANAGER to −22.5°. The Z axis should now be vertical to the front viewport. The P and B angles are set to 0°. The Y part of the position will be determined in a moment.

In USE MODEL TOOL mode, pull the orange handler of the deformer—in the front viewport—with the MOVE tool to the right, so the upper part bends according to the image in the background. Since the radius of this bend is determined by the Y length of the deformer, you have to adjust it so the result looks like the one in Figure 1.51. There you can also see the settings I've used for the deformer.

By moving the deformer along its Y axis we can define the starting point of the bend. If the cylinder is too short at the upper end, use the USE OBJECT AXIS TOOL mode to move the cylinder with the MOVE tool further up along its Y axis. The position of the BEND object is not changed by this move.

This is a specialty of the parametric objects since they are constantly calculated based on their position. When we move the local axis system of these objects, the location of the objects in 3D space is automatically changed as well, but the child objects remain at their original location.

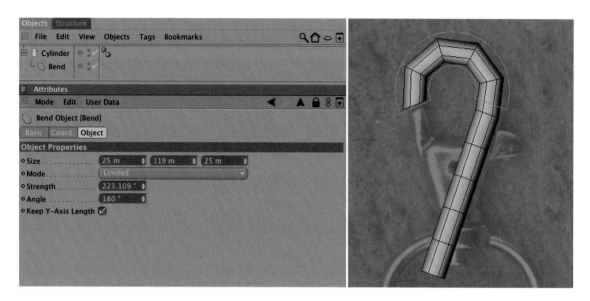

— Figure 1.51: The desired bend in the cylinder is created with a Bend object.

## Converting a Deformation

When you are happy with the result, then you have to further edit the cylinder at the point level. As you already know, we have to first convert the parametric cylinder into a POLYGON object. But when deformers are used this cannot be done with the MAKE EDITABLE function or the (C) key. This would make the cylinder editable, but wouldn't include the deformer in the calculation of the point positions. In these cases we need the CURRENT STATE TO OBJECT command in the FUNCTIONS menu of CINEMA 4D. It will include the deformation in the current state of geometry as well as conversion of the primitive into a POLYGON object.

This creates in the OBJECT MANAGER a new POLYGON object including the editable geometry of the bent cylinder. The original CYLINDER object, including the deformer, can now be deleted. Switch to the USE POINT TOOL mode and activate the LIVE SELECTION. Make sure that the selection of hidden points is possible. Since we work entirely in the front view, it is important to also select the points in the back of the object because they have to be moved as well.

Start by selecting the points at the lower left edge of the converted cylinder and adjusting them with the MOVE tool to the left edge of the carabiner in the background image. The left part of Figure 1.52 shows the desired result. The points of the cylinder that might be positioned below the visible base can be selected and then deleted with the (Delete) key.

## The Knife Tool

In order to better model the area of the base that creates the lower edge of the carabiner, we need more points in this area. So we will, for the first time, use the KNIFE tool, which, like almost all other POLYGON tools, can be found in the STRUCTURE menu of CINEMA 4D. As the name of the tool suggests, the knife cuts through polygons and adds new points and polygons by doing so—a very useful tool to add selective subdivisions. After selecting the knife, as with most tools, some settings appear in the ATTRIBUTE MANAGER, as seen in the center of Figure 1.52. Several modes allow us to cut, by dragging the mouse, along a line or along a plane that runs parallel to the world coordinates. In our

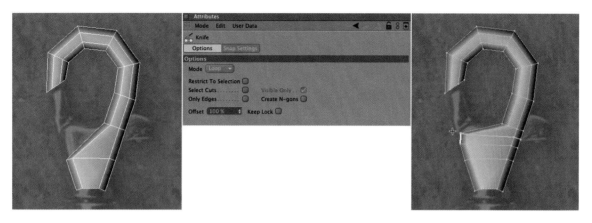

— Figure 1.52: Converting the cylinder and subdividing it with additional cuts.

case we will select the LOOP mode. It auto-matically makes the cut through a series of neighboring faces. A highlight function shows the course of the cut to be made in the editor before the cut is made by a mouse click.

Deactivate all options in the knife dialog, since we want neither to restrict the cut to only selected elements nor to generate n-gons. The latter would create new points at the edges and also fill the cut faces with n-gons. These types of faces should be avoided, though, when using HyperNURBS smoothing, since they don't give us any control over the internal interpolation of the n-gon faces.

Now move the mouse pointer, with the activated KNIFE tool, over one of the outer vertical lines of the carabiner. You will see a highlighted line that adjusts itself based on your mouse movement and indicates the course of the cut. When you like what you see, make a mouse click to apply the cut. For a more precise preview, push the (Shift) key while the preview of the cut is still high-lighted. Then you can position the cut with the OFFSET function in the ATTRIBUTE MAN-AGER. A mouse click in the editor then makes the cut.

Two horizontal cuts at the spot where the gate enters the base should generate enough points to further adjust the shape to the image. Select and move the new points on the left side of the model to align them with

the loaded background photo. The right side of Figure 1.52 shows the state of the model up to that point.

**The Shaping of the Base**

To shape the upper part of the base, we can't use the technique of horizontal cuts. We will need more subdivisions that run vertically through the base. Bear in mind, though, that we are dealing with slightly bent parts and should avoid using triangles. Remember, triangles are subdivided differently at Hyper-NURBS smoothing and could look funny in combination with surrounding quadrangles.

We should use only quadrangular subdivisions and pay special attention to the possible connection points. Therefore, we will delete a face for the moment, as shown on the left of Figure 1.53. A simple selection of the face in USE POLYGON TOOL mode and use of the (Delete) key will take care of that. Simply delete the visible face in the front viewport. The back of the deformed cylinder will be replaced anyway and can be disregarded.

The two diagonal arrows shown in the figure indicate where the two loop cuts should be added. The right cut continues the subdivision of the upper cylinder at the base. In the next step we will create a connection point at the upper edge of the base.

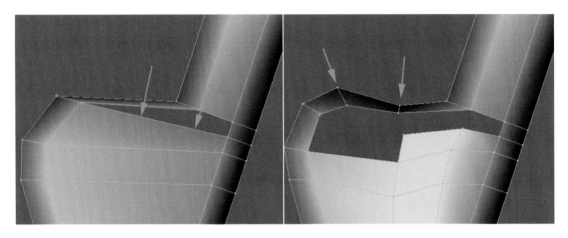

— Figure 1.53: Additional steps make it possible to shape the base.

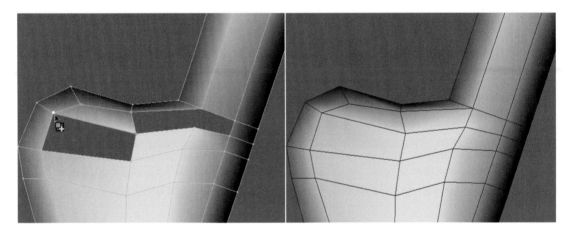

— Figure 1.54: Manual closing of the open areas at the base of the carabiner.

First, though, delete another polygon, as shown on the right in Figure 1.53. The arrows there point to another two cuts that should be executed in LOOP mode. Use the added points along the upper edge of the base to shape the desired course, following the background image.

In USE POINT TOOL mode activate the CREATE POLYGON tool in the STRUCTURE menu and create the left face, as seen in Figure 1.54, by consecutively clicking on the four corner points. Double click on the last point to close the face. Remember to not click randomly on the points but to select them clockwise or counterclockwise. Do the same with the

remaining three faces until the base is closed, as shown on the right side of Figure 1.54.

To eliminate incorrectly aligned normals use ALIGN NORMALS in the FUNCTIONS menu. When you are in USE POLYGON TOOL mode, make sure that no faces are selected. Otherwise, the function would be restricted to the selected faces. In that case use DESELECT ALL from the SELECTION menu.

**Creating the Hole in the Base**

In the center of the base there is a hole that goes all the way through. It will contain a riveted pin that will later hold the movable

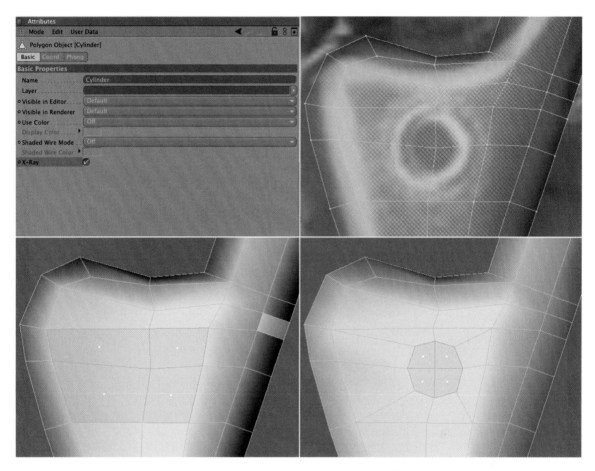

— Figure 1.55: The contours for the hole are built by extruded inner faces.

part of the carabiner. Such holes could be created with a BOOLE object. This method generates too many faces, though, and can not be used because of the resulting uncontrolled generation of triangles in the Booled area, which would create unexpected results during the HyperNURBS smoothing. Therefore, we will choose another way.

First activate the X-RAY mode for the deformed cylinder object. This option can be found in the basic settings of the cylinder in the ATTRIBUTE MANAGER. The object will then have a slightly transparent appearance in the viewports and will allow the background image to shine through in the front viewport. This way it is easier to compare the center and size of the hole with our model.

First, place the point located closest to the center of the hole as exactly as possible at the center, as shown on the top right of Figure 1.55. Then change to USE POLYGON TOOL mode and select the four faces surrounding this point. To generate additional faces within polygons, which can be used to model the edge of the hole, use the EXTRUDE INNER command from the STRUCTURE menu.

As you hold down the mouse button in the front viewport and move it to the left and right, new polygons are created in the same plane as the previously selected polygons. As an alternative, you could use the OFFSET value in the ATTRIBUTE MANAGER and then the APPLY button in the TOOL section of the dialog when you wish to use

a certain value. This is not necessary in our case.

Back in Use Point Tool mode, use the new points to shape an octagon around the center of the hole to indicate the desired opening. Remember that the HyperNURBS object will take care of the smoothing in this area, too, so don't be bothered by the angular look of the shape. The lower two images in Figure 1.55 show these steps.

**Modeling the Inside of the Base**

As already mentioned, we took these steps only in the visible part seen in the front viewport. The rear of the object will now be

deleted and then replaced by the mirrored part of the remaining object. First we make sure, by deleting some polygons, that the base underneath the branching of the upper arm is split into two halves.

The upper images in Figure 1.56 show this area of the opening with a highlighted frame.

Then we select the faces at the front of the base, seen in the lower left of Figure 1.56, and move them along the world Z axis. The image on the bottom right in Figure 1.56 shows the side of the model and the approximate size of this movement.

The reason for this movement is to create more space between the halves of the base

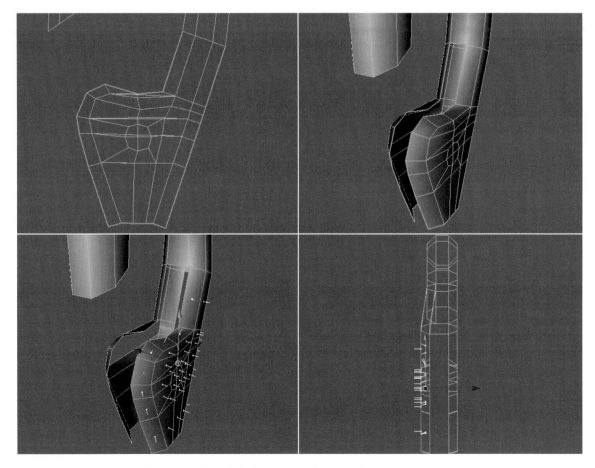

— Figure 1.56: Parting the two sides of the base by deleting polygons.

so that the arm of the movable part of the carabiner can be inserted later.

The corresponding faces that form the back of the base and that were not moved can now be deleted. Figure 1.57 shows the desired state of the object in the side view. Now we will close the inside of the base and implement the hole as an actual opening. In the first step we will use the CREATE POLYGON function in the STRUCTURE menu and close the areas with four quadrangles, as shown in the center top in Figure 1.57. Select the four quadrangles that mark the hole in the center

of the base and choose the EXTRUDE command in the STRUCTURE menu.

## Extruding Faces

The EXTRUDE command doubles selected faces and moves the duplicates along the normal direction by any given amount. This allows us to extend or split objects. It is, along with the knife and the previously used EXTRUDE INNER tool, one of the most-used tools.

Its function is similar to the EXTRUDE INNER tool. First select the face, then choose

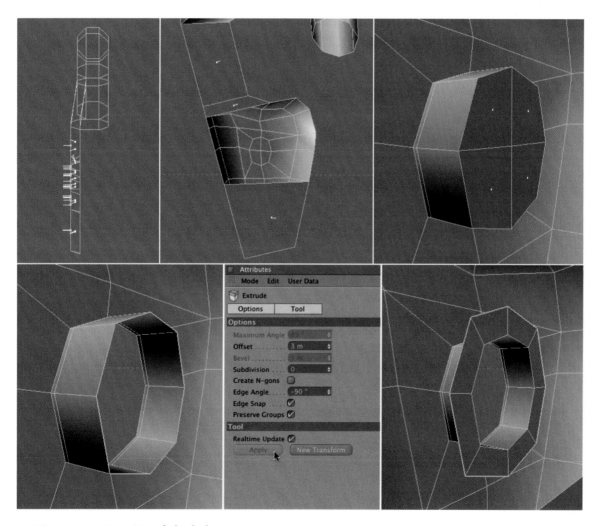

— Figure 1.57: Extrusion of the hole.

the EXTRUDE tool and move the mouse, while holding the mouse button, to the left or right in the editor. Here you could also work with numerical values in the ATTRIBUTE MANAGER, in case the movement of the duplicated faces has to be a certain amount. Again, this is not important to us. Just use the state of the object in the upper right image of Figure 1.57 as a guide.

You can see there that the faces were first extruded by a small amount in the direction of the rear of the base, and then to a larger degree. This is done by moving the mouse just a small bit while holding the mouse button, then letting go, and immediately holding the mouse button again. The mouse movement will then generate another face. That way, several extrusions can be created in succession without having to select the tool again. The short extrusion and the resulting close edges will cause less rounding and a more defined edge when HyperNURBS smoothing is used. In the side view make the extrusion in such a way that the new faces align approximately with the open edge at the sides of the base. Then delete the extruded polygons so an octagonal opening is created, as shown on the bottom left in Figure 1.57. You can also see that we now have to select the edges of the newly opened tunnel. Therefore, change to USE EDGE TOOL mode and choose the LOOP SELECTION in the SELECTION menu. This selection tool can automatically select neighboring elements.

Choose the option SELECT BOUNDARY LOOP in the settings of the LOOP SELECTION in the ATTRIBUTE MANAGER. Now when you place the mouse pointer over an edge of the opening, the faces should be highlighted and can be selected by a single mouse click.

**Extruding Edges**

We again activate the EXTRUDE function in the STRUCTURE menu, since it works not only with faces but also with edges. Also here you can duplicate and move the edges by holding the mouse button and moving the

mouse in the editor. Doing this creates new faces along the previously open edge of the structure—a good technique for expanding flat objects at their edge. To position the new faces vertical to the tunnel, take a look at the ATTRIBUTE MANAGER. As long as you don't execute another function or select another tool, the values of the last used tool can be seen and changed.

You can change the width of the extrusion with the OFFSET value or control the angle of the newly generated faces with the EDGE ANGLE parameter. A value of −90° should ensure that the new faces are placed exactly vertical to the inner tunnel faces. The lower images in Figure 1.57 show the desired result.

In USE POINT TOOL mode, select the CREATE POLYGON tool in the STRUCTURE menu and create the faces, shown highlighted in Figure 1.58, that close the inner area of the base and the end of the upper arm. You can see at the base that some triangles were used, too. They were used because the location of the points relative to each other doesn't restrict us to the exclusive use of quadrangles. It doesn't matter that much in this case since all these faces are located in a plane and the HyperNURBS will not have to calculate a bend for these faces. So in this special case it is okay to mix triangles and quadrangles, without worsening the result, as we will see later.

Now it is time to add the missing rear half of the base. It is the exact mirror image of the front half, thus saving us the time of having to model it. First, in EDIT POLYGON TOOL mode, select the polygons of the completed front half of the base. The best way to do this is to select them in the front view with LIVE SELECTION, where the selection of hidden faces is enabled, since all faces are supposed to be selected. The selected area can be seen on the very left in Figure 1.59.

Then select the DISCONNECT command in the FUNCTIONS menu. It duplicates the selected faces and copies them into a new object, leaving the original object unchanged. The coordinate system of the original is

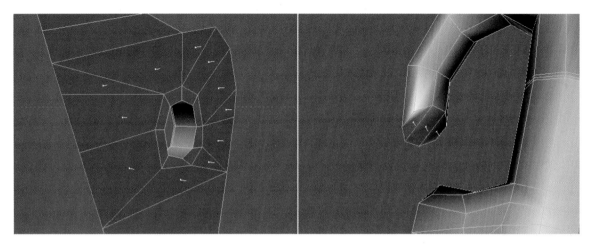

— Figure 1.58: Manual closing of open areas.

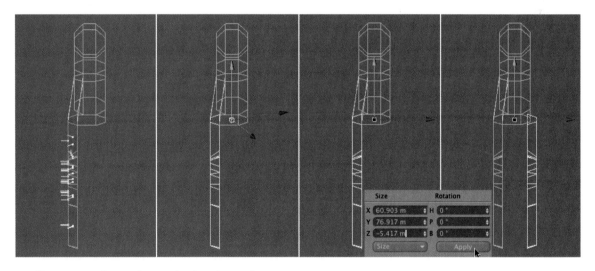

— Figure 1.59: Separating and mirroring polygons.

transferred to the copied faces as well. The necessary faces have already been duplicated and just need to be mirrored to the other side of the carabiner.

This mirroring should be done along one of the axes. Currently, though, the axis system of the disconnected faces is slightly twisted, as can be seen in the second image from the left in Figure 1.59. This can be easily corrected in the USE OBJECT AXIS TOOL mode. Just reset the three ROTATION values in the COORDINATE MANAGER to 0 to bring the axes

back into a neutral position. This does not change the position of the axis system, which is a good thing because it is positioned exactly in the middle of the former cylinder and therefore on the desired symmetry plane.

Now change to the USE MODEL TOOL mode and add a negative sign in front of the Z size of the object, created by the DISCONNECT function, before you use the APPLY button of the COORDINATE MANAGER. A negative size results in the mirroring of the geometry along the corresponding axis, as we can see

in the very right image of Figure 1.59. The disconnected faces were mirrored to the rear side of the carabiner.

## Connect and Stitch

The mirrored faces are in the right place but are still a separate object and have no connection to the main model of the carabiner. We will now fix that. Select the model of the carabiner and the model with the recently copied faces with a (Ctrl) click in the OBJECT MANAGER and choose CONNECT in the FUNCTIONS menu. This will create a new object containing the faces of both models. The two old objects can now be deleted.

The closing of the gap at the end of the bent cylinder loop will be done with the STITCH AND SEW command. It is located in the STRUCTURE menu of CINEMA 4D. It is very important that no points of the object be selected. Otherwise, this tool would affect only these elements. Switch to USE POINT TOOL mode and use the DESELECT ALL command in the SELECTION menu before you start STITCH AND SEW. The stitching itself is shown symbolically in Figure 1.60. First, click on the point that is supposed to snap to the other, and while holding the mouse button, pull a line to the point across. After you release the

mouse button, the point will snap to and be combined with the other point. This results in the generation of a complete symmetry and not just two points on top of each other. When you are finished stitching all the points between the loop and base together, the static part of the carabiner is almost done.

By looking diagonally into the gap of the base, from below, you can see a spot where a polygon is missing, right where the two halves of the base meet the upper loop. You can either close this hole manually with a quadrangular polygon by using the CREATE POLYGON tool or use the CLOSE POLYGON HOLE command. Select the latter one in the STRUCTURE menu and move the mouse pointer to the edge of the hole until a virtual face appears at that spot, bridging the gap. A mouse click then creates this polygon. The left image in Figure 1.61 shows this face.

## HyperNURBS Smoothing

Now we will use the HyperNURBS object. Select it in OBJECTS>NURBS and make the polygon model of the carabiner a child of this new HyperNURBS object in the OBJECT MANAGER. Instantly, the angular model transforms into a softened organic object, as seen in detail on the right side of Figure 1.61.

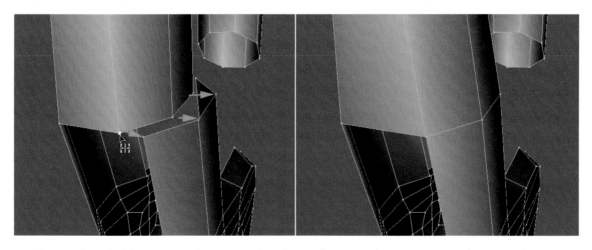

— Figure 1.60: Stitching snaps points to one location and merges the geometry at the same time.

— Figure 1.61: Bridging the two halves and smoothing the geometry.

The rounding is partially too strong so the desired angular or mechanical look gets lost. The reason for this is that any place where edges are spaced too far apart, the Hyper-NURBS has too much space to round the area. The radius of the rounding becomes too large and the shape gets too soft. This can be corrected by adding subdivisions in areas where the model should be more angular.

The first area will be the transition between the loop and base. To change the opening to a more angular one we have to select the KNIFE tool in the STRUCTURE menu and activate the LOOP mode. Figure 1.62 shows the correct cut in the left and center

image. First, create a looped cut slightly above the spot where the shape splits. Two additional cuts close to the connection point of the front and rear base parts make the shape look perfect. The result of these three cuts can be seen at the far right in the figure.

At flat and plane areas of the model we can use the EXTRUDE INNER command. This method also creates new edges that, when placed close together, severely restrict the rounding properties of the HyperNURBS. We can use the command at the end of the upper loop and inside the base. Select the polygons shown in Figure 1.63 and select

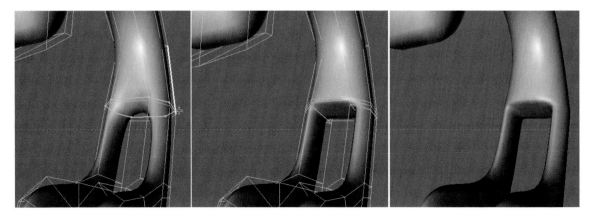

— Figure 1.62: Additional subdivisions force the HyperNURBS into a more angular shape.

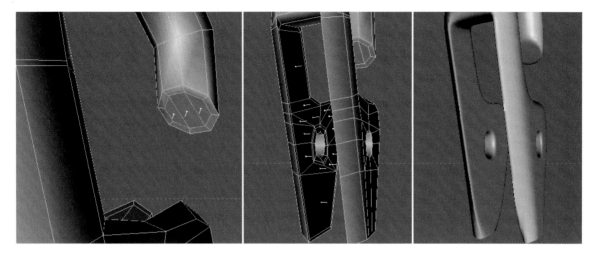

— Figure 1.63: Extrude Inner creates new subdivisions within the flat areas and also a hard edge at the HyperNURBS smoothing.

the EXTRUDE INNER command in the STRUCTURE menu. Either use the mouse inside the editor or enter a small OFFSET value directly in the ATTRIBUTE MANAGER, which is then executed with the APPLY button. Figure 1.63 shows on the far right the effect of this action. The edited areas are now flat and less rounded at the edges.

Since we started with a cylinder without caps, we now have to close the open areas at the bottom of the base. The points on the edge of these holes should be at the same position on the world Y axis and on the same plane. Use the LOOP SELECTION with activated SELECT BOUNDARY LOOP option to select the points, then correct the Y position in the COORDINATE MANAGER to 0. The COORDINATE MANAGER should be set to world mode for this step. Then use the CREATE POLYGON function in the STRUCTURE menu to create the three faces. Here too the use of triangles will not be a problem, since the area is a plane. The created faces on both sides of the base are then selected again, duplicated once with STRUCTURE > EXTRUDE INNER, and shrunk by a small OFFSET value, as shown in Figure 1.64. This will result in a defined hard edge in the HyperNURBS smoothing at the bottom of the base. This part is now complete.

## MODELING THE MOVABLE GATE

The movable gate of the carabiner closes the gap to the upper loop and sticks out of the carabiner as a lever. The gate is attached in the middle by an axis pin and fixated by a small spring. We will begin the modeling of this part with the creation of two cylinders without caps, as can be seen in Figure 1.65.

These cylinders will receive eight segments along their circumference and rotate 22.5° around the Y axis. Base this on the CYLINDER primitive from which we modeled the fixed carabiner part. Then rotate the two cylinders in the front viewport so they follow the V shape of the base. Afterward, bend the thinner of the two cylinders with a BEND deformer so that it emerges from the carabiner at the proper spot on the right side. The measurements and the position of the cylinders can be seen in Figure 1.65.

### Converting and Connecting the Objects

Use the MAKE EDITABLE function or the familiar (C) key on the thicker left cylinder to create an editable POLYGON object. The thinner cylinder is influenced by a deformer and thus

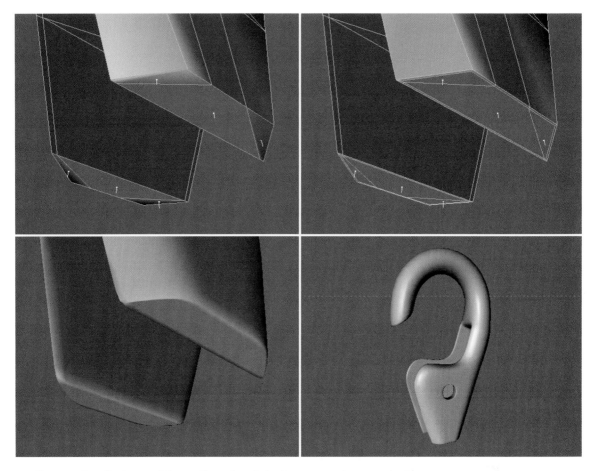

— Figure 1.64: Closing and Inner Extrude of the lower openings at the base.

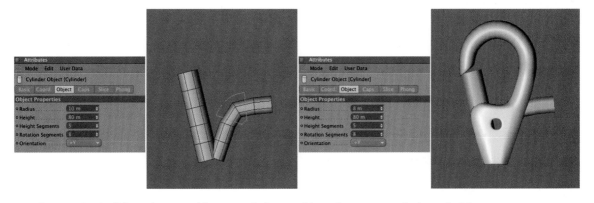

— Figure 1.65: Building the movable gate of the carabiner from two cylinder primitives.

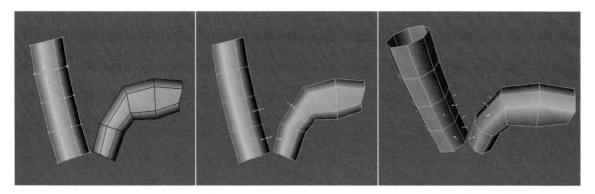

— Figure 1.66: Converting the two cylinders and preparing them for the connection.

has to be converted with FUNCTIONS > CURRENT STATE TO OBJECT. The original with the subordinated BEND deformer can then be deleted. In the USE POINT TOOL mode you can now further edit the two shapes. The left cylinder is slightly bent by moving the upper points and the wider cylinder is thickened at the end, as can be seen in Figure 1.66. The two objects can't remain separated and have to be connected; therefore, select the two cylinders and choose CONNECT in the FUNCTIONS menu. A new object appears in the OBJECT MANAGER. The original models of the separated cylinders can now be deleted.

To create a real connection between the two cylinders, change to the USE POLYGON TOOL mode and select the six faces that are across from each other at the lower part of each cylinder. Figure 1.66 shows these areas in the center and right image.

**The Bridge Tool**

This job is perfect for the BRIDGE tool located in the STRUCTURE menu. It creates connections between selected faces and deletes the original faces. Change to USE POLYGON TOOL mode, select the BRIDGE tool, and place the mouse pointer on one of the corners of the selected polygons. Hold down the mouse button and move the mouse pointer to the opposite polygon corner. The left image in Figure 1.67 depicts the movement of the mouse symbolically with an arrow.

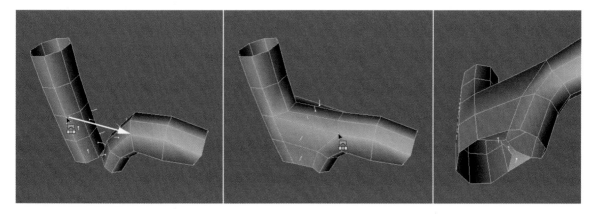

— Figure 1.67: Connecting faces with the Bridge tool.

After releasing the mouse button, all previously selected faces are deleted and new faces are created for the connection, as shown in the center of Figure 1.67. Of course, we could have done this manually with the CREATE POLYGON tool, but this way it is much faster. Note that the BRIDGE tool also created faces at the bottom of the model, as shown on the right in Figure 1.67. We don't need these faces and can delete them.

**Adding New Subdivisions**

In the center part of the movable gate we now have to create a hole for the pin and some space for the small spring that holds the bar in place when closed. First use the KNIFE tool in the STRUCTURE menu and activate the LOOP mode. The remaining options in the KNIFE dialog remain deactivated. Add the three cuts that are marked in the left part of Figure 1.68. This will add more points at the upper edge of the bar and more subdivisions at the base.

Before we use these new points to shape the model, change to EDIT POLYGON TOOL mode and select the front faces of the base in the front viewport. The right part of Figure 1.68 shows these faces in a different

color and how to handle them. These faces have to be moved along the world Z axis toward the rear of the gate. The center becomes thinner and creates some space for the still missing models of the pin and the spring.

This part will be smoothed later by a HyperNURBS. Therefore, we can keep the special requirements of this smoothing in mind by closing the remaining open areas and creating additional edges where a hard edge, despite the smoothing, is supposed to remain visible. We will use the CREATE POLYGON tool in the STRUCTURE menu of CINEMA 4D. Close the two ends, located on top and on the right of the former cylinders, with three quadrangles each, as shown in Figure 1.69.

As you can see in the figure, the new faces at the upper end of the left cylinder were selected, duplicated with the EXTRUDE tool in the STRUCTURE menu, and shrunk by a small amount. You already know this principle from the base and the upper loop of the stationary carabiner model. In the left part of Figure 1.69 there is a correction of a point position, indicated by an arrow, so the right part of the gate keeps its thickness up to the constricted part.

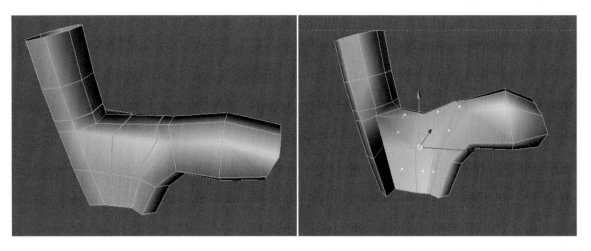

— Figure 1.68: Adding new subdivisions with the knife and constricting the shape in the center.

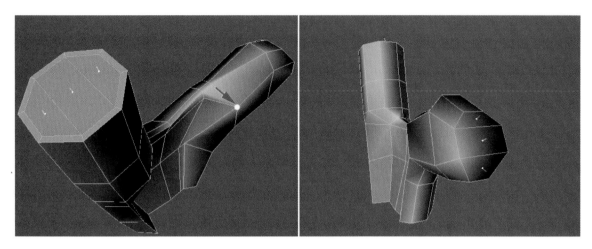

— Figure 1.69: Closing the open ends.

## Modeling the Opening for the Pin

The following principle is the same as the one we used at the base of the stationary carabiner piece to model the hole for the pin. Here, too, select the four faces surrounding a point in the center of the gate and use the EXTRUDE INNER command to duplicate and shrink these faces. In USE POINT TOOL mode use the newly created points to shape the round opening, modeling it after the hole in the carabiner base. These steps are shown in the images of Figure 1.70. Remember also that this time our model has a rear side that has to be treated in the same way. Consequently, make sure that, before you select the four faces for the inner extrusion with the LIVE SELECTION tool, you deactivate the ONLY SELECT VISIBLE ELEMENTS option. The rear faces will then be extruded as well. The best way is to work exclusively in the front viewport when selecting and moving the points and faces. That way you can be sure that the points at the rear side are selected and moved correctly as well.

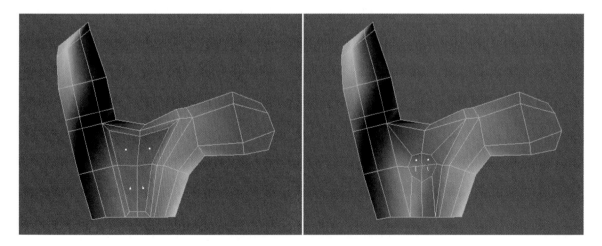

— Figure 1.70: Adding new faces with Extrude Inner to create an opening.

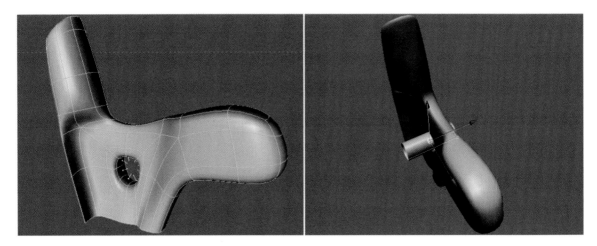

— Figure 1.71: Creating a connection with the Bridge tool and making the pin cylinder.

The adjusted faces that cover the opening now have to be connected to generate the opening. We already know how to use the tool for the connection of selected faces, the BRIDGE tool in the STRUCTURE menu. But it is more difficult this time since we can't see both faces at the same time. Therefore, select the perspective viewport and switch to a display mode that makes it possible to see the opposite side's selected faces through the model. A good mode to use is the LINE setting in the DISPLAY menu of the editor view.

Then, while holding the mouse button, pull a connection line between the selected faces in front of and in back of the gate. After releasing the mouse button, an octagonal breach should be created, as can be seen on the left side of Figure 1.71. Into this opening place a new CYLINDER without caps. The number of circumferential segments doesn't have to be changed since this cylinder will not be smoothed with a HyperNURBS.

### Finishing the Pin

Scale and place the cylinder so that it protrudes only a small amount from the front and back of the base, as shown on the left in Figure 1.72. For a better view, the pin cylinder is highlighted in another color. Then cre-

ate a new RING object, which can be found in the primitives of CINEMA 4D. Reshape it so the ring can be put at the open edge of the pin cylinder, like the end part of a rivet. Figure 1.72 shows my settings and the desired effect of the highlighted ring on the carabiner model.

Now create a duplicate of the ring by pulling it with the mouse while holding the (Ctrl) key in the OBJECT MANAGER, or by copy and paste. Move the duplicated ring to the other open end of the pin cylinder. This anchors the pin at both ends of the carabiner.

### The Spring of the Gate

Between the gate and the carabiner itself there is a simple spring at the pin. It will be created with a HELIX spline that already exists as a parametric object and can have its parameters adjusted in the ATTRIBUTE MANAGER. With the PLANE setting of XY you will put the spline into the same orientation as the pin. Then adjust the position of the spline and the two RADIUS values in the HELIX dialog so the position as well as the size fit to the size of the gate pin. It is helpful to blend out the rigid gate model in the editor to get a better view of the inner parts of the carabiner.

— Figure 1.72: Fade the ends of the pin cylinder into ring objects.

With START ANGLE and END ANGLE you can control the number of desired windings as well as the position of the open ends of the HELIX. With the HEIGHT value you can control the distance between the windings. This setting is best made when the HELIX spline is subordinated, together with a CIRCLE spline, as children of a SWEEP NURBS. Make sure that the CIRCLE spline is placed in the XY plane and subordinated directly under the SWEEP object so it is used as the profile. Then adjust the height and RADIUS of the profile circle so a spring-like shape is created. My settings and the desired look are shown in Figure 1.73.

— Figure 1.73: Simulating the spring shape with a Helix spline.

In order to move the ends of the HELIX to the desired position in the model to complete the spring, the HELIX spline first has to be converted. Before you do so, take a look at the SUBDIVISION value in the dialog of the HELIX spline. It determines how many points the helix is supposed to have after being converted into a normal spline. Since we have only a few windings of the HELIX, the value of 100 is too high and would generate way too many points. Reduce the SUBDIVISION to a value of about 20 before you use the (C) key.

Then switch to the USE POINT TOOL mode and select and move the two end points of the HELIX as shown in Figure 1.74. The short end nestles up against the protruding ridge of the movable gate and the longer end leans on the middle part of the carabiner at the spot where the opening for the gate is located.

### THE LOWER PART OF THE CARABINER

The carabiner and all the interior components are now complete. The only part missing is the connection piece on the bottom for the key chain. We can use primitives exclusively and finish this part quickly. However, there is one other property of primitives we have not talked about yet.

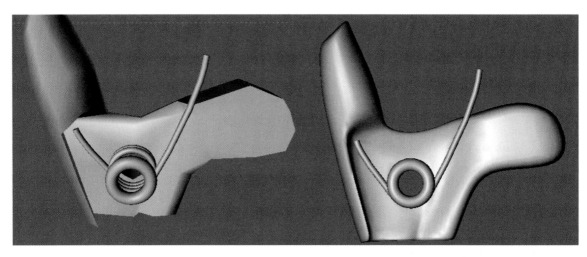

— Figure 1.74: Manually placing the ends of the helix.

## Distorting Primitives

Perhaps you thought during the modeling that it would be nice to be able to unevenly scale a primitive object, for example, to flatten a sphere to a lens or to model a cylinder with an elliptic profile. This is not a problem as long as the primitive is converted first, but then it loses all its parametric properties such as the ability to be rounded.

There is a way to get around that, though: switch to USE OBJECT TOOL before scaling the primitive object. This mode is similar to the USE MODEL TOOL mode but with the difference that the axes are scaled instead of the points the object is made of. We can also see

this in numbers in the COORDINATE MANAGER when we look at the size of the object. The standard is one unit in each direction, since it represents the length of the local axes system. But when we scale in USE OBJECT TOOL mode these values change.

We will use this mode now since the ring that has the hoop of the key chain attached is not supposed to be perfectly round. Figure 1.75 shows the desired shape of the new RING object. By scaling along the X axis in USE OBJECT TOOL mode the ring was widened by 18% in the X direction. Otherwise, you can orient the size and position of the ring on the loaded background image in the front viewport.

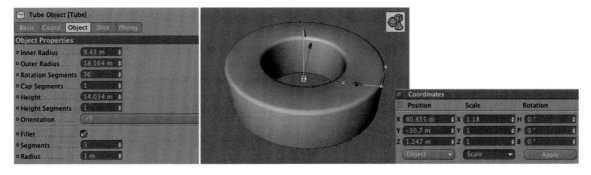

— Figure 1.75: Scaling primitives unevenly.

**The Lower Connection of the Carabiner**

The next steps are less interesting since all you have to do is complete the model with three CYLINDER primitives that will be scaled and intersected so they become the pin that connects the carabiner to the previously distorted ring. Figure 1.76 shows the three new cylinders with the ring in the center. Remember to round the cylinders at their caps so a highlight will appear at their edges later.

This, however, does not apply to the slim, vertical cylinder that passes through the ring. It doesn't need any caps since its ends disappear within the other two cylinders.

**The Lower Hoop of the Carabiner**

The only thing missing is the hoop of the distorted ring object through which the key chain band is pulled. We will start with a CIRCLE spline that is scaled and placed as shown on the very left of Figure 1.77. The CIRCLE has to be converted to a normal spline with the (C) key so we can switch to USE POINT TOOL mode, move the lowest point of the circle upward, and adjust the tangents at the two lateral points so the desired hoop shape is achieved. The desired shape is shown in the center of Figure 1.77. You can see the desired

result on the right side where the modified spline and another small CIRCLE spline were subordinated under a new SWEEP NURBS object. Again, make sure that CIRCLE spline is used as the profile is placed on the XY plane and that it is placed highest in the list under the SWEEP NURBS.

We are now finished with the modeling of the carabiner. I would like to take a small excursion into the world of XPRESSO so you can experience the practical use of this graphical programming part of CINEMA 4D.

**Making Models Move with XPresso**

XPRESSO is the graphical programming part of CINEMA 4D. It is used when several parameters are supposed to be combined or when object movements should be automated. With the example of the carabiner, I would like to show you the basic steps of using XPRESSO. You will get to know its use of so-called USER DATA as well as the connection of parameters. At our carabiner the act of opening and closing could be used for such an expression since we have a limited opening radius of the bar and the spring that is supposed to follow. The spring is the most complex part of this chain and therefore we will take care of it first.

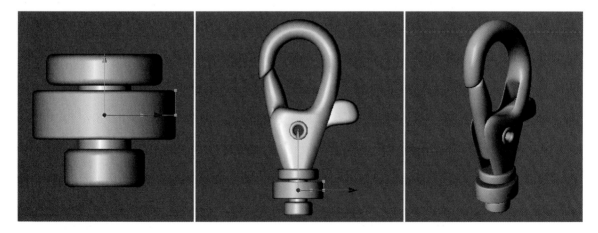

— Figure 1.76: Three cylinders in different sizes complete the model.

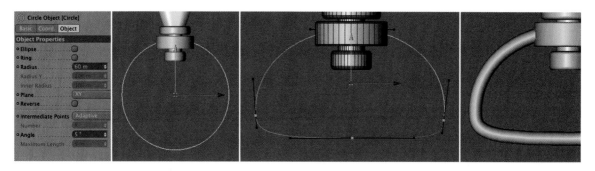

— Figure 1.77: The lower hoop is made from a converted Circle spline.

### Fixate the Ends of the Spring

The shape of the spring is determined by a spline. We are mostly interested in the ends of the spring since they have to remain fixated at the gate as well as at the stationary part of the carabiner, even when the gate is rotated. Basically, our job is to stabilize the two end points of the spring spline to a fixed location in 3D space. First we will add two NULL objects from the OBJECTS menu of CINEMA 4D and move them to the current position of the two end points.

*Interactive Snapping*

This could be done by manually transferring the point position of the spline to the Null objects, but it is easier to use the snap function. This function is activated by pressing the (p) key. A snapping context menu appears, as can be seen in Figure 1.78. In the upper part you can select the desired snapping method and underneath, the elements to snap to. Since the context menu closes after every mouse click you might have to use the (p) key more often until all settings are made.

The snapping methods are 2D SNAPPING, which snaps optically according to the current viewport, 2.5D SNAPPING, which only snaps when the elements are positioned on the same plane, or 3D SNAPPING, which snaps the objects in all three directions. After choosing the mode you have to select

whether you want to snap to points, splines, or axis systems. Several elements can be combined. In our case we want to snap to the end points of the helix spline. Therefore, you should activate 3D SNAPPING and POINT SNAPPING. The other options that are activated by default can remain that way. Make the objects not relevant for this step invisible in the editor for a moment and deactivate the Sweep NURBS of the spring by clicking on the green checkmark in the OBJECT MANAGER in order to have a clear view of the spline.

In USE MODEL TOOL mode, first move the one Null object close to the one end of the HELIX spline until it snaps to the point. Then do the same with the second Null object and the other end of the spline. Give the Null objects meaningful names such as *Mount Up* and *Mount Down* to be able to tell them apart.

Don't forget to deactivate the snapping so the objects can be moved freely again. Use the (p) key again and choose NO SNAPPING in the context menu. Then subordinate the Null objects, as shown in Figure 1.78. The Null object at the end of the movable gate is subordinated under the model of the gate in the OBJECT MANAGER. The other Null object can remain at the highest hierarchy level. For a better overview, all objects should be grouped. Choose SELECT ALL in the EDIT menu of the OBJECT MANAGER and use the key combination (Alt)+(g). As an alternative, you could also select GROUP OBJECTS from the

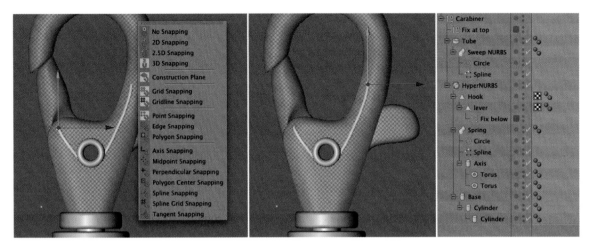

— Figure 1.78: Place two new Null objects at the end of the helix spring.

OBJECT menu in the OBJECT MANAGER. The new Null object containing all objects can be renamed *carabiner* and expanded again by clicking on the plus sign.

*Creating an Expression*

The goal of our first expression should be to attach the ends of the helix to the positions of the two Null objects at all times. This would mean that the spring would follow the rotation of the gate since the corresponding Null object moves with the gate.

First, right click on the new carabiner Null object in the OBJECT MANAGER and choose CINEMA 4D TAGS>XPRESSO from the context menu. The XPRESSO EDITOR, in which we can now assemble our expression, opens automatically. You can pull materials, tags, and objects directly from the different managers into the XPRESSO EDITOR. This generates so-called NODES, which allow you to request data or to set values.

We will try this by pulling both Null objects, which hold the helix ends of the model and the Helix spline itself, one by one from the OBJECT MANAGER into the XPRESSO EDITOR. This creates the nodes of these objects. The nodes have a blue and red area in the top left and right corners. Blue represents the

input and red the output of the node. A click on these areas will open a list with all the available parameters of the node. For the following expression we need the position in the world coordinate system of both Null objects. On the red output side activate the output for GLOBAL POSITION. The input and output of the nodes are also called PORTS.

To transfer the position of the Null objects to the corresponding points of the Helix spline, an intermediate step is necessary because the coordinates of the helix end points cannot be assigned directly to the node of the Helix spline. This requires a so-called POINT NODE. It can be created by right clicking in the empty area of the XPresso Editor. In the appearing context menu, select NEW NODE>XPRESSO>GENERAL>POINT. You can see in Figure 1.79 that there are many nodes available, sorted by themes, which can be used to make certain mathematical calculations or to simulate simple program structures like loops or if requests.

*The Point Node*

The POINT node is helpful when requesting point coordinates from POLYGON objects or splines, or to provide points within these objects with new coordinates. Therefore, this

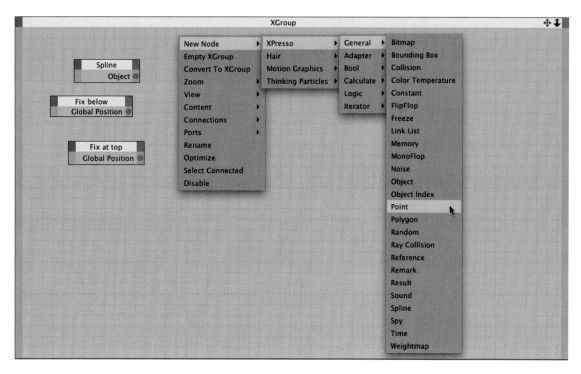

— Figure 1.79: The XPresso Editor.

node needs to get the following information: the object being affected, the point being targeted, the kind of coordinate system (object or world system), and, when defining a point coordinate, its position within 3D space as a vector. The object being affected is clear, but which points will be affected? Let us take a look at the STRUCTURE MAN-AGER, which is grouped with the OBJECT MAN-AGER. It contains a tabular list of all points of the spline, including their coordinates and tangents. they can be directly edited with a double click on the numerical values. This is very helpful for the exact positioning of tangents. If you don't see the list of points in the STRUCTURE MANAGER, ensure that the Helix spline is actually selected and the POINT MODE is activated in the MODE menu of the STRUCTURE MANAGER. As you can see by the other modes in the menu, this manager can also be used to show polygons or UVW coordinates. This list shows us that, in our case, the first point has the number 0 and the last

point the number 20. These point numbers are also called INDEX and can be assigned directly to the point node so it knows which point needs to be affected.

Because we want to influence two points, the two end points of the spring spline, we need two point nodes. So create a second point node and take a look at the ATTRIBUTE MANAGER. As shown in Figure 1.80, the index number can be entered directly in the PARAMETER section. The MATRIX MODE menu allows us to choose between global and local coordinates. We will select the global mode for both point nodes because this simplifies the assignment of the coordinates. Otherwise, we would have to convert the position of the two Null objects to the coordinate system of the helix, which could only be accomplished with a matrix calculation.

After the index 0 is assigned to the first point node and the index 20 to the other point node, the nodes have to be told which object and coordinate will be used.

| Point | X | Y | Z | <-- |
|---|---|---|---|---|
| 0 | -17.914 | 13.426 | -0.982 | -0.9 |
| 1 | -4.629 | -5.251 | -0.259 | -1.0 |
| 2 | 0.427 | -6.987 | -0.518 | -1.1 |
| 3 | 5.235 | -4.647 | -0.778 | -0.8 |
| 4 | 6.988 | 0.403 | -1.037 | 0.07 |
| 5 | 4.666 | 5.218 | -1.296 | 0.99 |
| 6 | -0.379 | 6.99 | -1.555 | 1.33 |
| 7 | -5.202 | 4.684 | -1.814 | 0.89 |
| 8 | -6.991 | -0.354 | -2.074 | -0.0 |
| 9 | -4.702 | -5.186 | -2.333 | -0.5 |
| 10 | 0.33 | -6.992 | -2.592 | -1.3 |
| 11 | 5.169 | -4.72 | -2.851 | -0.5 |
| 12 | 6.993 | 0.305 | -3.11 | 0.05 |
| 13 | 4.738 | 5.153 | -3.37 | 0.98 |
| 14 | -0.281 | 6.994 | -3.629 | 1.33 |
| 15 | -5.136 | 4.756 | -3.888 | 0.90 |
| 16 | -6.995 | -0.257 | -4.147 | -0.1 |
| 17 | -4.774 | -5.12 | -4.406 | -0.5 |
| 18 | 0.232 | -6.996 | -4.666 | -1.3 |
| 19 | 5.103 | -4.792 | -4.925 | -0.5 |
| 20 | 22.783 | 36.116 | -4.692 | -0.8 |

— Figure 1.80: Configuring the point nodes.

## Connecting Nodes

We get this information directly from the Null object and the Helix spline node, which are already part of the expression. As you can see at the input port side of the point node, we are asked for an object. We get this information from the output port of the spline node. Click on the red area of the spring node and select the object port. Then click onto the new red circle, which represents the port on the right side, and, while holding the mouse button, pull a connection line to the object input of the point node. This has to be done twice to get the object information to both point nodes.

The lines between the nodes are called connections. These connections transport the data from one node to another, in this case, the object information from the spline to the point nodes. Now we have to send the two global positions of the Null objects to the point nodes. First, click on the output port of the node representing the Null object at the movable gate of the carabiner. Hold the mouse button and pull a connection line to the blue area of the point node that stands for the point index 0. In my scene this is the index number of the spline point ending at the gate. When you release the mouse button, the input side of the point node unfolds and shows you all the available ports. Select the port for the point position, and the connection between the two nodes is automatically made. Do the same to the second Null object node and the corresponding point node, as shown in Figure 1.81. This completes the expression, and the XPRESSO EDITOR can now be closed. As you might have noticed, a new tag appeared behind the carabiner object in the OBJECT MANAGER after the expression was created. You can open the XPRESSO EDITOR again with a double click on the tag to further edit the expression.

### Working with User Data

To make the expression work, we need a control element that we can use to rotate the gate of the carabiner. USER DATA can be used

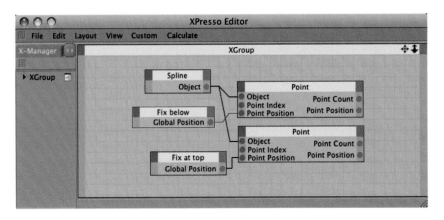

— Figure 1.81: Connecting nodes.

— Figure 1.82: Creating user data.

for this purpose. It is used to create your own dialogs and their entries become part of the expressions. User data can be assigned to any tag or object in the OBJECT MANAGER. The type of object doesn't affect the functionality. Choose an object that you have easy access to, even within collapsed hierarchies. In our case that would be the carabiner Null object. When you select it you might notice the USER DATA menu in the ATTRIBUTE MANAGER. Select MANAGE USER DATA and a menu opens, as shown in Figure 1.82. With the ADD button you can generate a new entry that can be substantiated on the right side of the dialog. First, give this entry a useful name under which this parameter will appear later in the ATTRIBUTE MANAGER, such as OPEN. The next decision pertains to the DATA TYPE of the parameter. Is it supposed to be text, a color, or even a drag and drop field for an object? In our case we will use a numerical value, the FLOAT. The look of the parameter in the ATTRIBUTE MANAGER is controlled by the INTERFACE setting. In the case of the float data type, it could be the FLOAT SLIDER, an entry field with an attached slider. Then we have to determine the type of UNIT, such as angle, meter, or percent. I decided to use PERCENT. A value of 100% would then represent a completely open carabiner and 0% a closed one.

The following settings for STEP, MIN, and MAX define the range for the numerical entry. The step value sets the range of the numerical steps executed when the small arrows behind the number field are used. I kept it at 1% and set the MIN value to 0% and the MAX value to 100%. Now everything is set and the dialog can be closed with the OK button. Now there is a new section in the ATTRIBUTE MANAGER called USER DATA containing your custom parameters. The value can be edited by entering a number or moving the slider, but it doesn't affect anything yet. We first have to connect this new value with another parameter. In our case this would be the rotation angle of the gate object of the carabiner.

**Requesting User Data in XPresso**

Select the carabiner object again in the Object Manager, right click on it, and choose CINEMA 4D TAGS>XPRESSO. Now pull the carabiner Null object from the OBJECT MANAGER into the new XPRESSO EDITOR. This Null

— Figure 1.83: Requesting user data.

object carries the user data value that we want to request and converts it into the rotation of the gate.

With a click on the red area of the carabiner node in the expression, we gain access to the USER DATA of this object and therefore also to our *Open* parameter, as can be seen in Figure 1.83.

The range of the *Open* parameter is between the extremes of 0% and 100%, as we have defined before. This represents a float value between 0 and 1. The entry of 76% is equal to the numerical value of 0.76. This value is supposed to be converted to an angle value that is then transferred to the gate object of the carabiner. For these kinds of jobs we will use the RANGE MAPPER node, which can calculate the rule of three. Right click in the XPRESSO EDITOR and choose NEW NODE > XPRESSO > CALCULATE > RANGE MAPPER.

The RANGE MAPPER compares a received value with the range between two preset values. These two threshold values are defined in INPUT LOWER and INPUT UPPER in the ATTRIBUTE MANAGER. In our case, the INPUT LOWER is the value 0 and INPUT UPPER represents the value of 1, since our user data values will be within this range.

The settings OUTPUT LOWER and OUTPUT UPPER define how the received value is supposed to be recalculated. For example, if we set the OUTPUT LOWER to 0 and OUTPUT UPPER to 5, then a user data value of 50% would result in a Range Mapper result of 2.5, exactly

half of the range between 1 and 5. Because we want to calculate an angle, change the OUTPUT RANGE menu to DEGREE. This is important since all angles otherwise have to be entered as radians in XPresso.

First, check whether the local axis system of the gate is actually centered, since this will be the gate's pivot point. For changes, switch to USE OBJECT AXIS TOOL mode and use the MOVE tool to place the axis system into the right position. The angle values should all indicate 0° in the COORDINATE MANAGER. Back in USE MODEL TOOL mode, the gate should now rotate correctly in the carabiner. You can reset the gate again to the neutral and closed position with a numerical entry of 0° for the angle in the COORDINATE MANAGER.

With my model I can rotate the movable gate by 46.5° around its Z axis until it touches the inside of the carabiner. Depending on the tolerance during modeling your angle could be slightly different. This angle should be transferred to the gate when the user data value is set to 100%. The 46.5° has to be entered into the OUTPUT UPPER field in the dialog of the Range Mapper in the ATTRIBUTE MANAGER. If you don't see this dialog, click once on the title bar of the RANGE MAPPER mode in the XPRESSO EDITOR.

Now pull the movable gate object directly from the OBJECT MANAGER into the expression and activate the port for ROTATION.B at the blue input side of the node. It can be found in the menu of the blue area in the section COORDINATES > ROTATION. Now connect the ports as shown in the center of Figure 1.84: the output of the carabiner node with the input of the Range Mapper and the output of the Range Mapper with the input of the gate node. You should already be able to rotate the gate by changing the user data value of the carabiner.

Don't forget the spring on the inside of the carabiner, since it will be turned as well. Pull the former Helix spline into the expression and also activate an input port for the ROTATION.B value, which represents the rotation around the Z axis. The ends of the

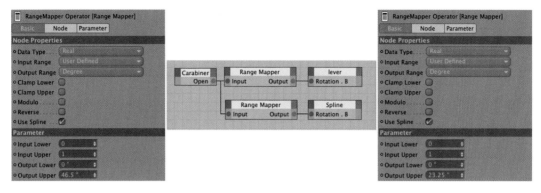

— Figure 1.84: Range mapper nodes convert the user data to angles.

spring are already fixated to the model by the other expression, but the windings will also turn slightly on the axis when the carabiner is opened. Thus add another RANGE MAPPER to the expression. The quickest way is to (Ctrl) drag and drop the existing Range Mapper directly inside the XPresso Editor, the same way objects are duplicated in the OBJECT MANAGER.

Make the same settings at the new Range Mapper as before, but use only half the angle for the OUTPUT UPPER value since the spring rotates only half as much as the gate. In my case I entered an angle of 23.25°. The connection works the same way as before and can be seen in Figure 1.84. The function of the expressions is now complete and the XPRESSO EDITOR can be closed.

**Adjusting the Priorities of Expressions**

After you have played a bit with the *Open* user data value and activated a transparent or wireframe display of the objects in the editor, you might notice that the ends of the spring have a slight delay at the rotation of the carabiner gate. This is because we have two expressions that request interacting values from each other. One expression rotates the gate and the spring with the user data value, and the other expression requests the position of the subordinated Null object of the gate and aligns the end point of the spring spline to it.

Since all expressions are executed at the same time or without a certain order, occasionally an expression uses old position or rotation values before they are updated by the other expression. In such cases, the PRIORITY of an expression is used. It is set in the PRIORITY menu of the BASIC PROPERTIES settings of the XPRESSO TAG in the ATTRIBUTE MANAGER. There you can find basic groups of priorities like INITIAL, EXPRESSION, or GENERATORS. But since the execution of objects and deformers in CINEMA 4D itself follows such priorities, you can determine at what point an expression is supposed to be executed. In the highest priority GENERATORS you can be sure that when you ask for deformed point coordinates in XPresso, you will always receive the up-to-date values.

The following numerical value sorts the priority within the chosen group. The higher the number, the later the calculation will occur. That way you can force an order over time of several expression tags within the same priority group. In our case, the standard priority EXPRESSION is enough, as we only have to control the order of the execution of the two XPresso tags.

As we can see in Figure 1.85, in our example it is best to leave the priority of the expression for the rotation of spring and gate at 0, and to elevate the expression of the following points to PRIORITY 1. This is enough to set the points after the rotation of the gate and to remove the delay.

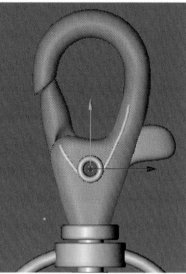

— Figure 1.85: Adjusting the priorities.

Now the carabiner is finished and can eas-
ily be moved with the user data value of
the carabiner object, as shown in Figure 1.86.
Especially when setting up animations, such
expressions can save us a lot of work since
complex relations between objects can be
controlled by using just one value.

## PUTTING THE CARABINER INTO
## A SCENE

We have come so far now that we might as
well add some fitting materials and a scene
as well. We will start with the metal material
of the carabiner and create a new stan-
dard material in the MATERIAL MANAGER with
FILE>NEW MATERIAL, which can be edited in
the MATERIAL EDITOR by a double click on the
gray preview sphere.

## The Lumas Shader

Metals are generally very dark but have high
gloss and reflective properties. The gloss is
controlled entirely by the SPECULAR channel
of the material. More control and additional
effects are only possible with the LUMAS
shader. Therefore, we load this shader into
the COLOR channel by clicking on the small
triangle in the TEXTURE section. The LUMAS
shader is part of the EFFECTS group.

The LUMAS shader makes it possible to
choose one base color and up to three in-
dividual highlights. Especially interesting is
that the shader is able to add anisotropic
effects as highlight distortion to its calcula-
tions. They appear when a surface contains
very fine ridges. Just think of the surface of a
DVD or human hair, which show such effects
as well because of their rough surface.

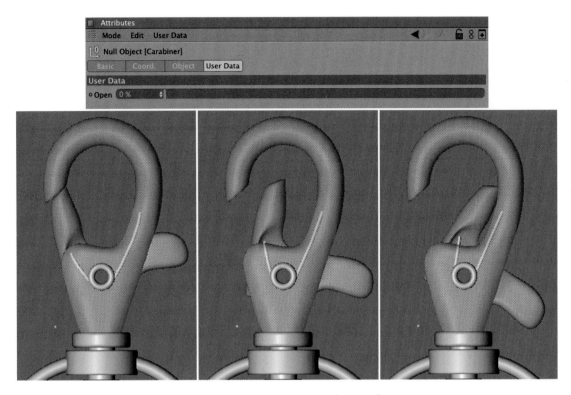

— Figure 1.86:  The complete carabiner and easy control with user data.

This effect offers two separate settings, one for the distortion of the highlights and the other for generating visible ridges within the highlights. The latter can make the surface appear like brushed metal without having to use specially adjusted images.

In our case we will first use a dark gray in the SHADER PROPERTIES of the LUMAS shader and exchange the red tones of the highlights with pure white ones. The brightness and size of the three highlights remain the same. Now activate the aforementioned ANISOTROPIC section and use the AUTO PLA-NAR projection mode. This mode controls the direction of the highlight distortion and can often be checked only on the object with test renderings. The projections with the term *Radial* in front are able to generate concentric grinding patterns like the ones used for decoration on old refrigerators or other special surfaces. Their effect is very

pronounced when used together with the ridges.

The amount of highlight distortion through the anisotropic calculation is controlled separately for each direction with the X Roughness and Y Roughness. The highlight options beneath determine which of the three highlights will be distorted. You can anisotropic-distort only one highlight, while the other highlights will be calculated in a concentric manner. We will keep everything active so all highlights will be distorted, as shown in Figure 1.87.

After the dividing line in the dialog you can find the values for amplitude, size, and length of the anisotropic scratches. Also, here the effect can be restricted to only one highlight or, like in our case, can be deactivated altogether. We don't need this effect since our carabiner is not supposed to appear scratched or rough, but instead perfectly smooth.

— Figure 1.87: The settings of the Lumas shader.

## Ambient Occlusion as Shader at Material Level

In the flashlight example, we got to know AMBIENT OCCLUSION as an effect in the REN-DER SETTINGS. It is used to naturally darken objects in areas where folds or the proximity of another object would restrict the amount of light. This effect can also be applied to certain materials with the AMBIENT OCCLU-SION shader, which helps to save some render time and to simulate different tints or detail levels on various objects.

Generally, the DIFFUSION channel is the right place for this shader, which can be found, like the LUMAS shader, in the EFFECTS shader group. I've kept the settings of the shader the same except for the dispersion, which I changed to 70% to generate more contrast. Test renderings later will show whether the effect has to be increased or

decreased. It is important in our material, which is mainly determined by its reflection, that in the DIFFUSE channel the option AFFECT REFLECTION is activated. It already affects the COLOR channel without us having to do any-thing. Figure 1.88 summarizes the settings in the DIFFUSION channel and in the AMBIENT OCCLUSION shader.

The settings for the reflection of the material don't give us any surprises, as Fig-ure 1.89 shows. I used a high BRIGHTNESS of 90% and didn't increase the BLURRINESS value since I wanted to depict a perfectly polished surface. This also saves us some render time.

### The Floor in the Scene

The carabiner shouldn't just hover in 3D space, but should lie on the floor. The floor shouldn't compete, by way of its color or

— Figure 1.88: Using Ambient Occlusion as a shader.

— Figure 1.89: The reflections of the carabiner.

brightness, with the mostly gloss-defined carabiner. Thus I will create a new material and apply a very dark red tone, as shown in Figure 1.90. Again, I loaded the AMBIENT OCCLUSION shader into the DIFFUSION channel. The settings are the same as in the carabiner material, which is why I didn't show them again in the figure.

I also activated a weak reflection of 7%, which is softened heavily by the BLURRINESS effect of 20%. The SPECULAR is wide and very flat. I also used the OREN-NAYAR model for the shading in the ILLUMINATION settings. This will generate soft shading on the floor. The

settings for the brightness of the color and the intensity of the highlight are so weak because I want to illuminate the carabiner with a very bright light from diagonally behind the object, creating a sharp highlight and strong contrast. At the same time, the floor shouldn't be brightened.

**The Light Source**

I decided to use a spotlight since I can align the light precisely and control it with the light cone. As already mentioned, I'll overdo it on purpose with the INTENSITY by setting its value to 800%. The spotlight will not cause a shadow. Place the spotlight at the side of the carabiner, with the protrusion of the gate, which is in the upper right based on the viewer's location.

*Aligning the Light Source*

Light sources can be easily aligned by using them as a camera. Just activate the light in the OBJECT MANAGER and then select LINK ACTIVE OBJECT in CAMERAS > SCENE CAMERAS of any viewport. You can then use the common icons for moving or rotating the camera, in the upper right corner of the viewport, to navigate the light source and align it to the rear of the carabiner. When you are finished,

— Figure 1.90: Settings for the floor material.

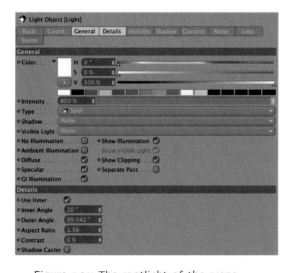

— Figure 1.91: The spotlight of the scene.

use the Editor Camera entry in the Cameras menu of the viewport to separate it again from the light source.

I changed the Aspect Ratio of the spotlight opening cone, on the Details page of the light source dialog, to a value above 1 so the cone has a more oval shape and fits better to the shape of the carabiner. The remaining settings regarding the opening angle of the spotlight can be seen in Figure 1.91. These values are only meant to be a guideline and could be different in your case. They also depend on the distance of your light source from the carabiner.

After my first test rendering the carabiner looked like Figure 1.92. The spotlight generates high-contrast highlighted areas on the

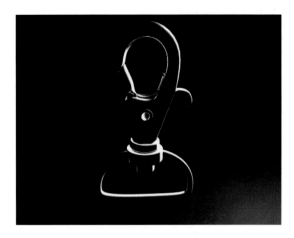

— Figure 1.92: The first test rendering.

carabiner and, at the same time, illuminates the floor only a little because of the strongly reduced intensity. I still miss some liveliness in the chrome material of the carabiner. This can only be changed by having additional objects reflected on the surface.

Just like in traditional photography, we will use simple white walls. We will create a new material and apply a perfect white color

with a brightness of 100%. In order to reduce the brightness of the walls toward the edges and to get a soft reflection, we will use a trick.

Activate the ALPHA channel in the material and load the GRADIENT shader into it. The shader can be found after clicking on the texture triangle at the center of the shader list. The gradient can take on different shapes and directions though its TYPE menu and is quite flexible. I will use the 2D—CIRCULAR type and adjust the positions of the two existing color tabs so a gradient is generated, as shown in Figure 1.93. The grayscale gradient should end before it reaches the edge of the square preview area of the shader, so the edges of the shader are perfectly black and the material is therefore invisible in this area.

For the walls we will use two POLYGON objects from the primitives of CINEMA 4D. We could also use the PLANE object but it is already highly subdivided, which would be unnecessary in our scene. Put one of the faces close and in front of the carabiner and

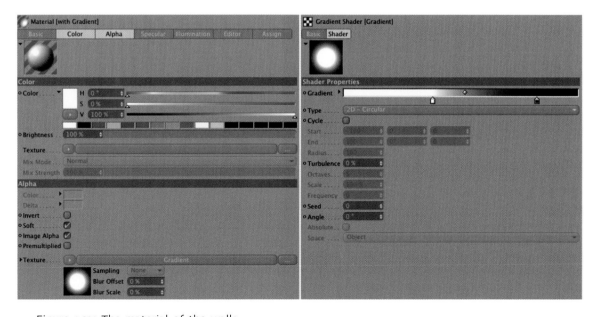

— Figure 1.93: The material of the walls.

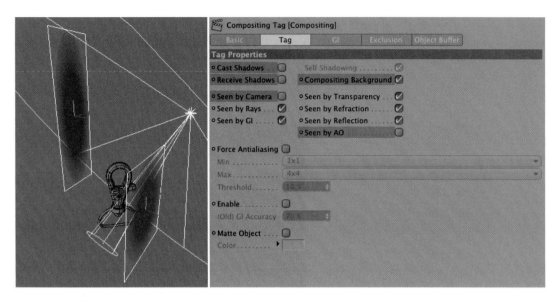

— Figure 1.94: The placement of the walls.

angle it slightly. The second face is placed on the left and to the rear left of the carabiner. Figure 1.94 shows the approximate placement of the objects.

Both polygons then receive the new material by a simple drag and drop. As is common with primitives, the material automatically adjusts to the object and we don't have to change anything at the TEXTURE TAGS. Both faces, however, should get a COMPOSITING tag, which can be found after a right click in the OBJECT MANAGER in the CINEMA 4D TAGS section.

In these COMPOSITING tags deactivate the SEEN BY CAMERA and SEEN BY AO. That way, there will not be any shading on the floor and we can place the walls in front of the camera without seeing the walls in the final rendering. Also, activate the option for COMPOSITING BACKGROUND. This suppresses any influence of the light and shading on the surface of the walls. The walls then glow in the color we applied with the material.

If you later want to use light sources that cast shadows, then the two shadow options should be deactivated, as shown in Figure 1.94.

As for the RENDER SETTINGS, I just entered the file format, activated BEST ANTI-ALIASING and defined a file path. After the rendering in the Picture Viewer, you will have a result similar to the one in Figure 1.95.

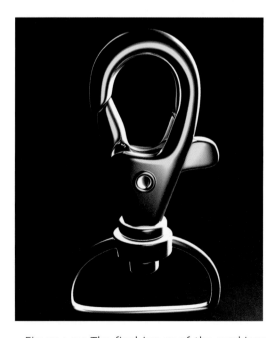

— Figure 1.95: The final image of the carabiner.

## Modeling an Antique Vase

In the following chapter we will dive deeper into the possibilities of the render process. We will be illuminating a room, so we need some objects to furnish the room with. Therefore, in this chapter we will next model an antique vase and a small table. In addition to the already known POLYGON tools, we will work with the modeling axis and soft selections. At the end of this chapter you will know all the important modeling tools needed for everyday work. The use of the KNIFE, EXTRUDE INNER, normal EXTRUDE, BRIDGE, and CREATE POLYGON tools should be second nature for you. With these few tools you can model any real or imaginative object.

## Modeling the Basic Shape of the Vase

We will start the modeling of the vase with a new BEZIER spline, which is created in the front viewport in such a way that it resembles the profile of a bulbous vase, like in Figure 1.96. By subdividing the spline under a LATHE NURBS object, the shape of the vase is generated. The vase will be smoothed later by a HyperNURBS object so we only need the 32 subdivisions along the Lathe NURBS circumference. The interpolation of the spline should be set to UNIFORM so the subdivisions are not concentrated only at the curved segments. This gives us more control over the shape.

Because the vase should be made of glass, we need a fitting inside wall. Switch to USE POINT TOOL mode, select the spline in the OBJECT MANAGER, and add points to the selected spline with (Ctrl) clicks to generate the inside. If you haven't created the spline from the base up, you might have to first switch the order of the spline points. To do so, right click in an empty area of the editor and select REVERSE SEQUENCE in the context menu. New points are only added at the end of a spline.

Make sure that the first and last points are positioned exactly on the world Y axis, as shown in Figure 1.97. Only that way will the base and bottom be closed automatically by the Lathe NURBS.

## Modeling the Bulge

The vase shouldn't be smooth, but should be encircled by vertical bulges. Therefore convert

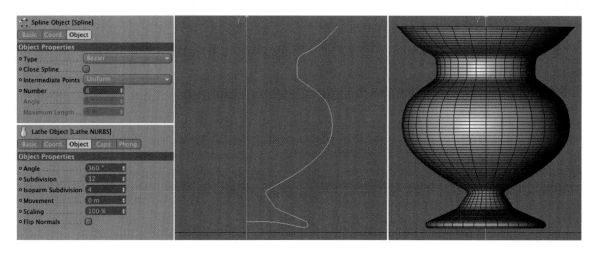

— Figure 1.96: The outer skin of the vase is created with a spline and a Lathe object.

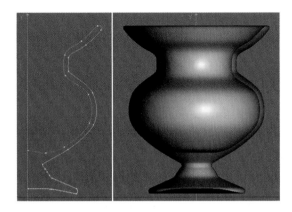

— Figure 1.97: Adding the inside of the vase.

the Lathe NURBS with the (C) key to a POLYGON object, switch to USE POLYGON TOOL mode, and select two vertical polygon sections next to each other, as shown in Figure 1.98. This leaves two sections free in between the neighboring polygon strips.

These selected polygons will later be moved outward to create the desired bulges when HyperNURBS smoothing is applied. To retain the basic shape of the vase between the bulging sections, we use the EXTRUDE INNER tool and shrink these selected areas by a small amount, as can be seen on the far right in Figure 1.98.

## WORKING WITH THE MODELING AXIS

Save this polygon selection now by using SELECTION>SET SELECTION. We will access this selection multiple times during the next steps. Since we have to edit every one of the selected sections separately, change to the top view and use any of the selection methods to deselect the other polygon sections. Make sure that the selection of invisible elements is possible. The left image in Figure 1.99 shows a possible result. It doesn't matter which of the originally selected polygon sections you start with.

Expand the polygon selection at the lower end by two more faces, as shown in the center of Figure 1.99. You can use the LIVE SELECTION while holding the (Shift) key. This time, only visible faces should be selected. Keep that in mind when adjusting the settings in the ATTRIBUTE MANAGER. Then activate the ROTATION tool and take a look at the MODELING AXIS section in the ATTRIBUTE MANAGER. Here, the axis system of the selected faces can be individually oriented and positioned. This makes it easier to rotate or scale around a certain point.

In the AXIS menu you can determine the position of the modeling axis in 3D space. In the WORLD setting it will jump to the origin of the world coordinate system, while

— Figure 1.98: Freeze selections and extrude them toward the inside.

— Figure 1.99: Moving the modeling axis.

in OBJECT it will jump to the position of the object coordinate system. The setting SELECTED centers the modeling axis in the middle of the selected elements of the object.

The ORIENTATION menu defines the orientation of the axes of the modeling system. Interesting here is the normal setting, which orients on the surface of the object itself. With the RETAIN CHANGES option the modeling system stays at its original position when the elements are rotated and their position changes. This makes it easier to test different rotations and scales.

ALONG NORMALS allows the increasing and decreasing of a shape during movement by simultaneously moving and scaling along the individual normal vectors. A similar function is provided by the NORMAL MOVE command in the STRUCTURE menu. The X, Y, and Z sliders in the lower part allow, in some modes, the individual placement of the modeling axis. We will use this in our example in order to position the axis system as exactly as possible at the lower edge of the selected polygons. The AXIS menu is set to SELECTED and the ORIENTATION menu is set to NORMAL. The RETAIN CHANGES option is activated as well.

Now rotate the polygons around the X axis of the modeling axis and outward, as shown on the left in Figure 1.100. Remember the angle that you can see in the

COORDINATE MANAGER during the rotation. All remaining polygon sections should be rotated using the same angle. Then select the vertical points located in the center of the rotated polygons and activate the SCALE TOOL. The modeling axis should be in the center of the selection again. The settings of the modeling axis in the ATTRIBUTE MANAGER should be set to ORIENTATION AXIS, and the X, Y, and Z sliders should be centered. Then scale the points evenly along all axes outward, as shown in the middle and on the right of Figure 1.100.

Restore the original selection of the polygon sections by double clicking on the POLYGON SELECTION tag behind the vase in the OBJECT MANAGER. The process will start all over again. In the top view, deselect all but one selected polygon section, add two additional faces at the lower end, activate the ROTATE TOOL, and move its modeling axis downward. The faces are then rotated by the memorized angle around the X axis. Then scale the center row of points. The left side of Figure 1.101 shows the result after applying all these steps to the remaining polygon sections. The spaces in between are still missing, however. The selected polygons there are also shown in the figure. After the combined EXTRUDE INNER and the saving of this new selection as a tag, these polygons have to be edited using the same process. Figure 1.101 shows the end result.

— Figure 1.100: Rotating polygons and scaling points.

— Figure 1.101: Continuing the modeling of the vase.

## SHAPING THE INSIDE OF THE VASE

Since the vase will be made of glass and therefore rendered to be transparent, we have to shape the inside as well. The outside bulges should be visible as well, so the wall thickness cannot appear to be too massive. This time we can work much faster, because it will be enough to simply scale the points positioned behind the bulge of the outside wall outward. In the perspective viewport, get close enough to the inside of the vase with the camera to be able to easily select the points. Always select the vertical point rows, which are located in the center of the bulge. Figure 1.102 shows part of the selection on the left. After all these points are selected on the inside, scale this group slightly outward along the X and Z direction. Be sure that the points don't get too close to the outer hull.

Now you just have to add a HYPERNURBS object and subordinate the vase under it. The result should look similar to the center and right image of Figure 1.102. The basic shape of the vase is now complete.

— Figure 1.102: Shaping the inner walls of the vase.

## Creating Ornate Elements and Handles

The vase should also have some ornate elements and some handles. We will start with a collar around the neck of the vase. Add a Tube primitive and adjust its radius and height to the area between the opening of the vase on top and where the bulges begin at the shoulder of the vase. The left image of

Figure 1.103 gives you a hint. Be sure that there's no big gap between the vase and the tube. The tube should be close to the vase but should not penetrate the surface.

Then place flat cylinders along the edge of the collar. On the whole they should look like a twisted wire. Since this is a circular placement, the Array object could be used. It can be found in the Object menu under Modeling objects. Subordinate a new Cylinder

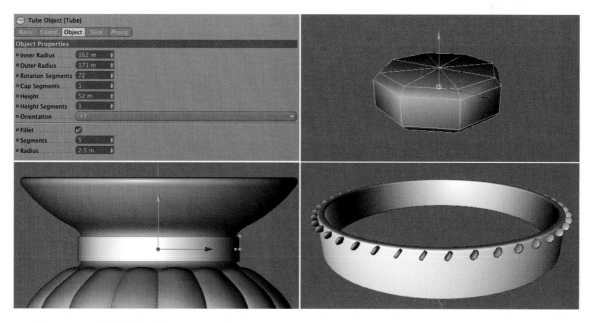

— Figure 1.103: Modeling the upper collar.

primitive under the array in the OBJECT MANAGER. Adjust the size of the cylinder, as well as the position and the radius of the Array objects, so the cylinder copies are created along the upper edge of the collar. The exact placement of the array can be simplified when it is subordinated directly under the tube and the X and Z position coordinates in OBJECT mode are reset to o in the COORDINATE MANAGER. The Array object is then automatically placed exactly on the rotation axis of the tube and only its height has to be adjusted.

As you can see in the lower right part of Figure 1.103, the cylinders should be slightly tilted. This can only be achieved by using a trick, since the ARRAY object orients the subordinated object with its Z axis outward and its Y axis upward. When the desired size and a slight fillet is set for the cylinder in the Array object, you have to convert the cylinder with the (C) key and switch to USE OBJECT AXIS TOOL mode. Then rotate the local coordinate system of the converted cylinder around its Z axis until the desired tilt is achieved.

Now we just have to determine the right number of copies in the ARRAY object so no gaps can be seen between the tilted cylinders. To do this, create an INSTANCE of the ARRAY object at OBJECTS > MODELING. Move it so far downward that the lower edge of the tube is covered with this ornate decoration. Figure 1.104 shows the desired result and the actual hierarchy of the used objects in the OBJECT MANAGER.

### THE SOFT SELECTION

So far we have used selections in absolute terms. Either an element is selected or it is not. But CINEMA 4D also knows SOFT SELECTIONS. Here the elements neighboring the selection can still be included in movements, rotations, or scaling. This results in soft transitions, even when the object is already finely subdivided with points.

— Figure 1.104: The finished ornate collar of the vase.

This special evaluation of selections is activated when the MOVE, ROTATE, or SCALE tool is selected and the tab for SOFT SELECTION in the ATTRIBUTE MANAGER is used. There you will find an option to activate this effect. With an active PREVIEW option you can get additional feedback about the effect through coloring in the viewports.

Since there are supposed to be two handles on the vase, one to the left and one to the right of the collar, which should extend upward from the vase, I would like to slightly constrict the opening of the vase. Because of the large number of points, the manual moving of points would be very tedious. But with soft selection, this process will be a walk in the park.

Start as usual with the selection of points. We need to select the points on the left and right edge of the vase, as is shown on the left of Figure 1.105. Remember that the vase has an inside and outside surface and that the points have to be selected on both sides. End the selection above the constriction of the neck of the vase, since this area shouldn't be deformed too much so the collar will still fit.

Then enable the SCALE tool and the SOFT SELECTION in the ATTRIBUTE MANAGER. With an activated PREVIEW you can see the extension

— Figure 1.105: Deforming soft selections.

and the influence of the soft selection appearing as yellow in the editor. When SURFACE is active, the selection field doesn't expand in all directions but instead follows the surface. This prevents the accidental selection of the protruding parts of the object that are close to the selected area. This will not happen with our vase, so the option can remain deactivated.

The RUBBER option results in a sort of dynamic pulling effect of moved elements, as if the surface of the object were made of rubber. Since the impact of this effect is difficult to control, it is used more often for free-form modeling than for objects that need more precise deformations. The RESTRICT option deactivates the soft selection and returns to the normal behavior of selected elements.

With the FALLOFF menu you define the falloff curve for the edge influence of the soft selection. As an alternative, the VERTEX MAP setting can use its own point weighting or the SPLINE setting can use a curve defined by its spline graph. The mode menu determines at which spot the soft selection should be calculated. In the GROUP setting, the center of connected selections is used. From this center the soft selection spreads based on the RADIUS setting. With CENTER, the center of all selected elements is used as the center of the soft selection. Depending on the position of

the selections, there can be large areal differences. With the ALL setting, the soft selection starts at the edge of the selected areas and therefore increases the selection by the RADIUS value.

In our case we use the GROUP mode and a LINEAR FALLOFF. You have to set the RADIUS value yourself based on the size of your vase. The yellow area of the soft selection shouldn't reach too far down the neck of the vase. Then scale the selected point groups together as shown in Figure 1.105 on the right. The outside of the vase should slope upward at these places to make space for the handles. When you are happy with the result, deactivate the SOFT SELECTION in the ATTRIBUTE MANAGER with the ENABLE option.

### THE CURVE OF THE HANDLE

The handles themselves are held by curved supports that start at the collar around the neck of the vase. We will create a spline for the shape as shown in Figure 1.106 and place it so that it nestles up against the surface in the area between the collar and the edge of the vase.

Add a small RECTANGLE spline and subordinate it, together with the other spline, under a new SWEEP NURBS. Remember that the profile, the small RECTANGLE spline, has to be

— Figure 1.106: The curve of the handle is created with a spline and a Sweep NURBS.

the topmost object. With the rotation curve of the SWEEP NURBS you can improve the look of the curved support, as shown in Figure 1.106 on the right.

At the same time, vary the size of the sweep profile with the SCALE curve, as shown in Figure 1.107. A slimmer profile of the collar makes it easier to integrate the curved part.

We can save ourselves some work by using two SYMMETRY objects instead of modeling the other curved supports, which we sorted in a hierarchy, as shown in Figure 1.108. One SYMMETRY object uses the XY and the other one the ZY MIRROR PLANE. The order of the SYMMETRY objects doesn't matter. It is assumed that your handles are placed, in the front viewport, to the left and right of the vase. When your handles are located at another position, you might need to rotate the SYMMETRY object group vertically.

Subordinate the Sweep NURBS object under the lower SYMMETRY object to create the missing curved parts. Figure 1.108 shows the desired result and the hierarchy of the objects.

### The Actual Handle

The handle itself is created to be a connection between the pair of curved supports. Add a CYLINDER object and position it between one of the two pairs of supports. Because the handle will be smoothed by HyperNURBS, we do not need that many segments. It is

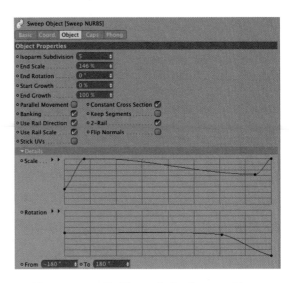

— Figure 1.107: Settings of the Sweep object.

enough to use 12 segments for the circumference, but since there will be an additional deformation we will need additional height segments as well. I used 10 segments, as you can see in Figure 1.109.

### Optimizing Objects

Because we want to work on the polygons of this cylinder, convert it with the (C) key to a POLYGON object. With cylinders and primitives, which have caps, because the conversion doesn't automatically result in an optimal geometry, we have to pay attention to something else. That means that the separately generated caps of the primitives are not

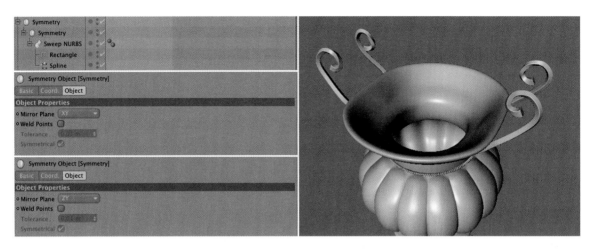

— Figure 1.108: Mirroring the curved support.

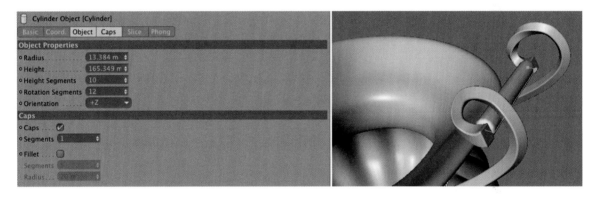

— Figure 1.109: A cylinder as handle.

combined with the walls of the object. We have to do that ourselves after the conversion. Select OPTIMIZE from the FUNCTIONS menu. With this function you can determine which elements of the object should be evaluated.

The option POLYGONS and UNUSED POINTS ensure that the elements that are duplicated or of no use are automatically removed. In our case, the POINTS option is of interest since it works together with a TOLERANCE numerical value. All points located within a certain distance of each other below the specified TOLERANCE are automatically merged to one point.

This will cause, in our case, the points at the edge of the caps and the points at the

edge of the walls to be combined. Generally, you don't have to change anything in the options of the OPTIMIZE function and can leave them activated at all times. The standard tolerance can also be used as is. Only when you have extremely large or small objects will an adjustment of that value possibly be necessary.

Now you can select every second polygon row of the cylinder and duplicate and shrink this selection with the EXTRUDE INNER function. Then we will use NORMAL MOVE from the STRUCTURE menu and move the new faces slightly toward the center axis of the cylinder. The right side of Figure 1.110 shows the desired result.

— Figure 1.110: Extruding and shrinking polygon strips.

### Deforming the Handle

Having been subordinated under a HYPER-NURBS, the handle should display a soft ridge structure like the left image in Figure 1.111. To improve the overall look of the handle we will expand it in the center. Subordinate a new BULGE object under the handle, found in OBJECTS>DEFORMATION. Make sure that it is placed in the center of the cylinder and rotated so the orange handler is located at one of the cylinder caps. The Y size of the deformer should be adjusted so the cylinder is completely enclosed. Using the STRENGTH value, the outward expansion or bulge of the handle can be set, as is shown in Figure 1.111.

Add another deformer, the TWIST object, which is located in the same menu as the BULGE object. This object also needs to be adjusted in height and position so that it follows the length of the cylinder and encloses it entirely. With the ANGLE value a twist of the cylinder can be calculated to make the ridges appear in a spiral manner. As a result, the TWIST object has to be subordinated under the cylinder as well, as shown in Figure 1.112.

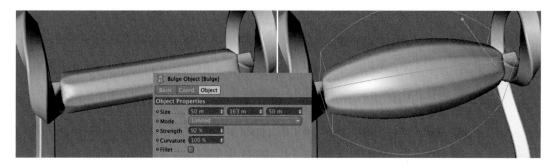

— Figure 1.111: Bending the handle with a Bulge object.

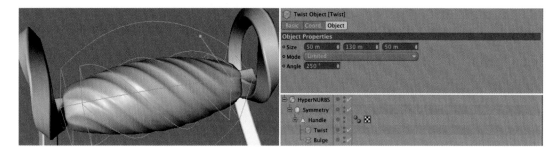

— Figure 1.112: An additional twisting of the handle.

Multiple deformers can affect an object at the same time without any problems. Note that they are applied in the order that they are sorted under the object in the OBJECT MANAGER, from the top to the bottom. The results therefore can vary depending on the order.

### THE PEDESTAL OF THE VASE

The vase will not just sit on a table or the floor, but will be placed on a pedestal. We will work again in the front viewport and create a linear spline shaping the desired profile of the pedestal. Figure 1.113 shows one possible look on the left.

To have points that are positioned in pairs vertically on top of each other or next to each other, we have to select them and then set the corresponding SIZE value to 0 in the COORDINATE MANAGER. This can also be done in STRUCTURE>SET POINT VALUE. In the menus of the ATTRIBUTE MANAGER the coordinates can then be centered separately with X, Y, or Z, or can be moved to a certain position.

We will round some of the hard edges a bit. Select the points along the spline, as shown in the center of Figure 1.113, and select the CHAMFER command with a right click in the viewport. Either by using the value entry in the ATTRIBUTE MANAGER or by pulling the mouse, add a small rounding before the spline is subordinated under a new LATHE

NURBS. This object can be found in OBJECTS> NURBS.

If the vase was created at the origin of the world coordinate system, then a correctly oriented pedestal should appear. You can decorate it, like the neck of the vase, with ARRAY objects and you can use the same small cylinders like the ones in the upper ARRAY object. A possible placement of this decoration can be seen in the right image of Figure 1.113. This concludes the modeling of the vase. Of course, you should feel free to add more decorations or details if you like.

## Adding a Simple Table

In order to give the vase some company, we will add a classic Asian-style side table. We won't get lost in details since these objects will only be a small part of the scene.

Let's start with a cube primitive that is adjusted in its size to the dimensions of the vase. My settings can be seen in Figure 1.114. The cube is then converted to a POLYGON object so we have access to its polygons. Select the upper face of the cube and use EXTRUDE INNER from the STRUCTURE menu to slightly shrink it. Then change to the BEVEL tool that can be found in the same menu. This command is a combination of the EXTRUDE INNER and EXTRUDE commands with the option of adding a rounding as well. We

— Figure 1.113: The pedestal of the vase including decorations.

— Figure 1.114: The table top is created from a simple cube.

will use this to lower the shrunken top face and to smooth the sides with a radius.

The EXTRUSION and INNER OFFSET values are equal to the OFFSET values of the separate EXTRUDE commands. We will use two identical values, but with different signs, so the face is shrunken and lowered a bit more. In the TYPE menu you can select the different kinds of rounding. With polygons, though, only the LINEAR and USER types are offered. We will choose USER so we can create an individual profile for the rounding with the PATH spline in the ATTRIBUTE MANAGER. This spline is shaped by moving the pre-existing points on the curve. We can also add more points to the path by clicking on the curve. Unnecessary points can be removed again by pulling them upward out of the graph.

To actually see the PATH curve we have to increase the number of SUBDIVISION. My settings and the desired result can be seen in Figure 1.114.

To make the table top appear as if it is put together by individual pieces of wood, we will again use the EXTRUDE INNER command to shrink the surface, as shown on the left side of Figure 1.115. The main surface of the table consists of five polygons that you now select and edit again with EXTRUDE INNER. This time, though, deactivate the PRESERVE GROUPS option in the dialog of the tool. Every face will then be extruded separately. This generates small gaps between the formerly adjacent faces. The right image of Figure 1.115 shows this.

Use the normal EXTRUDE command with these five single faces to move them slightly upward. This will give the impression of a table being assembled by separate pieces. The rendering in Figure 1.116 depicts this effect. If necessary, correct the distance between the table top and the pedestal of the vase so the vase sits on the table and doesn't hover over it.

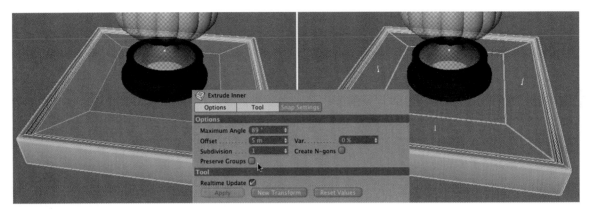

— Figure 1.115: Adding subdivisions.

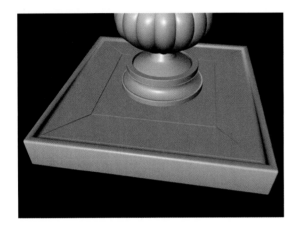

— Figure 1.116: The look of the finished table top.

Using the same principle we will add the lower part of the table. We will model it from a CUBE primitive whose dimensions can be seen in Figure 1.117. Your dimensions, of course, could be completely different. The base should be smaller than the table top and shouldn't be that tall. After all, the table is just a small side table. After the cube is converted to a POLYGON object, you can build elevated structures like you've already done with the table top. The rendering in Figure 1.117 gives some inspiration.

— Figure 1.117: The table base.

## The Materials of the Vase

We don't have fitting materials for the table and the vase yet. We will start with the settings for the vase and create a new material in the MATERIAL MANAGER in FILE>NEW MATERIAL. The goal is a clear glass material that is greenish in its thicker parts. We will start with the COLOR settings and select a dark gray. This color tone is only important later for the reflection and the highlights. The main color is generated by the transparency.

Thus, at the TRANSPARENCY channel we create a 95% transparent material with a REFRACTION index of 1.6. This is equivalent to regular glass. TOTAL INTERNAL REFLECTION and EXIT REFLECTIONS are activated to realistically simulate all physical effects of glass. Finally, we will use a pastel green ABSORPTION color with an ABSORPTION DISTANCE fitted to the dimensions of the model. This value shouldn't be set too small, so the thinner places around the upper opening remain clear and are not tinted. All of my settings are shown in detail in Figure 1.118.

### REFLECTION AND GLOSS

The FRESNEL part of the TRANSPARENCY channel already causes a reflection at the edges of the vase, but I want to increase it by activating the REFLECTION channel and setting the BRIGHTNESS to 50%. SPECULAR is adjusted to the desired smooth surface and therefore is very intense and not very wide. Figure 1.119 summarizes these settings.

### ILLUMINATION

Because we will work with global illumination again, we shouldn't forget the settings in the ILLUMINATION section of the material. Generally speaking, very transparent or very reflective materials don't profit much from global illumination, but this decision is left to us by CINEMA 4D. We therefore decide not to generate or receive global illumination with this material and deactivate the corresponding options. This also speeds up the render time since no additional samples have to be generated to evaluate the objects with this material applied. This can't be compared

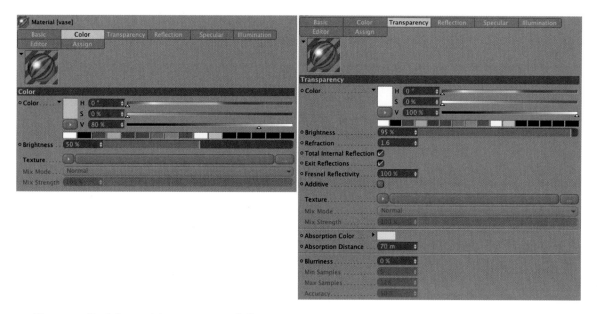

— Figure 1.118: Color and transparency of the vase.

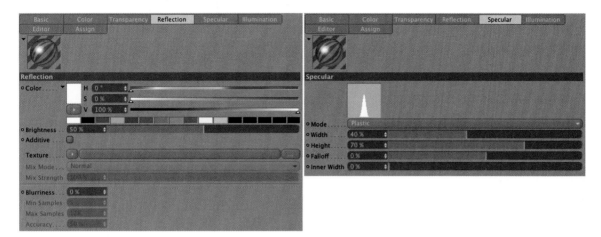

— Figure 1.119: Reflection and gloss.

with the options in a COMPOSITING tag, though. There, the option SEEN BY GI can be deactivated as well, but it only influences the cast shadow of the object and not its GI illumination. Lastly, I used the OREN-NAYAR shading model so the surface doesn't look too perfect. This effect will be minimal, though, since the transparent properties are so strong that there is hardly any shading on the surface. Figure 1.120 shows almost all these settings in detail.

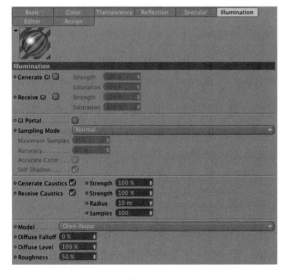

— Figure 1.120: The illumination settings for the vase.

## THE BRONZE MATERIAL

The handles and the pedestal of the vase should be made of a bronze material. We will need to create a new material and start again with the COLOR settings. Metals generally have a weak or very dark surface color. This only changes when lacquer or other sorts of coatings are added. Consequently, I used a dark brown tone. A similar but much brighter color is used in the REFLECTION channel. Since the surface reflection is not supposed to be perfect, I set the BLURRINESS to 20% to calculate a slight blur.

The BUMP channel goes in the same direction by using a NOISE shader with a LUKA pattern. Of course, you could also load an image with a scratch structure if you have one on hand. As you can see in Figure 1.121, I set the bump strength to 10%.

### The Highlights of the Material

Colored metals like copper, gold, or bronze can be simulated by using different colors for the reflection and highlights. Therefore, I will set a reddish highlight to contrast with the yellow-brown color of the surface. Otherwise, the highlight is wide and flat to maintain the overall impression. We also keep this in mind in the ILLUMINATION channel because

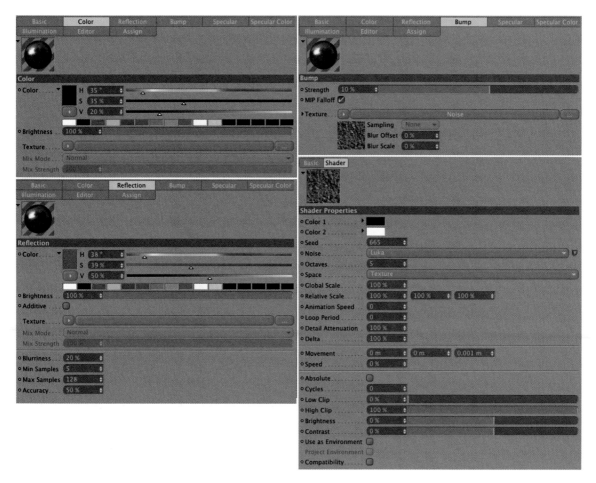

— Figure 1.121: Settings for the metal material of the vase.

we use the Oren-Nayar shading model again. All other settings can be taken from Figure 1.122.

## The Wood Material of the Side Table

The side table is supposed to have a subtle wood grain and have the expensive look of Asian furniture or piano lacquer. Therefore, we start with a new material and apply a very dark orange color. The reflection is kept moderate yet color neutral at 20%.

The desired wood grain is depicted with the Wood shader, which is loaded into the Diffusion channel of the material. This shader can be found in the group of the Surface shaders. Since the Diffusion shader only evaluates the brightness of the loaded shader or images, we reduce the gradient of the Wood shader to the colors white and gray, as shown in Figure 1.123. All other options in the upper part of the Diffusion channel are deactivated so the shader changes only the color of the material and not the reflection or the highlight. This will emphasize the impression of a perfectly smooth and varnished surface.

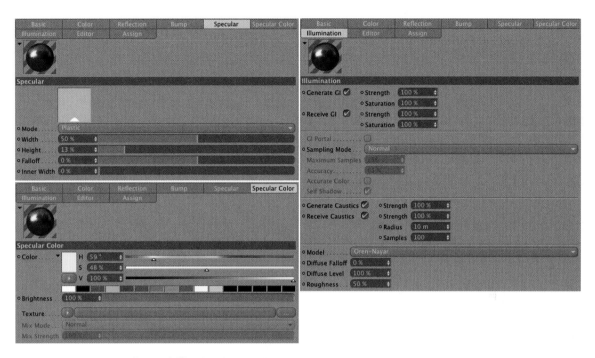

— Figure 1.122: Specular and illumination settings.

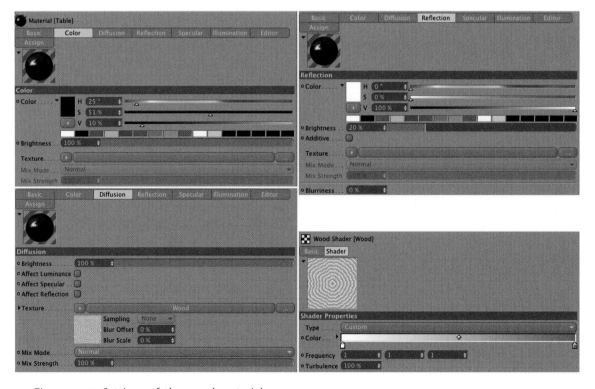

— Figure 1.123: Settings of the wood material.

### HIGHLIGHTS AND ILLUMINATION OF THE WOOD

The highlight will remain moderate in its settings since the reflection is supposed to take center stage. We therefore keep the PHONG shading in the ILLUMINATION settings, but reduce it to a DIFFUSE FALLOFF of −50%. This reduces the brightness of the shadows quicker than normal along the edge of an illuminated area and simulates a perfectly smooth surface without diffuse light scattering. Figure 1.124 shows these settings.

### The Environment of the Scene

In order to make a test rendering of our objects at the end of this chapter, we will add a simple environment to the scene. Add a SKY object from the SCENE objects in the OBJECTS menu. It simulates an infinite sphere that automatically encloses our scene.

We will create a material for this sky sphere and load the gradient into the COLOR channel. In the gradient, select the 2D—V type to generate a vertical gradient and use several colors. I used a gradient that starts with warm yellow colors on the left, continues

with white and blue tones, and ends in dark brown colors.

To make it easier to edit and manipulate this gradient, I changed to the main level of the COLOR channel in this material and add another shader, the so-called FILTER shader. It doesn't delete the gradient shader but imports it, as shown in Figure 1.125 on the left. For example, this allows us to change the entire saturation or brightness of the gradient without having to edit every single one of its colors.

The material is complete and can be applied to the sky by dragging it into the editor or onto the SKY object in the OBJECT MANAGER. Apply the glass and bronze materials in the same manner to the corresponding objects on the vase, and the wood material to the table.

The SKY object has, compared with other objects, some specialties. It not only has an automatically infinite size, but also suppresses all highlights, shading, and shadows. Other characteristics can be controlled with a COMPOSITING tag. For example, you can make the sky invisible for the camera but still use it for transparencies and reflections. This can be useful when you want to use the sky for reflections on an object but want to use

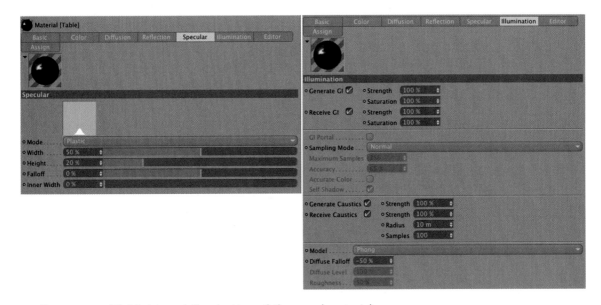

— Figure 1.124: Highlights and illumination of the wood material.

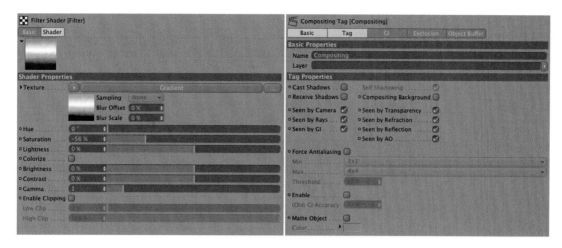

— Figure 1.125: The material and the settings for the environment.

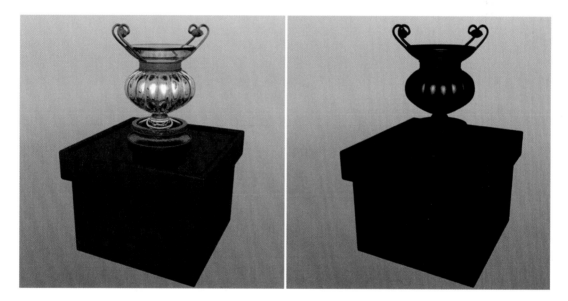

— Figure 1.126: The test rendering of our objects, on the left with the environment and on the right without.

another motif as your background image. In our case the sky can remain visible.

Take a look at the test rendering on the left in Figure 1.126. Compare it with the rendering of the same scene on the right, where, in the COMPOSITING tag of the sky, the SEEN BY REFRACTION and SEEN BY REFLECTION were deactivated. The transparent and reflective objects appear almost black because of their low surface brightness. You can see how important such materials are for the environment of your objects.

In the following chapter we will dive deeper into working with the renderer of CINEMA 4D. This will benefit all users of CINEMA 4D, regardless of whether you model your objects yourself or you work primarily with imported objects.

# Advanced Workshops

Nothing is more exciting than setting a 3D object into a scene, applying fitting textures, and setting up the lighting. The object itself doesn't really matter. A 3D character can be just as fascinating as a tastefully lit room. CINEMA 4D has made big improvements, especially in the area of realistic renderings with the Advanced Renderer. Not only did global illumination became easier to use, but it also delivers results of a much higher quality than before. Of course, global illumination doesn't have to be used at all times. With a little skill and basic knowledge about lighting, attractive images and animations can be rendered without having to use the Advanced Renderer. We therefore will literally "shed light" on each of these two methods.

## Illuminating a Room

This is the classic example of lighting. We are in a room, and sunlight shines through the window. In the following example we will model, texture, and illuminate such a room

using lights - as well as the physical sky. A variation of this example will show what changes have to be made in order to illuminate the room with an interior light source.

## The Modeling of the Room

What could be easier than to model a room? Well, you will see what problems can emerge even with such a simple task. We will begin, and this may surprise you, by redrawing the footprint of the room with a spline. Depending on the shape of the room you could start with a RECTANGLE spline, convert it with the (C) key, and, if necessary, add more points with (Ctrl) clicks. The footprint could also be imported as an Adobe Illustrator path or the spline could be drawn manually. As you can see in Figure 2.1, I started with a simple rectangular shape, which then is expanded by adding some points to one side. The spline should be positioned in the XZ plane, which

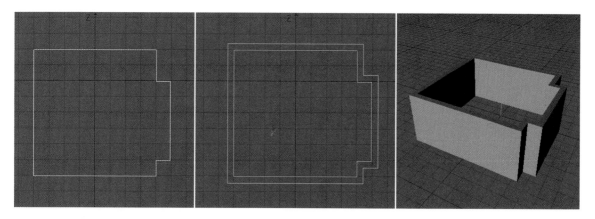

— Figure 2.1: Modeling the walls of the room.

means it must be drawn in the top viewport. If your spline was drawn in another viewport, or is oriented differently after the import, you should rotate it before continuing with the next steps.

Because the room will be given windows later on, we have to consider a certain wall thickness. This can automatically be done with the CREATE OUTLINE function. This function can be found in the STRUCTURE menu under EDIT SPLINE. The parallel structure should be larger than the original spline so the room volume does not shrink. If you'd like to work more precisely, you could enter the wall thickness for CREATE OUTLINE as DISTANCE in the ATTRIBUTE MANAGER. Otherwise, the CREATE OUTLINE tool can be used interactively in the editor viewports.

Finally, subordinate the spline under an EXTRUDE NURBS object. Use the MOVEMENT value in the Y direction to create the desired height of the room. Figure 2.1 shows the desired result on the right. The room is already taking shape.

As with all real objects, we have to remember that the edges need to be rounded. So change to the USE POINT TOOL mode and select all points of the spline that are placed inside the room. We will disregard the outer wall for now. Use STRUCTURE > EDIT SPLINE > CHAMFER to create a small rounding at the selected points, as you can see in the example of one corner in Figure 2.2 on the

left. A small radius is enough to remove the unnatural sharpness of the corner.

## INTEGRATING THE WINDOWS

The walls are done, and now we will concentrate on the windows. They are also quickly made because of the ability of the Boole object to combine objects and subtract them from each other. We will use it to subtract two cubes and one cylinder from the walls. The center image of Figure 2.2 shows the highlighted positions of the two cubes and the cylinder. It is important that the objects go all the way through the walls and that the cylinder contain a sufficient number of circumferential segments. Otherwise, the circular opening will show some linear segments, and the correction of such a mistake can be quite time consuming. Here I used 72 segments for the circumference of the cylinder. I also added a small rounding to the cubes so the window openings will have soft edges.

Then add a BOOLE object from MODELING in the OBJECT menu and activate the options CREATE SINGLE OBJECT and HIDE NEW EDGES. HIGH QUALITY and BOOLEAN TYPE A SUBTRACT B should be activated by default. That way, after the conversion of the Boole object, we will get an optimized object containing n-gons, which will make it easier to round the window opening. The hierarchy of the objects

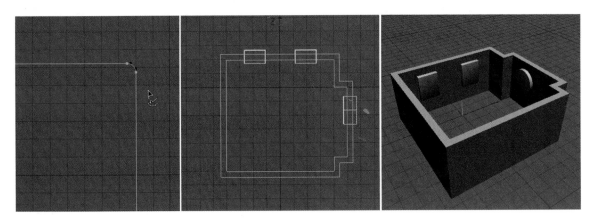

— Figure 2.2: Rounding the edges and placing the windows.

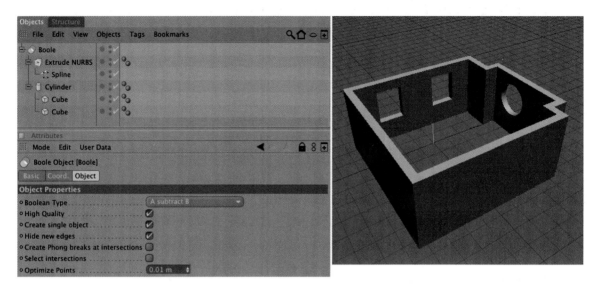

— Figure 2.3: Subtracting the window objects from the room.

can be seen in Figure 2.3. The Extrude NURBS comes first, followed by one of the window objects that was combined into a group. This setting makes it possible to cut the three holes by using just one Boole object.

There is still time to move the windows or to change their size. When you are happy with their placement, convert the Boole object. Use the MAKE EDITABLE command in the FUNCTIONS menu or the familiar (C) key.

## Smoothing the Openings

To be able to add a ceiling and a floor later, we should select and delete the former caps

of the Extrude NURBS. These faces can be seen highlighted in the left image of Figure 2.4. These faces were only necessary so that the Boole object could function, since it only works reliably with closed objects. Then use the RING SELECTION in the SELECTION menu to select the three window openings. Hold down the (Shift) key to select all three openings one after the other. These selections can be seen in the center and the right image of Figure 2.4.

From the STRUCTURE menu select the BEVEL command. You will use it to generate a small rounding along the openings. A small value of 1 for EXTRUSION and INNER OFFSET

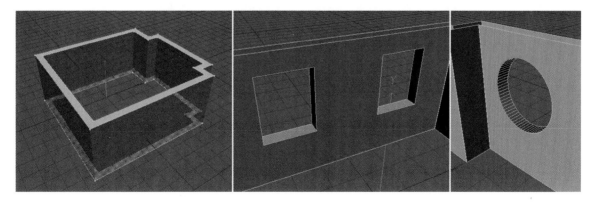

— Figure 2.4: Converting and modifying the Boole object.

should be enough, but it depends on the scale of your room and windows. It is important that the MAXIMUM ANGLE is set to a value above 90°. Otherwise, the sides of the rectangular windows could be rounded independent of each other. Thus the PRESERVE GROUPS option has to be active as well. The actual rounding is determined by the SUBDIVISION value and the TYPE. In the TYPE setting LINEAR you can create the path, defining the profile of the rounding. Figure 2.5 shows an example. As long as the tool is active, the values and the course of the path can be changed. Thus you can take your time and experiment until you find the desired rounding.

— Figure 2.5: Rounding the window openings.

Select only the polygon loop in the middle of the two rectangular openings with the RING SELECTION. The faces of the round opening should be deactivated completely. We will do something else with that opening. First, slightly shrink the selected faces of the rectangular window openings with the EXTRUDE INNER function, as shown in Figure 2.6. Here, too, it is important to preserve the groups and to use a MAXIMUM ANGLE above 90°. Then use the MOVE tool to reposition the shrunken faces, as far as the surrounding geometry allows, toward the outside of the wall. The arrow on the right side of Figure 2.6 indicates the direction and shows the end position of the polygons.

These faces are supposed to close the gap between the window frames and the window opening. So we will use the EXTRUDE command on these faces and reduce the size of the window openings. Here the requirements are again the same regarding the maximum angle and the preservation of the groups, as shown in Figure 2.7. You can see the desired result in the middle image. Then change to USE EDGE TOOL mode and use the LOOP SELECTION in the SELECTION menu to select the edges at the base of the extruded faces, as shown in Figure 2.7.

Here the BEVEL tool does a good job rounding the hard edges. This time it is easier, though, since edges, contrary to polygons,

— Figure 2.6: Preparing the base for the window frame.

— Figure 2.7: Finishing the base.

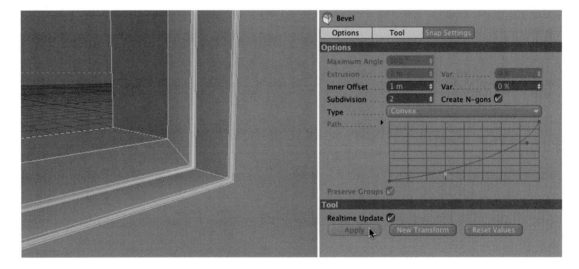

— Figure 2.8: Rounding the edges.

can have predefined rounding types applied to them. In most cases the convex type will be used. As can be seen in Figure 2.8, it is enough to use a small rounding to soften the hard edge. By the way, this is only necessary at the edge of the window opening inside the room. The corresponding edge on the outside can remain as is.

### Framing the Round Window

Let's shift our attention to the round window opening on the other wall. I decided to not use it as a window but as a decorative element

instead. I would like it to have a decorative grid with a reflective surface behind it. The mount of the grid is simulated with a TUBE object that can be found in OBJECTS > PRIMITIVE. First, set the direction of the tube so that it aligns with the round opening and then use the handler to adjust the size of the tube to the diameter of the opening. The tube may sink into the wall, as shown highlighted in Figure 2.9. There you can also see, in my settings of the TUBE object, that I added a rounding with a number of circumferential segments corresponding to the number of the opening segments.

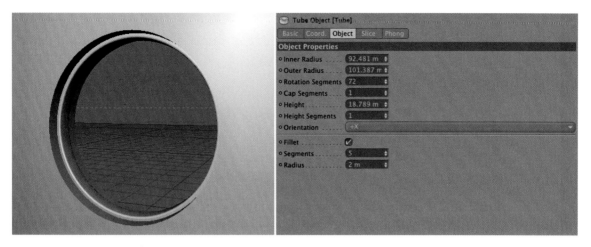

— Figure 2.9: Inserting a tube into the window opening.

## CORRECTING THE SHADING IRREGULARITIES

Upon closer examination of the room you might notice the distinctively different levels of shading on the walls, as shown in Figure 2.10 on the top left. This is always the case when small faces border large ones and the two faces are oriented in different directions. In our case, the walls consist of very large n-gons. The window openings, on the other hand, are surrounded by many small polygons that shape the rounding of the edges.

Sometimes this problem can be solved by lowering the angle in the PHONG tag of the object. In our case, though, this would make the roundings of the openings and the room corners look faceted. In these cases it helps to add faces at the border of the large polygons and to apply the same tilt to them as on the large faces. Select the two faces of the two walls with the window openings and select the EXTRUDE INNER command from the STRUCTURE menu. Use a small OFFSET value of maybe 1 or 2 and check what happens to the shading when it is applied. As you can see in the bottom row of Figure 2.10, the problem disappears instantly without us having to adjust the phong angle at all.

## MODELING THE CEILING

Let us now look at the ceiling of the room. Here, too, there are some problems waiting to be solved. At first glance everything looks easy. We deleted the caps of the converted room so that the open edges, on the top and bottom of the room, can be used for modeling the ceiling and, later, the floor. Therefore, use the CLOSE POLYGON HOLE tool in the STRUCTURE menu, as shown in Figure 2.11 and single click on the upper open edge of the inside wall.

The next step is to round the transition between the wall and the ceiling with a fillet or rounding. Let's try to use the EXTRUDE INNER tool and see what happens to the ceiling. Select the recently created surface of the ceiling and shrink it with the EXTRUDE INNER tool in the STRUCTURE MENU. Room corners protruding into the room don't cause any problems, as you can see in the left image of Figure 2.12, but what happens to the other corners?

As shown by the highlights on the right side of Figure 2.12, the new polygon edges part from the original edges and the result is intersecting faces. The problem is increased by the large number of points generated by

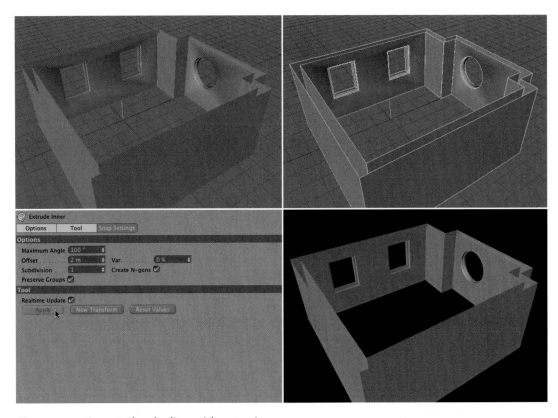

— Figure 2.10: Correct the shading with extrusions.

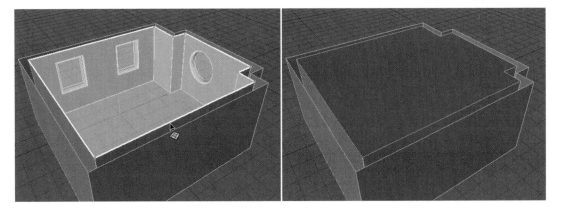

— Figure 2.11: Closing the open edge of the inner wall.

the rounding in the room corners. A manual correction would take too much time. Therefore, undo the rounding with the UNDO function in the EDIT menu of CINEMA 4D. We have to find a different solution.

## Shaping the Transition to the Walls

In our second try, we will use the EXTRUDE INNER command again, but this time with an OFFSET of 0. This generates new faces

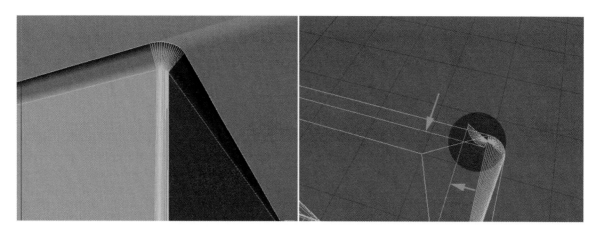

— Figure 2.12: Trying to round the edge between ceiling and wall.

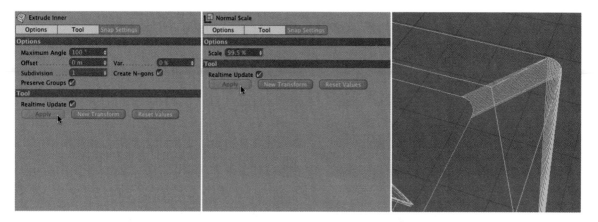

— Figure 2.13: Scaling along the normal direction.

that remain in the same position as the original ones. To shrink the new faces we will use the NORMAL MOVE command in the STRUCTURE menu. This takes into account the direction of the normal vector on the faces and therefore can help us avoid intersecting polygons during shrinking. Use the SCALE percentage value in the ATTRIBUTE MANAGER to shrink the ceiling. Since the tool works very well I decided to extend the small rounding and create a wide decorative bevel. A number of images in Figure 2.13 show my settings in the mentioned tools. Remember that your values could be different, depending on the shape and size of your room.

A view from above the shrunken ceiling reveals some irregularities regarding the distance to the walls, but this can be quickly corrected. Figure 2.14 shows the different distances to the walls in the example of a room corner. The selected points can easily be moved to an even distance, as can be seen in the figure. It is enough to just eyeball it.

Perhaps it confuses you that I mentioned a bevel several times, because the ceiling is actually still in the same plane as the deleted upper cap of the walls. This will now be changed by pulling up the shrunken ceiling polygon. Figure 2.15 indicates this movement with an arrow. At the edges of the moved

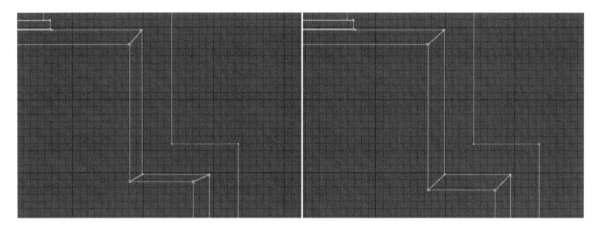

— Figure 2.14: Corrections for an evenly wide fillet.

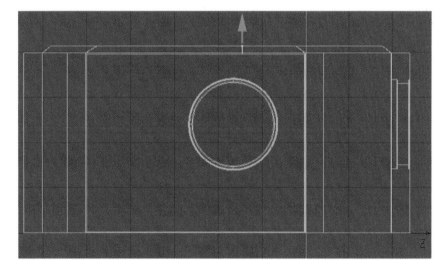

— Figure 2.15: Lifting the ceiling.

polygons you can see where the bevel between ceiling and walls has been created.

Viewed from the inside of the room, as can be seen in Figure 2.16 in the upper left corner, the bevel doesn't look that good. There is no sharply defined edge below and above the bevel. As a result we need to activate the KNIFE tool in PLANE or LOOP mode in the STRUCTURE menu and add two more cuts within the tilted faces of the bevel. One cut runs slightly above the lower edge of the bevel, and a second runs close to the upper edge near the shrunken ceiling. Then select

the actual ceiling polygon and use the EXTRUDE INNER tool with a very small or no OFFSET at all. This step and the result are documented in Figure 2.16. As you can see in the lower right view, the shading problems are solved and the bevel is clearly separated from the ceiling and wall.

## MODELING THE WINDOW FRAME

The next steps will focus on the creation of a window frame. If you have used two identically sized cubes for the openings, then you

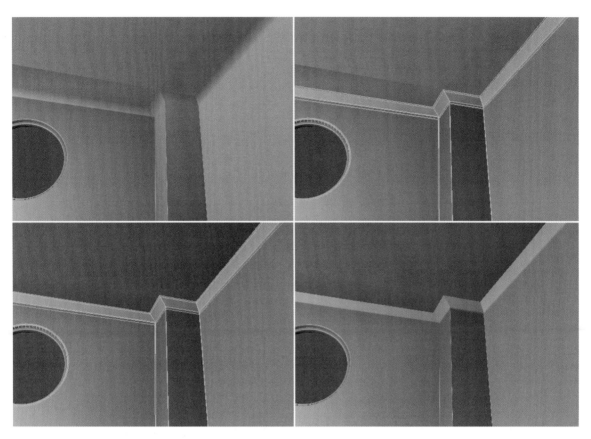

— Figure 2.16: Correcting the phong angle with new subdivisions.

have to model only one frame. The second frame can be added and moved to the other opening.

We start, as we have done so often before, with a CUBE primitive and adjust its size to the rectangular window openings. The portion of the wall protruding into the opening can be partly intersected by the cube. Figure 2.17 shows how such a scaled and positioned cube looks in the opening of the wall. We don't have to add roundings or segments to the cube for now.

To get from a cube to a frame we have to open the cube in the center. After the cube is fitted to the opening, it is converted with the (C) key. Change to USE POLYGON TOOL mode, select the large front and back side of the cube, and use the EXTRUDE INNER tool to define the width of the frame up to the glass

part. Figure 2.18 shows this in the left and center images. The connection of these two faces will create the opening where later the glass will be placed. Use the BRIDGE tool in the STRUCTURE menu and pull a connection line between the two upper or two lower corner points of the selected polygons. When you release the mouse button the two faces are connected, creating an opening, as can be seen in Figure 2.18.

**Modeling the Groove for the Glass Pane**

The glass pane doesn't just float inside the frame but is held with an additional groove that we will now model. Start by shrinking the four inside faces of the frame opening with EXTRUDE INNER. Again, it is important to preserve the groups and set a maximum

— Figure 2.17: Fitting a cube primitive.

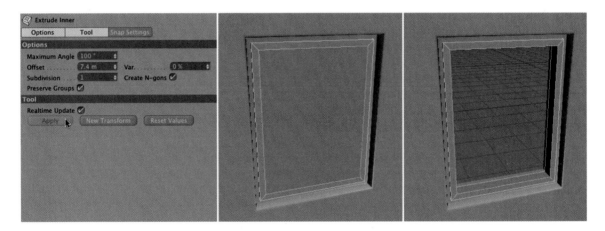

— Figure 2.18: Opening the frame in the middle.

angle above 90° to prevent four separate faces from being created. A possible result is shown on the upper left of Figure 2.19.

In USE EDGE TOOL mode, use the LOOP SELECTION to select the parallel rectangles that were created by the EXTRUDE INNER tool. Hold down the (Shift) key to make multiple selections. The two selected edge loops can be seen in the upper right image of Figure 2.19. These edges will now be duplicated with the BEVEL command in the STRUCTURE menu. This command can be used not only for

roundings but also to generate parallel edges. The only condition is that the selected edges can't be located at the angled edge of the object and must be in one plane.

Use the LINEAR type for roundings without any additional subdivisions. The option for n-gons can be activated but it won't make any difference here. The tool settings and the desired result can be seen in the lower row of Figure 2.19.

The additional subdivisions allow us to select two polygon loops with a gap between

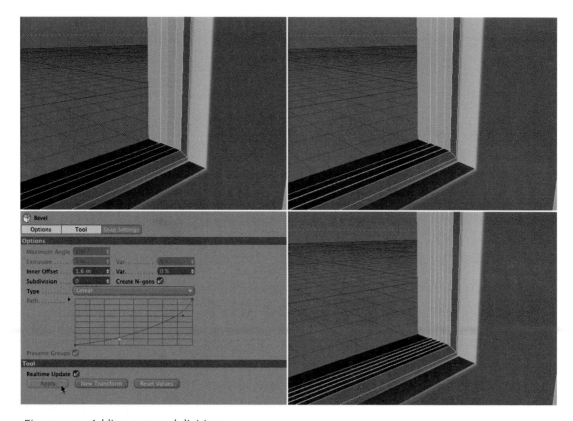

— Figure 2.19: Adding more subdivisions.

— Figure 2.20: Extruding the groove for the glass pane.

them. The best tool to use is the RING SELECTION in USE POLYGON TOOL mode, as shown in Figure 2.20 on the left. The actual groove for the glass pane is created with an extrusion of these faces, as shown on the right of the figure. Here, too, remember the maximum angle and the preserved groups.

Into this groove place a properly scaled new cube. The thickness of this cube has to be oriented to the width of the groove.

— Figure 2.21: Fitting the glass pane and duplicating the window.

Figure 2.21 shows the cube on the left, still hovering in front of the frame. In the OBJECT MANAGER, subordinate the glass pane under the window frame.

If both openings have the same size, you can add the missing second window by creating a simple copy. Select the window frame with the subordinated glass cube and choose the INSTANCE object in OBJECTS>MODELING> INSTANCE. The new INSTANCE object automatically takes on the selected object as a reference and can be moved to the second window opening. This could look like Figure 2.21.

## MODELING THE BASEBOARD

Now we come to the lower part of the room. There, the baseboards and, of course, the floor are still missing. In order to have the most freedom regarding the size and shape of the baseboard, we will start with a LOOP SELECTION in USE EDGE TOOL mode. We are interested in the edge loop at the lower end of the walls, as shown in Figure 2.22. When you activate the SELECT BOUNDARY LOOP option in the LOOP SELECTION settings, you can be sure that the correct edge loop will be selected.

With STRUCTURE>EDIT SPLINE>EDGE TO SPLINE, this selection can be converted to a normal spline object. This spline, together with a RECTANGLE spline, can then be subordi-

— Figure 2.22: Creating a path for the baseboard.

nated under a SWEEP NURBS, as shown in Figure 2.23.

Be sure that the profile, in our case the rectangle spline, is located in the XY plane so it can be used properly by the Sweep NURBS. In addition, the rectangle spline has to be positioned uppermost in the Sweep NURBS group, followed by the path we extracted from the walls. After that, two more steps are necessary so that the baseboard is located at the right place. First, the local axis system of the rectangle spline should be moved

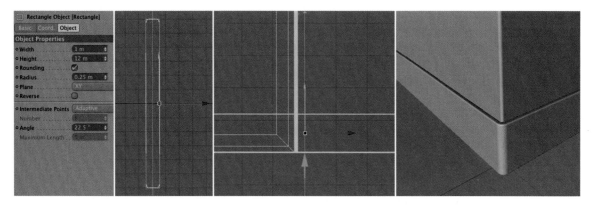

— Figure 2.23: Creating the baseboard with a Sweep NURBS.

along the X axis to the right. This will make the whole baseboard move out in front of the walls and not be halfway immersed into the walls. This manipulation, however, requires that the rectangle spline first be converted. Therefore, you should add a small rounding to this spline and then convert it with the (C) key. Afterward, switch to USE OBJECT AXIS TOOL mode to move the axis system.

The second step regards the position of the extracted path spline. It has to be moved so far upward that the baseboard is level with the bottom of the wall. The amount of this move depends on the height of the baseboard. The image series in Figure 2.23 summarizes the steps. From left to right you can see first my settings for the profile spline and then its conversion and the movement of its axis system. In the center, the movement of the path spline is indicated by an arrow, and on the right is the possible result.

### CREATING A DOUBLE-WALLED CEILING

Less because of aesthetics than for practical reasons, we will get back to the ceiling, but this time from the outside. Maybe you will later discover that you need an opening in the ceiling. In that case it would be better for the ceiling to have some thickness, making it easier to use the BOOLE object. In

USE EDGE TOOL mode, select the open upper edge of the outer wall with the LOOP SELECTION and move these edges so far up that they will surpass the edges of the inner ceiling. The upper face of the ceiling can then be closed with the CLOSE POLYGON function in the STRUCTURE menu, as shown in Figure 2.24.

A nice side effect of this step is that lower settings in global illumination can be used during rendering without having the light penetrate the walls from outside. The doubled polygons of the ceiling and outer walls filter out this irregularity.

### CREATING THE FLOOR

The floor is created using the same principle, only we don't have to move any edges. We simply use the CLOSE POLYGON function with the open edge loop of the outer wall, as shown on the right in Figure 2.25. The generated face then appears automatically under the baseboard on the inside. Only the orientation of this polygon has to be corrected, as can be seen in the middle of Figure 2.25. The face appears bluish when selected, which means it shows its rear side. This could cause problems later, for example, when baking textures. As a result, we should fix that problem right away by inverting the orientation of the selected face with FUNCTIONS > REVERSE NORMALS. As shown on

— Figure 2.24: Closing the outer room corner.

— Figure 2.25: Closing the floor.

the right in Figure 2.25, the polygon now depicts yellowish shading.

### FINE-TUNING THE ROOM MODEL

In this section we will take care of the fine points that make the room look more detailed and comfortable. We will start with the bevel at the ceiling, which, for my taste, is still too simple. A crown molding strip should improve the look of the transition between the wall and the ceiling. The modeling of such an element is not easy, since we have to consider a lot of corners with rounded edges. We previously discovered, when modeling the bevel and the ceiling, what difficulties can occur. Therefore, I want to use another method that is easier to handle.

### Editing the Bevel at the Ceiling

We first need two splines between which the crown molding strips will be stretched. Use the LOOP SELECTION in USE EDGE TOOL mode and select the edge loop that borders the bottom of the bevel. Make sure that in the settings for the LOOP SELECTION the SELECT BOUNDARY LOOP option, which was used in previous steps, is deactivated. Otherwise, edges on the inside of objects cannot be selected.

This selection is then converted to a spline object with STRUCTURE>EDIT SPLINE>EDGE TO SPLINE. Apply the same steps to the bevel edge loop that borders the ceiling. Figure 2.26 shows both selections. The two extracted splines are now used with a LOFT NURBS to

— Figure 2.26: Converting edge selections into paths.

create a polygon skin between them. These splines can be found subordinated under the object from which they were generated. In our case the splines are subordinated under the room object in the OBJECT MANAGER. As with all NURBS objects that work with splines, the order and direction of the points of the two splines used are very important. When extracting several splines from edge selections, it is likely that the starting points of the generated splines are not aligned. This should be corrected manually so the LOFT NURBS object can create clean results.

In USE POINT TOOL mode select a point of the lower spline and choose STRUCTURE > EDIT SPLINE > SET FIRST POINT. Repeat this with the second spline using the selected corresponding point. If the splines are running in the opposite direction from each other—you can identify this at the gradient of the splines— correct that as well at one of the splines in the STRUCTURE menu with EDIT SPLINE > REVERSE SEQUENCE. Then subordinate the splines under the new LOFT NURBS object. The Loft NURBS has the ability to set its own points along the splines and connect them. The intermediate points of the used splines don't affect this type of NURBS. Therefore, we have to significantly increase the subdivision in the horizontal U direction so the loft shape

adjusts enough to the shape of the walls and corners. Too many subdivisions wouldn't be that bad, but it would use more memory without improving the quality of the result. I also set the vertical V subdivisions quite high, even though it would theoretically be enough to use just one subdivision. After all, we just have a straight connection between two spline curves. My settings and the result can be seen in Figure 2.27. The shape of the Loft NURBS is highlighted and currently looks like the bevel we modeled at the ceiling.

**Deforming the Object with Displacement**

The reason for the fine subdivisions is that I would like to deform the object in the next step with displacement. Therefore, I need a lot of points in order to generate a soft deformation with many details. Create a new material for the LOFT NURBS in the MATERIAL MANAGER in FILE > NEW MATERIAL and load the GRADIENT shader in the COLOR channel. This shader works well with the Loft NURBS since the Loft NURBS automatically generates UV coordinates and causes the gradient to adjust perfectly to the shape of the modeled bevel.

Like in Figure 2.28, select the gradient in the vertical direction, the 2D – V TYPE, and

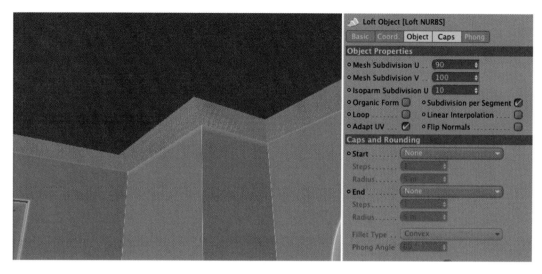

— Figure 2.27: The Loft NURBS above the ceiling bevel.

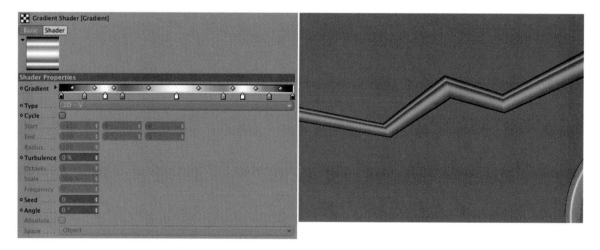

— Figure 2.28: A gradient at the Loft NURBS object.

create a grayscale gradient. It should end on the left and right in a very dark color. The displacement will apply the most deformation to the brightest areas in the gradient. Dark or black areas remain unchanged. This is important for the edges of the gradient because it makes sure that our deformed Loft object remains close to the walls and ceiling after the deformation.

As soon as the material is pulled onto the Loft object, you can take a look at the coloring in the editor and change the gradient until you like the width and position of the bands of color. Additional color tabs can be created with a single click under the gradient. Colors that aren't needed anymore can be deleted by pulling the tab upward, out of the gradient again.

Now use the Copy Channel command within the shader menu in the Texture area of the Color channel to copy the gradient. Then activate the Displacement channel and use the Past Channel command in the Texture area to paste the gradient. The gradient

— Figure 2.29: The displacement deformation.

in the COLOR channel can then be deleted by using CLEAR in the SHADER menu.

My settings for the DISPLACEMENT channel are in Figure 2.29. You only need to select the INTENSITY type, so black is used as the starting color in order to not trigger a deformation. The value for the HEIGHT defines the maximum deformation of the object. The use of either a positive or negative sign depends on the orientation of the faces on the object. This can only be clarified with a test rendering of the object, as can be seen in Figure 2.29 on the right. If the deformation is going into the wall, then the sign for the HEIGHT has to be reversed.

This is a very elegant tool to use to create wave-shaped profiles for the crown molding. The render time for the displacement remains reasonable since we work with real points and didn't use SUB-POLYGON DISPLACEMENT.

**The Window Handle**

Another object we could add to the window frame is the window handle. We will add a simple object to portray the handle by starting with a new CUBE primitive with two segments in the Y direction. The standard size of 200 units in all directions can remain the same. Convert the cube with the (C) key to a POLYGON object and select the SUBDIVIDE value from the FUNCTIONS menu. This adds

points to the object by subdividing every edge with the defined SUBDIVIDE value. We can also activate the HYPERNURBS SUBDIVIDE option. After activating this function the object will look like it was subdivided and rounded by a HyperNURBS object.

My settings can be seen in Figure 2.30. I used a simple subdivision of the cube, but with HyperNURBS smoothing. Now we have enough new faces on the object to extrude two neighboring polygons from the upper edge so a handle is created, like the one on the right in Figure 2.30. Since the EXTRUDE tool uses the normals of the polygons as the direction of movement, you should use only a small OFFSET value and do the actual movement manually with the MOVE tool. When the desired handle length is reached, shrink the two still-selected polygons at the end of the handle with the EXTRUDE INNER function. This will result in a sharper edge later when the HyperNURBS smoothing is applied. The right side of Figure 2.30 shows this step as well.

Subdivide the handle under a HyperNURBS object to get a better sense of the smoothed shape. If necessary add one or two cuts using the KNIFE tool in LOOP mode, vertical to the length of the handle, and use these additional subdivisions to give the handle a slight bend. Figure 2.31 shows an example in the side view. There you can also see that I have moved the

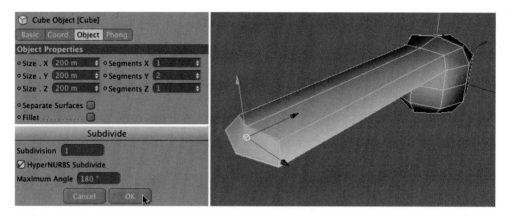

— Figure 2.30: Extruding the handle from the rounded cube.

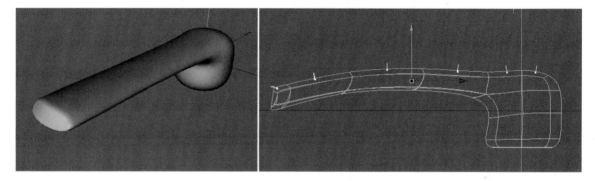

— Figure 2.31: Shaping the handle.

lower faces at the base of the handle upward, creating a small plane. We will add a small plate to this spot later.

To add more definition to the top of the handle, select the faces highlighted in Figure 2.31 and shrink them slightly with the EXTRUDE INNER command. The newly created subdivisions allow the handle to appear less rounded.

Once you are happy with the handle, you will need to add a plate that will be used to connect the handle to the window frame. Start by adding a new cube primitive and resizing it so the cube is in proportion to the handle. Three segments in both the Y and Z directions ensure that the cube will be rounded via HyperNURBS but not completely lose its shape. Figure 2.32 shows my settings.

You should base the size of the cube on the dimensions of your handle, though.

Then group the cube with the handle so both objects are smoothed by the Hyper-NURBS object and adjust their positions, as shown in Figure 2.32. Now it is time to adjust the handle unit to the window frame, as highlighted on the right in Figure 2.32. Adjust the proportions of the handle by scaling the complete handle hierarchy to the frame. Also control the position and level of the handle with the frame so there is no gap between the plate and the frame, and put the Hyper-NURBS with the handle into the window frame group. If you created the second window frame as an Instance, then the handle will appear there as well. Otherwise, you have to create a copy or an Instance of the handle

— Figure 2.32: A simple plate for attaching the handle to the frame.

itself and move it manually to the second window frame.

**Modeling the Decorative Grid**

I previously mentioned that the circular opening will not be a window but instead a decorative part of the room. Therefore, we will now model the round grid with decorative elements. Because of the tubular insert, we already know the approximate diameter of the opening. We will use this measurement as the radius for a new ARC object found in the SPLINE PRIMITIVE menu in the OBJECTS menu of CINEMA 4D. This object represents a sector of a circle. Choose the XY PLANE as the set plane in the dialog of the ARC object, which is the front view, and limit the range of the arc to be between 0° and 90°, as shown in Figure 2.33. After rotating the arc by −45° in the B ROTATION value field of the COORDINATE MANAGER, the arc should be standing on its tip. This represents the space that we will now fill with decorative spline elements. Later we can fill the circular area with mirrored copies of this arc area.

On the right side of Figure 2.33 you can see how I worked. First, I placed a slim cube along the world Y axis. It will later be the support beam for the elements of the decorative grid. It also helps to fit the spline curves into place. You have free range to create your own spline curves. As you can see in the figure, I created three spline curves in the front view that are oriented to the arc as well as the cube. These splines are subordinated under SWEEP NURBS objects to depict bent metal bars. You can also use the spline curves for scaling and rotation in the SWEEP NURBS objects to shape the bars to your liking. Just make sure that there are enough interpolation points set to create smooth looking bars.

Subordinate the three Sweep NURBS objects under a new Null object—it can be found in the OBJECTS menu of CINEMA 4D— and rotate them by 45° around the B axis, so the decorative elements are located to the right of the world X axis. If you want, you can add small CUBE primitives to simulate clips that hold the elements together. Subordinate them under the Null object. This Null object is then subordinated under a SYMMETRY object that can be found in OBJECTS > MODELING. Set the MIRROR PLANE of the SYMMETRY object to XZ. The result could look similar to the left image of Figure 2.34.

Create another SYMMETRY object and set the MIRROR PLANE to ZY. Subordinate the

— Figure 2.33: One element of the grid.

— Figure 2.34: Multiplying the decorative elements.

other symmetry object under the new one in the OBJECT MANAGER. The result is shown in the center of Figure 2.34. Select the last created SYMMETRY object and choose the INSTANCE object in the OBJECTS menu under MODELING. This represents a copy of the symmetry group and can now be rotated by 90° around the B angle in the COORDINATE MANAGER to complete the circle. The result is shown on the right of Figure 2.34. I also extended the vertical cube and rotated a copy horizontally to get a supporting cross structure for the grid.

If you want, you can add some more small cubes to simulate the connectors that hold all the elements together. The test rendering on the right in Figure 2.35 shows the entire grid, including the added cube clips. In the center image is the hierarchical structure of the grid. As you can see, I subordinated all the elements under a Null object to be able to scale and move the Instance, the symmetry group, and the separate cube clips at the same time. Fit the grid into the round window so it is anchored to the tube. The right image in Figure 2.35 shows this

— Figure 2.35: The finished decorative grid.

result. Looking out from the inside, place a PLANE object or, even better, a simple POLYGON object behind the grid. It is supposed to depict a mirror that closes the opening in the wall.

The modeling of new objects is now complete. We previously modeled and textured a vase, including a side table, in the first chapter. Load those objects into the scene by using FILE>MERGE. Place them in an appropriate place and adjust their size to be proportional to the room.

## The Materials of the Room

I want to keep the materials of the room simple. The room is supposed to generate a mood by way of its illumination. We will discover later, during the process of lighting with global illumination, what problems can occur.

### THE WALL MATERIAL

We will start with the settings for the wall and create a new material. I used a very subtle NOISE shader with two almost identical colors. This slightly structured look of wallpaper is supported by the OREN-NAYAR shading model in the ILLUMINATION settings of the material. The settings of the material can be

seen in Figure 2.36. The material can then simply be dropped onto the room object. Since the walls were for the most part generated by an Extrude NURBS object, the existing UV coordinates are enough to create a proper projection of the material.

### THE BASEBOARD AND THE CROWN MOLDING

We will use an understated material for the baseboard and the crown molding. I used a slightly warm color and the OREN-NAYAR as shading model, as shown in Figure 2.37. Remember that we already created a material for the crown molding and just have to adjust the color and the shading model. The material of the baseboard can again be applied by a simple drag and drop. Even the absence of UV coordinates isn't a problem, since the material doesn't contain any images or structures.

### THE CEILING MATERIAL

The ceiling is supposed to be perfectly white and with a rough composition. Therefore, we use the NOISE shader with a SEMA pattern in the BUMP channel of a new material. Set the STRENGTH of the bump to a low value so the effect doesn't appear to be too strong. Here, too, the OREN-NAYAR fits perfectly to the

— Figure 2.36: The wall material.

— Figure 2.37: The material for the baseboard.

desired surface type. All settings can be seen in Figure 2.38.

To be able to apply this material, you have to first make a polygon selection of the ceiling polygon and save it in a SELECTION tag. Use the SET SELECTION command in the SELECTION menu of CINEMA 4D. Give the new POLYGON SELECTION tag a meaningful name in

the ATTRIBUTE MANAGER, for instance, *ceiling*, and then pull the ceiling material onto the room geometry. In the new TEXTURE tag, add the name of the previously saved polygon selection to the SELECTION field so the material is seen exclusively on these polygons. Also make sure that in the OBJECT MANAGER, the TEXTURE tag of the ceiling material is

— Figure 2.38: The material for the ceiling.

placed to the right of the TEXTURE tag of the wall material. Then the ceiling material won't be covered by the wall material. Set the PROJECTION of the ceiling material to CUBIC. UVW MAPPING cannot be used here since the ceiling was created manually with an n-gon. Therefore, no reliable UV coordinates exist.

**THE WINDOW GLASS**

Of course, the window pane receives a mostly transparent material, as shown in Figure 2.39. I prefer to use a material with a high degree of transparency, but still under 100% since an absolutely transparent material doesn't exist. In addition, the reflections will look better. For the REFRACTION index I used the usual 1.5 while leaving the FRESNEL REFLECTIVITY at 100%. The latter increases the reflective capabilities when looking at the window pane from an angle. The options for TOTAL INTERNAL

REFLECTION and EXIT REFLECTIONS can remain deactivated since only two parallel polygons are positioned across from each other. These effects would hardly make a difference.

I also activated the REFLECTION channel to be able to control separately the reflective properties from the fresnel effect. The BRIGHTNESS value is set pretty high at 70%, but is balanced automatically by the high transparency of the window pane.

Now we will get to the ILLUMINATION settings of the glass material. We will keep the PHONG shading model, which is appropriate for smooth surfaces, but we will deactivate all options in the upper part of the dialog that are associated with generating and receiving global illumination. The more reflective and transparent a material is, the less it benefits from global illumination. Thus I recommend that you deactivate these options to save some render time later. Since sunlight is supposed to

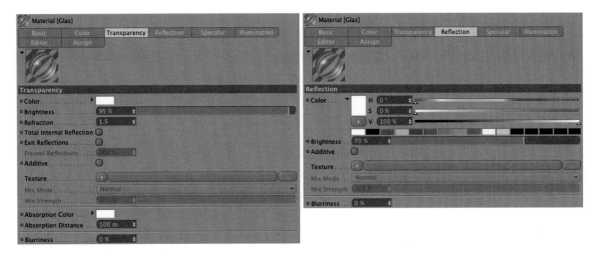

— Figure 2.39: The material for the window glass.

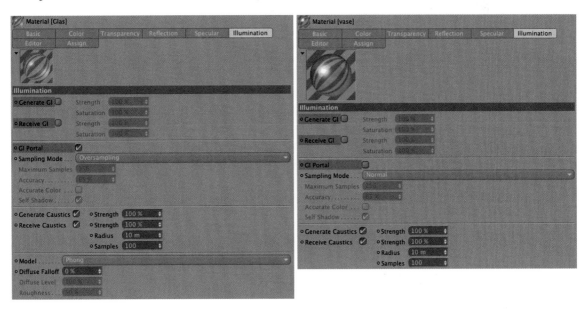

— Figure 2.40: Illumination settings of the glass materials in the scene.

enter the room through the window, we can support the global illumination by activating the GI PORTAL option. This option allows rays, which are used to calculate the global illumination, to concentrate on the objects that use this material.

Apply the same principle to the glass material used for the vase, keeping the GI PORTAL option deactivated. We do this because there is no light source in or behind

the vase and a concentration of rays on this object wouldn't make sense. Figure 2.40 shows the options for the two glass materials of the scene in detail.

### THE MIRROR MATERIAL

As previously mentioned, the calculation of global illumination for very reflective objects doesn't make sense, since the rays used for

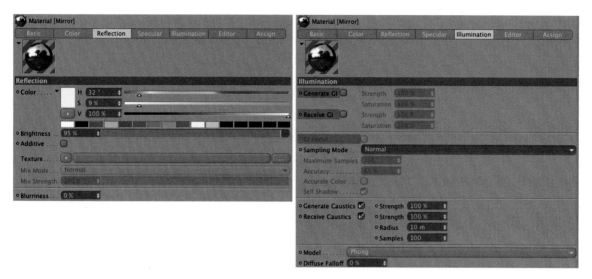

— Figure 2.41: The material for the mirror.

the calculation simply bounce off the object and hit other objects in the scene. This is balanced, of course, by a decreasing amount of reflection on the object. Objects with 50% or 60% reflection allow you to decide for yourself whether the surface color should also be influenced by the global illumination or not. With chrome or mirrored surfaces at almost 100% reflection, we don't have to worry about that. As you can see in Figure 2.41 I used a warm white color, with 95% BRIGHTNESS in the REFLECTION channel of the material, for the mirror behind the grid. The GI options in the ILLUMINATION channel all remain deactivated.

All remaining materials not yet mentioned are more subtle. You can apply a simple black material, without reflection, to the Sweep NURBS object of the decorative grid. The clips on the grid would look good with a contrasting color. Therefore, I re-used the bronze material of the vase. For the window frame and handles, it is enough to apply just a slightly glossy white material. The floor receives a wood texture that is applied with a cube mapping. Fitting images of different kinds of wood can be found at *www.cgtextures.com*. A certain data volume of textures

can be downloaded daily, free of charge, from this source. When you have found the right type of wood, load it into the COLOR channel of a new material and activate a 15% REFLECTION with 20% BLURRINESS. This completes the floor material.

**The Sky Object**

Especially with architectural visualizations, but generally with all scenes that are set outside, we need a depiction of the sky. The SKY object that can be found at OBJECTS>SKY> CREATE SKY offers multiple settings, of which we will closely examine just a few. Basically, the SKY object delivers three characteristics of a sky: the illumination by the sun, the illumination by the sky, and the depiction of clouds and gradients for the sky. The gradient of the sky and the direction and intensity of the illumination depend on the time of day, the season, and the location from where the sky is seen. These settings can be adjusted in the TIME AND LOCATION section of the SKY dialog in the ATTRIBUTE MANAGER.

The calculated position of the sun is based on the world axes of the CINEMA 4D world

coordinate system. The Z axis always points north and the X axis to the east. When you load architectural objects into the scene and you want to calculate a realistic positioning of the sun, you should place the buildings according to the orientation of the cardinal points.

## DATE AND TIME

In the TIME settings you can select any time or day in the calendar to recreate the typical position of the sun for the selected season. With the CITY setting you can select one of many cities in the world or define other places with the entry of latitude and longitude values. In this section there are also settings for the different time zones and daylight savings time.

In the TIME and POSITION section you can also find the option for SHOW LOCATION HUD. This will show a compass rose in the scene, which, besides the cardinal points, also shows the position of the sun and its course across the sky. This option is activated by default and makes it easier to evaluate the orientation of the compass rose in the editor.

## THE SKY

The settings of the SKY can be found in its corresponding section. Figure 2.42 shows this section of the dialog. A majority of the settings influence the coloring of the sky and its illumination. This is just a short overview of the most important parameters and options. The PHYSICAL SKY option activates the natural calculation of the color and illumination of the sky. This option wasn't available in older versions of CINEMA 4D so remember this when you load older scenes. Otherwise, the render results might differ from older versions. When this option is deactivated the sky can be colored with a custom gradient.

TURBIDITY and ATMOSPHERIC STRENGTH mainly influence the brightness of the sky. With TURBIDITY water droplets and dust in the air are

— Figure 2.42: Part of the Sky object settings.

simulated, resulting in reduced visibility and the scattering of light. Depending on the position of the sun, an increase of this value can increase the saturation and intensity of a sunset or sunrise. ATMOSPHERIC STRENGTH, on the other hand, can be understood as the degree of opacity of the sky plane in front of the universe plane. Smaller settings allow the universe plane and its stars to be more visible through the sky plane. A reduction of this value is mostly helpful when the sun is positioned low in the sky or when the environment on a high mountain is simulated to represent the naturally thinner upper atmosphere.

The OZONE value simulates the amount of ozone in the air. It causes the filtering of short-wave ultraviolet rays in the upper atmosphere, which, expressed in colors, results in a reduction of yellow and red sunlight. The sunlight therefore appears bluish with high ozone concentrations. The colors of the sky are not affected, though.

The INTENSITY value controls the brightness of light generated by the sky. This has nothing to do with the depiction of the colors, the brightness of the sky, or even the intensity of the sunlight. Therefore, the NIGHT INTENSITY RATIO affects only the depiction of the night sky with its stars. SATURATION CORRECTION controls the coloring of the sky

and the sky light. For example, at noon the sky is mainly blue and would create an intensely colored sky light. This value would then be used to reduce the coloring. With an extreme reduction of 0%, you would get only gray tones for the sky and its lighting. With Color Correction the color gradient can be moved within the color spectrum. That way, a reddish sky can also be shown at noon. With Gamma Correction and As Seen Intensity, you can manipulate the brightness and color contrast of the sky. These values work just like the values used during the manipulation of an image in a graphics program. They also influence the intensity of the night sky, but the illumination intensity remains unchanged by these parameters. Only the brightness of the sky is changed.

The colors of the sky are generated internally with spectral colors. Its color space is not identical to the color space used by the commonly used RGB system. The conversion of the color values can therefore be influenced by the Use Warm Colors and Use Chroma Color Map options. Use Warm Colors influences the conversion in favor of the red and yellow colors, while Use Chroma Color Map results in a cooler sky with more contrast. These options can also be combined.

For our scene we set the Intensity to 0%, so the sky color isn't also used for the illumination, and select 11:00 a.m. for the time and 19 September 2008 as the date. For the city I chose Essen in Germany. These are rather spontaneous settings. Important only is the sun's typical position on a late summer day.

In order to have the sunlight shine through the window, the side of the room with the windows should point south, which means to be oriented in the direction of the negative world Z axis. Therefore, turn the entire room if necessary. Figure 2.43 shows an example of how the light shines into the room and what influence the sky object has on the illumination. As you can see in the left image, the blue color penetrates the walls and causes the coloring of the room to be too intense. This wouldn't bother us with an outside scene, but in our case it looks unnatural. On the right side of Figure 2.43 you can see the same scene after the deactivation of the Intensity of the sky. The interior is now lit only by the sunlight.

To intensify the sunlight, the glass object in the window should receive a Compositing tag. It can be found after right clicking on the object in the Object Manager in the context menu under the Cinema 4D Tags. Deactivate the Cast Shadows and Receive Shadows, and also the Seen by AO option, so any shadows cast by the glass will be suppressed.

— Figure 2.43: With and without sky illumination.

## THE SETTINGS OF THE SUNLIGHT

The illumination of the scene is now entirely created by the SUN in the SKY object. The SUN of the SKY object has many properties that are comparable to those of a simple area light with area shadows. The option USE WARM COLORS works in a manner similar to its corresponding option in the settings of the sky. The conversion of the color values to the RGB color space shifts the colors to yellow and red tones. INTENSITY represents the brightness of the sun and therefore the brightness of the illumination. I will use a relatively high value of 180%, since the sun is our only light source so far and I'd like to portray a strong contrast inside the room. The SATURATION CORRECTION pertains to the coloring of the sunlight. At 0% you will get a white light. HUE CORRECTION and GAMMA CORRECTION work like the corresponding settings for the sky. SIZE RATIO controls the size of the visible body of the sun and therefore also the size of the area of the light from the sun as well. A larger sun will generate a softer shadow and a smaller sun will cast harder shadows. As SEEN INTENSITY scales the visibility of the body of the sun in the sky. This has no influence on the illumination by the sun. If you are bothered by the look of the sun, you can set the As SEEN INTENSITY to 0% and the sun will disappear.

With CUSTOM COLOR activated, the sun can be given custom coloring. Otherwise, the PREVIEW COLOR in the upper part of the section shows a preview of the sun's color set by the parameters. Additionally, LENSFLARES can be added to the look of the sun, simulating the interaction of the sunlight with a camera lens. With CUSTOM SUN OBJECT any other object can be used as the sun object. Simply pull it from the OBJECT MANAGER into the matching field in the SUN section. The remaining settings of this section are the same as the shadow settings of a normal light source with shadow maps and don't need further explanation. Here you can set the type, color, and level of precision of the shadow calculation.

## PLACE YOUR OWN SUN

As previously mentioned, you can use any other object as the sun. Just pull the object, with drag and drop, into the CUSTOM SUN OBJECT field in the SUN section of the SKY object. Then delete the object again from the field by using the CLEAR command in the menu on the right. This has the advantage that you can move the object yourself, for example, to pull it closer to the world origin along its Z axis. Another more practical variation is to place an area light at the spot where the HUD element of a compass rose is positioned. The left side of Figure 2.44 shows this position marked with the mouse pointer. When you then orient the Z axis of the light source toward the origin of the world coordinate system, as shown on the right in the figure, then you can move the light source yourself along the Z axis to the desired position. An advantage here is that you don't have to depend on the settings of time and place from the SKY section. Your own light source can be moved a bit until an optimally cast shadow is achieved. Special functions can also be used, such as creating a falloff.

Don't forget to deactivate the SUN of the SKY object so you don't have two suns and cast two sets of shadows in your scene. Change to the BASIC settings of the SKY object and deactivate the SUN option. Here there are other options, like the one for activating atmospheric effects, fog, rainbows, or clouds. With the light source I placed, I used the INFINITE type and AREA shadows. I set the INTENSITY to 125% with a slight yellow coloring. Figure 2.45 shows you the placement of my own sun. The direction of the light corresponds with that of the original sun from the sky object. Only the TYPE of the light and the distance to the room are now different.

Figure 2.46 shows two variations that were achieved by simply changing the type of light. On the left you can see the INFINITE LIGHT, and on the right a normal SPOT LIGHT. The brightness, as well as the shadows, can be varied by changing the distance of the

— Figure 2.44: Position your own light source.

— Figure 2.45: Positioning your own sun.

light source to the object. I will keep the INFINITE light, though, since it comes closest to the illumination properties of the sun.

## Manually Illuminating the Room

Before we take a look at the lighting using GLOBAL ILLUMINATION of the ADVANCED RENDERER, we will try to light the room with standard light sources. The sunlight has already been replaced by a normal light source. This light represents only the direct light part of the sun, though; the light scattered in the environment is missing completely. One part of this scattered light comes from all directions of the sky and thus finds its way through the windows into the room. This light generally has a blue tint and of course comes mainly from above. The portion

— Figure 2.46: Variations of the sunlight source.

of sunlight reflected from the surrounding buildings will be discussed later.

We will add a new Area Light and change the shape of the light to Hemisphere in the Details settings. The size should be large enough so the scene has enough room under the hemisphere. Therefore, increase the value for Outer Radius in the Details settings of the light source. These settings and the result can be seen in Figure 2.47. The intensity of 25% is quite moderate but is enough to give the room more definition. The shadows should be deactivated. Defined shadows with this kind of diffuse illumination would be rather distracting. The option for the calculation of Specular should generally be deactivated in the General settings of such diffuse light sources. Only small lights add a believable highlight to surfaces.

## The Scattered Light from the Environment

As already mentioned, the sunlight is also reflected by other objects in the environment of the room. The surface of a house in direct sunlight would reflect a large amount of that light to the houses across from it. We will simulate this scattered light with two rectangular area lights that are placed outside, a

certain distance away from the front of the windows. These lights will be used to calculate a shadow as well. I decided to use an Area shadow again since it looks the most natural.

Figure 2.48 shows on the right where I placed these area lights and on the left you can see my settings. Note that the calculation of Specular should be deactivated. In addition, I increased the Contrast value in the Details settings of the light source to 50%. This causes a less-soft illumination and sharper transitions between light and shadow. I used a slightly yellow tint for the coloring of the lights.

Inside the room itself there is a kind of scattered diffuse light, because all the light is reflected by the floor, walls, and ceiling to other parts of the scene. Instead of using multiple additional lights, I used a spherical Area Light in the center of the room as it is defined on the left in Figure 2.49. A temporary Intensity of 50% with a warm coloring of the light causes the illumination seen on the right in the same figure. This light source doesn't have any highlight properties and doesn't cast shadows. A shadow coming from the center of the room would look funny anyway. Again, we will use a contrast of

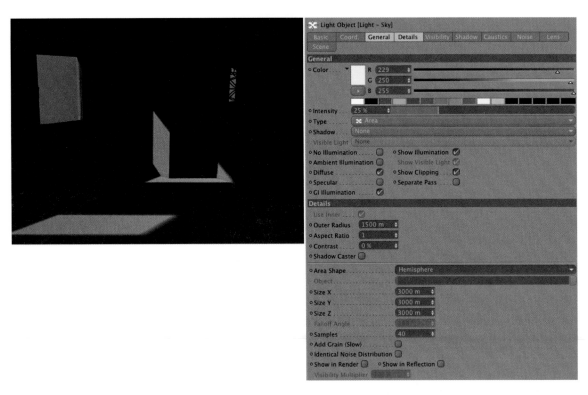

— Figure 2.47: Settings for the sky light.

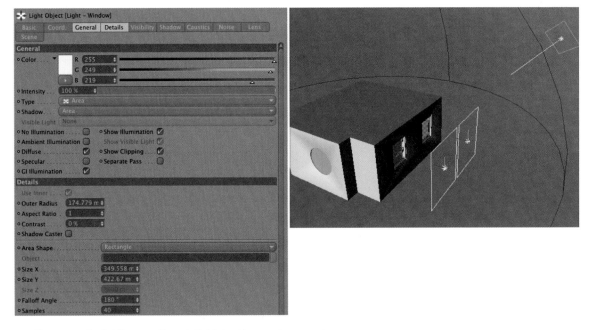

— Figure 2.48: Adding scattered light to the environment.

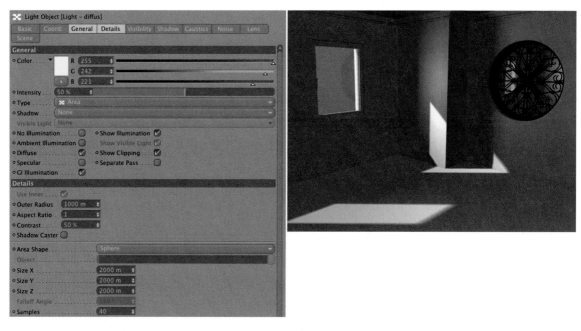

— Figure 2.49: Simulating diffuse scattering inside the room itself.

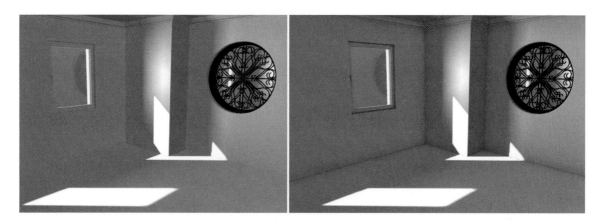

— Figure 2.50: The room with and without Ambient Occlusion calculation.

50% with this light source for more defined shadings.

Now you have a manageable number of light sources whose intensities can easily be adjusted to get the desired result. You can see in Figure 2.50 how the general increase of all intensities quickly gives us a good outcome. But at the same time, the increased brightness of the light sources without shadows cause a decrease in definition and three-dimensionality. The transitions between floor and walls take a back seat.

We can counteract this with the AMBIENT OCCLUSION calculation. Activate this effect in the RENDER SETTINGS of CINEMA 4D and reduce the CONTRAST value to −75%. Room corners that are too dark would look unnatural in a room flooded with sunlight. The right side of Figure 2.50 shows the result with otherwise unchanged lighting. The room

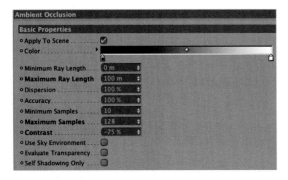

— Figure 2.51: Settings for the Ambient Occlusion in the render settings.

corners, as well as smaller details like the crown molding, are now more pronounced and allow the room to appear more substantial. The described settings of the AMBIENT OCCLUSION are also documented in Figure 2.51.

## COLOR MAPPING

Especially with illumination by several light sources, but also with global illumination, parts of the image can be overexposed and too bright. In order to correct this you have several possibilities. You could adjust the brightness of the light sources until the

brightness is at the correct level, but this could change well-lit areas as well. In addition, this process is time consuming in scenes with many light sources. The second possibility is to render the image in 32 bit color depth. This gives you enough leeway in postproduction to correct the illumination. Because the file size of the rendered image would increase tremendously, this method would be suitable only for still images and less so for animations. The third possibility is the use of the COLOR MAPPING post effect.

Figure 2.52 shows an example of the parameters used and how they affect the rendered image. The cores of these controls are two values: DARK MULTIPLIER and BRIGHT MULTIPLIER. The effects are quite different from what the names might imply. An increase of the DARK MULTIPLIER value brightens the image and an increase of BRIGHT MULTIPLIER darkens it. In any case, the effect causes a redistribution of brightness values in the image and helps to get good results, even with heavily overexposed images. When HSV MODEL is active, only the brightness of the colors of the image is changed, not the color or saturation values. If a background image or sky is to be excluded from the

— Figure 2.52: Illumination correction with color mapping.

— Figure 2.53: The result of traditional illumination with light sources.

post-effect calculation, then deactivate AFFECT BACKGROUND. Lastly, the EXPONENTIAL option creates an exponential transition between light and dark parts of the image. Without this option the transition would be calculated in a linear fashion.

Figure 2.53 gives you an impression of how the room could look with the wooden floor texture and the added objects. With a little effort we can get good results, even with normal light sources.

## Global Illumination

As we have seen in the first chapter, there are certain options available in the ADVANCED

RENDERER for calculating global illumination. By knowing the type of illumination and the scene, we can exclude some methods that are less well suited. The GI MODE QMC offers the highest quality since every pixel is treated in the same way, regardless of its position in the scene or its visibility to the light sources. This calculation needs many steps and takes longer to create results with low noise. In this regard the IR mode can't be beat because CINEMA 4D itself optimizes the number of calculation steps per image pixel. This optimization is traded, though, with a softer, and therefore less accurate, light distribution. Then there is the special SKY SAMPLER, which is meant to be used for outside scenes and exclusively calculates the

direct illumination by the sky or an HDRI image.

Due to the functionality of these modes, the IR mode is primarily used for interior spaces. A combination mode of IR and QMC is an alternative to the sky sampler for outside scenes. The QMC mode can be used for all scenes, but creates more noise than other modes in the same amount of render time. However, this style might be the one you want for the final image.

## GENERAL SETTINGS

To illuminate our room we will select the IR mode. It is short for *Irradiance Cache*. This GI mode is activated in the GENERAL settings of the global illumination after activation of the GI by clicking on the EFFECTS button in the RENDER SETTINGS. The next setting in this mode concerns the diffuse depth, which determines how often a ray is reflected off and forwarded from a surface. The higher the DIFFUSE DEPTH, the more the light is scattered and directed to previously shaded areas. The image gets brighter with increasing DIFFUSE DEPTH and needs more time to render. We will use a value of 2.

The PRIMARY INTENSITY is a multiplier for the brightness of the first light reflection. What's important is whether the scene is lit by a light source or by an illuminated object. With a light source, the directly illuminated surface is not included in the calculation of the global illumination and therefore also not included in the PRIMARY INTENSITY. Only the reflected light from the directly illuminated object is multiplied with this value. It is different with lighting from an illuminating material. Here, the light generated by the illumination is included in the global illumination calculation and also multiplied with the PRIMARY INTENSITY. At DIFFUSE DEPTHS over 1, the light intensity of subsequent light reflections can be controlled by SECONDARY INTENSITY. We will leave the two values at 100% for the moment. A gamma value can be used in addition to either darken or lighten the whole image. Values above 1 generally lighten the result and can, in some cases, save us the time needed to adjust the light sources or material properties of the scene. Values under 1, of course, reduce the image brightness. As you can see on the left of Figure 2.54, we will keep the standard value of 1.

## IRRADIANCE CACHE SETTINGS

In IR mode, so-called pre-passes and shading points are calculated and light distribution is interpolated between these two. To optimize the render time, there are several parameters available to achieve a balanced ratio between quality and render time. The meaning of these parameters was already explained in the first chapter, so I will just list the functions and the settings used for our scene. You can find them on the right of Figure 2.54.

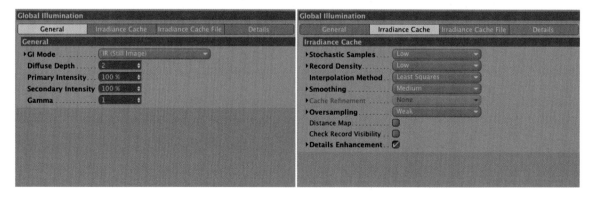

— Figure 2.54: Settings for global illumination.

STOCHASTIC SAMPLES represents the number of calculation rays per DIFFUSE DEPTH and pixel that are being sent into the scene. We will use the preset LOW. RECORD DENSITY takes care of the density of shading points. These points are then evaluated for the interpolation of color and brightness values of the finished image. This means that the result is more precise because more shading points are generated. Of course, this also increases the render time. As a result, we will first try our luck using the LOW setting to obtain a quick preview of the global illumination.

The INTERPOLATION METHOD defines, together with the SMOOTHING setting, the algorithm that is used to calculate the smoothness of the determined shading points. We will use LEAST SQUARES with a medium SMOOTHING. The OVERSAMPLING is used when illuminating materials or GI portals are used if those materials were activated by using OVERSAMPLING as SAMPLE MODE on the ILLUMINATION page. The setting WEAK should be sufficient for now.

The DISTANCE MAP option ensures that the distance between objects is taken more into consideration, thereby preventing light from penetrating objects in close proximity. Because of the double walls in our room we don't need this setting. CHECK RECORD VISIBILITY works the same way and also prevents light from penetrating single-walled objects. We can forego this setting as well for the same reason. DETAILS ENHANCEMENT works in a manner similar to the AMBIENT OCCLUSION calculation and can prevent the weakening of fine shadows that are caused by indirect light. We will activate that option.

### ADJUSTING THE SETTINGS OF THE SKY OBJECT

Deactivate or delete all light sources in our scene. Then open the dialog of the SKY object and activate the SUN and SKY in the BASIC settings. Set the INTENSITY in the SKY settings to 100% so its light is included in the calculation. In the settings of the sun we will use an INTENSITY of 180%. All other settings previously set stay the same. The SKY object is now the only light source in the scene. Now make a test rendering of the scene. The result is quite sobering, as you can see in Figure 2.55.

— Figure 2.55: First render tests with global illumination.

Besides the direct light of the sun, there is hardly any evidence of indirect illumination. Maybe our settings in the RENDER SETTINGS are too low?

Let us try it again, but this time with a PRIMARY INTENSITY of 200%. The brightness of the light reflected from the walls and the floor should now be twice as strong. Figure 2.56 disappoints us again. The differences are minimal. What could be the reason? During analysis, it helps to put yourself in the position of the light. Therefore, enter the room through the window and you will encounter the side wall and the floor first. This light is not yet generated by global illumination and is therefore shown correctly in the results. The first reflection starts either from the floor or the wall, from where it probably hits the floor again. The problem of the dark illumination is caused by the dark material of the floor. Remember, light doesn't consist entirely of brightness, but also of color values that are transferred by the reflecting light from one object to another. When a dark object is illuminated, then only dark light is reflected, regardless of the

intensity of the incoming light. What should we do? We like the look of the dark wooden floor and don't want to replace it with a light one.

**OPTIMIZING THE FLOOR FOR GI**

In cases like this we have to use a trick. We will solve the problem by using two separate objects. One will represent the visible floor and the other one will take care of the reflection of the light back into the room. In order to do this, we will select the floor polygon in our room and choose the DISCONNECT command in the FUNCTIONS menu. This creates a new object that contains only the floor surface. If your room object has subordinated objects in the OBJECT MANAGER, then these objects are copied as well and are placed in a hierarchy under the newly added and disconnected object in the OBJECT MANAGER. You can delete these duplicate objects. Also delete the floor polygon in the original room object.

Duplicate the previously disconnected new floor object and shrink it, by moving the

— Figure 2.56: The result after doubling the primary intensity.

corner points, so it shows a consistent gap to the baseboard all the way around. Figure 2.57 shows the shrunken object in two viewports. You can see the desired gap between the baseboard and the edge of the shrunken floor on the right. We do this because the baseboard should not be illuminated too much by the reflecting light. This would look unrealistic with such a dark floor. Also, pull the shrunken floor slightly beneath the original floor of the room. A minimal movement of maybe 0.1 units downward is enough so that the two floor objects don't occupy the same space.

In order to let CINEMA 4D know which object has what function, add a COMPOSITING tag to each floor object, as shown in Figure 2.58. Add them with a right click on the objects in the OBJECT MANAGER and by choosing CINEMA 4D TAGS > COMPOSITING. Also, remember that the object representing the visible floor can be removed from the now unnecessary TEXTURE and SELECTION tags. Only the material for the floor texture should remain. The entry for the limitation to the polygon selection has to be removed from the TEXTURE tag as well. The second lower floor object doesn't receive a material.

— Figure 2.57: Creating a double floor.

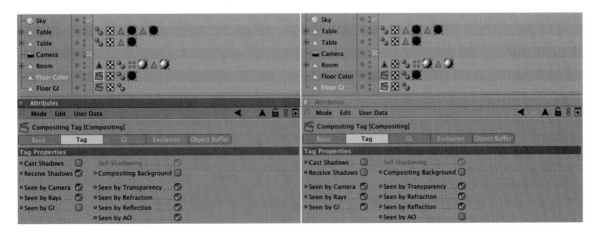

— Figure 2.58: Compositing tags for both floor objects.

In the compositing tag of the textured floor, deactivate CAST SHADOWS and SEEN BY GI. Otherwise, this object would cast a shadow onto the lower floor, making its function more difficult. The lower floor, on the other hand, should not be visible for AMBIENT OCCLUSION and shouldn't react to shadows. As a result, deactivate CAST SHADOWS, RECEIVE SHADOWS, and SEEN BY AO. SEEN BY GI needs to stay activated.

The positive change caused by this little tweak can be seen in Figure 2.59. The light can now be reflected by the floor and illuminates the room. Even the low detail and sample values seem to work well in this case and don't need to be increased. Like in the previous scene, I used AMBIENT OCCLUSION in the RENDER SETTINGS to increase the details in the room corners and behind the side tables. This time I reduced the maximum ray length from 100 to 30 units, to further inhibit the darkening of the corners. This value depends mainly on the scale of your room, so it is too difficult for me to provide binding values. You will have to run some test renderings to find the right value.

Another try can be seen in Figure 2.60. There I set the DIFFUSE DEPTH to just 1, but with a PRIMARY INTENSITY of 200% and a GAMMA of 1.8 to compensate for the removal of the second reflection of the light. This increases the render speed considerably. A slightly red tint of the lower duplicated floor results in a warmer, more diffuse color. Just remember that this coloring should be subtle so the illumination isn't reduced. Such color correction can also be done in postproduction, when corresponding Multi-Passes have been saved separately.

## AN ALTERNATIVE LIGHTING MOOD

In the previous example we simulated sunlight streaming through a window. I would like to change the scene now to simulate illumination from a torchiere in the room, without any light coming in from the outside. In the first step, remove the Sky object completely from the scene, so neither sunlight nor skylight is generated. The illuminated interior will look more realistic at night; therefore, we also don't need the gradient of the sky anymore.

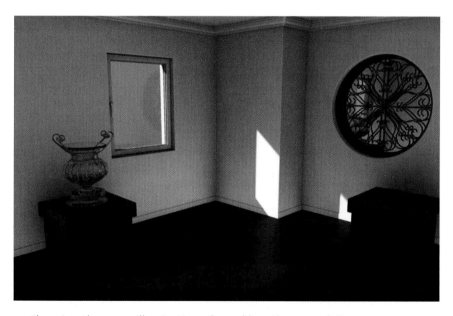

— Figure 2.59: Changing the room illumination after adding the second floor.

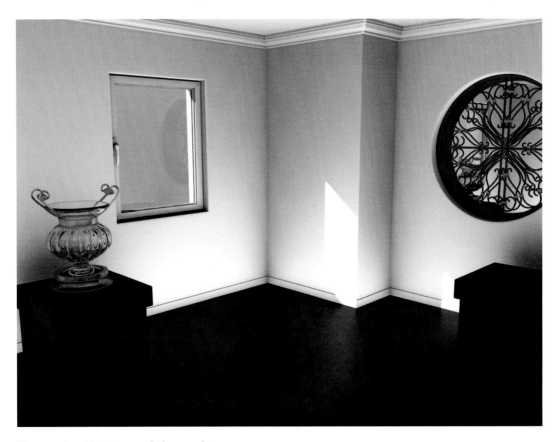

— Figure 2.60: Variations of the result.

## Modeling the Torchiere

For the torchiere we will model a playful shape from splines. I used a B-SPLINE as shown on the left of Figure 2.61. Together with a CIRCLE spline, I subordinated the spline under a SWEEP NURBS object. As you can see in Figure 2.61, I shaped the spline in such a way that it creates a vase-like and bulbous shape, with spheres placed in the middle as decorative elements. Using an ARRAY object from the OBJECTS>MODELING menu, create five copies of the Sweep NURBS. These are automatically arranged in a circular manner as long as you have placed the Sweep NURBS in the XY or XZ plane. Figure 2.61 shows the necessary hierarchical structure of the objects and a possible shape of the torchiere.

The object can be made more interesting with a deformation. We will use a TWIST object found at OBJECTS>DEFORMATION. It has to be subordinated under the ARRAY object, at the same level as the Sweep NURBS object. It is important, though, that the Sweep NURBS object is still on top of the list, as shown in Figure 2.62. Adjust the Y size of the deformer so it runs along the world Y axis and encloses the bulbous part of the lamp. A DIRECTION value of 270° in the TWIST settings in the ATTRIBUTE MANAGER will generate a twist, as shown in Figure 2.62.

The illumination component is positioned on top, inside a translucent bowl that we will model from a simple cube, as shown on the left in Figure 2.63. Then we will convert the cube, using the (C) key, to a POLYGON object

— Figure 2.61: Modeling a torchiere.

— Figure 2.62: Adding a twist object.

and switch to Use Polygon Tool mode. Select the two large caps, on top and bottom, with the Live Selection in the top viewport and make it possible to select hidden elements. After that use Extrude Inner, from the Structure menu, multiple times with these faces so you can have multiple subdivisions, as shown on the right in Figure 2.63.

The newly generated points can be used to change the cube into a funnel-like shape,

like the one shown in Figure 2.64. Remember to select and move simultaneously the points on the top and bottom of the cube so the thickness of the object remains constant. By subordinating the deformed cube under a HyperNURBS object it can be smoothed, as shown on the right in Figure 2.64. An alternative to this modeling method is the use of a Lathe NURBS object with a profile spline of the reflector bowl. The principle is the

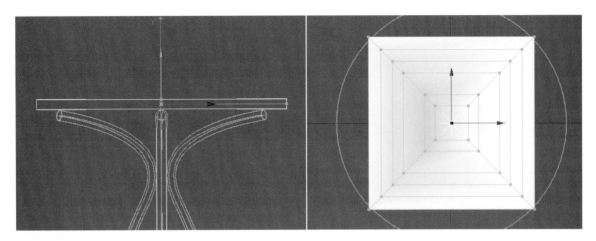

— Figure 2.63: Modeling the reflector.

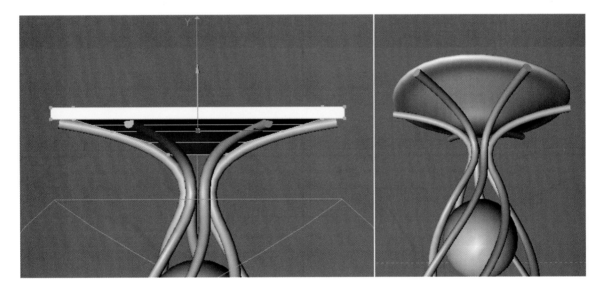

— Figure 2.64: Shaping the reflector.

same as the modeling of the vase in the previous chapter. There are always several ways that lead to the finish.

Still missing is the actual light source. For that we will use a point light with a soft shadow. It is important that the light source is located deep enough in the upper funnel of the torchiere so the direct light exits in a wide cone upward toward the ceiling. Figure 2.65 shows the positioning of the light source and the preliminary settings.

Then group all elements of the lamp together in order to move or scale them more easily. Select all objects of the lamp with (Ctrl) clicks in the OBJECT MANAGER, or by using a selection frame in the OBJECT MANAGER, and by selecting GROUP OBJECTS in the OBJECTS menu of the OBJECT MANAGER. Afterward, position the torchiere in a corner of the room next to the window or in another spot of your choice.

**The Materials of the Torchiere**

The frame of the lamp receives an understated dark material with a slight reflection.

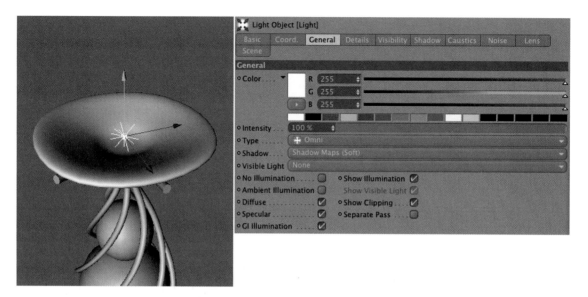

— Figure 2.65: The light source for the torchiere.

You could use the same material used for the decorative grid. The spheres enclosed in the lamp are supposed to be transparent, but at the same time very refractive and reflective. We will create a new material and set the brightness to 50% in the COLOR channel so the reflective properties can be easily seen. I colored the transparency slightly orange and assigned a REFRACTION index of 1.6 with a BRIGHTNESS of 70%. As ABSORPTION COLOR I used a desaturated blue whose ABSORPTION DISTANCE is adjusted to the radius of the sphere. Only test renderings help to find the correct settings. The value could be roughly oriented to the diameter of the largest sphere. The options for TOTAL INTERNAL REFLECTION and EXIT REFLECTIONS are activated as well.

The color of the reflection is a slight yellow and has a brightness of 70%, with the highlight being intense and small. Since the material has mainly reflective and transparent properties, generating and receiving global illumination can be deactivated. Figure 2.66 shows the most important parameters of this material.

**The Reflector Material**

The upper reflector bowl is supposed to consist of a translucent, slightly transparent material. We will start again in the COLOR channel of a new material. I loaded the NOISE shader and used two slightly different color tones in the yellow-red range of the color space. For the NOISE type I used ELECTRIC, but other patterns are possible, too. The goal here is to show slight irregularities in the surface color. In the COLOR channel itself I reduced the MIX STRENGTH to 50% so the standard gray color of the channel is visible through the NOISE, thereby weakening the NOISE a bit.

*Subsurface Scattering*

The chief characteristic of this material is not the surface color, but instead the illuminating part. Therefore, we will use the SUBSURFACE SCATTERING shader in the LUMINANCE channel. This shader can simulate continuous and scattered light within an object. Just think about the effect that occurs when you

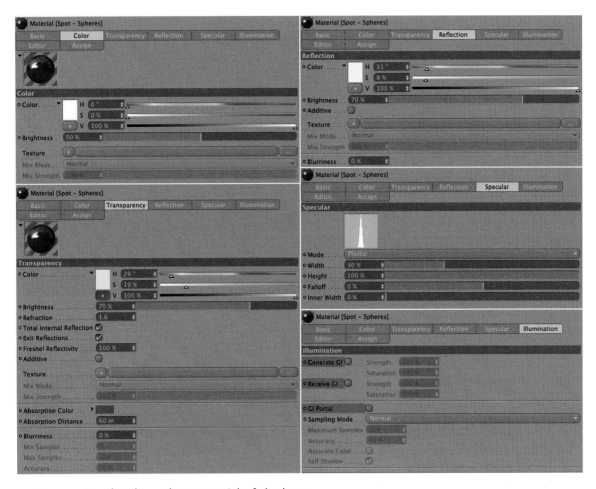

— Figure 2.66: The glass sphere material of the lamp.

hold your hand in front of a lamp. The light passes partially through the fingers, causing them to glow red at thinner parts. This effect is caused by the scattering of light within the objects and is characteristic of many organic, but also inorganic, materials. Even massive rocks and marble show that effect in nature.

The SUBSURFACE SCATTERING shader, or SSS shader, can be found in the effects group of the shader and is controlled mainly by entering lengths. The size of the object that is supposed to receive this shader is very important. The SCATTERING LENGTH defines the distance that a ray can travel within an object. This parameter is generally smaller than the dimensions of the object. ABSORPTION

represents the medium distance from where the light is scattered. An ABSORPTION value that is too big reduces the influence of the ABSORPTION FILTER.

The ABSORPTION FILTER defines the coloring of the scattered light at the various depths of penetration into the object. The left edge of the color gradient stands for the coloring in the thinnest segments of the object and the right one for the thickest parts. The color gradient orients itself based on the value for the FILTER LENGTH. The colors placed on the right side in the gradient will be visible after the scattered light distance defined in the FILTER LENGTH. The STRENGTH value is a simple multiplier of the effect's brightness. The SAMPLES

stand for the number of calculation steps per surface point. Higher values generate a result with less brightness noise, but it also takes longer. Lastly, MINIMAL THICKNESS defines the distance that a ray can travel through the object, measured from the surface, without scattering or losing its strength. Since the shader has to know if the ray is still traveling within the object or maybe within a cavity in order to calculate, the direction of the normals is important. With USE NORMALS active, the normals pointing outward are automatically recognized as the outer shell of the object. Without this option, the shader just counts the penetrated polygons and assumes that between the first and second (third and fourth, and so on) penetration the object is solid. This method is quicker when using

simple geometries. A summarization of my settings can be seen in Figure 2.67.

We can also use a slight REFLECTION of 10% in the material without a blurry effect. As for the illumination, RECEIVE GI and GENERATE GI should be active. I reduced the generating property to just 10%. This value is a result of multiple test renderings. You can leave this value at 100% and lower it later, based on your own needs. This value is important because illuminating materials act like light sources in the global illumination calculation and take part in the actual lighting of the environment. I reduced the receiving value to 80% and the SATURATION of the received GI light was reduced to 50%. The reflector itself emits light and therefore shouldn't absorb that much color of the other

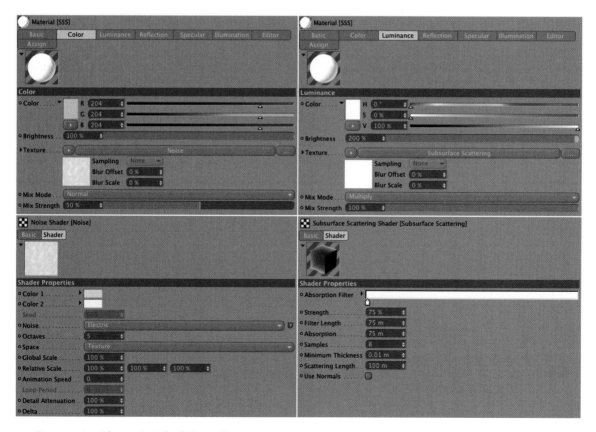

— Figure 2.67: The material of the reflector.

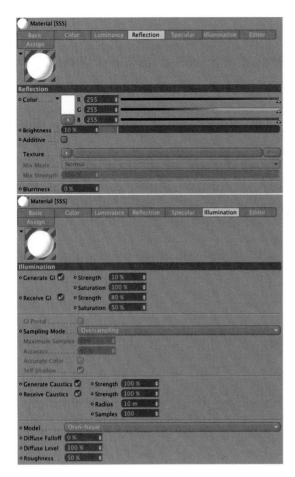

— Figure 2.68: More settings of the reflector material.

elements. It is also important to activate the SAMPLING MODE since we are dealing with an illuminating material. This setting makes sure that the calculation rays are focusing more on this material. The OVERSAMPLING setting should be precise enough. Figure 2.68 shows all these settings again.

**First Test Renderings**

Before we start with the settings for the global illumination, we should test the brightness of the real light source in the reflector. You have to keep in mind that its light, depending on the DIFFUSE DEPTH used, will be much brighter. Also, this light is added to the

emitted light of the illuminating reflector. Besides reducing the light source intensity, you should also use the falloff feature. Figure 2.69 shows my settings.

I used an INVERSE FALLOFF with a radius that reaches roughly from the light source to the corner of the room. The radii on top left of the figure indicate this distance. An INTENSITY of just 10% might seem very small but will be balanced by the previously mentioned characteristics of global illumination. Figure 2.69 shows the result in the upper right. The light cone of the lamp and the brightness of the reflector bowl can already be seen clearly.

**Settings of the Global Illumination**

You can always check, during the prepass calculation, whether the lighting is the way you imagined it to be or if the rendering should be stopped and repeated after changing the settings. Figure 2.70 shows such an early phase of the prepass calculation, which appears after just a few seconds. Already you can judge the brightness distribution and intensity without having to wait a few minutes for the finished image. You should also deactivate ANTI-ALIASING and AMBIENT OCCLUSION during test renderings to achieve a fast result.

We will now activate GLOBAL ILLUMINATION in the EFFECTS of the RENDER SETTINGS and start with IR (STILL IMAGE) mode and a DIFFUSE DEPTH of 1. When the PRIMARY INTENSITY is increased to 300% you will get a result as shown in Figure 2.71. This is far from realistic lighting, but that wasn't the goal of this first step. Instead, we are trying to create a transition of brightness between the light source and the walls of the room. We can already see—even if it is still very dark—how the walls are lit by the global illumination.

We could keep increasing the PRIMARY INTENSITY value until we have sufficient image brightness, but it is easier to use the GAMMA value. In the result shown in Figure 2.72, the GAMMA value was increased from 1 to 3 while

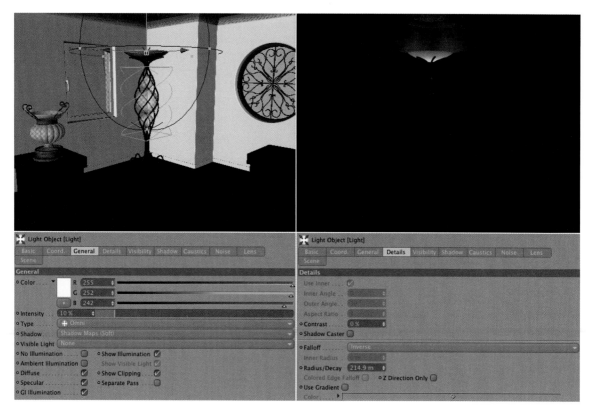

— Figure 2.69: The light source of the torchiere.

— Figure 2.70: The prepass of the global illumination.

all other settings remained the same. The room is quite realistically illuminated, but it also is apparent that the brightness above the reflector is too intense. We can correct this with the help of COLOR MAPPING, found in the effects of the RENDER SETTINGS. It reduces the brightness to eliminate overexposure. With the standard values of 1 each for DARK MULTI-PLIER and LIGHT MULTIPLIER, the image will probably be too balanced. The maximum brightness should still be located above the lamp. Consequently I used a value of 1.5 for DARK MULTIPLIER to increase the overall brightness. A slight increase of LIGHT MULTI-PLIER to 1.05 increases the contrast between the light walls and the dark wood of the floor and side tables. Figure 2.72 shows the result. We are going in the right direction.

The result can be improved even further by using an additional DIFFUSE DEPTH. On the left of Figure 2.73 you can see the result with a DIFFUSE DEPTH of 2, a PRIMARY INTENSITY of 300%, and a SECONDARY INTENSITY of 100%.

— Figure 2.71: First test renderings with global illuminations.

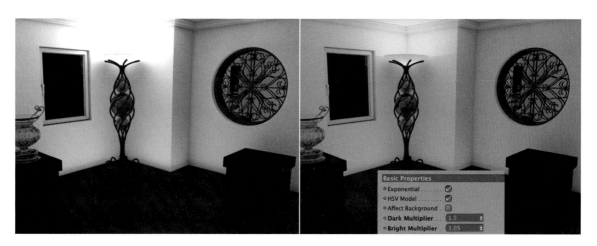

— Figure 2.72: Using the gamma value to increase the overall brightness.

Next to it is the finished image with 200% SECONDARY INTENSITY. The IRRADIANCE CACHE values can be seen there as well. Nothing has changed here in comparison to the illumination by sunlight. Medium standard settings result in a good quality.

Keep in mind that these render settings might have nothing to do with the simulation of realistic light. It is our goal to achieve a good result from an artistic viewpoint within a reasonable time frame. Using a photo of a real illuminated room, it would of course be easier to replicate the distribution of different brightness levels. We have to trust in our own judgment and abilities to find the right mood for the image.

Figure 2.74 shows the final image after the reactivation of AMBIENT OCCLUSION and a correction of the tonal value in postproduction.

With the following example we will leave the constricting scene of a room and step outside.

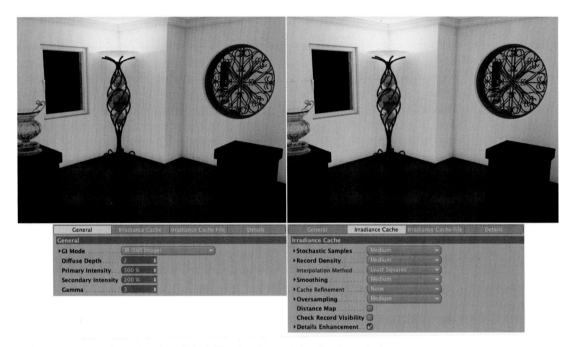

— Figure 2.73: Settings for the global illumination of the final rendering.

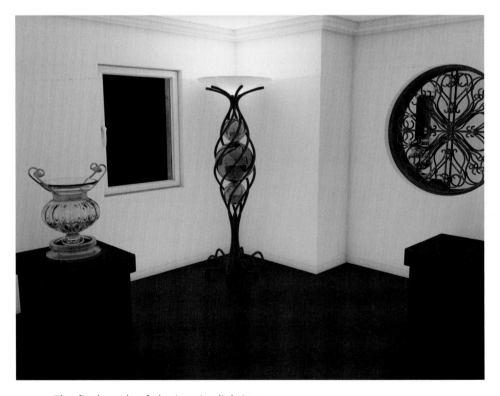

— Figure 2.74: The final result of the interior lighting.

# Lighting an Outdoor Scene

The theme of this new workshop is the lighting of an outdoor scene that consists mainly of stairs that are lit along the side by lanterns. We will take our inspiration from traditional temples in Japan and use existing shapes when modeling the lanterns. You will discover again how quickly complex-looking shapes can be made using simple shapes. Afterward we will model the rustic stone stairs with the help of NURBS objects and Deformer objects.

## Modeling the Lantern

We start the modeling of the lantern with the base plate, located between the post and the upper part that will later contain the light. Under this square plate, which has been built from a flat CUBE object, we will place an elongated cube in a diagonal direction, as shown in Figure 2.75. Here you can also see the measurements I used if you don't trust your own visual judgment. I didn't work with predetermined measurements, but instead with reference images of similar lanterns that I researched on the Internet.

Be sure to round all objects slightly. This will look more natural in the rendered image. Even if the number of polygons will increase

considerably, it is worth it. Now convert the diagonal beam using the familiar (C) key and activate the KNIFE tool in the STRUCTURE menu. In order to use that tool you have to work in USE POINT TOOL, USE EDGE TOOL, or USE POLYGON TOOL mode.

Add two LOOP cuts to the beam. One is placed exactly in the center and one just before the spot where the beam comes out from under the plate. In USE POINT TOOL mode, delete the end of the beam completely, as shown on the left in Figure 2.76. You can use the FRAME SELECTION to select all points on one side of the beam and then delete them with the (Delete) key. Just make sure that your mouse pointer is placed above the viewport and not over the OBJECT MANAGER; otherwise, the whole object will be deleted and not just the selected points. In addition, the selection of hidden elements should be allowed. Select the lower outer points at the end of the beam and move them slightly upward. The beam will be tapered at its end, as shown in the different views in Figure 2.76.

In USE MODEL TOOL mode create three copies of the shortened beam and rotate each by 90° around the Y axis. Because the original beam was positioned in the center of the square plate and the local axis system wasn't changed by deleting points, it should be possible to rotate the copies around the center of the plate. In the end, the four beams should be positioned diagonally under

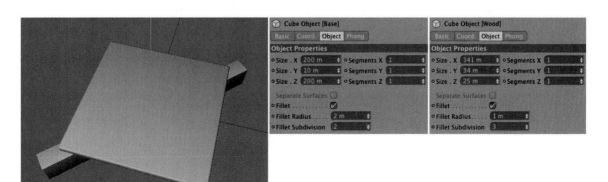

— Figure 2.75: Base plate and supporting square timber of the lantern.

— Figure 2.76: Tapering and shortening the lower support beam.

— Figure 2.77: The complete base of the lantern.

the plate as shown in Figure 2.77. Then create another cube, which is elongated along its height, to serve as a short post that we can place in the center of the plate. Because the four beams enter the post in the center, we don't have to close the open ends created by the deletion of the beam points.

### THE FRAMEWORK OF THE LANTERN

This completes the base of the lantern, and now we will start on the framework. We will

need four slim cubes, each pair having equal measurements. These cubes are placed parallel to the edge of the plate, on top of the plate. The ends of the cubes penetrate each other, as shown in Figure 2.78. The highlight shows the cubes with equal measurements. The height of one pair of cubes is slightly reduced so no unnatural shading will occur at the corners of the intersecting areas of the cubes.

Exactly into one of the cross points of the cubes we will place a new vertical cube whose

— Figure 2.78: The lower support construction.

profile corresponds with the four previously placed cubes. Set the height of the cube so it has the height you envisioned for the lantern. Figure 2.79 gives a reference and shows again the measurements I used.

Using the (C) key, convert the vertical cube to a POLYGON object and change to USE OBJECT AXIS TOOL mode. With the MOVE tool pull the axis system of the cube downward, so that it is positioned approximately at the cross point of the cubes lying on the plate.

Back in USE MODEL TOOL mode, activate the ROTATE tool and rotate the vertical cube slightly outward. Figure 2.80 shows this tilt from several views. As you can see there, the cube isn't rotated outward into the direction of the base plate corner, but only around one of its object axes. I decided to rotate it around the Z axis, but it doesn't really matter which one is used.

When you are happy with the tilt and rotation of this vertical support beam, create

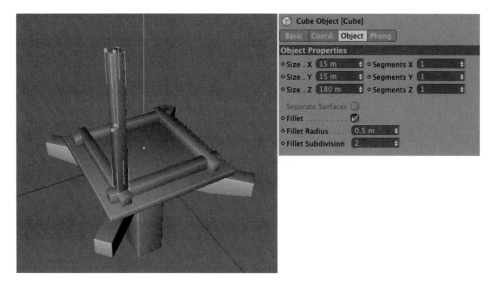

— Figure 2.79: The vertical beam.

— Figure 2.80: Rotating and duplicating the vertical support beams.

three copies in the OBJECT MANAGER by using the (Ctrl) key with drag and drop. Move these copies to the three other cross points on the base plate and create a symmetrical tilt of the beams by changing the signs in the COORDINATE MANAGER. This means that, when you previously rotated the vertical cube around its Z axis by 4°, you then have to change the numerical value of the B angle in the COORDINATE MANAGER from 4° to –4° to create a mirrored tilt.

### Modeling the Upper Immediate Ceiling

In order to give this construction stability, we will add another four cubes slightly beneath the upper ends of the vertical support beams. This time, though, they are not modeled from several objects but from one flat cube, as shown in Figure 2.81. The height of the cube is equal to the profile of the vertical support beams. Make sure that this plate protrudes on all sides, slightly past the

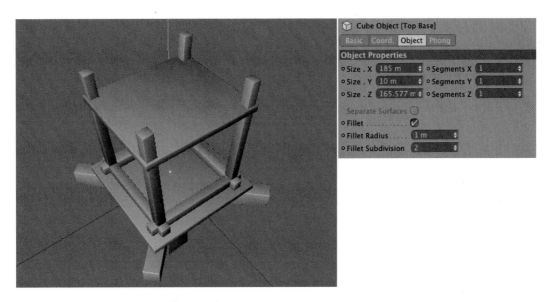

— Figure 2.81: The upper intermediate ceiling.

— Figure 2.82: Creating additional subdivisions using the Knife tool on the converted cube.

support beams. Because of the rotation of the support beams this plate cannot have a square base plane like the lower base plate.

Convert the newly created plane with the (C) key to a POLYGON object and switch to the USE POLYGON TOOL mode. Using the KNIFE tool from the STRUCTURE menu, make some LOOP cuts along the support beams that protrude through the plate, as in Figure 2.82. Select the polygons along the edge of

the subdivided plate that are supposed to belong to the new, horizontal stabilization bar. Figure 2.83 clarifies which faces are meant.

After these faces are selected, use the DIS-CONNECT command in the FUNCTIONS menu to copy these faces into a new POLYGON object. The original plate can be made invisible for the moment. Use the CREATE POLYGON function in the STRUCTURE menu to close the highlighted

opening of the disconnected object, shown in Figure 2.83, with a quadrangle made of new polygons. To do this, click clockwise, in consecutive order, onto the corner points at the open edge of the object. On the fourth point double click so the new face is generated between the previously clicked points.

Use the same principle for the other sides of the subdivided plate. This creates four flat beams with cutouts for the vertical beams. Figure 2.84 shows these objects alone and then on the right side in connection with the other groups of the lantern. The highlights emphasize where the borders of the disconnected and then closed parts are located.

— Figure 2.83: Manual closing of the disconnected area of the plate.

Make sure that there are no intersections and that the four beams are exactly aligned, especially at the corners.

### THE ROOF OF THE LANTERN

In the next steps we will put a typical roof on top of the lantern. We will start with the support structure, which again contains four cubes, two identical pairs. The longer cubes are used on the sides where the vertical support beams tilt outward. These elements can be seen in the upper part of Figure 2.85. Note the generous overlap of these highlighted cubes. The two shorter cubes are shown underneath. They are modeled taller so the faces at the cross points don't intersect at the corners.

The actual roof consists of two cube plates with different angles that are placed, slightly overlapping each other, above the support structure of the lantern. Since the roof is symmetrical we only have to create half of the roof, as shown in Figure 2.86. Once you have modeled the lantern around the world origin, then you can use the world Y axis as the symmetry axis and align the tilt of the upper cube on it. The cubes should be

— Figure 2.84: Complete upper support frame of the lantern.

— Figure 2.85: The support beam for the roof construction.

— Figure 2.86: Simple roof construction from two cubes.

adjusted in their width so that they also overlap the longer support beams a bit.

As I just mentioned, we don't have to put in the effort to model the other half of the roof. A new SYMMETRY object with the two cubes of the roof subordinated under it will take care of that. Note that the SYMMETRY object only mirrors the uppermost subordinated object and its hierarchy. Therefore, create a hierarchical relationship between the two cubes of the roof construction under the SYMMETRY object, as seen in Figure 2.87. If the MIRROR PLANE in the SYMMETRY object was set correctly, then you should now see the complete roof.

In order to have such a roof construction work, we need some connecting elements. We will use splines, because we need a bar that nestles against the two roof cubes. Figure 2.88 shows how such a spline curve

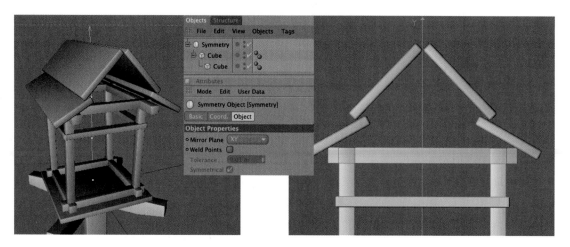

— Figure 2.87: Symmetrical doubling of the half roof.

— Figure 2.88: Connection element of the half roof.

could look. I used a Bezier spline and utilized its tangents to create roundings and hard edges. The spline should be closed with the CLOSE SPLINE option in the ATTRIBUTE MANAGER so we can convert it, in the next step, to a solid-looking object with the help of an EXTRUDE NURBS.

Create a new EXTRUDE NURBS object and subordinate the spline under it. Then make a copy of the spline and leave it in the group of the NURBS object, as shown in Figure 2.88. For the EXTRUDE NURBS object to utilize both splines you have to activate the HIERARCHICAL option. Then use the MOVEMENT value and the option for closing and rounding the caps to give the spline mass.

Pull apart both splines, located along the roof construction, so that evenly sized gaps are generated at the outer edges of the roof. Figure 2.89 can be used as an example. There you can see that the subordination of the EXTRUDE NURBS objects, in the roof group under the SYMMETRY object, automatically completes the missing side. The remaining gap between all NURBS objects at the peak of the roof is closed by a new cube object that is highlighted on the right side of Figure 2.89. In the front and back this ridge extends past the roof quite a bit. Don't forget to round the cube here, too.

Despite all efforts, the roof construction still appears a bit shaky since a support from

— Figure 2.89: Adding the roof ridge.

below is missing. To add it, start again with a new spline created in a linear manner. Depending on the orientation of your lantern, you will have to create the spline in the side or front viewport and use it to close one-half of the roof gable, as shown in Figure 2.90. Check in the COORDINATE MANAGER to be sure that the points in the center are positioned exactly on the symmetry axis of the lantern. The X and Y point coordinates should be 0 as long as your lantern was built at the world origin.

The finished spline is then subordinated under a new EXTRUDE NURBS object. This time, leave the MOVEMENT value at 0 and use only one of the two cap functions, as shown on the right side of Figure 2.90. This ensures that the closed spline of the half gable is closed by a face.

Select the EXTRUDE NURBS and convert it, with FUNCTIONS>MAKE EDITABLE, into a POLYGON object. Add a new SYMMETRY object from OBJECTS>MODELING and subordinate the converted EXTRUDE NURBS under it. As shown in Figure 2.91, one side of the gable should be completely closed, as long as you have moved the face of the EXTRUDE NURBS to an appropriate position.

The SYMMETRY object is also just a parametric object and can therefore be converted. Select the most recently created SYMMETRY object and use the (C) key to convert it to a POLYGON object. There should now be a POLYGON object with two faces in front of you, as shown on the left in Figure 2.92. This structure can be further simplified. Select the two faces in USE POLYGON TOOL mode and choose

— Figure 2.90: Closing the gable.

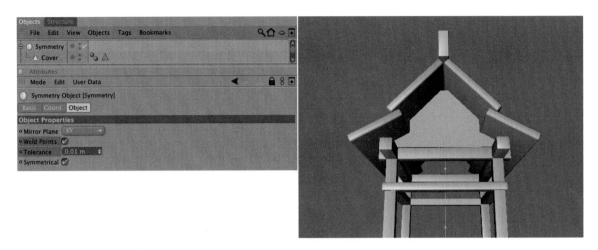

— Figure 2.91: Mirroring the converted Extrude NURBS object.

— Figure 2.92: Converted and optimized symmetry object.

MELT in the FUNCTIONS menu. The two faces are then combined into one large n-gon, as can be seen on the right of Figure 2.92. If this doesn't work with your object, then most likely the points in the middle weren't located exactly on top of each other and haven't been combined by the SYMMETRY object. In this case, use the UNDO function in the EDIT menu to go backward until you have the SYMMETRY object back. Select the points positioned on the symmetry plane and control their position.

Duplicate this closed object of the gable and move the copy to the opposite side of

the lantern. The following steps will deal with the spaces in between. If we use a tea light candle for the illumination it has to be protected from drafts.

### MODELING THE SIDE PARTS OF THE LANTERN

We will start by closing the remaining open areas on the sides of the upper portion of the lantern, in between the upper support framework. Create a new CUBE object, but this time we won't need to round the edges since they will be completely covered by the

surrounding cubes. Adjust the size of the cube so that it intersects slightly with the cubes around its perimeter. This will ensure that light will not leak through small gaps. Figure 2.93 shows the size and position of the highlighted cube.

Then convert this cube with the (C) key to a POLYGON object and delete, in USE POLYGON TOOL mode, the two large faces on top and bottom of the cube. What remains are the four side faces of the lantern construction. Select these four polygons and activate the EXTRUDE INNER command in the STRUCTURE menu. Deactivate the PRESERVE GROUPS option in the settings of the command in the

ATTRIBUTE MANAGER so that all four sides can be edited separately. Reduce the size of the selected faces, as shown on the top left of Figure 2.94.

Then deselect a facing polygon pair. Now only two faces that were shrunk with EXTRUDE INNER remain selected. In the COORDINATE MANAGER reduce the value for the lateral size of these polygons and use the APPLY button. You could also use the SCALE tool that is restricted to lateral scaling. The goal is to get faces twice as wide as they are high. Repeat this with the second polygon pair generated by EXTRUDE INNER. Figure 2.94 shows the desired result on the bottom left.

— Figure 2.93: Closing the upper segment.

— Figure 2.94: Extruding side faces inward.

The shrunken faces located in the center of the side polygons represent windows that are covered with translucent glass or paper. The surrounding polygons build a solid frame that could be made of wood. Select the four shrunken faces in the center of the four sides and use INVERT in the SELECTION menu. The result is also shown in Figure 2.94 on the right. With this simple method the polygons surrounding the windows are now selected.

Select the EXTRUDE command in the STRUCTURE menu and activate the CREATE CAPS option in the ATTRIBUTE MANAGER. This will ensure that during the following extrusion the original polygons aren't deleted, thereby creating a solid object. Figure 2.95 shows a possible result. The goal is to extrude the selected faces a little bit toward the inside of the lantern and by doing so, create a wall or thickness around the window polygons.

Now select and delete the four small windows, each consisting of just one simple polygon, and change to USE EDGE TOOL mode. Use the RING SELECTION in the SELECTION menu to select the four edges in the corners of the window openings. Hold down the (Shift) key so you can select the edges at the other window openings as well. Then use the BEVEL command in the STRUCTURE menu to round these edges, as shown in Figure 2.96. In the BEVEL tool settings, activate the CREATE N-GONS option and the CONVEX TYPE with three to four SUBDIVISIONS. The extent of the rounding can be seen in Figure 2.96.

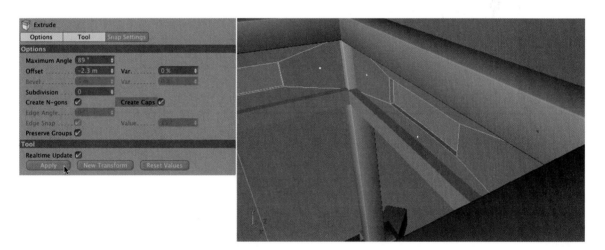

— Figure 2.95: Extruding with activated cap option.

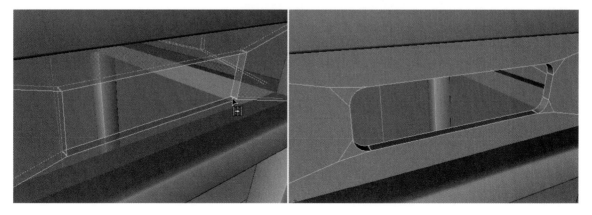

— Figure 2.96: Rounding the windows.

A candle will create the light emanating from the inside of the lantern. Its light will be diffusely scattered by the side paper walls. These paper walls will be modeled from a simple cube. Figure 2.97 shows the high-lighted cube. After you adjust its size to the height of the inner base polygon of the lantern, convert the cube with the (C) key and delete the upper and lower cap in USE POLY-GON TOOL mode. Then switch to USE POINT TOOL mode and adjust the upper corner points by moving them so the object matches the tapered interior of the lantern, as shown in Figure 2.97.

### The Decorative Grid of the Lantern

The paper walls are supported by an outer decorative grid made from slim wooden sticks. For their modeling we will first make a copy of the paper wall object and then change to USE EDGE TOOL mode. With the KNIFE tool from the STRUCTURE menu add subdivisions as evenly as possible to each of the side faces of the copied object. Figure 2.98 shows, especially on the right side, the desired result of this step.

Then select the edges that are located in the area of the openings and run parallel to

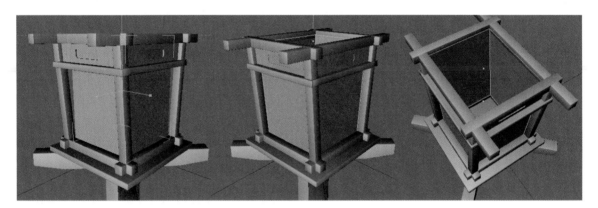

— Figure 2.97: The inner paper hull of the lantern.

— Figure 2.98: Additional subdivisions of a copy of the paper walls.

the vertical support beams, and select the EDGE CUT command in the STRUCTURE menu. This allows you to cut in the same way as the KNIFE tool in LOOP mode. The advantage here is that these cuts are automatically spread out evenly, based on the edge length. As you can see on the left of Figure 2.99 I've added a lot of even subdivisions parallel to the floor of the lantern. The SUBDIVISION value of the EDGE CUT function should be set to about 25. The goal is to generate a pattern that we can use later to model the decorative grid.

Then use the RING SELECTION in the SELECTION menu and select all horizontal subdivisions of the object. The right side of Figure 2.99 shows the completed selection of these edges. These edges also have to be cut with the EDGE CUT function. Ideally, this will create almost identical square polygons in the area of the four side faces of the lantern.

In USE POLYGON TOOL mode, use the LOOP or RING SELECTION in the SELECTION menu to select the geometric pattern, as shown in Figure 2.100. These faces will be extruded to

— Figure 2.99: Using the edge cut function to create parallel subdivisions.

— Figure 2.100: Polygon selection of the desired pattern.

give them a thickness and the remaining faces can then be deleted. Therefore, use the INVERT SELECTION command in the SELECTION menu so that all faces that are not part of the decorative grid are selected. With the (Delete) or (Backspace) key these faces can now be deleted as long as the mouse cursor is placed over the editor viewport. What remains is the actual pattern of the decorative grid, as shown in Figure 2.101. The paper object used for the cover underneath was set to invisible in order to get a better view of the faces to be edited.

The object of the decorative grid contains a lot of unnecessary points, edges, and polygons. In the first step use FUNCTIONS>OPTIMIZE to delete UNUSED POINTS. You can leave all three options activated and close the dialog again with a click on the OK button. Then add a POLYGON REDUCTION object from the OBJECTS>DEFORMATION menu and subordinate it under the decorative grid. Figure 2.101 shows this step and the possible result. The REDUCTION STRENGTH can be set to a very low 1%. The other options of the object should be activated as well. Because all the small polygons lie in one plane they can easily be detected by the POLYGON REDUCTION object and filtered out.

When you have the display of edges activated in the editor viewports you can see the extent of the reduction directly in the editor. To further improve the result, select the decorative grid object and choose FUNCTIONS>CURRENT STATE TO OBJECT. This will create a new object in the OBJECT MANAGER that represents the polygon-reduced version of the object. The original, including the subordinated POLYGON REDUCTION object, can now be deleted. Use the UNTRIANGULATE command in the FUNCTIONS menu and activate only the EVALUATE ANGLE option. The standard value of 0.1° can be left the same. This function ensures that when two triangles share an edge and the angle between them is smaller than the angle specified in the dialog, they are combined into a quadrangle. In the best possible case, the number of polygons can be cut in half. In this case, the majority of triangles can be removed from the decorative grid. Now there are only triangular faces at the outer frame of the grid, as shown in Figure 2.102. Select all faces of this frame and use the MELT function in the FUNCTIONS menu. The faces are combined into a single n-gon, as shown on the right in Figure 2.102.

After you've done this to all four sides of the decorative grid you have to make sure that the normals point uniformly outward. This is indicated by an orange color when the faces are selected. Select all polygons that are aligned differently and use REVERSE

— Figure 2.101: Reduction of the decorative grid.

— Figure 2.102: Optimizing the filtered object.

— Figure 2.103: Thickening the decorative grid by extruding with caps option.

NORMALS from the FUNCTIONS menu. This uniform orientation is important for the future shading of these faces but also for the following editing with the EXTRUDE command because it uses the direction of the normals on the faces as the direction in which to extrude.

Make sure that the CREATE CAPS option is activated in the EXTRUDE tool so a solid object will be generated from the polygons of the decorative grid. Choose the amount and direction of the extrusion in such a way that the selected faces move slightly outward, as can be seen in Figure 2.103.

If you want, you can convert the cube on top at the ridge and refine its shape by moving the lower points at the cube's ends. This concludes the modeling of the lantern.

— Figure 2.104: The finished lantern.

Figure 2.104 shows an illuminated version of the finished model. In the following section we will work on the materials of the lantern

and the preparations for the global illumination through this object.

## The Materials of the Lantern

For the lantern we will use simple materials with intense colors and a slight wood grain. We will start with the material for the roof of the lantern. It is rather dark, so benefits from a bit of reflection and highlight.

### THE ROOF MATERIAL OF THE LANTERN

Add a new material in the MATERIAL MANAGER and load the WOOD shader into the COLOR channel. This shader can be found in the SURFACE section. We will leave the standard settings, but reduce the MIX STRENGTH of the COLOR channel to 15%. This will reduce the opacity of the WOOD shader and allow the color in the COLOR channel to show through. For the color we will use a

dark and very desaturated blue, as shown in Figure 2.105.

In addition to the COLOR and SPECULAR channels, also activate the REFLECTION and BUMP channels in this material. The REFLECTION, at 15%, is moderate, but strong enough to depict a lacquered surface.

To make the surface look less smooth I loaded the NOISE shader into the BUMP channel and used a FIRE noise that is heavily scaled in the Y direction but has a STRENGTH of only 4%. It is intended to simulate the fine grain of the wood surface. The highlight will be set higher than usual so it looks appropriate for the lacquered surface. In addition, the BLINN shading model set in the ILLUMINATION settings will support the gloss of the material. Since the scene will be lit by global illumination, we should already be thinking about the settings for GENERATE GI and RECEIVE GI. Because the surface is quite dark and the lantern will be quite small in comparison to the overall scene, we can deactivate the GENERATE GI and save some render time. The receiving properties for

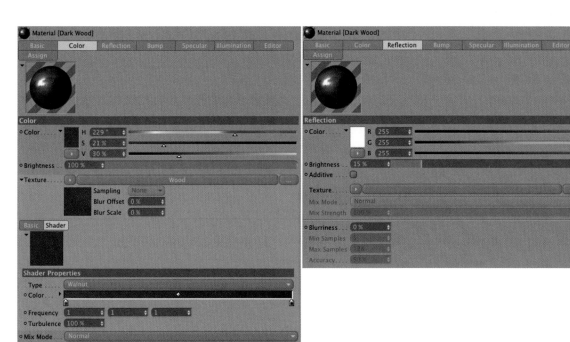

— Figure 2.105: Color and reflection of the roof material.

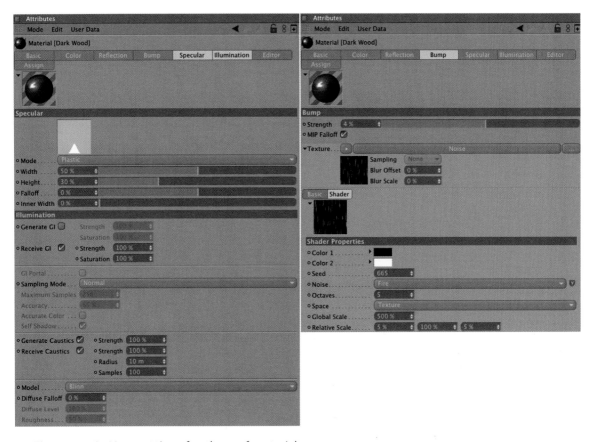

— Figure 2.106: More settings for the roof material.

global illumination remain activated, however. You can see these settings in Figure 2.106.

Apply the material to the SYMMETRY objects that comprise the roof construction of the lantern.

## COLORING THE ENDS OF THE CUBES

As a subtle decorative element I'd like to color the open ends of the crossing cubes at the base and under the gable. We will create another material and activate the REFLECTION channel in addition to the standard channels. For COLOR we use a warm but light color. The brightness of the REFLECTION is set again to 15%. Figure 2.107 summarizes these settings. Also, the generation of global illumination has been deactivated.

By using the (C) key, convert the eight cubes located directly under the roof and the ones that form the lower frame at the base plate of the lantern. In USE POLYGON TOOL mode, select the two end faces of these cubes and save this selection with SELECTION > SET SELECTION. This creates SELECTION tags in the OBJECT MANAGER that don't need to be renamed because this will be the only saved selection. Pull the newly created light material to one of the cubes in the OBJECT MANAGER and enter the name POLYGON SELECTION into the SELECTION field of the TEXTURE tag in the ATTRIBUTE MANAGER. Now this material is only applied to the end faces of this cube. Pull this TEXTURE tag with (Ctrl) drag and drop onto the other seven cubes that already have this polygon selection.

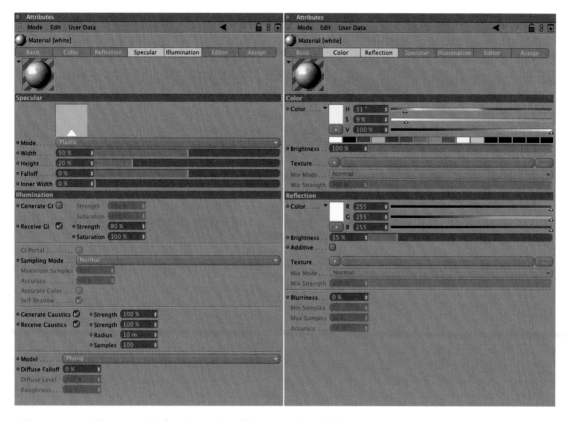

— Figure 2.107: The material for the ends of the wooden sticks.

### THE MAIN MATERIAL OF THE LANTERN

The main material used, besides the dark roof material, simulates red lacquered wood. Therefore, we can use a copy of the roof material by using COPY and PASTE in the MATERIAL MANAGER. We will also use the WOOD shader in the COLOR channel and reduce its opacity to 15%, but this time we will pick a bright red. Then load the AMBIENT OCCLUSION shader from the EFFECTS group into the DIFFUSION channel of the material. This will result in a sharper contrast between the wood elements of the lantern. We will leave the standard settings for now. Test renderings will show if we will need to adjust the MAXIMUM RAY LENGTH. The REFLECTION of 15% is the same as in all the other materials. Figure 2.108 shows all these settings again.

The settings for the BUMP channel remain the same. As Figure 2.109 shows, there are no changes in the other channels, either. That is no surprise since this material is basically the same as the roof material, just with another color. Pull the material onto all the objects without a material. If you already created groups, then just apply it to the top object and the objects subordinated underneath will automatically receive the material as well. The cubes with the colored ends receive this material, too. Just make sure that in the OBJECT MANAGER the TEXTURE tag of the light material is to the right and therefore hierarchically above the red wood material. Otherwise, it would be covered, despite the polygon selection.

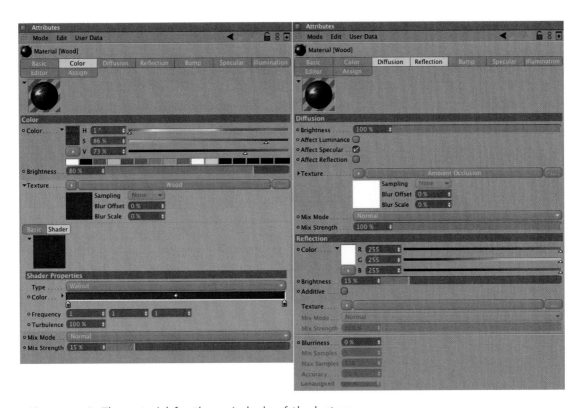

— Figure 2.108: The material for the main body of the lantern.

— Figure 2.109: Further settings of the red wood material.

## THE PAPER WALL MATERIAL

The texturing of the paper walls of the lantern will be a bit more difficult. They are supposed to look as if a tea light is illuminating them from the inside. We will start again with a new material and deactivate the COLOR channel. The material will be defined primarily by its illuminating properties. Therefore, activate the LUMINANCE channel and load the GRADIENT shader into it. The shader will generate a circular brightness gradient that looks like a translucent wall being lit from behind. It would be even better if the light source were to have a three-dimensional range and able to be moved within the four sides of the PAPER object. Then the flicker of a candle inside the lantern could be simulated.

This effect can be precisely simulated using the 3D SPHERICAL type in the GRADIENT

shader. With the RADIUS value and the midpoint coordinate START, a spherical space is defined within an object that will be colored with the gradient. The center of this sphere receives color values from the left end of the gradient, and the outer areas are represented by the colors from the other end of the gradient. Depending on the size of your paper wall object, set an appropriate value for the RADIUS. Test renderings are necessary to determine the size and intensity of the light spot. In my case I set the MIX MODE of the LUMINANCE channel to MULTIPLY to make it easier to color the illumination and to control the channel's brightness.

By comparison, the settings for the highlight and the reflective properties are rather traditional, and can be seen in Figure 2.110. It will become interesting on the ILLUMINATION page since, contrary to the other materials,

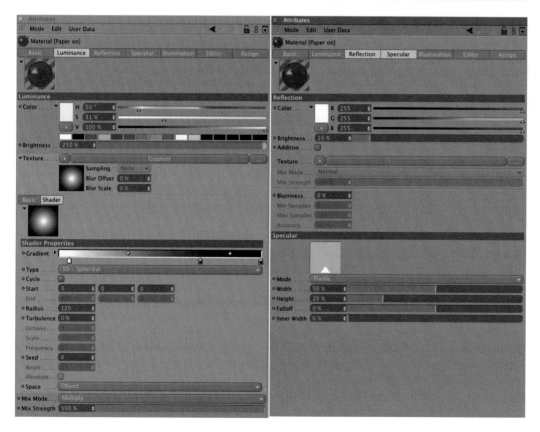

— Figure 2.110: Settings for the material of the paper walls.

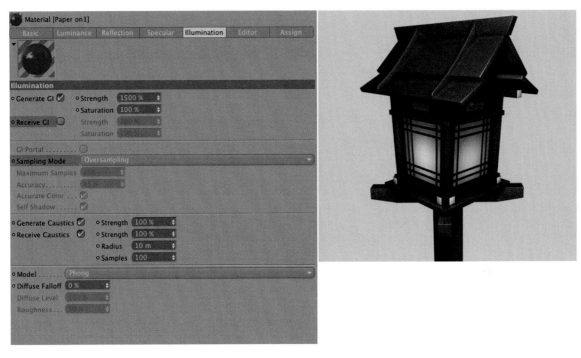

— Figure 2.111: Test rendering of the lantern.

we will activate only the generating properties regarding the global illumination. I've entered a relatively large STRENGTH value of 1500%, which was determined from test renderings.

As shown in Figure 2.111 OVERSAMPLING should be activated as SAMPLE MODE because this material will mainly be used to help illuminate the scene. The same figure also shows you the look of the lantern. I combined the two cubes that built the roof, made polygon selections for the faces on the bottom, and applied the red wood material to those selections. This is just a small detail that doesn't necessarily have to be done.

### THE FLICKERING OF THE TEA LIGHT

As previously mentioned, we used the GRADI-ENT shader in a special 3D mode so a spherical brightness gradient would be calculated. In order to make this appear realistic, the position of the gradient should change during the animation. The START vector in the dialog of the GRADIENT shader is responsible for this effect. It defines the center of the shader calculation. In order to not have to painstakingly animate this by hand, we will use a nice feature. By using the VIBRATE tag, CINEMA 4D is able to change objects in cycles or randomly, based on their position, rotation, or size.

### Random Vibration with XPresso

We will create a new NULL object from the OBJECTS menu, right click on it in the OBJECT MANAGER, and assign a VIBRATE tag from the CINEMA 4D TAGS list. In the VIBRATE tag select the ENABLE POSITION option and set the three AMPLITUDE numbers that define the maximum movement of the candlelight. As you can see in Figure 2.112, I decided to use 40 units each in the X and Z direction and 30 units along the Y axis. This defines the range of movement of the NULL object during the random position change. The FREQUENCY controls the

— Figure 2.112: Connecting parameter.

speed of the vibration and is measured in vibrations per second. A value of 2 should ensure that the brightness variations don't appear too hectic.

We will now get a random change of position of the Null object when the animation is played. If we transfer these position values to the START value of the GRADIENT shader, then the depiction of the candlelight on the paper walls could change realistically. We will achieve this with an expression that can be created with a right click on the Null object and by selecting CINEMA 4D TAGS > XPRESSO.

The XPRESSO EDITOR appears automatically. Pull the NULL object from the OBJECT MANAGER and the paper material from the MATERIAL MANAGER into the editor. Two function knots or *Nodes* are created that can be connected to each other. Note that the red side of the node represents the output and the blue side represents the input. First, click on the red area in the title bar of the Null object node and select POSITION from the menu. You

can find it under COORDINATES > POSITION. At the blue input of the material node select the START vector from the list of possible inputs. Figure 2.113 shows where to find it. The circular symbols that appear at the sides of the nodes are called *Ports*. By clicking on one of these ports and pulling with the mouse while holding down the button, you can make connections. Try it and create a connection between the two ports. The local position of the NULL object is now transferred to the START value of the shader. The XPRESSO EDITOR can now be closed since the desired connections between the objects and parameters were made.

Now when you calculate still images of the lantern at various moments during the animation, the paper material will look different every time. Figure 2.114 shows some test renderings that include global illumination and additional lighting by a SKY object. You can imagine how much more realistic and less static the lantern will look during an animation. We will leave our scene the way it is,

— Figure 2.113: Creating the expression.

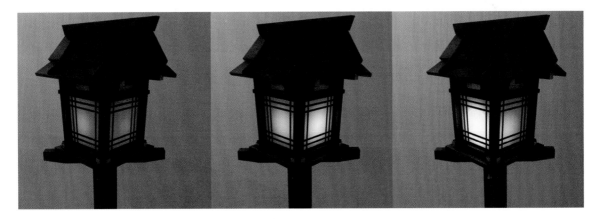

— Figure 2.114: Automatic variations of the illumination with the expression.

though, and combine the parts of the lantern, and also the NULL object, with the VIBRATE tag in a new NULL object. You can use the SELECT ALL function in the edit menu of the OBJECT MANAGER and then select GROUP OBJECTS in the OBJECTS menu of the OBJECT MANAGER. Then save the scene.

## Modeling the Stone Stairs

Since our scene depicts a climb up to an old temple, we need to model the missing stairs that will be illuminated from the previously modeled lanterns. These stairs should be made out of roughly chiseled stone blocks.

Important here is the variation of the stones so there is no visible repetition in the stairs.

We will start in the top view, the XZ view, by creating several stone profiles from spline curves for one step. I decided to use the AKIMA spline because it can generate rather tight radii and we don't have to bother with adjusting tangents. You can use another interpolation method if it suits you better. Figure 2.115 shows my complete step and how these splines, subordinated under an EXTRUDE NURBS object, generate a massive object. The length and width of the step shouldn't be too short. If the step ends up being too long, the ends can be cut or hidden later. The same is true for the extent of the

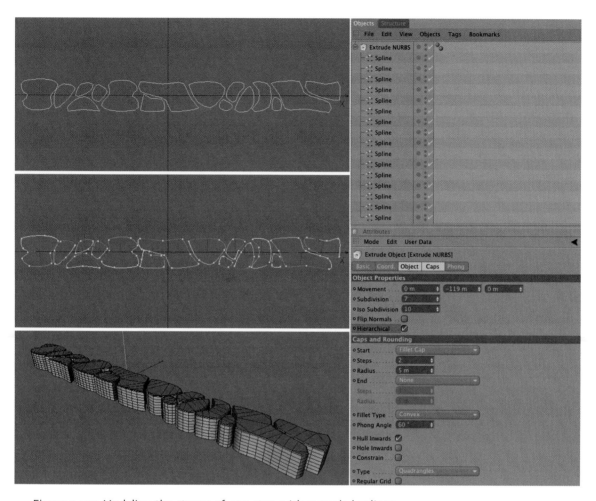

— Figure 2.115: Modeling the stones of one step with extruded splines.

extrusion. Make the step a bit higher than needed. In order to save some polygons, you only have to create a rounded cap for the top of the step, as shown in Figure 2.115. Make sure that at the Extrude NURBS the HIERARCHICAL option is activated so all splines are used. Increase the SUBDIVISION value to get additional faces at the sides of the stones. We will use them in a moment to further deform the stones.

**DEFORMING THE STEP INDIVIDUALLY**

If necessary, correct the gaps between the stone blocks so there are no large spaces and convert the Extrude NURBS with the (C)

key. Because of the hierarchical use of the splines by the Extrude NURBS, not just one POLYGON object is generated, but a group that contains a new Extrude NURBS object for each spline. Select all these Extrude NURBS objects and convert them with the (C) key. The now-converted objects still contain separate objects for the caps and roundings. After selecting all of these objects, with the use of FUNCTIONS>CONNECT, we will finally get a single POLYGON object. All other groups can be deleted. After that, use FUNCTIONS>OPTIMIZE and apply the standard settings by clicking on the OK button. The duplicate points located at the edges of the roundings and caps are then optimized and

combined as well. The object is finally ready for the first deformation.

Change to the Use Polygon Tool mode and choose the Rectangle Selection. In the dialog of the tool in the Attribute Manager deactivate the option Only Select Visible Elements and then pull a selection frame in the side viewport around all the polygons on the side of the stones. Figure 2.116 shows the resulting selection from different views.

In the Structure menu activate the Brush tool and set its mode to Smear. This represents the behavior of a smearing finger but is applied to geometries instead of paint. Reduce the Strength of the tool to 30% and adjust the Radius to the size of the stones so you can work more precisely. When the mouse is over the object, a circle indicates the area the tool is influencing. The brush is automatically restricted to the side faces and leaves the edge rounding and tread area unchanged. Use the brush tool in different viewports to make the sides of the stones look less monotone and straight. Figure 2.117 gives a hint of this process. After deselecting

— Figure 2.117: Using the brush for the deformation.

all faces you can use the tool on the treads as well; just be careful with the deformation. The steps shouldn't turn into a trip hazard, and since the caps of the stones consist of large triangles, too much deformation would generate strange shadows.

**ADDING SEVERAL STEPS**

Now it is time to generate several of these steps. Make a copy of the step and place it higher and further back, based on the first step. The stones of the step copy can't remain the way they are because the obvious repeat of the structure would negatively influence the overall look. Therefore, exchange the positions and orientation of the stone blocks so no two identical stones are placed in the same position within the span of two steps. Since we deal with combined objects within the steps, they can't simply be selected and moved. We have to switch to Use Polygon Tool mode, select a polygon of the stone to be moved, and then choose Select Connected in the Selection menu. All faces of the stone are automatically selected and can then be edited with the Move, Rotate, or Scale tool.

— Figure 2.116: Selection of the side faces.

— Figure 2.118: Modeling several stair steps.

Create six steps with different stone arrangements using this method. Figure 2.118 shows how they might look in the end. Note that the steps are overlapping slightly at the base. That way, slivers of light between the objects can be avoided. For each step add a large cube that is spanned across the whole width of the step. Scale the cube so that the stone blocks enter the cube at the front and tread sides. We will use this cube later to simulate the material between the stones. This could be dirt or cement, for example.

### ADDING GRASS

With such rough steps grass will inevitably grow between the stones. We will simulate that grass with the HAIR module. If you don't have this module available you can skip this step. We will start with adjusting small polygons to fit into the spaces between the stones, as shown in Figure 2.119. You could use a POLYGON object from OBJECTS>PRIMITIVE, convert it with the (C) key, and adjust its points. To extend this face you could use the KNIFE tool or EXTRUDE tool from the STRUCTURE menu. Make several copies of these objects and place them using your own judgment. Then select all of these single objects and combine them with FUNCTIONS>CONNECT into a single object.

### The Hair Object

At HAIR>ADD HAIR a so-called HAIR object is created that automatically creates GUIDES and hairs on the selected object. When only polygons are selected on the object, the growth of the GUIDES is restricted to these polygons. GUIDES are control paths whose tilt and course control the direction and length of

— Figure 2.119: Basic surfaces for the growth of grass between the stones.

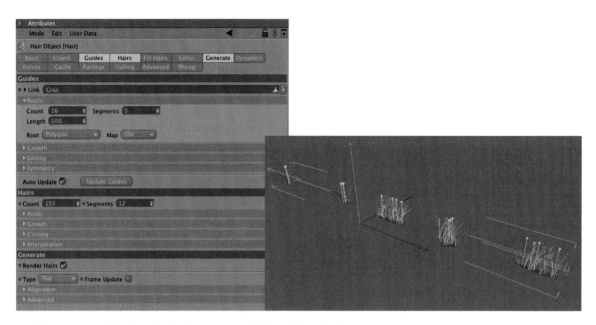

— Figure 2.120: Creating hair structures with the hair object.

the hairs. Many tools of the HAIR module exist to manipulate these GUIDES, such as a virtual brush, comb, and scissors. In our case, though, we don't have to worry about the guides. In the GUIDES part of the HAIR object dialog, set the LENGTH so that hairs are created that are in proportion to the steps. The SEGMENTS value indirectly determines the stiffness of the hairs that can be animated later. The fewer SEGMENTS the guides have, the less they react to the movement of the object on which the hairs grow, or to outer influences like gravitation. A value of 5 is enough so that the grass blades will not be too soft or flexible.

In the ROOT menu you can determine where the GUIDES are generated from. In the POLYGON setting the guides are automatically spread across the entire available surface of the applied object. In the HAIR section of the dialog, the COUNT value is interesting since it controls—as you might already know—the number of hairs generated during rendering. You shouldn't be bothered by the name *Hair*. Hairs can take on multiple shapes and can even be instances of objects. Hairs also have segments,

but they are more like the intermediate points of splines and therefore define the curve of the hairs during rendering. The more SEGMENTS that are used, the better the hair will look— especially longer hair—in the final output. However, this also uses more memory and causes longer render times. In our case we will not use hairs, but instead POLYGON objects that the HAIR object can generate as well. Take a look at the GENERATE section of the HAIR dialog that is also shown in Figure 2.120. In the TYPE menu you can pick the desired shape of the hair. FLAT means the generation of polygon strips, which is exactly what we need to depict blades of grass.

**The Hair Material**

The shape of the hairs is influenced by the mentioned GUIDES, which influence the physical behavior of the hairs and the general growth direction. An equally large influence on the look of the hair is the HAIR material. It is responsible for the coloring and a range of shapes that the hair can take on. The material controls the length variations, thickness,

curliness, and frizz of the strands of hairs. The use of these properties is activated at the BASIC page of the HAIR material, as shown in Figure 2.121. We will need the properties CLUMP, FRIZZ, and THICKNESS to give the growth of the grass enough variety. In the preview of the HAIR material you can see immediately the influence an activated option has on the hair growth. Playing with the settings is a must. As you can see in Figure 2.121, I worked with a THICKNESS at the ROOT of 2 units. The TIPS are tapered to 0.5 units.

The COLOR and SPECULAR settings have no influence on the display of the grass hairs since we don't work with standard hairs, but instead the FLAT type. We will take care of that later. The same is true for the ILLUMINA-TION settings of the HAIR material, as shown in Figure 2.122. These parameters are also only of interest with real hairs.

To solve the problem of the coloring, for the moment we can create a new material and set the desired grass color in the COLOR channel. Apply this material to the HAIR object. The original HAIR material remains as well, for controlling the shape of the hair. Figure 2.122 shows as an example the first step and how a test rendering of the grass clump could look. Now you could increase the COUNT of the grass blades in the HAIR object. You should also pull the faces on which the grass is growing lower so they are hidden by the cubes or stones of the steps.

In Figure 2.123 you can see the entire hierarchy of the stairs scene and what settings I applied for the number of grass blades. One thousand blades sounds like a lot, but they are balanced out by the many small clumps and the number of steps.

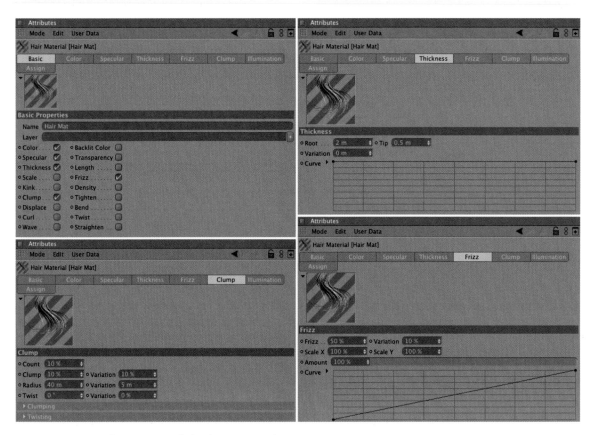

— Figure 2.121: The settings of the hair material.

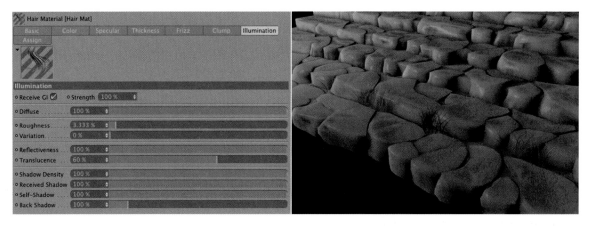

— Figure 2.122: Illumination settings of the hairs.

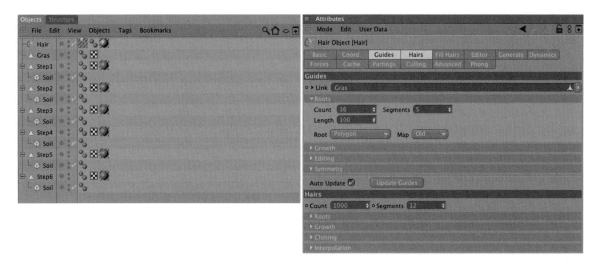

— Figure 2.123: The final settings for the hair object.

## The Polygon Hair Shader

We already encountered the problem of the color and highlight properties of the HAIR material applying only to real hairs, and not to special shapes like a polygon. For these cases you can use the POLYGON HAIR shader, which can be found in the normal list of shaders in the texture area of a material channel as well. Figure 2.124 gives you an idea of the dialog of this shader. I loaded the shader into the COLOR channel of the material we used to color the grass blades. If, like in this case, the option FROM HAIR MATERIALS

is activated, then the shader automatically uses the color values of the HAIR material. This is a good solution if you already defined a gradient in the HAIR material.

You could also click on the term COLOR next to the gradient of the HAIR material and, after a right click, select the COPY command. Figure 2.125 shows this step. That way, more complex information, like the color gradient between the shaders, can be exchanged. We will use this for exchanging the already made gradient from the HAIR material with the POLYGON HAIR shader. Before this is done the FROM HAIR MATERIALS option has to be

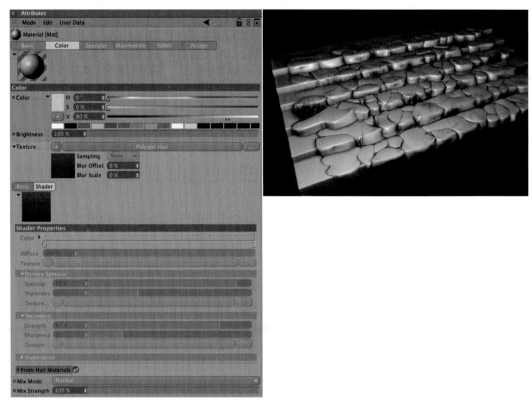

— Figure 2.124: The polygon hair shader.

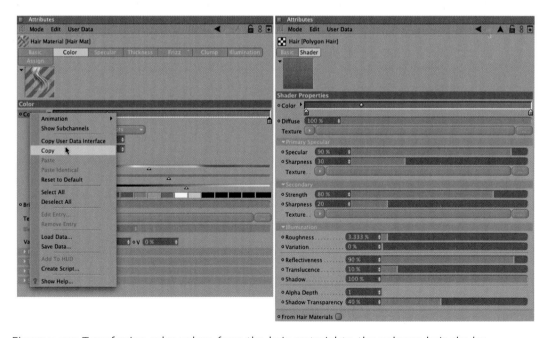

— Figure 2.125: Transferring color values from the hair material to the polygon hair shader.

deactivated. In return you gain access to several parameters for controlling the gloss properties.

To give the grass clumps more variety you should move forward, one frame at a time, in the animation. Use the (g) key several times to do so. You should be able to see how the grass blades are bending down because of gravity. If you go too far in the animation, use the (shift)+(g) keys to return to the beginning and the original position of the hairs. When you see a shape you like, use the (C) key to convert the object. You will get a normal POLYGON object that contains all grass blades. The HAIR material, including TEXTURE tag, can now be deleted since all information about the shape of the grass hairs is implemented in the POLYGON object. The coloring is now completely done by the POLYGON HAIR shader. The newly generated HAIR TANGENTS tag behind the converted hairs can also be deleted.

## The Materials for the Stairs

For texturing the stairs I will again use bitmap textures that I found at *www.cgtextures.com* in the categories *Ground* and *Stone/Rock*. You can download a certain number of textures every day free of charge or, for a small fee, get an unlimited download. Which texture to use for the materials of the stairs is up to you and isn't that important for the following steps. The image textures I have used can be found with the scenefiles. Many thanks to Marcel Vijfwinkel from www.cgtextures.com for letting me use them. The textures are subject to the licensing agreement of www.cgtextures.com, so take a look at the accompanying read-me file.

I like combining the loaded images with the FILTER shader in order to make quick color corrections or to change the brightness. Figure 2.126 shows an example of this method

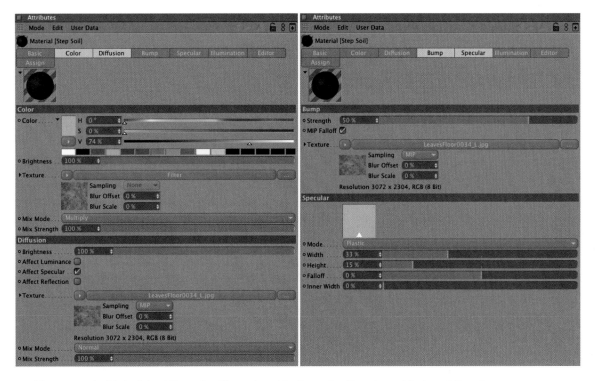

— Figure 2.126: Material settings for the cube objects under the stone blocks of the steps.

in the COLOR channel. This material is meant to be used for the large CUBE objects that run along the entire width of the steps and extend a bit on the left and right of them as well. These objects are intended to resemble forest soil covered with leaves. Because the image is too bright I also used the DIFFUSION channel. It will darken the material in an irregular manner. The image is used in the BUMP channel as well, but this will not necessarily result in a realistic roughness of the surface. However, this isn't always the goal. It is often more important that the BUMP and the used image in the COLOR channel are synchronized and that the structures relate to each other. All other settings in the material are pretty common and can be seen in Figure 2.126.

We can simply pull the material onto the cube, since it already has UV coordinates applied to it. This would cause a stretching of the material, though, which wouldn't fit to the structure of the image. Therefore, it is better to select CUBE mapping after applying the material, since it can be easily positioned with the visual aid in the USE TEXTURE AXIS TOOL mode. Figure 2.127 shows the described settings in the TEXTURE tag and the visual positioning aid in the editor. Use the MOVE and SCALE tools in USE TEXTURE AXIS TOOL mode to adjust the texture the way you want

it on the cube. You should also use a slightly different position for the texture projection on each step to avoid repetition. In the TEXTURE tag, the TILE option has to be active as well so the material covers the whole object, despite its small projection area.

### THE BASIC MATERIAL OF THE STONES

We will cover the stones with a more complex combination of three different materials that overlay each other with alpha parts. By using this technique, visible repetitions can be avoided. We will start with the basic material of the stones and create a new material. Here, too, I used a texture from www.cgtextures .com that was loaded into a FILTER shader in the COLOR channel. I reduced the opacity of this material, using a MIX STRENGTH value of 25%, and left a dark gray in the color settings as the dominant color.

As can be seen in Figure 2.128, I loaded the AMBIENT OCCLUSION shader from the EFFECTS group into the DIFFUSION channel as well. This will generate more contrast between the stones. The BUMP channel of this material will not use an image this time, but a custom-made pattern instead. We will begin by loading two NOISE shaders into a DISTORTER shader. Load the DISTORTER shader from the EFFECTS shader group into the BUMP channel and fill

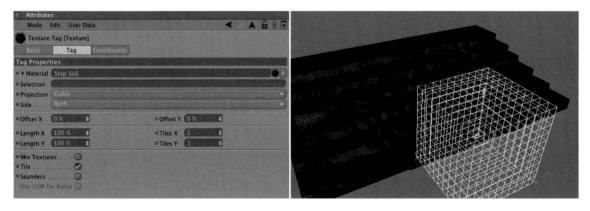

— Figure 2.127: Applying the floor material.

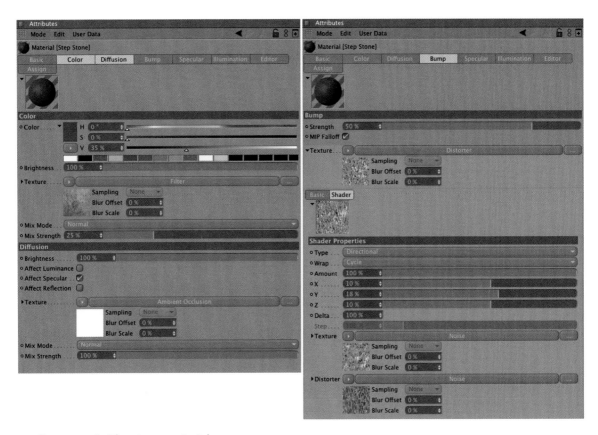

— Figure 2.128: The stone material.

the TEXTURE and DISTORT fields in these shaders with NOISE shaders, as shown in Figure 2.128 on the right.

The DISTORTER uses the brightness variations of the DISTORTION texture to distort the shader or image in the TEXTURE channel. You can control the amount of the distortion with the X, Y, and Z sliders as well as with the STRENGTH slider in the upper part of the dialog. There are also several distortion types available. I used the standard settings and slightly increased the distortion, only in the Y direction, to 18%.

You can see the settings I used for the two NOISE shaders in Figure 2.129. This is just one possibility and is not set in stone. The structures should only be stretched along the Y axis. The remaining settings and the choice of noise pattern were rather random.

The result of this distortion is a completely new pattern that received additional details and contrasts that didn't exist in the single shaders. Figure 2.130 shows a large image of the distorted shaders.

The SPECULAR and ILLUMINATION settings are again of a simple nature. The highlight is wide and flat, since the stones are not supposed to be wet or polished. For the shading model I used OREN-NAYAR since it is best suited for rough surfaces. Apply this material to the lowest step and select the CUBE mapping again as the projection method. In USE TEXTURE AXIS TOOL mode, adjust the size and position of the texture to your liking.

— Figure 2.129: On the left is the texture noise, on the right, the distortion noise.

— Figure 2.130: The distorted noise pattern.

Figure 2.131 shows a possible placement of the texture. Use the same principle with the remaining steps. Just remember to use a slight variation of the projection, such as a lateral movement of the projection cube.

## THE SECOND STONE MATERIAL

On top of the basic material that is mainly responsible for the roughness and color of the stones, we will place two additional materials to add some moss and dirt. Create a new material and load a texture into the COLOR channel that portrays a stone covered with moss. Here, too, I used AMBIENT OCCLUSION in the DIFFUSION channel. A more contrast-intense version of the image used in the COLOR channel is utilized in the BUMP channel. By using the ALPHA channel we will ensure that this material doesn't cover the basic stone completely. I used the CLOUD shader from the SURFACE shader group and reduced its gradient to grayscale. The level of the clouds is set to 35%, as shown in Figure 2.132.

The highlight is smaller this time, but we will use OREN-NAYAR here as well. The projection is comparable in its shape and size to the cube under the step. Figure 2.133 shows these settings. Remember to vary the texture

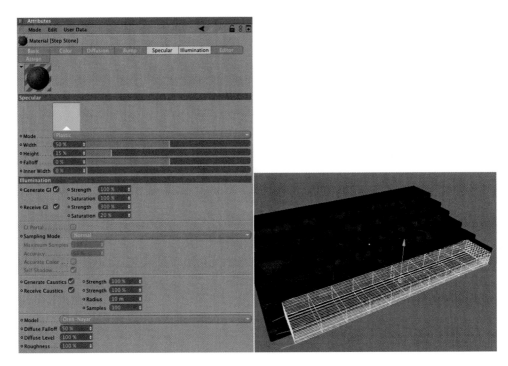

— Figure 2.131: More settings of the stone material.

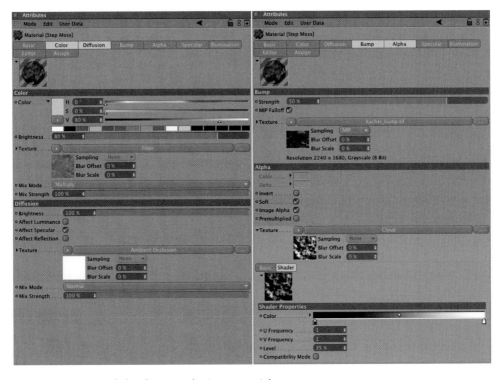

— Figure 2.132: Settings of the first overlaying material.

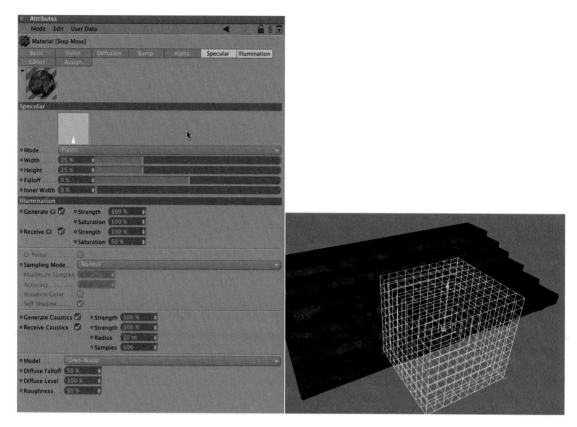

— Figure 2.133: More settings of the moss material.

projection by moving it, but don't restrict this to lateral movements only. The variation in Y direction is important, too, so the front edge of the step gets some variations as well.

### THE THIRD MATERIAL OF THE STONE STEPS

Again, create a new material. This will be the third material layer on the stones. I used the same image in the COLOR channel that was used with the large cubes under the steps. This should create a connection between the forest soil texture and the stone steps, as well as visually integrate them better. This time, in order to get a material layer that is not so influenced by the gaps between the stones, I did not use AMBIENT OCCLUSION in the DIFFUSION channel. I used the diffusion in this case only to control the

general material brightness. The image from the COLOR channel is also used in the BUMP channel so the surfaces don't look too smooth. Blending with the other two materials on the stones is achieved with the SIMPLE TURBULENCE shader in the ALPHA channel. This shader can be found in the SURFACE shader group. Figure 2.134 shows these settings. You can also use the NOISE shader and pick another suitable pattern. It is only important that there are enough differences from the CLOUDS shader, which was used in the other material, so that other areas are revealed.

This material also uses OREN-NAYAR as the shading model. It is again applied with a CUBE mapping and can be adjusted randomly to the size and shape of the stone steps. Figure 2.135 shows the current state of the scene. As you can see, all three materials are

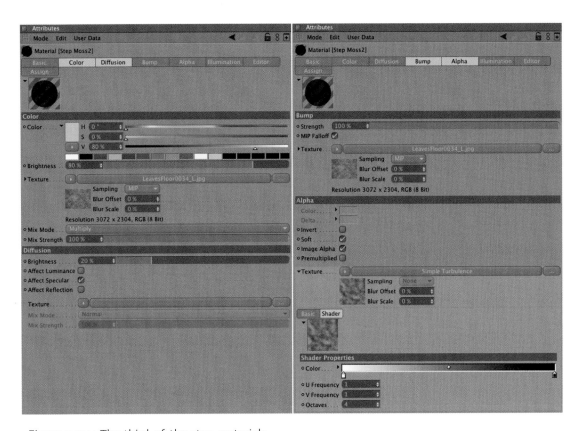

— Figure 2.134: The third of the step materials.

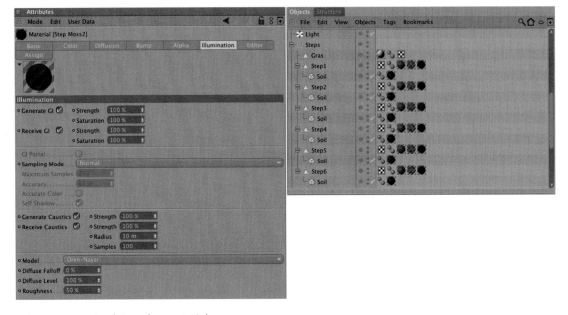

— Figure 2.135: Applying the materials.

— Figure 2.136: Test rendering of the steps.

— Figure 2.137: Extension of the stairs and adding a Bend object.

applied to the steps and are combined into one complex surface with their alpha parts. The only important part here is that the two materials with the alpha parts are positioned to the right of the massive stone material. You should also subordinate all the components of the six steps under a new NULL object so the scene is clearly arranged.

The first test rendering of the steps looks promising. As you can see in Figure 2.136, the stairs appear to be slightly weathered. In the following steps we will multiply these steps to build longer stairs and integrate the lanterns at the edge of the stairs.

## Putting the Scene Together

The main components of the scene are now available as textured models. We can now start to arrange the scene. We will start with the elongation of the stairs by adding copies of the stairs group that we previously modeled. As you can see in Figure 2.137, impressive-looking stairs can be created with just a few copies. Group these repositioned stair copies under a NULL object, as shown in Figure 2.137, and add a BEND object from the OBJECTS > DEFORMATION menu. Adjust its position so that the Y axis runs parallel to the ascending stairs.

The Y length should be about half the length of the stairs. The BEND object also belongs in the group with the copied steps because we will give the stairs a soft curvature as if the path leads us around a mountain.

As you can see in Figure 2.138 we will use the UNLIMITED mode so the bend affects all the stairs and not just the segment that lies within the BEND object. For the STRENGTH, I used an angle slightly under 50°, which was randomly chosen. Trust in your own sense for the image composition. It is only important that the first and last step of the stairs not be seen in the image, which will make the stairs appear to be longer.

To be sure that the bend and length of the stairs are correct, we should now determine the final camera position. Set up the perspective editor viewport to achieve a view like the one in Figure 2.139. Then add a CAMERA object from OBJECTS > SCENE > CAMERA and activate it by clicking on the symbol behind

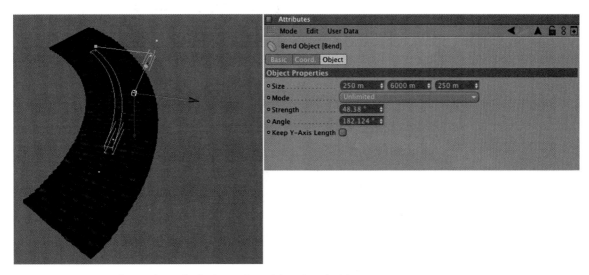

— Figure 2.138: Deformation of all the stairs with a Bend object.

— Figure 2.139: The bent stairs in the final camera perspective.

it in the OBJECT MANAGER. You can also select this camera in the CAMERAS menu of the perspective viewport under the entry SCENE CAMERAS. In any case, this activates the camera and will be used later for the final rendering. In the dialog of the camera in the ATTRIBUTE MANAGER, I decided to use a FOCAL LENGTH of 50. It could be necessary to move the camera away a bit from the stairs in order to restore the original distance and viewing angle. Use the navigation icons on the top right in the perspective viewport.

After activating the camera, these icons control its position and orientation.

## PLACING THE LANTERNS

The lanterns should be placed on the left and right of the stairs. In order to not create and place the lanterns manually, we will add two spline curves, with any interpolation, that will follow the course of the bent stairs along the left and right sides. Make sure that the distance between the spline and the

— Figure 2.140: Using a spline curve as a positioning aid for the lanterns.

stairs is constant, but small irregularities are allowed. Figure 2.140 shows the left of the two splines in two views. The height of the splines, based on the steps, is not so important. The spline can run slightly below or above them.

### The XRef Object

We don't simply merge the scene with the lantern. Instead, we will use the XREF object for that purpose. It can be found at OBJECTS>SCENE. The dialog of this object can be seen in Figure 2.141. The XREF can be compared to an Instance, but it has more possibilities. For example, it can be used to load a scene from another computer in the network. Also, scenes containing animations can be controlled. The XREF can even be used for the handling of materials. The advantage is that you don't have to work with copies of an object or scene. A change to the original data automatically updates all scenes that have access to this data over XREF. This is especially helpful with larger projects, when several people are working on different components of a scene. You could work and animate, using preliminary versions of the objects, without having to update everything manually

— Figure 2.141: The XRef dialog.

should a change in the material or on the object occur. In the dialog of the XREF object, use the button with the three dots behind the FILENAME field to select the CINEMA 4D scene with the lantern. The lantern then appears in the stairs scene. If there are any

errors in the XREF scene, then you can open the lantern scene with the EDIT SCENE button. With animated objects or expressions in the XREF scene, you should click on the TAKE ANIMATION button after loading the scene. This is the case with our scene, so therefore use the button after loading the lantern file. That way, you can influence the course of the animation, for example, to change the timing so the lanterns don't flicker all the same way. The buttons RELOAD SCENE and RELOAD ALL are only important if the XREF scene isn't saved on your computer. Otherwise, the XREF object updates itself automatically when changes occur in the referred scene.

With the settings in the PIVOT MATRIX, you can change the position and size of the XREF scene. If the lantern appears to be too small or too big in the stairs scene, then you can work with the SIZE values to correct that. In our scene it would be advisable to do this in the original file, since the paper material with its 3D gradient would have to be adjusted to the changed size as well. A scaling of the object wouldn't automatically scale the shader.

The INFO section of the XREF shows general information about the loaded scene. You can see the memory use and the number of included objects. Important here is the file setting for the frame rate of animated scenes. It should correspond with the settings in the scene where the XREF object is used. Otherwise, this could cause a slower or faster animation. The lists with the columns XREF O and XREF M show the objects and materials contained in the loaded file. You can pull a material from the XREF M list and apply it directly onto an object in the OBJECT MANAGER.

Select the XREF object and choose FUNCTIONS > DUPLICATE, as shown in Figure 2.142. Set the mode to ALONG SPLINE and pull the spline located on the left of the stairs into the SPLINE field of the DUPLICATE dialog. Use the APPLY button to generate the desired number of XREF copies. As long as the DUPLICATE tool is active, you can adjust the COPIES value to control the number of lanterns. I set the value so that at about every second step a lantern is placed. In order to control the orientation of the lanterns better, you can activate the ENABLE ROTATION

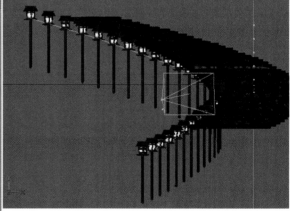

— Figure 2.142: Multiplying the XRef lanterns.

— Figure 2.143: Using the rail spline in the duplication.

option and pull the spline from the other side of the stairs into it. It will then be used as a so-called RAIL SPLINE for the alignment of one axis of the copies. Figure 2.143 shows the settings in the DUPLICATE tool dialog.

By selecting the ALIGN axis, you can align the copies to the second spline. It is only important that the courses of the two splines to the left and right of the stairs are the same. When you are happy with the result, pull the original XREF object into the new group with the XREF copies and then pull the group up or down until the lanterns reach the desired position along the edge of the stairs.

Use the same principle for the other side of the stairs. Create a manual copy of the XREF object and pull it from the group of the other XRefs to the uppermost level in the OBJECT MANAGER. Use the DUPLICATE command in the FUNCTIONS menu again for this XREF object. This time the splines just have to be switched. Pull the right spline of the stairs into the SPLINE field and the left spline into the RAIL SPLINE field. If necessary, adjust the number of generated copies in the dialog so the ratio of lanterns to the left and right is balanced. Then pull the original XREF object into the Null object group of the right XREF

copies and move this group as well, until the position of the lanterns is correct.

To loosen the rigid order of the lanterns, select all XREF objects in the scene with a selection frame in the OBJECT MANAGER. You could also select the uppermost NULL object of an XREF group and choose SELECT CHILDREN in the EDIT menu of the OBJECT MANAGER. Then deactivate the NULL object of this group again with a (Ctrl) click in the OBJECT MANAGER.

The variation of all these objects will now be achieved with the RANDOMIZE tool from the FUNCTIONS menu, as shown in Figure 2.144. This tool offers several settings for the maximum movement, scale change, and angle variation of the selected objects. I decided to use a maximum of 40 units along the Y direction as the MOVE value and a rotation of 10° around the H axis as the ROTATE value. The latter value is entered into the first field since angle vectors in CINEMA 4D are not seen as rotations around the X, Y, and Z axes, but instead as vectors H, B, and P. This should result in a random rotation of the lanterns around their Y axes. The result can be seen on the right in Figure 2.144.

In order to get a more randomized lighting of the lanterns, select the XREF lanterns one by one and vary the SCENE TIME so that all lanterns are loaded into the scene with a different SCENE TIME. This will affect our XPresso and Vibrate expression in the original scene of the lanterns and cause different settings for the 3D gradient in the paper material of each lantern. As explained earlier, the TAKE ANIMATION button has to be pressed for the randomization to take effect. If you have done this already, as described in the first XREF scene, then the XREF duplicates have assumed this information.

**ADDING A GREEN HILL**

The scene still looks unnatural, and lacks some vegetation. We are outdoors, after all, and I'd like to have the stairs merge, on the left side of the scene, into a mountainside

— Figure 2.144: The aligned and positioned lanterns.

covered with ivy. Add a new CUBE primitive and place it to the left of the stairs. Create a copy of the BEND object from the stair steps group and subordinate it under the cube. After increasing the segments of the cube along the stairs and enlarging the cube in this direction, the result could look like that shown in Figure 2.145. The cube became a wall that runs parallel to the stairs.

This rectangular wall profile doesn't look much like a realistic mountainside yet. Select the CUBE and use FUNCTIONS>CURRENT STATE TO OBJECT. The deformation of the BEND object is then transferred permanently to a POLYGON object copy of the cube. The original CUBE object, including the BEND deformer, can then be deleted. Use the MOVE tool or the BRUSH tool, which we previously used with the steps, to reshape the cube so it looks more like a mountain, at least through the view of the camera. Figure 2.146 shows different views of this object. You can also

— Figure 2.145: Using a bent cube as the scene border.

— Figure 2.146: Converting and triangulating the cube.

see that I changed the structure of the cube. This is necessary since we will edit this object in another program that can only handle triangular faces. Therefore, all quadrangles have to be exchanged with two triangles. Don't worry, because there is the TRIANGULATE tool in the FUNCTIONS menu that will do the job for us.

The deformed and triangulated cube now has to be saved as an OBJ file. The best way to do this is to use the COPY command in the EDIT menu of the OBJECT MANAGER and select FILE>NEW in the CINEMA 4D layout. Then, using PASTE in the EDIT menu, put the object into a new, empty scene. Now you can save the object with FILE>EXPORT>WAVEFRONT as an OBJ file.

### The Ivy Generator of Thomas Luft

The modeling of organic shapes like plants and trees can take a lot of time. There are many special solutions for this kind of object. You can use already-modeled trees and bushes, or so-called plug-ins, or independent programs specialize in the generation of such 3D objects. A very useful program in

this category is the IVY GENERATOR by Thomas Luft. This program enables you to grow ivy on any geometry with the push of a button. Many parameters for adjusting the size and density of the leaves are available and make this free program indispensable. The current versions for Linux, Windows, and MacOS X can be found at *http://graphics.uni-konstanz .de/~luft/ivy_generator/*. The software works correctly only with triangles. In addition, all polygon normals should point outward. This is automatically the case with our converted cube. The objects should have a simple geometry so the calculations of the IVY GENERATOR can be completed faster. The program has to do several collision calculations of the plants, thus the simpler the geometries are, the more precise these calculations will be.

With the program open, use the IMPORT OBJ + MTL button to load our deformed cube geometry. You can find this button in the SCENE area of the program, as shown in Figure 2.147. Use the left mouse button to rotate the 3D view. By holding the (Shift) key at the same time, you can rotate around the center of the viewport. The left mouse button can be used in combination with the (Ctrl) key to

— Figure 2.147: The imported cube in the Ivy Generator.

move the view. Additional information about the use of the program and the functions of its parameter can be found in the read-me file accompanying the software.

The starting point for the growth of the ivy tendril is set with a double click on the loaded geometry in the 3D view of the IVY GENERATOR. You can see the point marked in green in Figure 2.148. With a click on the GROWTH button in the GROWING part of the dialog, the growth of the tendrils is started. They are calculated based on the settings on the GROWING page. This is not yet the actual geometry of the tendrils, but the growth paths of the tendrils. When the desired complexity and expansion of the plant is reached, click on the GROW button again to stop the calculation. Figure 2.149 shows a possible result. If you don't like your result, just change the parameters and double click on the model again to create a new starting point for the calculation, then click again on the GROW button.

When you have achieved a course of the tendrils you like, change to the BIRTH page of the dialog and define the profile of the tendrils and the size and the density of the leaves. Keep in mind that we might need to use several ivy plants in the scene, so don't overdo it with the density of the leaves. Also, try to get the size of the leaves to be in proportion with the size of the mountainside, which can be used to estimate the scale in our scene.

You can experiment with the settings without having to recalculate the tendrils every time. A click on the BIRTH button uses the existing tendrils for the changed BIRTH settings. Figure 2.150 shows a possible result for the virtual ivy.

The only thing left to do here is use the EXPORT OBJ + MTL button in the SCENE part of the dialog to save the 3D geometry of the ivy. Figure 2.151 shows this final step. The OBJ format can be opened again in CINEMA 4D without any problems. If you like,

— Figure 2.148: Settings for the growth of the ivy.

— Figure 2.149: Finished growth of the ivy tendrils.

— Figure 2.150: Settings for the number and size of the leaves and tendrils.

— Figure 2.151: Exporting the 3D geometry.

you can generate and save many different ivy plants for our mountainside. Then later you will have a choice of several different plants and can pick the best one.

## CREATING THE ENVIRONMENT OF THE SCENE

Use FILE>MERGE to load the OBJ file with the ivy into the stairs scene of CINEMA 4D. The loaded image should be the right size and at the right location in the scene. If that is not the case, check the settings at EDIT> PREFERENCES>IMPORT/EXPORT for loading and saving Wavefront files. Both values should be identical. If necessary, scale the new objects manually and move them to the correct position.

The ivy should already contain POLYGON selections, which will make it easier to apply materials to the leaves and tendrils. You can create your own leaf texture or use the leaf

textures offered at *http://graphics.uni-konstanz .de/~luft/ivy_generator/*. The creator of these textures is Tim Ellis. These materials contain color bitmaps, NORMAL, and ALPHA maps. Figure 2.152 shows how you can use these images in the leaf material.

### Texturing the Ivy

The color texture belongs of course in the COLOR channel, where the coloring of the leaf can be adjusted with the FILTER shader. The NORMAL image goes into the NORMAL channel and will simulate fine leaf structures. The alpha image will be loaded into the ALPHA channel of the material. Make sure that the INVERT option is checked, since the material system of CINEMA 4D works with the opposite brightness of the texture being used.

Because the leaves are very small in comparison to the overall scene, the GENERATE GI

— Figure 2.152: Material settings for the ivy leaf.

— Figure 2.153: Illumination settings of the leaf material.

— Figure 2.154: Step-by-step vegetating of the scene with copies of the ivy object.

option on the Illumination page can be deactivated to save some render time. As shown in Figure 2.153, we will leave the rest of the standard settings as is.

The material of the tendrils is created in the same way. These textures can be found at the aforementioned website as well. Only the Alpha channel is not needed.

As you can see in the series of images in Figure 2.154, ivy can be used not only for a floor covering but also for the simulation of bushes and trees when they are far enough from the camera. In our example, I simply created copies of the textured Ivy object and rotated them by 90° so the tendrils reach toward the sky, resulting in a simple tree. These ivy copies are placed to the right side of the stairs and moved backward, based on the camera's view.

We shouldn't forget the MountainSide object. We will use the same forest soil material that was applied to the large cubes under the stairs. Since we have different proportions here, the texture should be repeated several times on the surface. As you can see in Figure 2.155, you have to increase the tile X and

tile Y values evenly until the right texture size on the object is reached. We have to use the UVW Mapping in the Projection settings because the cube was deformed by the Bend object. Cube mapping could cause, in extreme cases, a distortion of the texture.

**The Sky in the Scene**

I would like to use a photo as the sky, one that I created by stitching together a series of shots of the evening sky. This panorama is

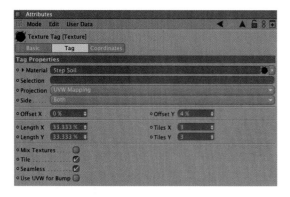

— Figure 2.155: Texture tag of the mountain side.

going to illuminate the scene as well as be a visible background. The corresponding image can be seen in Figure 2.156.

First, create a PLANE object from OBJECTS> PRIMITIVE. Then create a new material and load the sky image into the LUMINANCE channel. All other channels can be left deactivated. The calculation of highlights in the sky would look funny. In the LUMINANCE channel you can see the resolution of the bitmap after it is loaded. Transfer these values to the size of the PLANE object. In our case, this means a width of 5896 and a height of 1195 units. This ensures that the texture will be displayed without distortion on the object and that the ratio is correct. The plane can be adjusted to the proportion of our scene by scaling it evenly. In the ILLUMINATION settings, change the STRENGTH value for GENERATE GI to 500%, since the image is quite dark and we still want some illuminative effect in the scene. RECEIVE GI can be deactivated because

the sky doesn't have to be lit. We will use OVERSAMPLING as the sampling mode since it calculates quickly, although not as precisely as other methods in this menu.

As shown in Figure 2.157, pull the material onto the SKY plane and place it in the scene so the desired section of the sky texture is captured by the camera. I decided to use the clouds that are lit from behind by the setting sun. Don't worry if the plane doesn't cover the entire background of the scene. As you can see on the left of Figure 2.157, the right side can remain open. This area will simply be calculated in black. Since we will render an evening scene, it shouldn't affect the overall mood. You should now subordinate a BEND object under the PLANE object and rotate the BEND object so its Y axis points to the left and right side of the scene. With this BEND object you can bend the plane, as shown on the right of Figure 2.157. This is an advantage for the global illumination of this plane, since the light will enter the scene in a natural way from different directions.

As can be seen in Figure 2.158, I applied a COMPOSITING tag to the SKY plane with deactivated CAST SHADOWS and RECEIVE SHADOWS options. If we use light sources with cast shadows later, this will prevent any interaction of the sky with these shadows. The COMPOSITING tag is created with a right click on the SKY object and the selection of CINEMA 4D TAGS>COMPOSITING.

Since the global illumination works best within a limited area, we will add a SPHERE primitive and scale it so the camera and the stairs, including the ivy objects, fit within it.

— Figure 2.156: The sky panorama.

— Figure 2.157: Placing the Sky object.

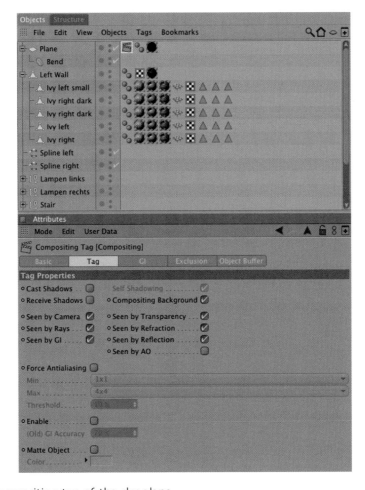

— Figure 2.158: Compositing tag of the sky plane.

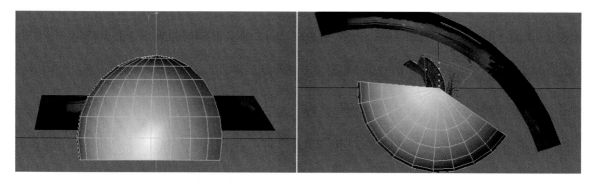

— Figure 2.159: Adding a reflector for the scattering.

Then convert this sphere with the (C) key to a POLYGON object and change to USE POINT TOOL mode. Select and delete some points so that a shape like the one shown in Figure 2.159 is created. This object is now used as a reflector for the light beams that will be sent into the scene by the sky. Because of this geometry the light beams aren't lost, but are, when the diffuse depth is set large enough, reflected to the stairs and the lanterns.

**Simulating the Sun**

A general problem of global illumination is that it is often difficult to generate highlights. This can only be prevented by using high-resolution HDR images. In our case, we receive the illumination exclusively from a rather dark 24-bit image and some illuminating faces of the lanterns. Therefore, I added a normal POINT light to the scene and placed it where the stairs leave the image on the top left. The right side of Figure 2.160 shows a view of the scene from the position of the new light source, to give you a better idea of its location. I will give the light an intense orange color, 100% intensity, and no shadow. I also deactivated the options for DIFFUSE and GI ILLUMINATION. Only the SPECULAR option stays active so this property can be added to the scene. As you can see in Figure 2.160 I also subordinated a DISC primitive, under the light source, which also receives a material with an intense orange color. The disc

should be oriented with its surface facing the scene and should have a COMPOSITING tag with deactivated SHADOW options applied to it. I also activated the COMPOSITING BACKGROUND option so no shading appears on the disc. The disc has to be positioned slightly behind the light source so it doesn't cover the light. The purpose of this object is to act as the reflection of the sun onto our reflective objects. The lacquered materials of the lanterns will benefit nicely from that.

**Defining the Depth of Field**

Scenes like this can benefit from a slightly blurry background. It gives the image more realism and depth when this effect is used in a subtle way. Select the CAMERA object in our scene and take a look at the DEPTH section of the dialog in the ATTRIBUTE MANAGER. The TARGET DISTANCE defines the area in front of the camera that is supposed to be sharp. With REAR BLUR active, the START and END values define the area behind the TARGET DISTANCE where the blurriness is slowly increased. With the distance TARGET DISTANCE + END, the blurriness is at its maximum. Since all this is a bit abstract, there are additional handlers and guides for this effect in the editor viewports. In Figure 2.161 they are pointed out by arrows. You can see that the image remains sharp up to the first step and then becomes blurry toward the end of the stairs.

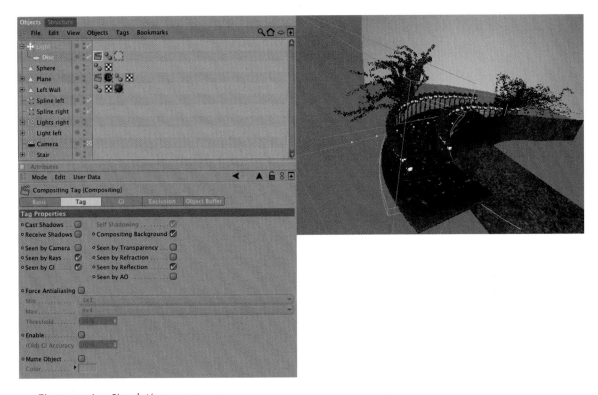

— Figure 2.160: Simulating a sun.

— Figure 2.161: Setting the depth of field of the camera.

## Rendering and Saving the Scene

Now we get to the RENDER SETTINGS. Generally, it is beneficial for the postproduction process if you save the images with multiple passes. Only then can fast corrections be made to the shadows, the sharpness of reflections, the depth of field, or the intensity of the global illumination without having to render the image all over again. Therefore,

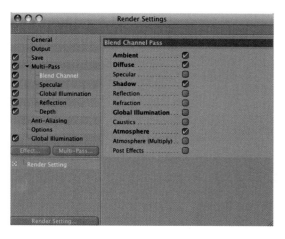

— Figure 2.162: The render settings of the scene.

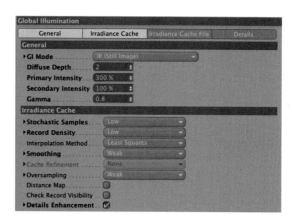

— Figure 2.163: Settings for global illumination.

I will add through the Multi-Pass button the channels Blend Channel, Specular, Global Illumination, Reflection, and Depth. As you can see in Figure 2.162, I activated in Blend Channel all image properties that aren't covered by the other Multi-Passes. That way, we can mix components with the image and adjust them to our liking.

In the Save settings, define the file path and the file format. The Photoshop or BodyPaint 3D format is generally used since they can handle multiple layers and apply the correct layer settings to put the image together again from single passes.

## THE GLOBAL ILLUMINATION SETTINGS

As for the global illumination, I decided to use the IR mode since our sky doesn't enclose the entire scene and the Sky Sampler wouldn't be precise enough. A diffuse depth of 2 should be sufficient to create enough diffuse samples. I increased the Primary Intensity to 300% so the scene doesn't end up too dark. This is a result of my test renderings. The Gamma value, on the other hand, was lowered to less than 1 so I could achieve more image contrast. Otherwise, my stairs would have

become too bright and would not have enough contrast.

As you can see in Figure 2.163, I used generally low and weak settings for the GI. This helps to reduce the render time and gives us good results with our scene. As a counterbalance, though, I activated the Details Enhancement option so I don't lose too many details of the image.

After some color corrections and blurring of the depth of field, the result looks like that in Figure 2.164. The lighting mood is of course heavily influenced by the environment. You could remove the fake sun, the reflector sphere, and the bent sky plane again and use the Sky object exclusively. Figure 2.165 shows a possible result with the exclusive use of the Sky object for the illumination and depiction of the sky.

### Using the Sky Object for the Lighting

In daytime situations you have to remember to modify the material for the illuminating paper of the lanterns. I deactivated the Luminance channel completely and activated the Color channel again. Also, the Sample Mode in the Illumination settings has to be set back to Normal.

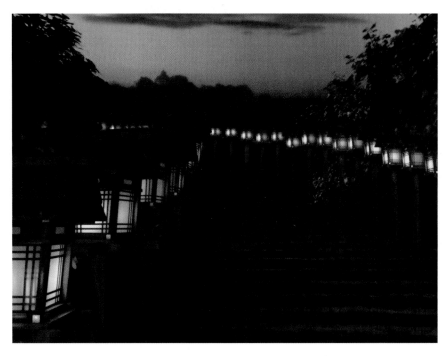

— Figure 2.164: The finished evening mood image.

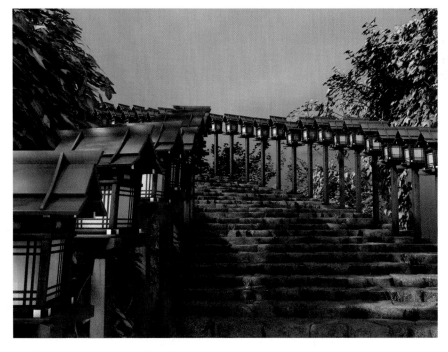

— Figure 2.165: Illumination by the Sky object.

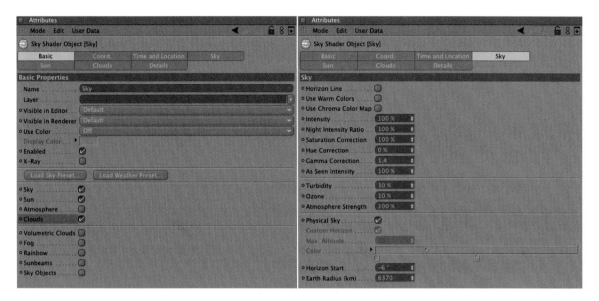

— Figure 2.166: Settings of the Sky object.

In the SKY object itself, simply set the time and watch how the position of the sun and the illumination change in the editor. To have the sky consist of something other than a gradient, you can activate the CLOUDS option in the BASIC settings, as shown in Figure 2.166.

It is important for our scene that the horizon, the spot where the cloud cover ends, isn't visible in the image. Otherwise, it would be obvious that we don't have a floor in our scene. Therefore, we need to pretend to be at a higher elevation, such as on top of a mountain, and move the value for the HORIZON START in the SKY section slightly into the negative range. Figure 2.166 shows this value on the right side.

The shape and density of the clouds themselves are defined in the CLOUD section of the SKY object. There are six layers that can be filled with different NOISE patterns. These patterns should look familiar to you since they are also used in the NOISE shader. The individual layers can be assigned to separate heights and moved separately during an animation to simulate wind. As you can see in Figure 2.167, I kept the standard settings for a sparse cloud

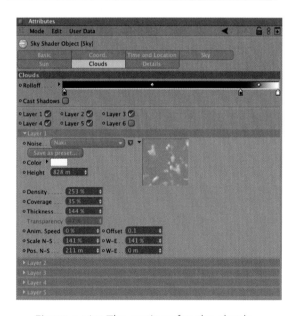

— Figure 2.167: The settings for the clouds.

cover, indicating nice weather, and changed the gradient for the ROLLOFF instead. This can be found in the top of the dialog. This gradient ensures that the noise structure of the clouds is turned off close to the horizon and is replaced by the color of the clouds. The

transition to the horizon disappears and is replaced by a sort of colored fog, which looks more natural. When the brightness is moved closer to the left side of the gradient, this blending starts earlier, at a greater distance from the horizon. I like that look and used it to end the clouds earlier and blend them into a fog. You can see, in Figure 2.168, another lighting mood that was calculated with an even lower sunset by the SKY object.

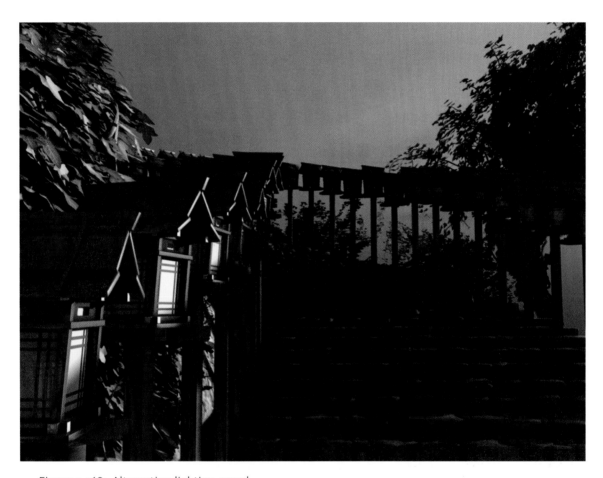

— Figure 2.168: Alternative lighting mood.

# Animation Techniques

There are different techniques and modules available in CINEMA 4D for animation, the output of movies, the movement of 3D objects, and the change of parameters over time. The base module offers a variety of animation possibilities, and special solutions expand this functionality, such as PyroCluster for the generation of smoke and fire, ThinkingParticles for particle effects, Dynamics for collision recognition and other physical behaviors, and MoGraph for abstract animations in motion graphics.

Basically, there are two types of animations: simulations and keyframe animations. Simulations don't need any keyframes since force fields affect the objects there. Keyframes, on the other hand, are manually determined conditions of parameters and objects. Keyframes, or keys, can contain any values. They can be responsible for a color change as well as for the rotation of an object.

## Basic Settings of a Scene

When you create a scene with the goal of creating an animation later, you should decide early on what the frame rate should be. The frame rate defines the number of images used for one second of film. This value can't be randomly chosen, but depends directly on the medium in which the movie will be shown. Feature films use 24 images per second, Pal movies 25, and NTSC videos 30. The rules aren't as rigid when using computers or the Internet to play back movies. Keep in mind, though, that every additional image per second enables the movie to play smoother, while at the same time, the processor power needed to decode and play the movie, as well as the memory used for the entire movie, increases.

The early determination of a frame rate is so important because the keyframes are aligned with certain images in the animation and therefore define the speed of a movement. However, this only makes sense, for example, if you know that 25 images represent one second. If the animating was started using a wrong frame rate, it is quite time consuming to move the already placed keys to new positions. Therefore, open the PROJECT SETTINGS in the EDIT menu of CINEMA 4D as early as possible and check the value for the frame rate. Figure 3.1 shows the dialog. The other settings are not as important since they can be changed at any time.

When this value is set, check the playback behavior of the animations in the editor. It cannot always be guaranteed with complex animations that 25 images per real second are actually being shown, but generally you should use the same frame rate value in the editor as in the PROJECT SETTINGS.

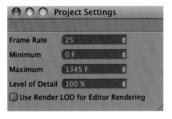

— Figure 3.1: Project settings.

— Figure 3.2: Settings for the playback behavior of animations in the editor.

Click on the document symbol with the film strip, under the editor viewports, as shown in Figure 3.2. A context menu opens, as seen in the figure as well. The option ALL FRAMES ensures that all images are shown when the animation plays. This could mean that the animation plays much longer than the rendered version, but you won't miss any part of the animation. When the option is deactivated, CINEMA 4D follows the default and plays one second of animation during one second of time. This could cause some *Drop Frames*, the skipping of some images. The advantage of this faster playback is that the timing of the animation can be better evaluated. With an active DOCUMENT option, CINEMA 4D uses the settings in PROJECT SET-TINGS as the basis for the number of images per second. This option would be best as the standard setting. You can also deactivate this option and determine a frame rate from the list in the lower part of the context menu.

The third element of this chain of frame rate values is located in the RENDER SETTINGS. You can determine the FRAME RATE on the

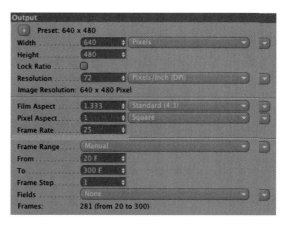

— Figure 3.3: Frame rate in the render settings.

OUTPUT page that is used to render the animation. For example, if the PROJECT SETTINGS is set to 25 images per second and the RENDER SETTINGS to 50 frames per second, then the animation will play with half the speed. Generally, you should make sure that both use the same rate. Figure 3.3 shows the corresponding setting in the RENDER SETTINGS.

# The Animation Palette and the Editing of Animations

A basic requirement for the creation of an animation is an overview of the necessary amount of time and the possibility to move within that time. For this purpose, in the area between the editor viewports and the MATERIAL MANAGER you can find several functions for navigating within the animation, playing the animation, and also recording keyframes. Figure 3.4 shows these functions in detail. The timeline ruler (1) shows a section of the total number of available images. The numbers of the first and last image in the timeline ruler can be set in the fields (2 and 3). These minimum and maximum numbers regulate how much space you have available for the animation. If you enter a 0 in field #2 and a value of 100 in field #3, then you have a total of 101 images available. At a frame rate of 25 images per second, this would be four seconds. These values can be changed anytime, even if you already started setting keyframes.

The powerslider (4) controls which part of the animation can be seen in the timeline ruler (1). This powerslider can be scaled by pulling on its ends. This results in a zoom to a certain time section of the animation. The movement of the entire powerslider to the left or right allows you to see earlier or later sections of the timeline ruler.

The actual moment where the animation currently resides is shown by the green cube (5) and by a numerical value (6). You can also enter an image number to which you want to jump.

In the area marked with the letter A in Figure 3.4, you will find the functions for playing the animation forward and backward within the editor. You can also move image by image within the animation or jump to the beginning or end of the animation. The icons shown in area B can generate keyframes. The symbol with the key within the red circle activates the recording of keyframes. The type of keyframe is set with the icons in area C in Figure 3.4. So if you would like to record the position of an object in the animation, deactivate all symbols in this group (C) except the one for movement, then click on the record button with the key in group B. The icons in group C can be combined by clicking on them. You should only activate the symbols that you want to animate, though. Otherwise, the clarity and playback speed suffer. The loudspeaker symbol (D) activates the playback of loaded sound tracks when the animation is played. The loading of such sound tracks, which we will discuss later, must be done in the timeline. You already know the button at the letter E. Besides the general settings for the frame rate, you can also find here settings for the interpolation between the keyframes. The standard setting is a spline interpolation

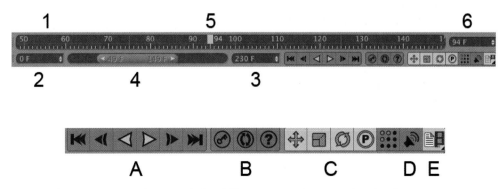

— Figure 3.4: The animation palette and the different icons for recording keyframes.

that generates a soft transition between values of neighboring keys as well as an automatic ease-in and ease-out behavior. For an object that moves from point A to point B, it will cause the object to start slowly, then speed up, and slow down again before the ending position is reached.

## Parameter Keyframes

Perhaps you already noticed the circles in front of the parameters in the ATTRIBUTE MANAGER. These can be used to create keyframes and animate these parameters. Figure 3.5 makes this clear, using the example of a SPHERE primitive. In order to enlarge the sphere during an animation, the RADIUS value of the sphere has to be animated in the ATTRIBUTE MANAGER. First, jump to the point in time where the change is supposed to start, then make a (Ctrl) click on the circle in front of the RADIUS parameter. The result can be seen in the middle of Figure 3.5. The circle is now solid red, indicating that at the current point in time, a keyframe exists for this parameter. When you move back in time, the circle changes its appearance to having a red border. This means that the parameter has keyframes assigned to it, but at the current point in time there is no keyframe. Move the time slider manually, or by entering a value, to the end of the animation and change the RADIUS value so the sphere is enlarged. This change has to be made permanent by setting a new key, so make a (Ctrl) click onto the circle. The animation is now

complete and can be viewed by using the play button.

## Editing Keyframes

The generated keyframes are not always placed correctly. Maybe you used the wrong values for the keyframes or later want to change the distance between the keys to make the animation run faster or slower. In these cases take a look at the timeline ruler. Keyframes are shown there as blue squares, as seen on the upper left side of Figure 3.6. With a click on such a square, the keyframe can be selected, causing the square to change its color. Now you can see and edit the settings of this key in the ATTRIBUTE MANAGER. This is shown on the right side of Figure 3.6. There you can see the KEY TIME and the KEY VALUE, as well as the INTERPOLATION, which is used for the calculation of changes between neighboring keyframes.

If an animation needs to be scaled or moved, then multiple keys can be selected in the timeline ruler. Simply select the necessary keys by creating a frame selection with the mouse in the lower part of the timeline ruler. Figure 3.7 shows this highlighted selection on the top left. By clicking and holding the mouse button in the highlighted area the keyframes can be moved together to make the animation occur at an earlier or later time.

At the ends of the selection strip there are small handlers, marked by arrows in Figure 3.7. By pulling on these ends, the enclosed animation

— Figure 3.5: Creating parametric keyframes.

— Figure 3.6: Editing keyframes in the timeline ruler.

— Figure 3.7: Editing multiple keyframes.

can be lengthened or shortened. The animation will then be slower or faster, since the distances between the keyframes change. This can be even more precise when the selection strip is fitted exactly to the enclosed keys. Hold the (Shift) key and pull the handler of the selection in the direction of the next enclosed key. The selection strip will then snap to it. The result, after snapping the two handlers to the keys, is shown on the bottom left of Figure 3.7. The (Shift) key can also be used to move the selection strip without moving the enclosed keys.

A right click on the selection opens a context menu that can be seen in Figure 3.7 as well. There you can find the common commands for DELETE, COPY, and PASTE of keyframes. For the copying of keyframes it is enough to just hold the (Ctrl) key and pull the keys with the mouse. Simple animations can be easily handled with this method. You can

move the keyframes, change their value, or delete them. Complex animations would get too confusing, though. The TIMELINE is better suited for this task.

## The Timeline

The TIMELINE can be found in the WINDOW menu of CINEMA 4D or in the ANIMATION layout, which is better suited for working on a computer with just one monitor. The switch between layouts can be done in WINDOW> LAYOUT.

The TIMELINE combines the display of materials, tags, and objects with the display of keyframes and their interpolation curves. That way, you get a complete overview of

the animation of your scene. Figure 3.8 shows an example of the TIMELINE in an animated scene. In the following section I will refer to the number labels used in the figure.

As you can see at number 1 on the top left, there is a listing of all the elements of your scene, whether they are animated or not. When properties have keyframes assigned to them that contain vector information such as position, rotation, or size, they can be displayed separately. You can see this in the figure at number 2. There, the animation of the position of an object was expanded. The single components for the X, Y, and Z parts of the movement can be edited separately. This

also shows the interpolation curves in the right part of the timeline, which are shown beneath the keyframes, and the graphical depiction of the value change between keys.

This display only exists where an interpolation is used. At number 3 you can see keyframes for the visibility of an object when it is in the editor and during rendering. This property of the object has only three settings that can't be blended into each other. The object can only be visible or invisible; therefore, there are no interpolation curves shown.

The icons at number 4 of Figure 3.8 allow you to switch between different layouts of the TIMELINE and activate special filters and

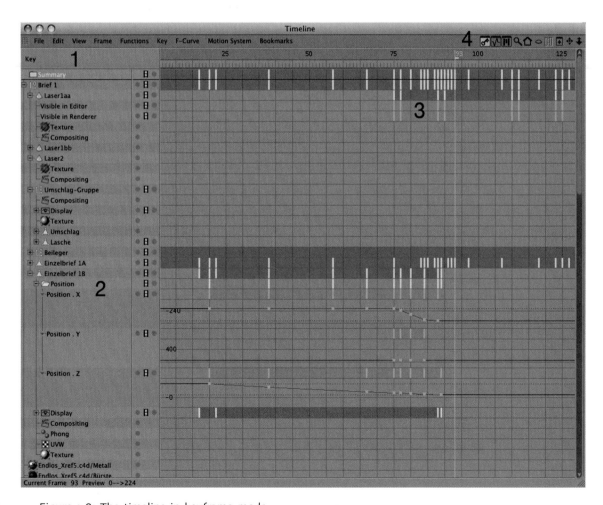

— Figure 3.8: The timeline in keyframe mode.

searches. The icons to the very right can be used for the movement and scaling of the TIMELINE content.

## Display Options

The TIMELINE normally works in AUTOMATIC MODE, as the VIEW menu in the TIMELINE and Figure 3.9 show. This results in the automatic display of all elements of the scene in the timeline. When you deactivate the mode, you have to manually pull the objects from the OBJECT MANAGER into the TIMELINE in order to see their animation and keyframes. You can also create connections to the other windows and managers, as shown on the right of Figure 3.9. LINK VIEW WITH PREVIEW RANGE creates a connection between the powerslider and the timeline. The numeric ranges are then identical, whether zooming in or out or moving the view in the TIMELINE. The LINK TL/OM SELECTION helps with working on complex scenes because, in this mode, the objects selected in the OBJECT MANAGER are selected in the TIMELINE at the same time. This works in the opposite way as well. The LINK VIEW TO OBJECT MANAGER option shows only the hierarchies and objects in the TIMELINE selected in the OBJECT MANAGER.

The TIMELINE also contains extensive settings for filtering and searching for certain objects or groups of elements. You can find these options in the VIEW menu of the TIMELINE at FILTER. Quicker access can be achieved by using the labeled icons in the upper right, as shown in Figure 3.10. The magnifying glass (A) activates a search field that can be used to search for the name of objects. The house symbol (B) activates a path entry. When you select an object with VIEW>SET AS ROOT, by using the arrow symbol next to the path field you can browse up the hierarchy of this object. A click on the house symbol in front of the path lets you jump to the uppermost level. Then all elements are shown again based on their other settings.

The eye symbol (C) opens an additional list that can be seen on the left of Figure 3.10. There, the display of element groups or single types of objects, materials, or tags in the TIMELINE can be deactivated and then can no longer be found by the search function. In the example in the figure, all tags, materials, and RENDER SETTINGS were turned off in the TIMELINE. Generally, this makes sense for all elements that are not part of an animation. This keeps the TIMELINE less cluttered. The icon at the letter D enables an overview of MOTION CLIPS. This only works in MOTION MODE of the TIMELINE, though.

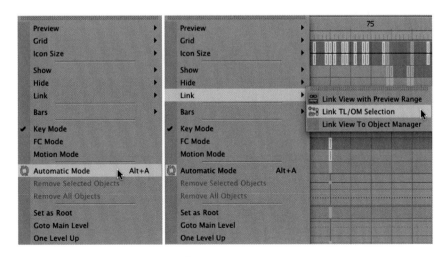

— Figure 3.9: The display modes of the timeline.

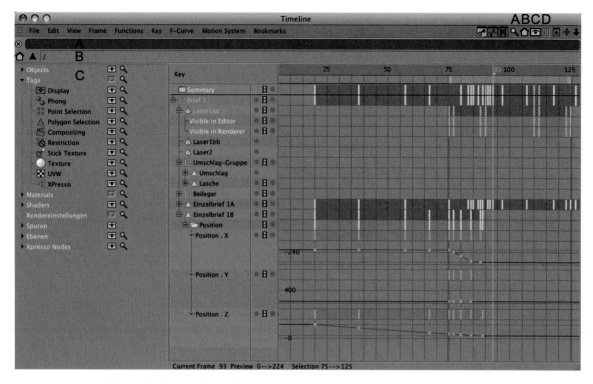

We will get to this mode in the following chapter on character animation.

## Controlling the Interpolation

It would be too much work to set a keyframe for every image of an animation, considering the way traditional cartoon and stop-motion film work. Our goal should be to set up the animation with the least possible number of keyframes. This makes it much easier to edit or manipulate. A keyframe animation always needs at least two keys, one for the start and one for the end state of an object or parameter. The distance between these keyframes determines how fast an animation will play. It also doesn't make sense to always calculate linear interpolated values between the keyframes. Just think of a car that needs to move from A to B. The mass of the car has to be set into motion, accelerated, and at the

end slowed down again. In a linear calculation the car would show a constant speed from the first to the last image of the animation and would be put instantly into motion. The type of interpolation can generally be set with the previously mentioned settings of the animation palette, or individually for every keyframe. Therefore, select one or multiple keyframes and look at the settings in the ATTRIBUTE MANAGER, as shown in Figure 3.11. There you can select from the interpolation types LINEAR, SPLINE, and STEP. The linear interpolation is well suited for mechanical animations where abrupt movement changes occur. The STEP animation keeps the value of a key until the next keyframe is reached. Then there is a sudden jump to the new value. It means that between the keyframes, only the old value is being held. This interpolation method is useful for some mechanical animations as well, but is also used for the so-called *Blocking* of animations. In

— Figure 3.11: Keyframe settings.

these animations, only the important stages of an object are recorded as keyframes, to determine the correct time ranges and to be able to evaluate the timing of the animation. When the timing is right the keyframes are usually changed to SPLINE interpolation.

The SPLINE interpolation is comparable in its effect to a Bezier spline curve with its tangents. Here, the curves are only two-dimensional, though, and controlled by the values in the keyframes. When AUTO TANGENTS is active, soft interpolations are automatically calculated and the tangents are automatically oriented and scaled. The CLAMP option prevents the overshoot of curves. Overshoot means that the curve overshoots the set keyframe value. This can be annoying when an object is to be placed exactly on top of another object. Every merging of one object into another would destroy the illusion of one solid object. When AUTO TANGENTS is deactivated, additional options and values are activated, as shown in Figure 3.12. With LEFT TIME and RIGHT TIME the lengths of the tangent arms can be set separately. The same is true for the tilt of the tangents, which can be edited with LEFT VALUE and RIGHT VALUE. ZERO ANGLE creates a horizontal tangent; ZERO LENGTH creates a tangent shortened to a 0 length. This is the same as hard interpolation of a Bezier spline. As shown in the lower part of Figure 3.12, tan-

gents are also drawn inside the function curve. When AUTO TANGENTS is deactivated, the tangent can be edited directly. As previously explained, each key can have its own interpolation method. In this example, the selected key has a SPLINE interpolation and the neighboring keys have a LINEAR interpolation. When you zoom close enough to the keys in the TIMELINE, you can see small symbols in the keyframes that indicate the interpolation method used without having to select the key. When spline and other interpolation methods alternate, the SPLINE interpolation is valid only in the direction of the animation, which means to the right in the timeline ruler. You can see this as well in Figure 3.12.

To work more exactly, you can use the option for breaking the tangent, called BREAK TANGENTS. This allows you to move the left and right tangent arms independently of each other. As the names of the LOCK TANGENT ANGLES and LOCK TANGENT LENGTH options indicate, they lock the angle and length of the tangents. To avoid accidental changes of a keyframe value, there are the LOCK TIME and LOCK VALUE options. These options are also shown in Figure 3.12. With MUTE the animation can be turned off between one key and the following key so during playback there won't be any changes of this value. MAKE RELATIVE makes the

— Figure 3.12: Interpolation settings for keyframes.

keyframe move relative to the movement of the neighboring keys when they are moved.

### MANIPULATE F-CURVES

As you can see in Figure 3.12, the function curve of the interpolation is bordered by dotted lines on top and bottom. By moving these lines the whole animation can be intensified or softened. Since the space for the manipulation of the function curves is limited, we can switch the TIMELINE to FC MODE in the VIEW menu or with the correspondent icon in the title bar. Figure 3.13 shows a typical view of the TIMELINE in this mode. The display of the sequences and keyframes disappeared to make more space for the interpolation curves.

In order to keep it simple, only the curves of the elements selected in the left area are shown. For example, that way you can display only the Y part of an animated position or the entire vector. To show the entire curves, use the navigation icons on the top right to move and zoom into the TIMELINE, or select FRAME ALL in the FRAME menu. You can also show curves of several elements or

objects at the same time when you select them in the left part of the TIMELINE with (Ctrl) clicks.

The curves can be shaped with the points that are the actual keyframes and with the tangents. This changes not only the interpolation between the keyframes, but also the values of the keyframes. If you want to apply complex modifications, then use the so-called modification curves. These are curves that manipulate the interpolation curves. Their advantage is that they contain fewer points yet can control an interpolation curve with a lot of keyframes.

First, activate in the F-CURVE menu of the TIMELINE the entry for REDUCED MODIFICATION MODE. Underneath the original F-Curve—in the area seen on the left in Figure 3.14—a new curve appears. It is shown in green on the right side of Figure 3.14. By moving the points of this curve or by manipulating its tangents, the F-Curve can be deformed and scaled in a simple way. If you want to change just one property, like the MOVE or SCALE of the F-Curve values, then you can switch to a restricted mode in the F-CURVE menu at REDUCED MODIFICATION TYPE.

— Figure 3.13: The FC mode.

— Figure 3.14: On the left is an F-Curve; on the right is a modification curve with the changed F-Curve.

## CREATING SNAPSHOTS

The only disadvantage of this method is that when you leave the reduced modification mode, you can only return to the original F-Curve with the UNDO function in the EDIT menu of the timeline. This can be avoided by creating a so-called snapshot of the curve before the manipulation. This function can be found in the F-CURVE menu at MAKE SNAPSHOT. Up to five of these F-Curve states can be saved. With SWAP SNAPSHOT

you can load the F-Curve state again, making it possible to experiment with several F-Curve shapes.

## Influencing Sequences

Besides the keyframes, whole sequences can be controlled individually. Several icons that can be used for this purpose are found to the right of the element name in the timeline. First, there is the filmstrip symbol. When it is turned off, the animation of this element and all subordinated objects is not calculated. That way, parts of the scene can be turned off to improve the playback performance in the editor. As you can see in Figure 3.15, the filmstrip symbol has three states. The first is yellow, which means that the element is fully animated, and the second is gray, which indicates that the animations are suppressed. The third is blue, which marks elements that are animated, but there are subordinated objects whose animation is deactivated.

A click on the gray spot to the right of the filmstrip activates the SOLO mode. When it is active, all other elements in the animation are ignored. The blue color indicates the different settings in the hierarchy, as demonstrated in Figure 3.15. In the timeline as well you can find a possible way to organize elements into layers. Use the gray button right next to the name of the elements. In the layer browser, which can also be opened with

— Figure 3.15: Options for evaluating animations.

a click on the circles, you then have the ability to lock an animation sequence or to block any manipulation.

This gives you the basic knowledge needed for animating objects and parameters as well as the adjustment of keyframes and interpolation curves. Let us look at some examples of complex animations that often work without using any keyframes.

## Animating with Dynamics

The DYNAMICS module simplifies the animation of forces acting between rigid objects. A typical case would be a sphere that swings on a spring up and down, or a cube that falls onto a plane. In both cases the shape of the objects doesn't change, but the movement can be so complex that the recording of manual keyframes would not be exact enough and would take too long. The following example shows how to create a pendulum that bounces against two cubes, which then collide with each other.

### A Work Sample

The setting of the scene is quite simple. We will start modeling the pendulum with the creation of a new SPHERE primitive. A radius of 30 units should be enough, but that is not really important for the next steps. You can also keep the standard settings of the sphere. This pendulum should be guided by two strings or ropes. Figure 3.16 shows the desired look.

#### MODELING THE PENDULUM

We will use a cylinder primitive with the standard length of 200 units and apply a small RADIUS of just 1 unit. Therefore, you can reduce the number of circumference

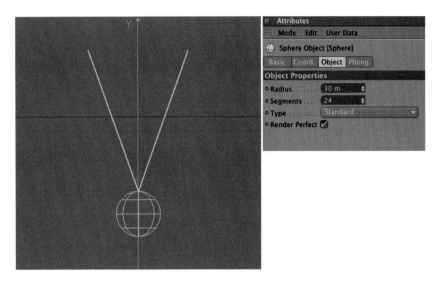

— Figure 3.16: Modeling of the pendulum.

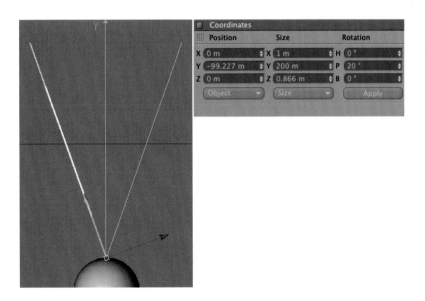

— Figure 3.17: Orienting the string of the pendulum.

SEGMENTS to five or six. We also don't need caps because of the small profile of the cylinder. Convert the cylinder with the (C) key and change to the USE OBJECT AXIS TOOL mode. Move the local axis system to one end of the cylinder, switch to USE MODEL TOOL mode, and position this end at the upper pole of the sphere. Figure 3.17 shows this position and the following step.

Turn the cylinder if necessary so it is placed vertically on the sphere and set all angles in the COORDINATE MANAGER to 0°. You can then rotate the cylinder around one axis to generate the lateral move. I used a tilt of 20°, as you can see in Figure 3.17. Then copy this cylinder and change the angle sign of the copy in the COORDINATE MANAGER. This will automatically create a mirror image of

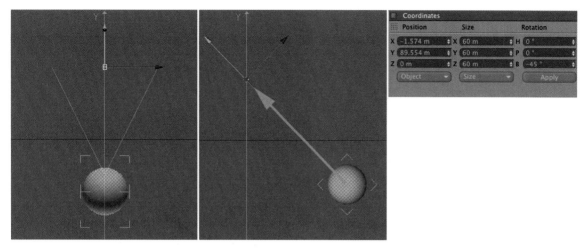

— Figure 3.18: Moving the axis system of the sphere.

the first string cylinder. Both cylinders are then subordinated under the sphere.

As you know, the local axis system of an object is used as the origin for rotations. Since our pendulum is supposed to rotate around the anchor points of the two cylinder strings, we have to move the axis system of the sphere to the appropriate position. Convert the sphere with the (C) key to a polygon object and change to the USE OBJECT AXIS TOOL mode. Move the axis system of the sphere up the Y axis until it arrives at the height of the upper cylinder ends in the front or side viewport. Then change back to the USE MODEL TOOL mode to rotate the sphere, including the subordinated cylinders, so the pendulum shows a move of 45°. Figure 3.18 shows the desired result. The arrow points to the new position of the axis system of the sphere.

**DEFINING THE DYNAMIC BEHAVIOR**

Dynamic calculations are influenced by several forces and factors like friction, gravity, and/or collision. This could result in inaccurate or even unpredictable animations. In order to minimize this risk, some restric-

tions of movement have to be put upon the objects. For example, our pendulum is not supposed to change its position or be rotated around other axes, the ones we used to rotate it away from its original position.

**The Constraint Tag**

For such dynamic restrictions there is the CONSTRAINT tag, which can be found after a right click on the sphere under the entry DYNAMICS TAG.

First use the button for USE CURRENT in the dialog of this tag, as shown in Figure 3.19. This transfers the current position and angle values of the sphere to the tag. Then put a checkmark in front of the values that are not supposed to change during the animation. In my case only the ROTATION.B value remains, which allows the swinging motion of the object around its Z axis.

The CONSTRAINT tag offers a TYPE menu that can be used to transfer a continuous force or circular motion to the object. In our case, only the JOINT type would be suitable since the movement of the pendulum is a result of its own weight and gravity.

— Figure 3.19: Settings of the Constraint tag for the pendulum.

## The Rigid Body Dynamic Tag

The CONSTRAINT tag alone cannot control the behavior of a massive object. We need another tag for the pendulum, and that is the RIGID BODY DYNAMIC TAG. You can find it in the same menu as the CONSTRAINT tag. This tag makes sure that the dynamic simulation will recognize this object as a massive object and that it can be influenced by the applied forces. One of the most important settings is the mass of the object and the position of the mass center. Generally, the mass center

is located at the position of the local axis system. In our case, though, the mass center is certainly in the center of the sphere and not on top, at the virtual connection between the string and the sphere. You can use the three mass center points to move it to another position.

As Figure 3.20 shows, the mass center is indicated with a small yellow cross. It can be most easily seen in the display type LINES and the CUBE setting since all objects are then shown as cubes and do not block the view to the mass center anymore. All other settings remain the same. You can come back to this dialog anytime after applying the simulation if you need to vary the mass of the pendulum to achieve a different behavior.

Also very important for the simulation is the calculation of collisions. If our pendulum will not only swing, but also collide with other objects, then you have to activate COLLISION DETECTION in the menu with the same name. Figure 3.21 shows the corresponding dialog on the left side. The settings BOX and ELLIPSOID enclose the object with a virtual cube or an appropriate deformed sphere. These shapes can be evaluated quite quickly for collisions, but are not always close enough to the surface of the object. This can

— Figure 3.20: The Rigid Body Dynamic tag.

only be achieved in the FULL setting, where all faces are actually evaluated for collisions. In our case the BOX setting should be sufficient since we only expect collisions on the front and back of the pendulum. The elasticity determines the amount of energy that will be passed on between colliding objects. My tests have determined that 300% is a fitting value. You can start with a value of 100%. The values for STATIC and DYNAMIC act like a brake. The STATIC holds an object on a surface even if the surface is slightly tilted. Only when the tilt becomes too much does the object start to slide. At this moment the DYNAMIC comes into play because it only affects objects already in motion. Other settings on the AERODYNAMICS page take effect only when the object is blown upon by the WIND object, which can be found in the DYNAMICS menu of CINEMA 4D. The many parameters define the buoyancy and the resistance of the object. This can be interesting should you want to animate an aircraft wing or a leaf with the force of the wind on it. In practice, though, this can hardly be planned because of its unpredictability.

The start settings define the start state of the object in the beginning of the simulation.

The object isn't always sitting still at the start of the animation. With the v values you can define a start speed. The speed consists of X, Y, and Z values because speed doesn't have only a value but also a direction. The same is true for the start force that is defined at the letter F. This force only acts in the first image of the animation and can be used to push the object.

The w values define the strength of the start rotation, and the I values determine a torque. Just like the F force, this affects only the first image of the animation and could be used to start, for instance, a carousel.

**Adding Two Cubes**

In order to put the collision detection of the pendulum to good use and so it doesn't just swing back and forth, we will create two new CUBE primitives and resize them to a size fitting for the pendulum. I used a side length of 58 units. All objects used with dynamics have to be POLYGON objects. Therefore, our cubes have to be converted with the (C) key. The cubes should be placed in such a way that a collision with the pendulum is certain. Figure 3.22 shows a possible arrangement.

— Figure 3.22: Adding two cubes.

The CONSTRAINT tag can help the simulation of the cubes, since the cubes are supposed to be positioned on a sort of table or plane. We therefore can exclude the possibility of the cube being moved in the Y direction. This again implies that the cube will only be rotated around its vertical axis. As you can see in Figure 3.23, you should use the USE CURRENT button again, provided that the cubes are placed at the chosen position, and apply a checkmark to the values Y, P, and B. Do the same with the second cube.

— Figure 3.23: The Constraint tag of one of the cubes.

The two cubes also need collision detection so they can bounce off the pendulum. Apply a new RIGID BODY DYNAMIC tag to the cubes and activate the BOX COLLISION DETECTION, as can be seen in Figure 3.24. The box shape fits perfectly to the shape of the objects. The MASS CENTER can remain in the center of the cube this time. Further tests showed that the reduction of the ROTATIONAL MASS to 10% gives us more dynamic results. The cubes start to rotate faster when hit by another object at an angle or toward an edge. This behavior depends on one's individual taste, though.

**THE SIMULATIONS OBJECT**

This completes the preparation of the objects for the simulation, and we can now concentrate on the outer forces. The pendulum will only start to move when it is pulled down by gravity, so add a GRAVITY object from the DYNAMICS menu of CINEMA 4D. Its size and shape can be adjusted, in case you want to use the gravity as a local force field. Figure 3.25 shows on the left side possible settings for the shape, size, and falloff behavior of the gravity's force field.

— Figure 3.24: The Rigid Body settings for the cubes.

— Figure 3.25: The dialog of the Gravitation object.

We leave the SHAPE setting at UNLIMITED. The direction of the force is defined in the FIELD menu. With the AXIAL setting the gravity works in one direction, for example, downward along the world Y axis. With the RADIAL setting the gravity would work spherically, toward the center. This would be useful for simulating the gravity of planets and the sun in the solar system. The NEWTON setting is a bit different; it turns every Rigid Body object of the simulation into a force field. This can be used to deflect several objects from each other, like billiard balls. It also might be used to avoid time-consuming collision detections between objects. The objects are, even before the collision, simply deflected from each other by their own force field. The strength and direction of the force field can be individually set. You can see this on the right side of Figure 3.25.

Our ability to achieve a dynamic simulation is still missing one element: the SOLVER object. You can find it in the DYNAMICS menu of CINEMA 4D. Subordinate all elements of the scene under this object, as shown in Figure 3.26. Only that way does CINEMA 4D know which objects are included in the simulation. The time frame of the simulation is controlled with the START and STOP values. Make sure that the STOP value is large enough so that the simulation doesn't end abruptly during a movement. The precision of a calculation is determined by the choice of the INTEGRATION METHOD and the OVERSAMPLING. From the EULER to the ADAPTIVE method the calculations get more and more exact, but also slower. Often the only thing that helps is to see whether the precision of a simpler method is enough, or if a more complex method is necessary. The OVERSAMPLING determines the number of calculation steps. In the setting ADAPTIVE, SUBSAMPLING is available, which makes additional calculations at the critical parts of the simulation. The SOFT BODY method is meant especially for objects that are deformed during the simulation, like

a blanket that falls onto another object. For this kind of simulation we now have the CLOTHILDE function in the MOCCA module, which is better suited for this sort of simulation since it offers more settings.

With the ENERGY LOSS value, the buildup of movement or perpetual motion can be avoided because this value is continuously subtracted as a kind of friction from the dynamic of the system. Detailed settings, such as the EPS value, are important for the early detection of collisions. The Epsilon value is added to the dimensions of the objects for the early detection of collisions with fast-moving objects. If you experiment with quick movements, this value might have to be increased to avoid intersecting objects, despite the collision detection.

The COLLISION REST SPEED can prevent the slow submerging of objects when they are positioned in a motionless state on top of each other. The collision rest speed defines the lowest speed that an object must have until an additional force pushes it away from the neighboring object. We will prevent this problem with our cubes by using the locked Y axis, which renders the collision detection with the floor unnecessary.

The BAKING FRAME STEP is only of interest for the so-called "baking" of the SIMULATION object, which is the conversion of the simulation into a sequence of keyframes. This has advantages in connection with expressions or when rendering over a network. The BAKING FRAME STEP defines the number of keyframes created when the SIMULATION object is converted to a keyframe animation with DYNAMICS > BAKE SOLVER. BAKING LAYER then determines the layer in which the baked animation is saved.

### EDITING THE SIMULATION

When you use the start button of the animation palette to play the animation, the pendulum should swing downward against the cube. The cubes are moved by this collision and might collide with each other. If you

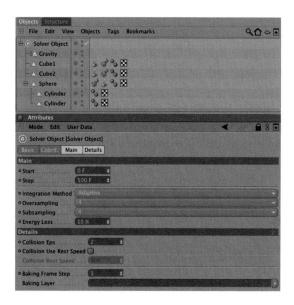

— Figure 3.26: Hierarchy of the scene and settings of the Solver object.

don't like the course of the simulation, then simply stop the animation and return to frame 0. Deactivate the SIMULATION object by clicking on its green checkmark in the OBJECT MANAGER and move the cube to a new position. To fixate this position again, you have to open the CONSTRAINT tags of the modified objects and use the CURRENT VALUE button. Then select INITIALIZE ALL OBJECTS in the DYNAMICS menu. This informs the SIMULATION object about the changes, and it can be turned on again in the OBJECT MANAGER.

### IMPROVING THE SIMULATION

You probably noticed that our scene is still a bit dull and without color. This is because dynamic simulations function best with low resolution POLYGON objects. There is a trick, though, to get around that. Just make the dynamic objects invisible and replace them with higher resolution objects. That way, the simulation can still be calculated, but with simple objects that are replaced with more complex models for the rendering of the animation.

Subordinate a new SPHERE primitive under the pendulum and adjust its size and position to the sphere of the pendulum. This sphere is

not converted to a POLYGON object, but will take advantage of its PERFECT SPHERE option. Do the same with the cubes. Subordinate new cubes, with soft edges, under the original cubes to improve the look. All new objects are set to be visible for the renderer and the old ones are set to be invisible. Use the small dots behind the objects in the OBJECT MANAGER to change the visibility settings, as seen in Figure 3.27.

As you can see there, I added a FLOOR object to the scene so the cubes don't just float in the air. It can be found at OBJECTS> SCENE. Compared with a PLANE or POLYGON primitive, the FLOOR object has the advantage that it automatically expands up to the horizon during rendering. There are also additional BOOLE objects under the dynamically animated cubes. I used them to improve the otherwise boring shape of the cubes. The result of all this is shown in Figure 3.28.

Create a copy of the cube, with the soft edges, under the dynamically animated cube object. Enlarge the cube evenly by a small amount. The best tool to use for this is the SCALE tool in USE MODEL TOOL mode. Then create a new sphere and place it in exactly the same position of the enlarged cube. Change the sphere radius so that only the

— Figure 3.27: Subordinating higher definition objects.

corners of the cube are still visible. This can be seen in the center of Figure 3.28. The third element is a PLATONIC object, found in the primitive objects as well. It is also placed in the same position as the enlarged cube and the new sphere.

For this we will use the OCTA TYPE with one SEGMENT. You can see the shape on the right of Figure 3.28. Adjust the size of this platonic object so that small segments of the sphere still protrude through its surface. When you subordinate the SPHERE under the PLATONIC primitive and group all three objects

under a BOOLE object, as shown in Figure 3.29, you can then activate A SUBTRACT B. The A object is the cube and the B object is the group of the platonic primitive.

The result can be seen on the left in Figure 3.30. The BOOLE object removes from the cube the volume between the sphere and the platonic primitive. If necessary, add more SEGMENTS to the SPHERE in case the result appears too angular. I used a value of 60 units. The right side of Figure 3.30 shows how the Boole result looks, together with the rounded cube, under the dynamic cube object.

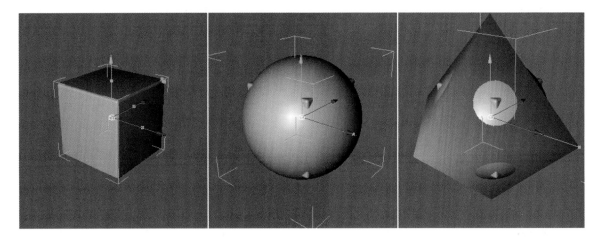

— Figure 3.28: Combination of three different objects with the Boole object.

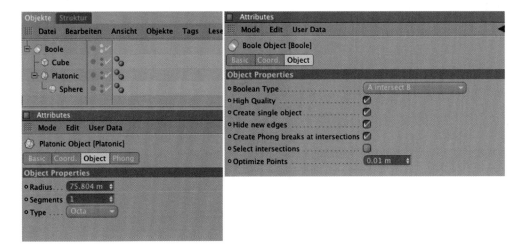

— Figure 3.29: Settings for the Boole object.

— Figure 3.30: Result of the Boole action and the combination with the rounded cube.

## THE MATERIALS OF THE SCENE

I would like to use global illumination in the scene and use its special qualities in regard to illuminating materials. The scene will then be lit mainly by the surfaces of the objects. We will start with the material of the FLOOR object. It will have minimal reflective properties. As you can see in Figure 3.31, 8% brightness is enough, while the remaining channels keep their standard settings.

### The Material of the Cubes

The cubes themselves are to be transparent, yet also reflective. I set the TRANSPARENCY to a somewhat high 50% and weakened it slightly with a BLURRINESS of 10%. I used a REFRACTION value of 1.6, which represents normal glass.

Because of the intense transparency the REFLECTION has to be set higher than usual to still be visible. I used 100% BRIGHTNESS in the REFLECTION channel. These settings can be seen in Figure 3.32.

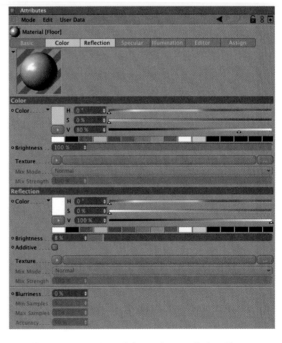

— Figure 3.31: Material settings of the Floor object.

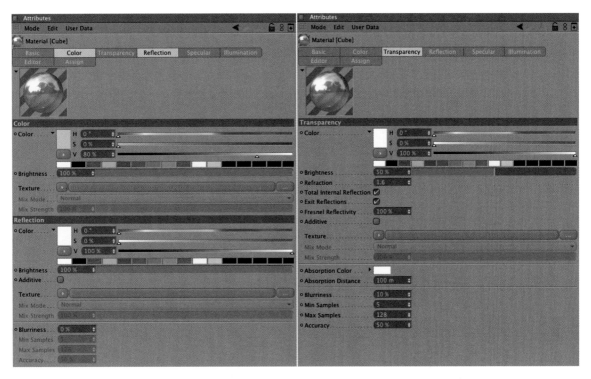

— Figure 3.32: Settings of the cube material.

## The Material of the Cube Corners

As for the corners of the cube created by the Boole object, we will think about something special. These objects are meant to have illuminating properties and therefore light the scene. I used a light blue in the LUMINANCE channel and reduced the brightness in the COLOR channel. Shadows will not appear on these faces when using such an intense illumination.

Because this material is intended to emit light, the settings in the ILLUMINATION part of the material are very important. Figure 3.33 shows these settings. The receiving of global illumination can be deactivated because of the intense self-illumination. A value of 500% increases the brightness in the rendered image to the desired level,

which was determined with test renderings. You can also leave it at 100% for now. The SAMPLING MODE defines the precision of the sampling during the GLOBAL ILLUMINATION calculation. I decided to use the QMC SAMPLING. Tests with the faster OVERSAMPLING looked good at first, but then showed slight variations in brightness during the animation. The option ACCURATE COLOR became available when QMC SAMPLING was selected, but it isn't needed here. The final result would benefit from this option only if the scene were to be lit by this material, with just a part of the material visible to the camera. This would be the case if an HDR image in a SKY object were to illuminate the scene, or with illumination by way of shaders whose calculations depend on the viewing angle.

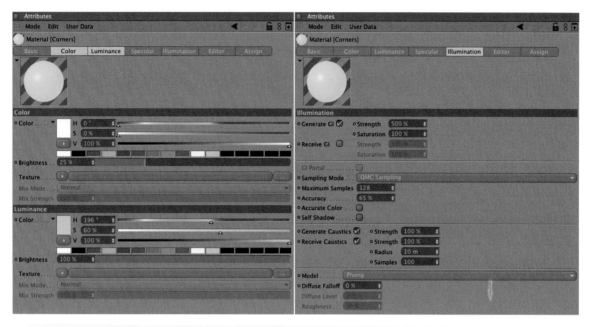

— Figure 3.33: Settings for the material of the corners at the cubes.

## The Material of the Pendulum

The pendulum should be made of transparent glass and should glow from the inside. Therefore, the material is given an orange coloring in the COLOR channel and a red tone with similar brightness in the LUMINANCE channel. As shown in Figure 3.34, the transparency is set quite high, at 90%. Consequently, we do not need a visible refraction and should leave it at the standard value of 1. We will apply a bright red as the ABSORPTION color. The center of the sphere will then have a reddish transparency and the edges will stay clear.

I intentionally increased the BRIGHTNESS of the REFLECTION to 300%. The majority of this brightness will be balanced by the similarly strong transparency. Since this material also has illumination properties we will use the SAMPLING MODE of OVERSAMPLING. I set the generating of global illumination to a rather

high 1000%. This is necessary since the illumination is quite weak and will be absorbed by the transparency. As can be seen in Figure 3.35, I deactivated the receipt of global illumination because transparent objects hardly benefit from this option.

### SETTINGS FOR THE LIGHT SOURCE INSIDE THE PENDULUM

To intensify the glow inside the pendulum I inserted a new light source. Group this light source with the perfect sphere of the pendulum and set the TYPE of the light to OMNI to depict a radial light source. In the GENERAL settings, deactivate the options for DIFFUSE and SPECULAR so the light doesn't take part in the illumination of the scene. Instead, activate the VISIBLE setting in the VISIBLE LIGHT menu.

As can be seen in Figure 3.36, you can set a random value for the OUTER DISTANCE on

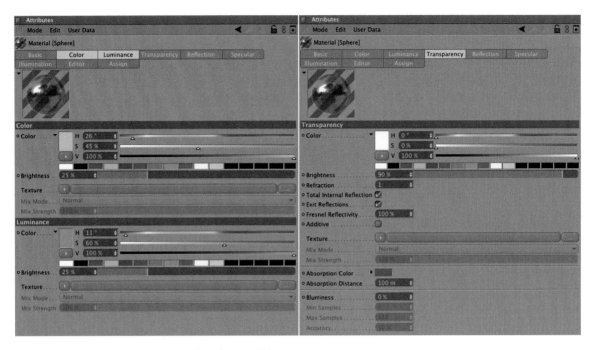

— Figure 3.34: Material settings for the pendulum.

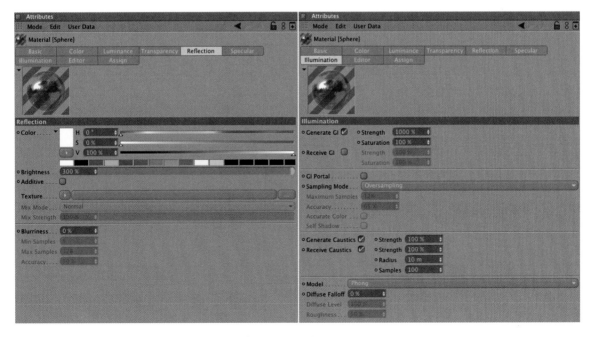

— Figure 3.35: More settings of the pendulum material.

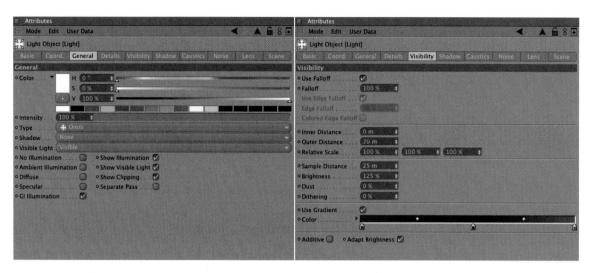

— Figure 3.36: Settings for the light source inside the sphere of the pendulum.

the VISIBILITY page of the light source dialog. You will see a preview of this distance in the editor and should set it so the visible properties of the light are about twice as large as the sphere of the pendulum.

We can achieve a special effect when the USE GRADIENT option is active. The colors on the left side represent the position of the light source. The colors on the right will be used at the outer edge of the light. With the gradient seen in Figure 3.36, a spectrum ranging from an intense red to a dark violet then to a desaturated red, the sphere will look like it has a diffused light source inside. The additional illumination outside the sphere intensifies the impression of emitted light.

## THE RENDER SETTINGS

In order for the materials to be recognized as the light source in the scene, the GLOBAL ILLUMINATION effect has to be activated in the RENDER SETTINGS. For this mode, we can only use IR + QMC (FULL ANIMATION), since all objects move during the animation. For now a DIFFUSE DEPTH of 1 should be sufficient since our scene is not enclosed. The

majority of samples of another DIFFUSE DEPTH increase would disappear unused into the depths of the scene. Instead, we increase the GAMMA value to 1.5 to raise the overall brightness of the scene. The remaining settings for the IRRADIANCE CACHE can be left at their standard values. Figure 3.37 shows these settings.

A first test rendering in the editor can be seen in Figure 3.38. There you see the effect

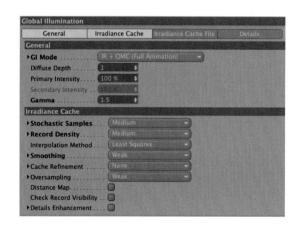

— Figure 3.37: Render settings of the scene.

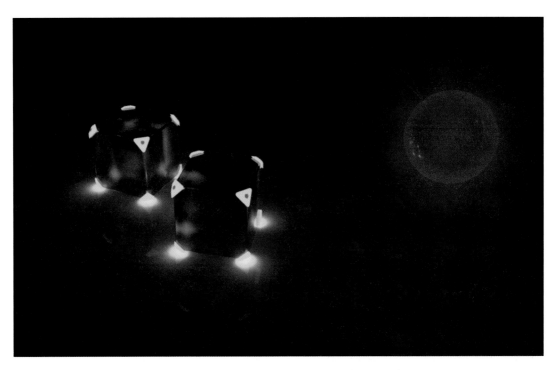

— Figure 3.38: Test rendering of the scene.

of the visible light source within the sphere and the corners of the cube that actually take part in the illumination of the scene. The reflective floor supports the overall mood, as you can see with the reflection of the visible light under the pendulum.

You can start the rendering of the animation after you have entered the desired range of images for the calculation at the OUTPUT page in the RENDER SETTINGS and selected a file path and an image or movie format for the encoding on the SAVE page. Just click on the corresponding icon in the title bar of CINEMA 4D or select RENDER>RENDER TO PICTURE VIEWER. The calculation starts with a special pre-pass for the animation. The displayed information can be seen in Figure 3.39.

CINEMA 4D first calculates different optimized pre-passes for the animation and saves them. This makes it possible to render the animation without any flickering. If the result

— Figure 3.39: GI pre-pass of the animation.

doesn't meet your expectations, then the settings for the samples and diffuse depth have to be checked. Also, switching to a more precise sampling mode can vastly improve the results from using illuminating materials. Just switch the SAMPLING MODE in the ILLUMINATION settings of these materials. Figure 3.40 shows several snapshots of the final animation of this example.

— Figure 3.40: Images from the rendered animation.

## Particle Effects

Particles are used when a large number of objects are needed and possibly need to be animated as well. This makes it possible to quickly send an army of polygon warriors into battle, or to generate delicate wafts of smoke or fog. In this example you will learn more about the use of particles and the PYROCLUSTER material, which is part of the ADVANCED RENDERER.

### The Emitter

The emitter object generates the particles and sends them along the Z axis into the scene. It can be found in the OBJECTS menu at PARTICLE. The speed of the particles, their lifespan, and a possible rotation of the particles is determined in the dialog of the emitter in the ATTRIBUTE MANAGER. Figure 3.41 shows this dialog on the left.

First you set the BIRTH RATE, separate for the editor and renderer. This is the number of particles that are generated every second of the animation. With VISIBILITY the particles can be seamlessly faded out or in. START EMISSION and STOP EMISSION define the time frame in which the emitter is active. The LIFETIME represents the time during which the particle remains visible after being generated by the emitter. With SPEED, the entering speed of the particles is set. The speed can later be increased or reduced by using help objects.

When the TANGENTIAL option is active, the particles are aligned along their Z axis in the direction of flight. You can also set a custom rotation that can be randomized, just like all these parameters, so the particles act differently from each other. With END SCALE the particles can be, depending on their lifetime, enlarged or shrunk. This might be helpful with clouds of smoke that start as a thin trail and then expand with increasing height. When the particles are not used with PYROCLUSTER but instead with normal objects, then the SHOW OBJECTS option should be activated. Particles, like Null objects, are invisible when rendered.

In the EMITTER settings you will select the EMITTER type, which will define whether the particles will be emitted in the shape of a cone or pyramid. X-SIZE and Y-SIZE determine

— Figure 3.41: Particle Emitter object.

the size of the emitter area, and ANGLE HORIZONTAL and ANGLE VERTICAL represent the scattering angle of the particles after they leave the emitter area. As you can see in Figure 3.41, I used a small strip as the emitter and have the particles leave it at exactly a right angle.

## USING OBJECTS AS PARTICLES

Since particles are invisible even in the final rendering, an object or material has to be assigned to them. In the case of an object, this is done simply by grouping it with the EMITTER object in the OBJECT MANAGER. Figure 3.42 shows this using an example of a subordinated PYRAMID primitive.

When the orientation of the pyramid is set to +Z and the EMITTER uses the TANGENTIAL and the SHOW OBJECTS options, the particles are displayed as aligned pyramids. The size of the particles can easily be set by resizing the subordinated pyramid. Variation using different shapes as particles is also possible.

Simply subordinate more objects under the emitter. It will then assign these new shapes randomly to the particles.

## CONTROLLING THE FLIGHT PATH OF THE PARTICLES

If the particles were to leave the emitter in a straight line only, then their use would be severely limited. Therefore, there are several MODIFIER objects, especially made for particles, that can also be found at OBJECTS > PARTICLES. From this list select the GRAVITY object. It works similarly to the corresponding object from the previous DYNAMICS example, but this time for use with particles. Figure 3.43 shows the dialog of this object and its effect on the particles.

The force of the gravitational pull follows the negative Y axis of the GRAVITY object. The value for ACCELERATION defines the amount of force applied to the particles. The gravity is only active within the outer boundaries of the GRAVITY object. Its shape and size can be

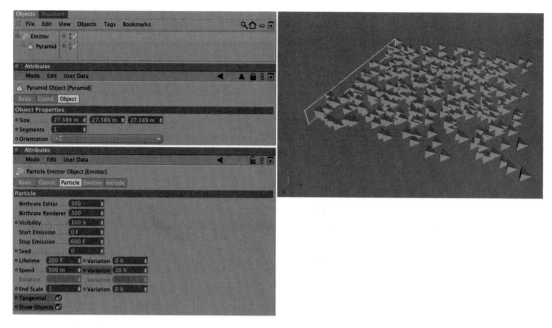

— Figure 3.42: Subordinating an object as particle.

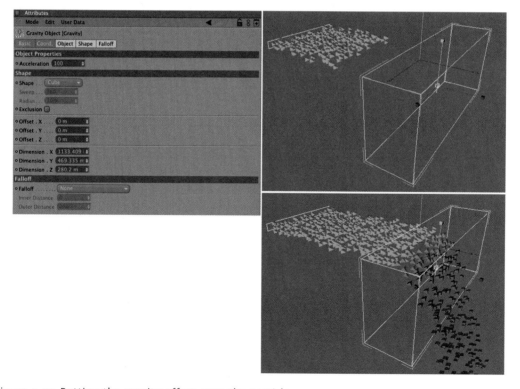

— Figure 3.43: Putting the gravity effect onto the particles.

set as well, in this dialog of the ATTRIBUTER MANAGER. As you can see on the right side of Figure 3.43, the particles are pulled down the moment they enter the gravity cube. Because of the high velocity of the particles, it is not possible to generate a softly rounded transition to a vertically sloped particle path. I therefore added another force field, the WIND object, which can be found in OBJECTS>PARTICLES as well. As the name suggests, this object acts like a steady wind along the Z axis of the WIND object. As shown in Figure 3.44, the settings are almost identical to those of the GRAVITY object.

The WIND SPEED can be used as a force field, making the particles take a more vertical downward movement after the particles have been bent by the GRAVITY object. Make sure that the WIND object is large enough so that all particles of the stream are captured

and influenced. Figure 3.44 shows, on the right side, the modified behavior of the particles and the positioning of the WIND object within the particle stream.

## PyroCluster

The PYROCLUSTER functionality consists basically of two materials, which can be found at FILE>SHADER in the MATERIAL MANAGER. I'd like to create a sort of waterfall with the particles and add some volumetric clouds to this effect. We will start with a new PYROCLUSTER material that you can open at the previously mentioned menu in the MATERIAL MANAGER. At the GLOBAL page of this material, you will find the PREVIEW button, which opens a window as shown in Figure 3.45. With the slider at the lower end, you can evaluate the

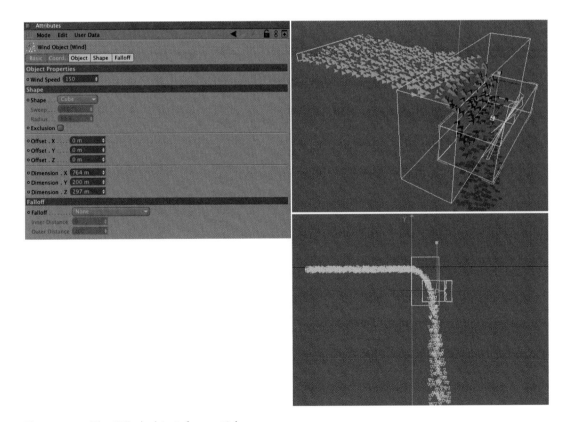

— Figure 3.44: The Wind object for particles.

different phases of the material. The terms BIRTH and DEATH represent the lifetime of the particles that will receive this material.

PYROCLUSTER offers several presets for fire, smoke, and clouds that can be selected directly in the SETTINGS on the GLOBAL page. Even if you want to generate a different look, it makes sense to use one of these SETTINGS and then further refine it.

Generally, there are two calculation methods available in the RENDER MODE menu, ATMOSPHERIC and VIDEOPOST. The latter calculates faster, but does not offer the realism of the real volumetric calculation. In addition, there are disadvantages to using other post effects, such as the glow. Post effect results can't be seen behind transparent objects or in reflections. The VOLUME value sets the complexity of the cloud. Higher settings show more fine structures, but also take longer to calculate. The LUMINOSITY controls the brightness of the cloud in relation to its density. This value acts as the maximum brightness that can be achieved in the calculation. DENSITY defines the transparency of the cloud; the smaller the value, the more transparent the cloud.

With the COLOR gradient, you can control the coloring of the particle clouds. Figure 3.46 shows this in the middle of the dialog. The left color value represents the center of

the clouds and the right one is used for the outer edge. The application of these colors on the clouds is controlled with the gradient mode. FLAT RADIUS projects the gradient from the current view of the camera onto the particles, and LOCAL RADIUS uses the particles themselves as the center of the projection. The right edge of the color gradient always colors the edge of the cloud, regardless of its size. The MIN and MAX values can be used to determine the spread of the colors on the clouds. For example, a MAX value of 80% means that the color on the right side of the gradient is already used at 80% of the total radial size of the cloud.

WORLD RADIUS relates the gradient to the absolute measurements of the clouds in the world coordinate system. This could cause the color gradient on the cloud to change when the size of the cloud changes. Different than at the local radius, the right side of the gradient is not necessarily connected to the edge of the cloud but depends on the MIN and MAX percentage values. The DENSITY mode colors the cloud depending on its density. The left edge of the gradient is responsible for the transparent sections and the right edge for the more dense parts. Here, the MIN and MAX values control the percentage of cloud density, between which the color gradient is applied.

— Figure 3.45: Phases of the material animation.

— Figure 3.46: Global settings of the PyroCluster material.

— Figure 3.47: Age settings of the PyroCluster material.

The Use Intersection option is important when fog or clouds are to be bordered by normal polygon objects. The clouds are then only calculated on the side where the particle is located. The Ray Bias value can be used if the result is not yet precise enough. Similar to the bias value of a soft shadow, it can be used to manually shift the calculated intersection point between geometry and cloud.

### Age Settings of PyroCluster

A big advantage of PyroCluster is that we don't have to manually animate the changes in the shape and size of the particles. They can simply be controlled at the Age page. The different gradients are related to the lifespan of the particles. The left edge of the gradients is always identical to the moment when the particle is created. Figure 3.47 shows an overview of this dialog page.

When Use Age Effects is activated, you can then control the size of the clouds with the Radius gradient. With smoke, it is often the case that the clouds become more diffuse and larger with increasing height. This would correspond to a gradient from dark to light color values at the Radius. The Luminosity gradient acts as a multiplier for the brightness of the clouds. That way, you can display hot and bright gases that cool down over time and become darker. The Color gradient controls, at the same time, the color change of the clouds between the birth and death of a particle and the transparency of the cloud. Unfold the triangle in front of the Color gradient and you will gain access to the Edit Alpha option. When this option is activated, the gradient changes its appearance and can be used for setting the transparency. Without this option, the gradient makes available the normal color tabs that are used to adjust the colors within the gradient. The Color Mix gradient is used as an alpha mask to blend between Color on the Global page of the PyroCluster material, and the Color gradient of the age effect during the course of a particle's life.

## DEFINING SHAPE AND SIZE OF THE CLOUD

In the SHAPE settings you can define the shape and size of the clouds. The volume of the shape can be set as a sphere, cylinder, cube, or ring in the SHAPE TYPE menu. Depending on your choice, there are then multiple radii available to determine the size. When the PREVIEW option is active, simplified versions of the cloud shapes are shown in the editor. This is useful for the adjustment of the following parameters. Also note the value for MAX. VISIBLE. It determines the maximum number of preview objects in the editor. Increase the value if necessary to achieve a more meaningful result. The material has to be assigned to the emitter so PYROCLUSTER knows which particles are meant. Objects that are still subordinated under the emitter should be deleted.

As my settings in Figure 3.48 show, we will use the sphere as our shape. Generally, it is best suited for the simulation of clouds and smoke. The USE PARTICLE TM option takes the rotation of the EMITTER object and transfers it to the clouds. You could also activate USE AUTO ROTATION. This will make the PyroCluster clouds align based on the direction the particles are moving. If you selected a

— Figure 3.48: Settings for the shape of the clouds.

shape other than the sphere, you can use the ROTATION values for the rotation of this shape. The SCALE parameters are useful for deforming the cloud shapes. The standard value is 1 unit in each direction. With a value of 0.5 you can squeeze the shape along the chosen direction. In this example we will use the VELOCITY SCALE vector. The X part of this vector represents the direction of travel of the particles. If these particles are supposed to be spread out along the direction of travel, then the value has to be increased above 0, as shown in Figure 3.48. Depending on the speed of the particles, very small values are enough for large spacings. Again, it is best to work in PREVIEW mode to find an appropriate value.

## LIGHTING AND SHADING OF A PYROCLUSTER CLOUD

As you can imagine, volumetric calculations of smoke and clouds are quite complex. In addition, depending on the density of a cloud, the interaction with light and shadow becomes important to achieve a realistic look. There are two dialog pages available just for the shading of the cloud surface. When USE ILLUMINATION is active, light sources will influence the shading of the clouds. Also, be sure to activate the options for illumination of PyroCluster clouds in the SCENE area of the light source.

As you can see in Figure 3.49, you can select different shading methods in the MODE menu. The DIFFUSE mode is suitable for smoke and clouds. The RAY ANGLE setting includes the vector between the light source and the cloud and delivers contrast-intense images. This can be used for more dense columns of smoke. The BUMP mode works best for massive structures, like the depiction of lava.

The SELF ILLUM. represents brightness that is added to every pixel of the cloud, regardless of the illumination on the cloud. The TRANS. ILLUM. creates a softer transition between the transparent edges of the cloud and the background color of the scene. With

— Figure 3.49: Illumination of a cloud.

increasing values, the elements of the cloud
that lie in the shade or are not being lit are
faded out. The following four parameters are
only available when the BUMP mode is se-
lected. The higher the SHININESS value, the
smaller the highlights. STRENGTH is responsi-
ble for the intensity of the shininess. The
SOFT parameter delivers soft transitions of
the shadows of several light sources, and
BUMP controls the intensity of the bump.

### Shadow Settings

Like in the COMPOSITING tag of a polygon
object, a PyroCluster cloud can also be config-
ured separately for the receiving and emitting
of shadows, as shown in Figure 3.50. With
transparency and ambient color, the shadows
can be colored and their density adjusted. To
obtain realistic results, activate the SHADOW
COLOR FILTER option. The shadow will then
receive its color directly from the volume cal-
culation of the cloud.

Since the shadow calculation for volumet-
ric clouds takes up most of the calculation
time, you can control the precision of
the shadows in the following options. USE
SHADOWMAPS SAMPLES is only relevant for the
calculation of soft shadows. The calculation
time can be reduced with the VOLUME value.
A value of 100 means that the whole volume

— Figure 3.50: Shadow settings of the
PyroCluster material.

of the cloud is evaluated when calculating
the shadow. This result is precise, but its
calculation is also very slow. A moderate
reduction of the value can be helpful, espe-
cially with animations, for rendering single
frames faster. The same settings can be found
underneath for raytraced shadows. DARKEN
OPACITY activates an alternative calculation
algorithm that brightens more dense cloud
segments with light. The cloud therefore has
more contrast. The DARK FACTOR defines the
borderline of the density from which the light
affects the cloud in a normal way. BRIGHTNESS
adds light to the cloud areas filtered by the
DARK FACTOR. The appearance of a cloud is
mainly created by the fact that a portion of
the cloud casts a shadow onto another part.
If this is not the desired effect, then deacti-
vate the SELF SHADOWS option in the upper
part of the dialog. With the SELF SHADOW
OPTIONS active, the BIAS value controls the
distance between the part of the cloud cast-
ing the shadow and the shadow itself. This
principle is the same as that of the shadow
settings of a light source. The higher the SMP.
RANGE, the softer the shadow will appear.

### The Noise Structure in the PyroCluster Material

The actual appearance of the PyroCluster clouds can be defined in the Fractal Type in the Noise settings. The differences of the noise patterns can be evaluated best in the editor with activated Preview at the Global page of the dialog. Regularity controls the complexity of the pattern. The smaller the value, the more details are visible. With the Grow Radius you can control the scale of the pattern in ratio to the size change of the cloud. With large values, the expansion of the cloud also causes the enlargement of the pattern. Scale changes the size of the noise pattern, as you are already used to doing with the noise shader. Peak Blend lets you accentuate either the core region or the outer areas of the fractal. Positive as well as negative values are possible. Detail determines the maximum number of steps for the calculation. More Detail means a more complex depiction of the noise structure, but also a longer calculation time. Values between 2 and 6 should be enough in most cases. Figure 3.51 shows you the entire dialog.

— Figure 3.51: Noise settings in the PyroCluster.

With the Phase value, the fractal can be rotated. With a keyframe animation of this value, rolling clouds, for example, can be realized. Gain defines the relationship between opaque and transparent parts in the fractal. A Gain of 0% results in a completely opaque fractal. The Bias value acts in a similar manner but influences the density of the fractal. Very airy fractals are created with a small Bias value.

The values for Low Thres. and High Thres. are similar to the clipping values in the noise shader and you can influence the number of holes in the fractal structure with them. For adding holes, you will usually use the Low Thres. and increase it moderately. The Color gradient can be released with the Use Color option, which allows you to color the fractal. The left edge of the gradient colors the denser parts of the fractal and the right one colors the transparent areas.

Static Pos places the origin of the fractal calculation in the screen coordinates. The particles then move through a set noise pattern. Without this option, each particle becomes the center of the fractal. When No Scale is deactivated, the fractal is distorted with the shape of the cloud. Otherwise, the calculation of the fractal stays independent of the scaling. Invert Noise creates dense structures from holes and renders previously opaque segments invisible.

### The PyroCluster—VolumeTracer

As previously described, pull the finished material onto the Emitter object and remove any subordinated objects from the emitter. In order to inform CINEMA 4D about the requested quality of the calculation, we need to create an Environment object. You can find this in Objects>Scene. With this object you can add fog or additional light to a scene. These functions don't interest us, though, since we need the environment object only as the host for the PyroCluster—VolumeTracer, which you can find in File>Shader in the Material Manager as well. Assign this shader to the Environment object as a texture, and then you

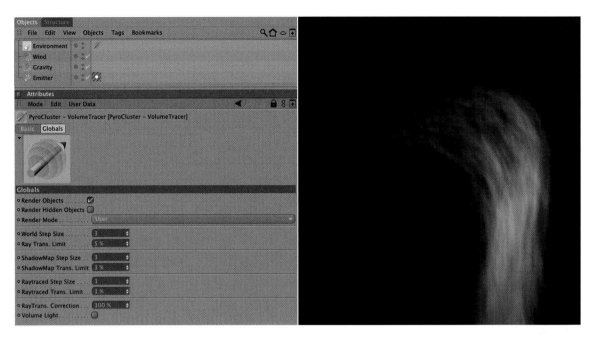

— Figure 3.52: The VolumeTracer.

can create a test rendering of our waterfall in the editor. Figure 3.52 shows a possible result.

As you can see in the figure, I adjusted the AGE settings of the PyroCluster material so that the clouds become visible just before the bend of the particle flight path. This is supposed to simulate the spray that is created by the acceleration and the falling of the water. You can either choose from the three settings, CRISPY, CRISPY-GAS, and HAZY, or use the manual mode. Of the three presets, CRISPY delivers the result with the best quality and HAZY the worst. Regarding the render times, it is exactly the opposite; HAZY is rendered the fastest.

In manual mode you can determine the precision of the calculation yourself. One of the most important settings is the value for the RAY TRANS. LIMIT. It defines the distance between the sampling rays that are sent into the scene. This value should be in a reasonable ratio to the size of your cloud. Values too small will slow down the calculation unnecessarily without creating better results. All following values with the word "limit" in the name are also well suited for the acceleration

of the calculation. These percentage values define the smallest transparencies still visible for the raytracer. The smaller these values are, the deeper the rays have to enter into the volume. SHADOWMAP STEP SIZE and SHADOWMAP TRANS. LIMIT define distances between sampling rays and can therefore reduce the render time when moderately increased.

The value for RAYTRANS. CORRECTION corrects a too transparent depiction of the clouds, which happens when the RAYTRACED TRANS. LIMIT IS increased. The VOLUME LIGHT option allows the volumetric light to interact realistically with the PyroCluster clouds. As you can see in Figure 3.52, I slightly increased the values in USER mode in order to render faster. The quality reduction is small, as can be seen in the test rendering.

## The Animated River

The particles alone look good already, but do not yet depict a river. It still misses the characteristic reflection and shininess. We will

add a SMALL CAPS SWEEP NURBS and subordinate a new spline under it, as shown in Figure 3.53. This spline starts in the center of the emitter and follows the course of the particles. For the profile I used a RECTANGLE spline that you can add from the group of spline primitives. The width and height of the rectangle have to be adjusted so that the SWEEP NURBS is positioned slightly beneath the mass of the particles and has the approximate width of the particle stream.

How this might look, in the camera view or the perspective editor viewport, is shown in Figure 3.54. Notice the order of the subordinated splines under the SWEEP NURBS. At the uppermost spot there has to be the rectangle. I also applied a uniform distribution of intermediate points to the rectangle, as well as the path spline. If you take a look at the SWEEP NURBS in wireframe display in the editor, it should have an even subdivision, as shown on the right in Figure 3.54.

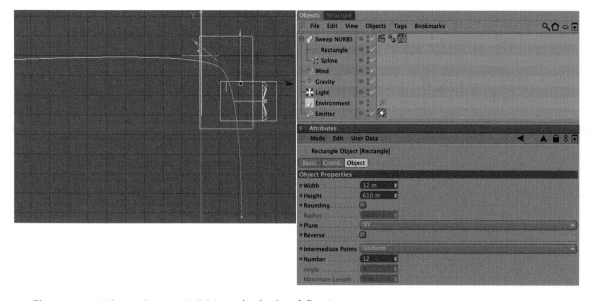

— Figure 3.53: Using a Sweep NURBS as the body of flowing water.

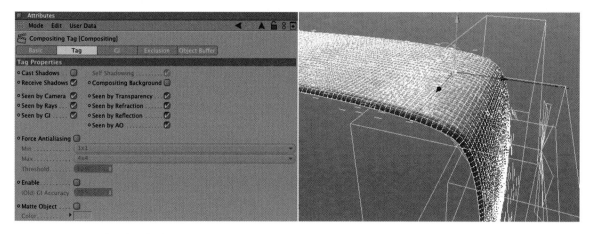

— Figure 3.54: The finished geometry of the waterfall.

This even subdivision will have advantages when the materials are applied, since I want to deform the object using displacement. Add a COMPOSITING tag to the SWEEP NURBS and deactivate the generation of shadows in the tag. This will save us some render time. For the illumination I recommend using a SKY object so we will get not only light, but also a realistic sky gradient that will then be reflected in the water. The SKY object can be found at OBJECTS>SKY. For the SKY object, set a random time that will generate the desired type of lighting. I have chosen 4:30 p.m. and left all other settings alone. I deactivated only the shadows cast by the sun, since it takes too long to calculate AREA or RAYTRACED shadows with PYROCLUSTER. Instead, I added a normal LIGHT source with a soft shadow and activated, in its DETAIL settings, the SHADOW CASTER option. This calculates the shadow only, without the additional illumination. This light source can then be roughly positioned in the direction where the sunlight of the Sky object comes from.

## SETTINGS OF THE WATERFALL MATERIAL

The material of the waterfall provides us with some interesting challenges; therefore, I would like to get more into detail here. Create a new material and apply white at 100% as the color. This will provide strong reflections and highlights later, despite the strong transparency. The first difference from previous materials is set in the TRANSPARENCY channel, since the transparency of the water is supposed to change over time. The fact that the SWEEP NURBS already contains UV coordinates makes it easy, since we can use the GRADIENT. Load it into the TRANSPARENCY channel and set the range of the gradient colors to white/black/white. Increase the TURBULENCE and the SCALE to achieve an effect as shown in Figure 3.55.

Also increase the frequency of the gradient to 2, so the turbulence changes along with the animation. The white areas of the gradient will allow the water to appear clear, while the dark areas of the gradient allow for

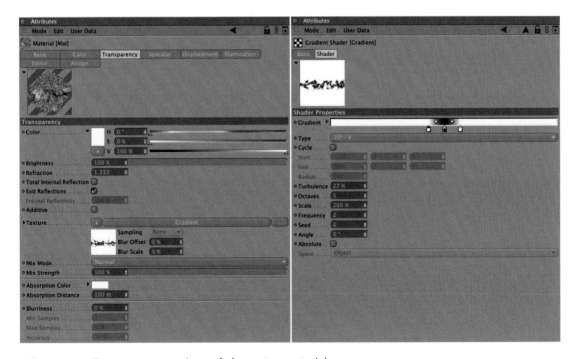

— Figure 3.55: Transparency settings of the water material.

a more opaque appearance. This opaque area should be on top of the waterfall's edge, since there will be little transparency at this spot because of the swirling in the water. If your path spline in the SWEEP NURBS has about an equal length before and after the bend, then the dark area of the gradient is exactly in the middle. Otherwise, you would have to use test renderings to see whether the gradient is placed correctly.

The TRANSPARENCY settings are less interesting. The refraction index of running water is 1.333 and is entered as the REFRACTION value. We will support the material with a strong SPECULAR with a height of about 75%, as shown in Figure 3.56, before we move on to the DISPLACEMENT channel.

To make the water look a bit more rough and wavy instead of just flat, I would like to use the displacement of the surface, the deformation of the surface, when the anima-

tion is rendered. This time, the strength of this effect is going to change over the course of the water. At the ridge of the waterfall I would like to see the most deformations. In addition, all this shouldn't be static, but instead be animated. The deformations are meant to follow the course of the water. This can only be achieved with a combination of three shaders. We will start by loading the LAYER shader into the TEXTURE area of the DISPLACEMENT channel. I also activated the SUB-POLYGON DISPLACEMENT and set the SUB-DIVISION LEVEL to 2. This depends, though, on how finely your SWEEP NURBS was subdivided by the even distribution of the splines.

In the LAYER shader, load the GRADIENT and the PROJECTOR shader by using the SHADER button, as shown on the right in Figure 3.56. The PROJECTOR shader can be found in the EFFECTS group of the SHADER menu. The projector itself is used when an image or

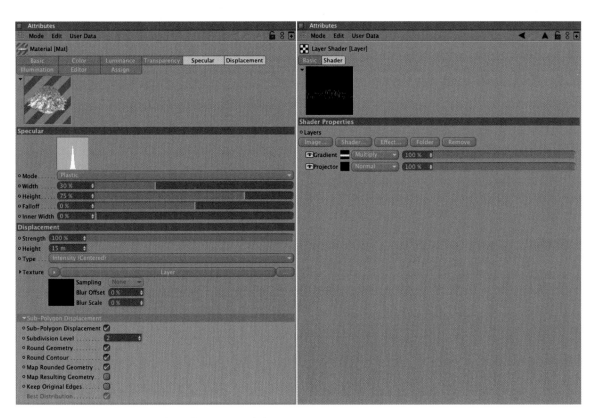

— Figure 3.56: Specular and displacement of the water.

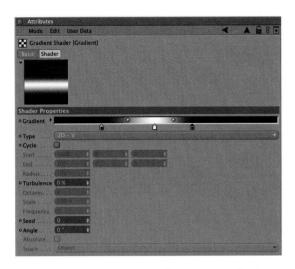

— Figure 3.57: Settings of the Gradient shader.

shader is to be put onto the object in a manner different from what's described in the texture tag. That way, you can apply a material as a UV projection, but project the image in the COLOR channel in a spherical way. In our case we also use UV mapping, but with an animated offset parameter so the material continuously moves across the object.

The color gradient is placed in the LAYER shader above the PROJECTOR via drag and drop, and is run in MULTIPLY mode. The settings of the GRADIENT correspond with the ones in the Transparency channel, but with inverted brightness and without turbulence. Also, the edges don't end in black, but in low brightness between 10% and 40%, so the DISPLACEMENT at the ends of the Sweep NURBS doesn't completely disappear. Figure 3.57 shows the resulting gradients.

**The Animated Projector Shader**

With a click on the small preview area in front of the PROJECTOR in the LAYER shader, you can open its dialog. The PROJECTOR itself just changes the projection of the assigned image or shader. That way, an otherwise spherically projected material can contain an image that is projected flat. For the displacement I chose the WATER shader, which can

be found in the SURFACE section. Load the WATER shader into the PROJECTOR shader, as shown in Figure 3.58. This shader produces grayscale waves that can easily be scaled and animated, with the different FREQUENCY values, in the dialog of the shader. Set the values for U FREQUENCY and V FREQUENCY so that the desired length and density of waves are generated. Check this with test renderings in the editor. The purpose of the PROJECTOR is to generate an animated movement of the WATER shader. This can be accomplished with the OFFSET Y value.

As I explained at the beginning of this chapter, the parameters can be saved as keyframes with a (Ctrl) click on the circle in front of the parameters. Make sure that you are at frame 0 of your animation and save the OFFSET Y value of 0 in the PROJECTOR shader as a key. Then move the time slider to the end frame of the desired animation and increase the OFFSET Y value to 300%. Save this value with another keyframe. This way the water material is moved, during the course of the animation, three times over the whole length of the Sweep NURBS in the direction of the waterfall. The speed of this material movement can be checked later with test renderings in low quality, to see whether it matches the speed of the particles. There are too many unknown variables, such as the size of your Sweep NURBS, to give you precise numbers. You can see in Figure 3.59 some rendered views of our waterfall. With additional elements like a river bed and rocks on both sides, it can look quite realistic and be used for 2D/3D compositions.

More complex particle animations are possible with the separate THINKINGPARTICLES module. However, it requires XPresso for its control and using it would go beyond the scope of this workshop. If you are interested in COFFEE, XPresso programming, and ThinkingParticles, I suggest that you take a look at my DVD workshop, which deals with just these subjects. Parts of this workshop can be found on the disc accompanying this book.

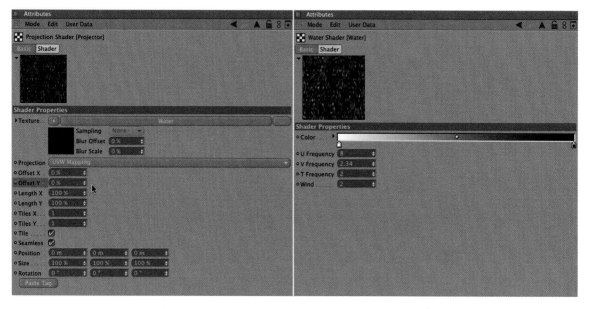

— Figure 3.58: The Water shader in the projector.

— Figure 3.59: Different views of the waterfall.

## Filling a Stadium with MoGraph

The CINEMA 4D module MoGraph special-
izes in the creation of several effects that are
often related to the manipulation of object
copies. It can be used to comfortably control
large numbers of objects. I would like to
demonstrate this module to you in this work-
shop, which is about the simulation of a soc-
cer stadium. We will fill the stadium with
thousands of virtual visitors and apply ran-
dom and determined movement patterns to
them.

## Modeling the Stadium

We don't want to spend too much time with
the modeling. Therefore, I will use simple
geometry for this example. Feel free to add
more details to the stadium if you like. The
stadium is modeled from two RECTANGLE
splines that are subordinated under a LOFT
NURBS object. As you can see in Figure 3.60,
the two rectangles are extremely rounded,
resized, and placed in such a way that the
typical shape of a stadium is generated.

CINEMA 4D rounds the rectangles with-
out increasing the number of points. The

splines contain two points in the center of this rounding where one of these points is not needed anymore. The disadvantage of this extra point is apparent after the subordination under the Loft NURBS, as shown on the right in Figure 3.60, marked by arrows. The subdivision of the shape is condensed where the two points are located. Therefore, convert the two RECTANGLE splines with the (C) key and change to USE POINT TOOL mode. Then select and delete one of the duplicate points in the center of the rounding. Figure 3.61 shows these points on the left.

After deleting these points by using the (Backspace) or (Delete) key, select the remain-ing points at the rounding and place them, in the COORDINATE MANAGER, exactly onto the symmetry axis. Generally this will be the X axis. In this case enter 0 for the X position of these points. Then make a right click in the editor and select SOFT INTERPOLATION in the context menu. The result is shown on the right in Figure 3.61.

A similar problem occurs along the sides of the splines. There the points have only one tangent in the direction of the round-ings. This pulls the faces of the subdivision, calculated by the Loft NURBS, more than necessary in the direction of the roundings. Figure 3.62 shows this effect on the left side. Next to it you can see the adjusted spline

— Figure 3.60: Modeling of the stadium.

— Figure 3.61: Correcting the number of points and the tangents of the rounding.

— Figure 3.62: Adjusting the tangent lengths.

| Punkt | X | Y | Z | <- X | <- Y | <- Z | X -> | Y -> | Z -> |
|---|---|---|---|---|---|---|---|---|---|
| 0 | 434 | 0 | 5.5 | 0 | 0 | -95.106 | 0 | 0 | 95.106 |
| 1 | 165 | 0 | 274.5 | 111.635 | 0 | 0 | 0 | 0 | 0 |
| 2 | -165 | 0 | 274.5 | 0 | 0 | 0 | -111.635 | 0 | 0 |
| 3 | -434 | 0 | 5.5 | 0 | 0 | 95.106 | 0 | 0 | -95.106 |
| 4 | -165 | 0 | -274.5 | -111.635 | 0 | 0 | 0 | 0 | 0 |
| 5 | 165 | 0 | -274.5 | 0 | 0 | 0 | 111.635 | 0 | 0 |

| Punkt | X | Y | Z | <- X | <- Y | <- Z | X -> | Y -> | Z -> |
|---|---|---|---|---|---|---|---|---|---|
| 0 | 434 | 0 | 5.5 | 0 | 0 | -95.106 | 0 | 0 | 95.106 |
| 1 | 165 | 0 | 274.5 | 111.635 | 0 | 0 | -100 | 0 | 0 |
| 2 | -165 | 0 | 274.5 | 100 | 0 | 0 | -111.635 | 0 | 0 |
| 3 | -434 | 0 | 5.5 | 0 | 0 | 95.106 | 0 | 0 | -95.106 |
| 4 | -165 | 0 | -274.5 | -111.635 | 0 | 0 | 100 | 0 | 0 |
| 5 | 165 | 0 | -274.5 | -100 | 0 | 0 | 111.635 | 0 | 0 |

— Figure 3.63: Editing tangents numerically.

tangents and the changes in the subdivided faces along the sides of the Loft NURBS.

In order to precisely edit the tangents, select the upper of the two splines and switch to the STRUCTURE MANAGER. When the POINT MODE is activated, you can see a list of the current numerical point coordinates and tangents. Figure 3.63 shows this in the upper part. The highlighted fields indicate the values that have to be changed. As you can see, only the sides of the tangents that are of 0 length have to be changed to a fitting length in the X direction. The lower half of Figure 3.63 shows my changes.

The right side of Figure 3.62 shows the result at the Loft NURBS. The faces are now more evenly distributed around the upper edge.

## Creating the Stadium Visitors

We will determine the number of visitors indirectly, using the number of faces at the Loft NURBS object. Use the values for MESH SUBDIVISION U and MESH SUBDIVISION V, and increase them so the desired amount of seats is created. Figure 3.64 shows a possible result.

— Figure 3.64: Finer subdivisions of the Loft NURBS object.

— Figure 3.65: Placing polygons as the visitors.

You can work with fewer faces if you like and increase them anytime later on.

For the representation of the virtual visitor in the stadium, we will use a POLYGON primitive. You could also use a more complex geometry, but remember that we will need several thousand copies of it to fill the stadium. Add a CLONER object from the MOGRAPH menu of CINEMA 4D and subordinate the POLYGON object under it. In the CLONER object dialog, activate the OBJECT mode in the OBJECT settings. This will make an object field available into which you can pull the Loft NURBS from the OBJECT MANAGER. As indicated in

Figure 3.65, also activate the ALIGN CLONE option, choose the positive Y axis as UP VECTOR for the orientation of the polygons, and select the POLYGON CENTER mode. This will place the subordinated polygon in the center, with its Y axis pointing upward, onto the polygons of the Loft NURBS object.

**THE RANDOM EFFECTOR**

In order to loosen up the density of the number of visitors and to create more color variety, select the CLONER object in the OBJECT MANAGER and then choose the RANDOM

EFFECTOR in the MOGRAPH menu. As the name indicates, several properties can be randomized with it. Because the CLONER object was active when we added the RANDOM EFFECTOR, it was automatically assigned to the clones. As you can see on the right of Figure 3.66, you can check this directly on the EFFECTORS page in the dialog of the CLONER object.

In the dialog of the RANDOM EFFECTOR, activate the options for POSITION and ROTATION. You can determine, separate for X, Y, and Z and also H, P, and B, the maximum deviation from the original orientation of the polygons. This will loosen up the rows in a natural way. Also activate the COLOR MODE in the COLOR settings. As shown in Figure 3.66, all clones receive random color values.

**THE MULTI SHADER**

Of course, it is not very useful to randomly apply color values to the clones without having the means to further control this color assignment. In these cases the MULTI SHADER of MOGRAPH can help us. Create a new material and load the MULTI SHADER from the MOGRAPH category into the COLOR channel.

Figure 3.67 shows this shader and how you can add images or shaders to it.

Click on the ADD button in the dialog of the MULTI SHADER and load the desired shader, or an image, into the new channel. In our example I used three simple COLOR shaders and assigned different color values to them. How these textures are distributed to the clones is controlled with the MULTI SHADER mode.

In Figure 3.68 on the left you can see the rendered result in INDEX RATIO mode. In this mode, the textures in the MULTI SHADER are assigned to the UV coordinates of the CLONER object. This will result in a striped coloring. This is different in the COLOR RED mode used in the MULTI SHADER in our example. As you can see on the right in Figure 3.68, the red color values of every clone are calculated. This results in a random assignment of the textures in the MULTI SHADER.

## Creating an Audience Wave

To create the right mood in the stadium, the polygons are supposed to behave like people

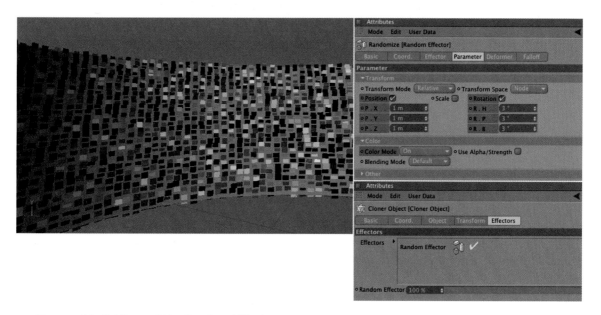

— Figure 3.66: Settings of the Random Effector.

— Figure 3.67: The Multi shader.

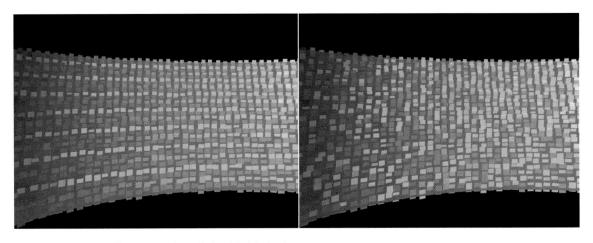

— Figure 3.68: Different modes of the Multi shader.

doing the "wave." In preparation, we will create a spline course that is positioned in the center of the bleachers. Duplicate the LOFT NURBS object, convert this copy with the (C) key, and then change into USE EDGE TOOL mode.

In the SELECTION menu, select the LOOP SELECTION and place the mouse pointer over an edge in the approximate center of the bleachers so a continuous edge is highlighted. Then apply this preview with a click. The desired

selection is shown on the left in Figure 3.69. In the STRUCTURE>EDIT SPLINES menu select EDGE TO SPLINE. Now there is a new spline subordinated under the converted Loft NURBS in the OBJECT MANAGER that is equal to the course of the edge selection. Figure 3.69 shows this spline on the right.

This spline will control the direction of the wave in a moment. If you want to use a certain place at which the wave will start,

— Figure 3.69: Turning an edge selection into a spline.

then click on the spot in the spline in USE POINT TOOL mode. Then right click and select SET FIRST POINT in the context menu. Figure 3.69 shows, on the right side, a spline point that was set as the starting point in this manner. You can also control the future direction of the wave by using the polygons. If necessary turn the direction of the spline by using REVERSE SEQUENCE in the context menu of the editor viewports.

### THE STEP EFFECTOR

The polygons of the CLONER object now have to be moved up and down within a certain space so the effect of a running wave through the bleachers is achieved. This can be done with the STEP EFFECTOR of MoGraph. First, select the CLONER object and then choose the STEP EFFECTOR in the MOGRAPH menu. It will then automatically be added to the EFFECTORS list of the CLONER object. Figure 3.70 shows on the left the current hierarchy of the objects in the OBJECT MANAGER. Next to it you can see the parameters of the STEP EFFECTOR. In the EFFECTOR settings correct the SPLINE so that it creates a horizontal line at the upper edge in the function graph. That way, all clones are treated in the same way by the following parameters.

Then use the FALLOFF settings to control the spatial influence of the effector. As you

can see on the right of Figure 3.70, I decided to use the SHAPE of a CAPSULE and reduced its size, using the SIZE value, so it fits to the dimensions of the bleachers. When the VISIBLE option is active, you can evaluate the falloff radii and the shape of the effector directly in the editor views. The PARAMETER part of the dialog takes care of the actual manipulation of the clones. It would be enough to change the Y position, but I also activated the SCALE and ROTATION so the polygons in the center of the wave appear slightly tilted and enlarged, as if the person had stood up. Move the STEP EFFECTOR, if necessary, above the polygon clones to be able to better evaluate the strength of the effect.

The actual movement of the wave is achieved by the movement of the STEP EFFECTOR above the bleachers. For that reason, we placed the spline halfway up the stadium. Right click on the STEP EFFECTOR in the OBJECT MANAGER and select, in the context menu, CINEMA 4D TAGS>ALIGN TO SPLINE. With the help of this tag, objects can be placed exactly on a spline and also moved along it. For this purpose the tag provides us with the SPLINE PATH field. Pull the previously generated spline from the edge selection of the Loft NURBS into this field. The STEP EFFECTOR should now automatically jump to the position of the start point at this spline.

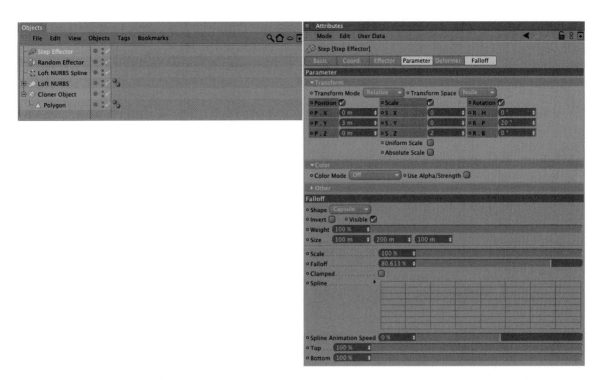

— Figure 3.70: Settings of the Step Effector.

If you also activate the TANGENTIAL option, then a second spline can be used for the alignment of the STEP EFFECTOR. The spline that defined the upper edge of the stadium in the LOFT NURBS can be used for that purpose. With the AXIS menu of the ALIGN TO SPLINE tag you can define the axis that is supposed to be aligned to this RAIL PATH. In my case, this is the X axis. With the percentage value of the POSITION parameter, you can determine at which point of the SPLINE PATH the STEP EFFECTOR should be positioned. By simply animating that value between the extremes of 0% and 100%, the effector can be moved once around the bleachers of the stadium. Figure 3.71 shows an example. This completes the animation, but I would like to add more variations to the movement.

## CREATING ADDITIONAL VARIATIONS

Currently, we use just one RANDOM EFFECTOR for the variation of the clone colors and their positions. To assign additional variations to the clones without affecting their coloring, we will use a copy of the RANDOM EFFECTOR. Duplicate the RANDOM EFFECTOR with COPY/PASTE or with (Ctrl) or (Strg), drag and drop in the OBJECT MANAGER, and rename this effector copy by adding *color*. Deactivate the options for POSITION and ROTATION in this new effector so only the color variations remain.

In the original RANDOM EFFECTOR, deactivate this COLOR mode and change the RANDOM MODE in the EFFECTOR settings to TURBULENCE. This makes it possible to influence the calculation of the random values by changing the ANIMATION SPEED value. The higher the value, the faster the random values change during the animation. With the SCALE value, the size of the used noise pattern can be defined. Smaller SCALE values cause more variations between neighboring clones. I used a value of 100% for the ANIMATION SPEED and 10% for the SCALE. The

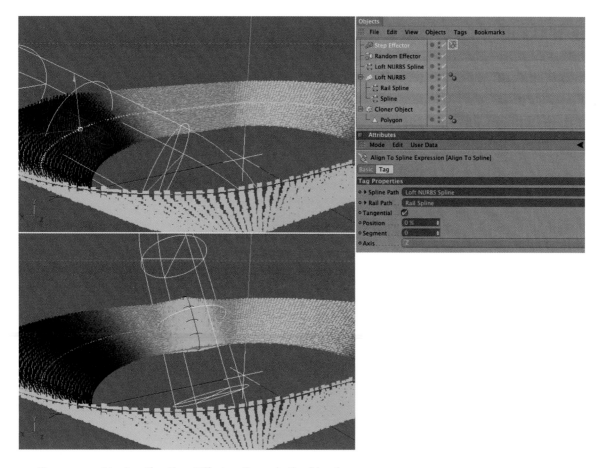

— Figure 3.71: Moving the Step Effector through the bleachers.

INDEXED option should also be activated. This generates random values for all randomly varied parameters, which causes even more variations.

In the EFFECTORS list of the CLONER object, both RANDOM EFFECTORS have to appear so they both affect the polygons. Simply pull the still-missing effector from the OBJECT MANAGER into the list. When the animation is played in the editor, you should be able to notice that the polygons change slightly from frame to frame, but the colors stay the same.

In order to create variations in the wave itself—maybe some visitors don't partake in the wave at all—we will work with weightings. Open the dialog of the CLONER object

and increase the WEIGHT value in the TRANSFORM settings to 100%. This is comparable with the vertex map weighting of a polygon object. This weighting can now be randomized by the RANDOM EFFECTOR, which controls the random movements of the polygons in the stadium. You can find the settings in the PARAMETER section at the OTHER tab. Increase the value of the WEIGHT TRANSFORM to 50%. When the DISPLAY menu is set to WEIGHT in the CLONER object, you should be able to see the different coloring of the clones directly in the editor. Deactivate the green checkmark behind the POLYGON primitive under the CLONER object to get a better view of the weightings.

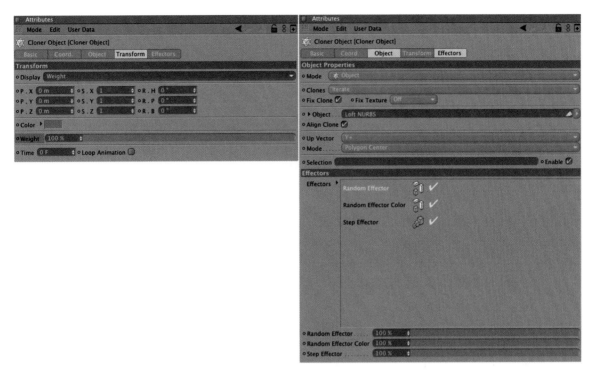

— Figure 3.72: Modifications in the Cloner object for creating weightings.

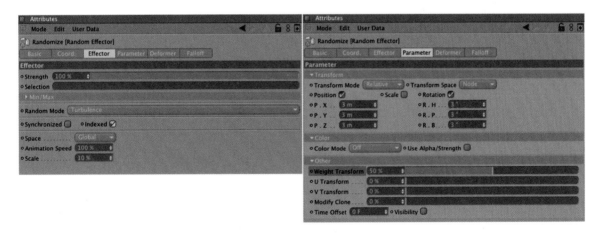

— Figure 3.73: Changes in the duplicated Random Effector.

It is also important that you check the order of the EFFECTORS in the corresponding part of the CLONER object. In the uppermost position there has to be the RANDOM EFFECTOR, which is responsible for the movement of the polygons. Only in that way can the weightings be randomly varied before the

STEP EFFECTOR does its job. As with the deformers, here too the order of the effectors makes a difference. The right side of Figure 3.72 shows the desired order of the effectors.

In Figure 3.73 you can take a look at the described changes in the RANDOM EFFECTOR. On the left you see the settings that cause

the animated change of the clones and on the right the increase of the WEIGHT TRANS-FORM values.

When you now move the STEP EFFECTOR over the bleachers, by animating the POSITION value in the ALIGN TO SPLINE expression as I described, an effect will appear like the one shown in Figure 3.74. At the same time, the RANDOM EFFECTOR takes care of the continuous movement of all clones in the stadium.

— Figure 3.74: Single frames from the animation.

# Character Animation

Character animation is one of the most interesting, but also the most challenging, projects that can be realized with CINEMA 4D. The MOCCA module of CINEMA 4D is used almost exclusively for this purpose. In this chapter, with the help of an example, you will learn about all the important functions of CINEMA 4D and MOCCA used to model a character, to edit the UV coordinates with BodyPaint 3D and apply a texture to it, to prepare the character for animation, and finally to animate it. At the conclusion there will be a short excursion into the world of game development. Using the Unity 3D software, we will explore the possibility of exporting the developed character to a game engine and to interactively control it there.

## The Sketch Phase

Before the first polygon is set we should have at least a rough idea of how the object to be modeled should look. This is especially true for characters. In the case of realistic characters, photos of humans and animals can be used as templates to achieve the right proportions. Since the whole process up to the finished animation will be demonstrated in this chapter,

we will not spend much time with the modeling of a complex character, but instead create a more simply constructed creature.

## Sketching with Doodle

Thanks to the new DOODLE function, we can do the necessary sketching directly in CINEMA 4D. Even the so-called blocking, the evaluation of an animation using key poses, is possible. Open the brush tool in the TOOLS menus of CINEMA 4D under DOODLE. In the ATTRIBUTE MANAGER there are some basic settings, as shown in Figure 4.1, such as the COLOR, OPACITY, and SIZE of the brush. When you plan an animation with several Doodle images, activate the AUTO-ADD FRAMES option. This will create a new sketch whenever you move to another position in the timeline and use the DOODLE brush. Otherwise, the new brush strokes are added to the existing sketch. If you make a mistake, you can use the DOODLE ERASER, which can be found in the same menu as the brush.

With the DOODLE brush active, I start to sketch the desired shape of my character in

— Figure 4.1: Using the Doodle brush to create sketches in CINEMA 4D.

the side viewport. My idea of the character is a mix between a frog and a troll and should be easy enough to model. Figure 4.2 shows my finished sketch. We will adjust the modeling to this sketch in the following steps. Doodle is automatically placed in the foreground of the viewport. If this distracts you during modeling, deactivate the DOODLE object, which was automatically created when the Doodle brush was used, in the OBJECT MANAGER. Simply click on the green checkmark behind this object in the OBJECT MANAGER to turn it off.

A quick look at the TIMELINE, which can be opened in the WINDOW menu of CINEMA 4D, shows that something happened here as well. The DOODLE object sets the keyframes for the created sketches when the AUTO-ADD FRAMES option is active. Otherwise, you can set a manual keyframe anytime with TOOLS> DOODLE>ADD DOODLE FRAME and fill it with a new sketch directly in the editor. In the same menu you will find commands for duplicating, erasing, or deleting a Doodle sketch.

Clicking on the keyframe will open a small preview in the ATTRIBUTE MANAGER, with an arrow button next to it, as you can see in Figure 4.3. This arrow button can be used to navigate to other drawn Doodle sketches.

— Figure 4.2: A sketch of the character to be modeled in the side viewport.

— Figure 4.3: Keyframes with Doodle.

# The Modeling of the Character

The modeling of the sketched character doesn't require many steps. The basic shape of the body can be shaped using a sphere, while arms and legs can be shaped with the extrusion of faces. We will start with a new SPHERE primitive and adjust its size and position to the sketch in the side viewport. The polygonal structure of the sphere can be influenced in the TYPE menu in the ATTRIBUTE MANAGER. In the HEXAHEDRON setting only quadrangles are used. This will be helpful later when the shape is smoothed by a HyperNURBS. Figure 4.4 shows these settings.

To further adjust the shape of the sphere to the sketch, convert it with the (C) key and then activate the BRUSH tool in the STRUCTURE menu. The brush has several settings available in the MODE menu in the ATTRIBUTE MANAGER to define its function. These range from painting and blurring of vertex maps to the distortion and smoothing of surfaces. In SMEAR mode, the brush works in a manner similar to the MAGNET tool, found in the STRUCTURE menu as well, and provides a simple way of deforming the object.

In USE POINT TOOL mode, edit the sphere so it conforms more to the contours of the Doodle sketch and looks pear-shaped in the front viewport. Figure 4.5 shows a possible result.

# Modeling the Mouth

To create a mouth, we need to open the structure in the front half of the sphere. We will use the KNIFE tool in the STRUCTURE menu and set it to LOOP mode. Make sure that the creation of n-gons is deactivated. First, make a horizontal cut where the mouth line was drawn in the sketch. The left image of Figure 4.6 shows this highlighted cut. After that, switch to USE POLYGON TOOL mode and select the polygons above this cut, which are supposed to be the upper lip. This selection is shown in the middle image of the figure. Then use the DISCONNECT command in the FUNCTIONS menu, which disconnects the selected faces from the surface. These polygons now have their own new corner points. Don't confuse this with the CLONE command in the same menu. The CLONE command copies the selected faces into a new object and leaves the original object unchanged.

In order to partially reattach the disconnected polygons to the faces of the sphere, change back to USE POINT TOOL mode and select all points along the upper edge of the disconnected faces. The points of the sphere as well as the points of the disconnected faces have to be selected, so enable the selection of hidden elements as well. The desired selection is shown on the left of Figure 4.7.

Then select the OPTIMIZE command in the FUNCTIONS menu and activate all its options. In our case, only the POINTS option in connection with the TOLERANCE value is important. It ensures that points within the specified

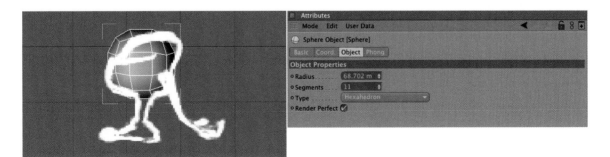

— Figure 4.4: A hexahedron sphere primitive as the start object for the modeling.

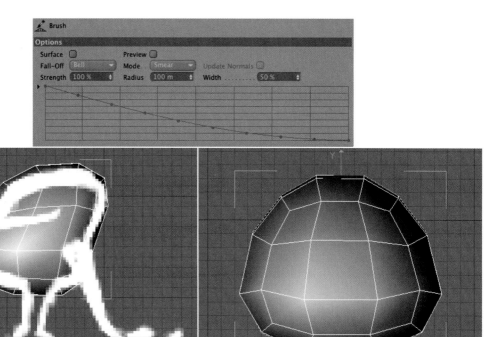

— Figure 4.5: Shaping the sphere with the brush.

— Figure 4.6: Creating the opening for the mouth.

distance from each other are combined into one point. Because of the previous selection, the combination of points is limited to those at the upper edge of the disconnected faces.

After the optimization, expand the still selected points with SELECTION > GROW SELECTION.

This automatically selects the points at the lower edge of the disconnected polygons, too, but not the points of the sphere located at the same position. Deselect all other points while holding the (Ctrl) key. Now only the points at the lower edge of the disconnected faces

should be active. Shrink these points with the SCALE tool, as shown on the right in Figure 4.7. A gap is created where the upper and lower jaw meet.

## MAKING POLYGONS TEMPORARILY INVISIBLE

During modeling you can quickly get lost within details, especially when a model becomes more complex. Sometimes the view is simply obstructed. This problem can be solved by temporarily turning off some of the polygons. In our case I want to further model the

inside of the lower jaw, but because of the closed sphere shape this is made difficult. Therefore, we will select all faces on the upper part of the head as shown on the left in Figure 4.8, then use HIDE SELECTED in the SELECTION menu. In the same menu there are also commands for making the elements visible again or to invert the visibility, meaning that the faces will not get lost.

In the now open lower bowl shape, select the edges marked on the right in Figure 4.8 in USE EDGE TOOL mode. These are the edges leading to the corners of the character's mouth.

— Figure 4.7: Merging the upper row of points.

— Figure 4.8: Making faces invisible to simplify the work on the inside.

The EXTRUDE tool in the TOOLS menu can extrude not only polygons but also edges. The selected edges are duplicated and create new faces with the OFFSET movement, as shown in Figure 4.9. In order to have these faces placed perpendicular to the outer polygons, we will use an EDGE ANGLE of 90°. Either combine this with a negative OFFSET value or use a positive OFFSET with a negative EDGE ANGLE value. The goal is to create faces on the inside of the head, as shown on the right of Figure 4.9. Now make all polygons of the head visible again by using SELECTION > UNHIDE ALL.

### SHAPING THE CORNER OF THE MOUTH

With the future smoothing of the Hyper-NURBS in mind, we will create the connecting faces in the corner of the mouth of the character. There, the faces of the upper and lower lips should blend into each other as softly as possible. The first step is the manual creation of a quadrangular polygon, as shown on the left part of Figure 4.10. Use the CREATE POLYGON tool of the STRUCTURE menu and click in USE POINT TOOL mode on the four points that form the corner of the mouth, in consecutive order. Double click on the last point to create the face. Repeat this at the

other mouth corner. Then use the new points on the lower lip to reshape it, as shown in the left part of Figure 4.10.

### THE ORAL CAVITY

Turn off the upper faces of the head again with HIDE SELECTED. Then use the EXTRUDE tool at the still-active edge selection of the lower lip to create another row of polygons, as shown on the left in Figure 4.11. This time the edge angle is smaller than 90°. The new faces are supposed to run, slightly tilted, in the direction of the lower half of the sphere. The CREATE POLYGON tool in the STRUCTURE menu will help you to close the gap between the new polygons. As you can see in the middle of Figure 4.11, four quadrangles are sufficient for that. These faces can then be compressed along the X axis. The temporary subordination of the model under a Hyper-NURBS shows the effect. The lower jaw is supposed to have a distinctive edge along the lips, but then should swing down in a soft bulge.

### THE UPPER JAW

The upper oral cavity is shaped using the same principle. We will make some space

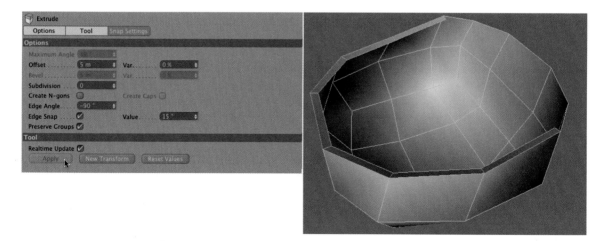

— Figure 4.9: Extruding edges.

— Figure 4.10: Adding a connecting polygon at the mouth corner.

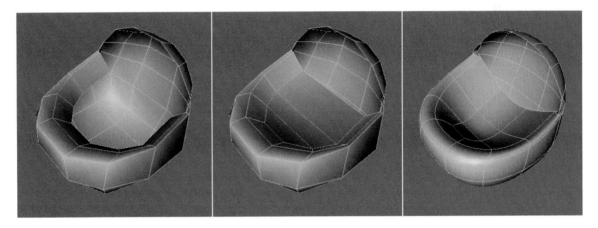

— Figure 4.11: Closing and shaping the lower oral cavity.

first by making all faces visible again with SELECTION>UNHIDE ALL. Make sure that you are in USE POLYGON TOOL mode again, since points and edges can also be turned off.

Then turn off the faces of the lower half of the head the same way as before. This could look like the left side of Figure 4.12. Again, switch to USE EDGE TOOL mode and select the edges of the open edge, but this time at the upper lip. Use the EXTRUDE command to create a row of polygons perpendicular to the outer faces on the inside of the head, as shown on the right of Figure 4.12.

**Stitching Points**

In the area of the corner of the mouth we will get a point, by way of this extrusion, that has no connection to the faces of the lower lip. We will therefore combine this point with the corresponding point of the lower lip. The points in question are highlighted in the middle of Figure 4.13. For a better understanding, the image on the left shows where the previously extruded faces of the upper lip, in the area of the inner mouth corner, are still selected.

Because the lower of the two points is supposed to remain at its current location, we will use the STITCH AND SEW function in the STRUCTURE menu. This allows us, by holding down the mouse button, to pull a connecting line between the points that should be combined. The arrows on the right of Figure 4.13 indicate this. Because the open point at the inner edge of the upper lip is to be moved, it has to be clicked on first and, while holding the mouse button, pulled to the lower point so it snaps to this point. Make sure when you use the STITCH

AND SEW tool that either no points of the object, or just the two points that are supposed to be combined, are selected. This function is limited to only these selected elements.

The following steps are again identical to the ones used at the lower jaw. Extend the faces at the open edge of the inside of the upper lip with an extrusion, so they move further toward the inside of the head and upward. Then manually close the gap in between using four quadrangles, with the help of the CREATE POLYGON function in the

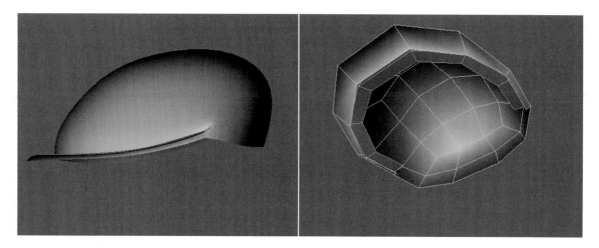

— Figure 4.12: Turning off the lower half of the head and extruding the lower lip.

— Figure 4.13: Combining the new faces with the corner of the mouth.

STRUCTURE menu. The right part of Figure 4.14 highlights the previously extruded faces and the closing faces on the inside. The left part of the figure shows how the corner of the mouth is supposed to look with activated HyperNURBS smoothing.

## Closing Holes Automatically

Make all polygons visible again by using UNHIDE ALL in the SELECTION menu, and then turn some faces off again at the back of the head with HIDE SELECTED. You should see an opening there, as shown on the left in Figure 4.15. It is the result of the missing connection in the back of the head between the upper gum and the lower mouth cavity. Such holes, openings bordered on all sides, can be automatically closed. Select CLOSE POLYGON HOLE in the STRUCTURE menu and place the mouse pointer over a section of the open edge. A highlighted preview face appears that represents a preview of the closing of the hole. A mouse click then actually generates this face and closes the hole, as can be seen on the right of Figure 4.15. This almost completes the modeling of the head. In USE POLYGON TOOL mode, you can turn on all faces again.

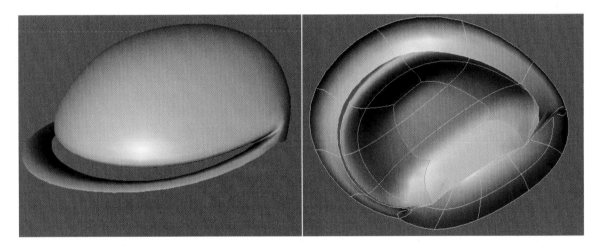

— Figure 4.14: Closing the upper mouth cavity.

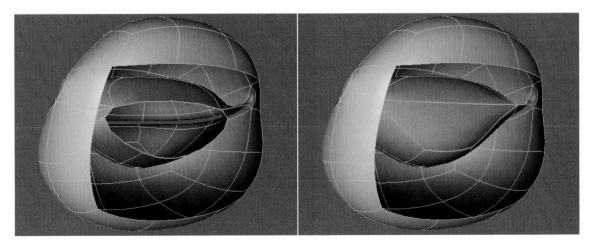

— Figure 4.15: Combining and closing the mouth cavity.

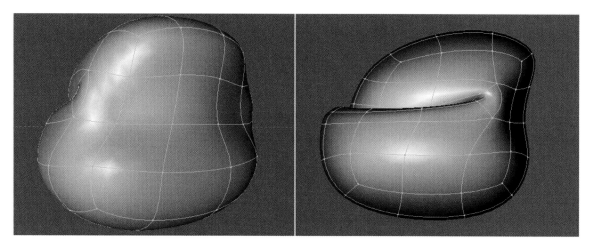

— Figure 4.16: Final shaping of the head.

Take some time and take a long look at the head with activated HyperNURBS smoothing. If you didn't use a HyperNURBS yet, add one from the OBJECTS menu under NURBS, and subordinate the head model under it in the OBJECT MANAGER. The function of the HyperNURBS can be deactivated anytime by clicking away the green checkmark behind it in the OBJECT MANAGER. A possible result can be seen in Figure 4.16. Make sure that the lips are placed on top of each other and that there is no visible gap.

## Modeling the Legs

The modeling of the legs can be achieved by just using the EXTRUDE tool. In USE POLYGON TOOL mode start with a selection of the two faces at the underside of the head where the legs are supposed to be developed. The faces and the first extrusion of these faces are shown in Figure 4.17.

Since we need more subdivisions, especially in the area of the groin to improve the flexibility during animation, we will use a little trick. Move outward the inside points created by the extrusion of the legs, as the arrows on the left side of Figure 4.18 indicate. The face previously located on the

inside of the legs then turns toward the floor and can be extruded, as shown on the right side of Figure 4.19.

### EXTRUDING THE FEET

Extrude these faces another two times downward until the desired leg length is reached. Widen the last two segments by moving the points, following the example shown on the left of Figure 4.19. This takes care of the base of the feet as well. Because of the needed clarity in the figures, the Doodle sketch is often turned off. You should keep it visible, though, and compare it with your model, since it gives you an indication of the length of the legs, the position of the knees, and the size of the feet.

The two faces in front and back at the lower leg base are then extruded individually to build the basic shape of the feet. The back face is extruded in one step to form the heel, and the front face is extended in two steps, first to the base of the toes and then to the tip of the toes.

### Shaping the Toes

In order to keep the modeling effort to a minimum, and in keeping with the simple

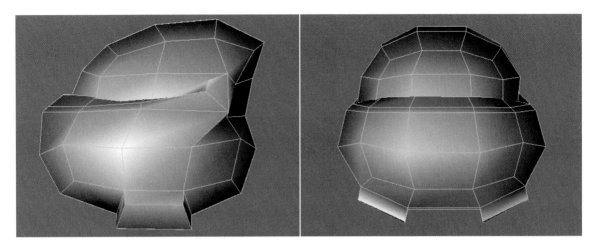

— Figure 4.17: Extruding the upper leg.

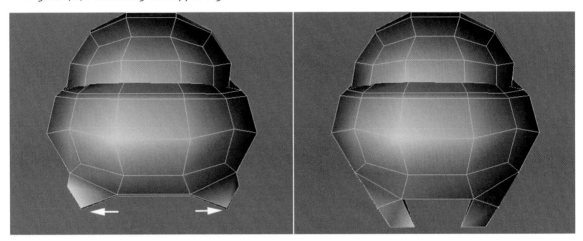

— Figure 4.18: Preparations for the second extrusion.

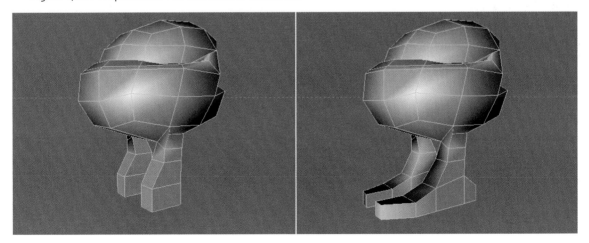

— Figure 4.19: Extruding legs and feet.

nature of the character, I gave the little guy a big toe and a combined shape for the remaining toes. The big toe can be formed from the frontal polygon at the tip of the foot. Just shrink this face along the world X axis, so we almost get a square, and place it on the inside of each foot, as indicated on the left of Figure 4.20. Then select the face that now runs slightly tilted on the outside of each foot. From these faces we will shape the remaining toes by extruding them.

Extrude and move these faces as shown on the left of Figure 4.21. This will look a bit

chaotic without HyperNURBS smoothing, but after the activation of HyperNURBS it will all come together, as shown on the right side of the figure. The outer toes should huddle against the big toes and give the front of the feet a nice appearance.

The HyperNURBS smoothes and gives the roughly modeled shape a nice organic form. However, this can be a bit distracting on the bottom of the feet, where the sole should be plain and less curved. This can be achieved by adding a polygon ring. Select all polygons on the bottom of the feet, but skip the two

— Figure 4.20: Shaping the big toe.

— Figure 4.21: Shaping the toes.

faces under the toes. The toes can look more round since they don't have to be flat on the ground.

Use the INNER EXTRUDE command in the STRUCTURE menu to shrink these faces. Figure 4.22 shows the desired result on the very left. The images in the middle and on the right show that the soles have become nice and flat.

### FINISHING THE FEET

To be able to show details like the width of the toes or the indication of an ankle, we will make some additional KNIFE cuts in LOOP

mode. Figure 4.23 shows some suggestions for these cuts, indicated by arrows. All toes are cut once in the middle, and we will add another subdivision at the last segment of the leg. Use the new points to refine the shape in these areas. At the same time, these subdivisions will improve the maneuverability of the feet during the animation.

## Modeling the Arms

We will now take care of the arms, which start at the sides of the back of the head and end with hands that will lie on the floor. We

— Figure 4.22: Extruding the bottom of the feet inward.

— Figure 4.23: Shaping the feet.

start again with a simple extrusion of two faces, as shown on the left in Figure 4.24. In order to set the profile of the arms more exactly, the points of the newly extruded faces should be straightened, as seen in the middle of the figure. Switch to USE POINT TOOL mode and select the two lower points of each of the extruded faces. Force them onto one plane by entering 0 at the Y and Z SIZE settings of the COORDINATE MANAGER. Then the faces under the arm stumps that are almost parallel to the floor can be extruded further downward, as shown on the far right in Figure 4.24.

Another extrusion extends the arms up to the location of the wrists and leads them in a soft curve downward and back, as shown in Figure 4.25. The finishing touch is made with the EXTRUDE INNER command, which slightly tapers the arms. Pull these new faces slightly backwards along the world Z axis so a little rounding at the end of the arm stumps is created. You can see this in the middle and on the right of Figure 4.25. It is helpful here as well to turn on the HyperNURBS smoothing to better evaluate the curvature of the arms.

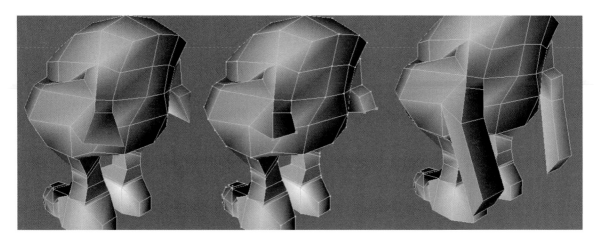

— Figure 4.24: Modeling shoulders and arms.

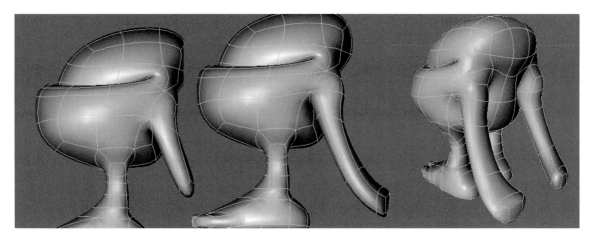

— Figure 4.25: Extending the arms and shaping the transition to the hand.

## MODELING THE HANDS

As can be seen on the far left in Figure 4.26, we will widen the ends of the arms a bit. The arrows in the figure indicate the movement of the two edges. There you also can see the two highlighted faces at the ends of the arm stumps, which will be extruded in three steps and rotated slightly to depict the palms and the stylized fingers at the end. Figure 4.27 shows on the very left how the smoothed HyperNURBS shape might look.

Now the only parts missing are the thumbs, which we can shape out of the origi-nal third face of the arm stumps. Extrude this face a short distance in the direction of the fingers, as shown on the right of Figure 4.27. Then select the two faces that are marked with colored points in the figure and extrude them one step diagonally upward, to shape the actual thumb. Figure 4.28 shows (highlighted) the extruded faces and the desired form of the thumbs. Here you can refer to the original shape in your Doodle sketch.

This completes the modeling of the char-acter for the moment. As I promised, we were able to use just a few tools and we kept

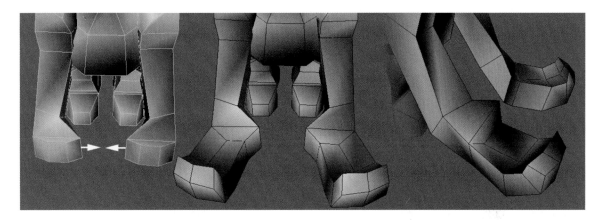

— Figure 4.26: Shaping the palm and the stylized fingers.

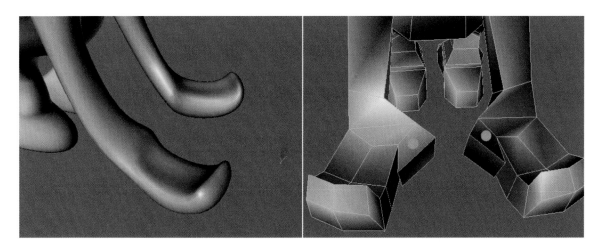

— Figure 4.27: Modeling the base of the thumbs.

— Figure 4.28: Finishing the thumb.

— Figure 4.29: The finished character.

the number of polygons very low. This is especially important with characters built for animations, since it keeps the efforts for texturing and the so-called rigging at a manageable level. Figure 4.29 shows you again the whole character in the side view. If you are looking for more information and workshops about modeling and texturing complex characters, then I recommend my book VIRTUAL VIXENS, published by Focal Press. The workshops there can be completed in CINEMA 4D as well. A short excerpt, in the form of a workshop, can be found as a bonus on the disc accompanying this book.

## Applying Joints and Weightings to the Character

Generally, it is recommended that you always add joints to all characters. They offer the most comfortable tools for weighting, which is the connection of the geometry to the animation of the joints. But there are situations where the character has to be optimized for exporting to other programs. Then the use of bone objects might be better. We will talk about both systems, starting with the joints.

### The Joint Tool

One of the main differences between joints and bones is that joints determine only one position in 3D space and therefore aren't able to deform themselves. Only by using a hierarchical structure of several joints are chains created that can be indirectly used for deformation. The advantage of this is that joints can be oriented individually without disturbing the course of the chain. This is different with bones. They have a defined length and are comparable to a rigid object. When a bone is rotated, then the subordinated objects are automatically rotated and moved as well.

Joints also offer an automated weight mode that is not available with bones.

If you have to work with bones, existing joint setups can be converted to a bone hierarchy. This procedure will be discussed later in this example.

For the creation of joints, activate the JOINT tool in the CHARACTER menu. It allows the creation and positioning of joints in the editor viewports. In the MODIFIERS group within the OPTIONS of the tool in the ATTRIBUTE MANAGER, you will find the presets of the keyboard shortcuts for using this tool. You can change them to your liking. The (Ctrl) keys are the presets for generating new joints by clicking in the editor viewport; just by holding the mouse button, previously set joints can be moved. A (Shift) click onto a connection between two joints creates a new joint halfway. Figure 4.30 shows these basic settings in the lower part of the dialog.

### SYMMETRY SETTINGS

Generally, characters are modeled symmetrically. The arms and legs are positioned at identical locations on both sides of the body and have the same structure. With the SYMMETRY settings of the JOINT tool, we can save ourselves some work with such body parts. Only the joints of one arm or leg have to be drawn in. The other half of the body is then automatically amended. The necessary settings can be found in the SYMMETRY part of the JOINT tool. These settings are shown in the middle of Figure 4.30.

The SYMMETRY function is activated in the corresponding menu. The setting NONE deactivates the symmetry so joints are only created where a (Ctrl) click is made. At the DRAW setting, joints are set symmetrically according to the PLANE and ORIGIN settings. The LINK setting functions in a similar manner but generates a permanent connection between the joints on both sides, so symmetrical changes at the joint positions can be applied, even when the tool has been deactivated. Depending on the kind of character,

— Figure 4.30: The dialog of the Joint tool.

this can be helpful or distracting for its future animation.

PLANE determines the mirror plane. For a character visible in the front XY viewport, this would be the WORLD YZ PLANE. If the character was modeled in an angled way, then the planes can be defined in the local coordinate system. ORIGIN defines the position of the mirror plane in 3D space. This could be the WORLD system, the ROOT (the uppermost joint of the hierarchy), the PARENT of the currently active joint, or any OBJECT of the scene. This object can then be pulled into the OBJECT field in the dialog. The HUB setting accesses the same option in the dialog of the joints. When this option of a joint is activated in its symmetry settings, the joint automatically acts as the origin during painting of symmetrical joint chains.

### GENERAL INFORMATION ABOUT INVERSE KINEMATICS

The options of the JOINT object determine how the joints are evaluated with automatic weighting and whether an inverse kinematics solution should be generated after the joints are drawn. As the name indicates, inverse kinematics is the flow of movement through the joint hierarchy. Without any

other preparations, all objects can be animated with just forward kinematics. This is often abbreviated with FK. Here, all bones have to be rotated manually to create the desired pose. The advantage is that we have full control over the position and rotation of every object. To clarify the disadvantage of this animation technique, imagine a character that is supposed to do a deep knee bend. By animating with FK, the character would have to be moved completely downward. Then all bones or joints would have to be rotated so the feet are again planted on the ground—a very complicated procedure. When the character is animated with inverse kinematics, or IK, then it would only have to be moved downward. The feet automatically remain fixed to the floor and the legs automatically bend.

Because of the fixed position of the feet, an energy flow is generated through the legs up to the beginning of the corresponding hierarchy. Some settings in CINEMA 4D call it the anchor, which defines the uppermost link of such an IK chain. Despite the practical use of IK, this technique isn't used everywhere on the character. Arms, fingers, and the complete spine/neck/head hierarchy are generally animated with FK. An exception would be a character that is supposed to do a headstand. Then it would be better to use IK to fix the hands and the head on the floor, while the body would be moved manually with FK.

## THE IK CHAIN SETTINGS

Let us get back to the settings of the JOINT tool. In this tool, such IK relationships can be created automatically when the joint chain is created. Figure 4.31 shows a simple example. Use the settings of the IK CHAIN menu in the OPTIONS of the JOINT tool. At the 2D setting, the future mobility of the joints is restricted by an imaginary plane that is placed at the starting position of the joints. This can be helpful to prevent the

— Figure 4.31: Automated creation of an IK chain.

lateral movement of the knee when doing a knee bend or to avoid the backward bending of the knee when the body is moved up and down. When complete mobility is needed, then the 3D setting should be used. Then, only the position of the target object is important for the IK chain. All involved joints then try to move toward the target point as much as possible. The SPLINE setting assigns in a newly created spline object, after the deactivation of the JOINT tool, a point to every active joint of the chain. With the movement of these spline points, the position of these joints can then be changed. This can be useful for the depiction of ropes, longer animal tails, or the spine of a character.

In the 2D and 3D settings the POLE NULL option can also be selected. It will add another Null object after the JOINT tool is deactivated. The Null object is used for the orientation of the Y axis of the joints. Figure 4.32 shows a simple example. It can be used for additional control over the rotation of joint connections and avoids possible unwanted rotations around the longitudinal axis. The setting NONE prevents the automatic generation of IK relationships. They can still be manually created later.

— Figure 4.33: Different size settings for the bones.

— Figure 4.32: An IK chain including Pole Null vector.

## BONE SETTINGS

The BONE menu determines how the bone connections between the joints are interpreted. At the AXIS setting, these connections run, like normal bone objects, along the Z axis of the joints. With an active ALIGN AXIS option, the joints are automatically oriented so their Z axis points to the following joint. With TO CHILD, the bone connection ends at the subordinated joint object. With TO PARENT, this direction is reversed. The direction of the bone connections is important for the assignment of weightings. Depending on the choice in the BONE menu, the weightings are applied either to the section of the following joint or to the section in between the current joint and the one above. The results are quite different and cannot be switched later. The setting TO CHILD should be the more logical choice in most cases.

## THE SIZE OF THE BONES

The connections between the joints are also called bones but aren't real objects, as is the case with the bone objects. Therefore, the size of these joint bones can be determined independently from the joint positions. In the SIZE setting LENGTH, the measurements of the drawn bones adjust to the length of the segments between the joint objects. At CUSTOM the circumference of the bones can be set with the CUSTOM value, as shown in Figure 4.33. These settings are a mere visual change and don't have anything to do with the future function of the bones and joints. Also, the highlighting of the joints and bones in the DISPLAY part of the JOINT tool can be influenced with the HIGHLIGHT and BOUNDING BOX option. HIGHLIGHT changes the brightness of the bone when the mouse pointer is above it. BOUNDING BOX draws an orange box, familiar to us from the selection of normal objects, around the bone.

## The Joint Setup of the Character

Let's get back to our character. We will use the JOINT tool to create some joint chains. It is helpful to orient ourselves on an imaginary skeleton of the character, as if we were working with a living creature. On every spot

where the character needs a joint or where you want to gain control over the mobility, you have to place a joint. Many joint objects in a section can increase the mobility of the character, but also make it more difficult to animate. We have to find a compromise between the two goals.

After activating the JOINT tool we will start with (Ctrl) clicks in the side viewport, starting at the hip, to place the joints marked 1, 2, and 3 in Figure 4.34. I used the standard settings of the JOINT tool, no SYMMETRY, and no IK CHAIN. The bones are aligned TO CHILD and the axis aligned with ALIGN AXIS. The ROOT NULL option can remain deactivated; otherwise, it would create another Null object under which all other created joint objects would be subordinated.

The joint marked number 4 in Figure 4.34 is supposed to be connected to joint number 2. Therefore, the creation of the joints is finished after the creation of joint 3. Then select the joint second from the top in the OBJECT MANAGER and set, with another (Ctrl) click, joint 4 at the crown of the character. Joint 4 is automatically subordinated under the last selected object in the OBJECT MANAGER. That way, you can generate branched joint hierarchies without having to leave the JOINT tool. The main body now contains enough joints.

## THE RIG OF THE LEGS

We now move on to the legs. These naturally belong under the joint object of the hip, which is generally called the root joint and acts as the uppermost object of a character rig. Because the legs of our character are symmetrical, we can save ourselves half the work by using the SYMMETRY function of the JOINT tool. Activate DRAW as the SYMMETRY option for the drawing of the joints and use WORLD as the ORIGIN and YZ as PLANE. Local or world system doesn't make a difference here, as long as the sphere wasn't rotated around the Y or Z axis in the beginning of the modeling. Figure 4.35 summarizes these settings.

Select the hip joint in the OBJECT MANAGER and create, with (Ctrl) clicks in the side viewport, the joints marked with the numbers 1 to 5 in Figure 4.36. After creating the first joint, move it in the front viewport along the X axis so it is placed in the correct position at the base of the leg. Because of the activated symmetry, the mirrored joint in the other leg is automatically moved as well; we don't have to hold any other key for moving the joint. Just click on the yellow circle of the joint object and pull it to the desired position. As you continue to create

— Figure 4.34: The joints for the body and the head of the character.

— Figure 4.35: The leg joints can be created symmetrically.

— Figure 4.36: The joint objects within the legs of the character.

the remaining leg joints in the side viewport, they should automatically be generated in the same ZY plane and placed in the center of the legs. Check and correct this, if necessary, in the front viewport.

Regarding the number and location of the joints, the order of the joints shown in Figure 4.36 has proven to be the best setup. In addition to the joint object of the hip, a joint is placed at the knee, one at the ankle, and another one at the base of the toes. The connecting joint is placed at the tip of the toes. Depending on the complexity of the character, it might be useful to create individual

joints for all toes. This will not be necessary for our simple comic figure.

### THE RIG FOR THE ARMS AND LEGS

Normally, it would be enough to use three joint objects for the arms: one for the shoulder, one for the elbow, and one for the wrist. The joint objects for the hands and the fingers would be connected to these. In our case, I would like the arms to be more elastic, though, without a set joint in the center. As you can see in Figure 4.37, I created an almost evenly subdivided joint chain from

— Figure 4.37: The joint objects in the arms and hands.

the shoulder down to the wrist. The wrist is indicated in green in the figure.

The joints of the arms can be created symmetrically as well. Therefore, keep the settings in the JOINT tool which we used for the legs. Select the hip joint again as the uppermost object for the chains about to be created, and start in the side viewport with the placement of the first shoulder joint. Correct its position by moving it in the front viewport, then continue to set the joints down to the wrist in the side viewport. From there, add two more joint objects that span the length of the palm and the fingers, with the last joint placed at the finger tips. In the OBJECT MANAGER select the joint that is placed at the wrist, marked in green in Figure 4.37. Based on its position add three additional joint objects to enable the mobility of the thumbs. These joint objects can be placed properly into the character using the top viewport. Correct their location if necessary in the other viewports. That completes the job of the JOINT tool and all necessary joint objects have now been created.

## The Weight Tag and the Creation of Weightings

Contrary to the function of the bone objects, the joint objects aren't deformers. Therefore, they don't have to be placed in one group with the object to be deformed. It is recommended, though, just as with the bone objects, that you give all joint objects new names before the next step. Figure 4.38 shows an example and the current hierarchy of the joints in the OBJECT MANAGER. You can see there that a new tag was created behind our model *Trolly*. This WEIGHT tag will be needed later for the assignment to and management of the weightings of the joints. It is created by right clicking on the character model in the OBJECT MANAGER and by selecting CHARACTER TAGS>WEIGHT. This automatically opens the WEIGHT tool, and its settings

— Figure 4.38: The weighting tag.

are then shown in the ATTRIBUTE MANAGER. This tool can be used for the individual painting and correcting of the weightings. The big advantage of joints is that they can add automatically generated weight distributions, meaning that a majority of the manual weight painting can be skipped. Therefore, click again once on the WEIGHT tag in the OBJECT MANAGER to see its settings in the ATTRIBUTE MANAGER. Figure 4.38 shows the tag dialog.

In the JOINTS area of the WEIGHT tag, there is still an empty list that has to be filled with all the joints that will influence the object. In our case these are all the joints previously created. Select the root joint of the hip, right click on it, and choose SELECT CHILDREN in the context menu. The dialog of the WEIGHT tag then disappears from the ATTRIBUTE MANAGER, but you can activate it again with multiple clicks on the arrow pointing to the left in the title bar of the ATTRIBUTE MANAGER. With drag and drop, pull the selected joint hierarchy into the OBJECTS list of the WEIGHT tag, as shown on the left of Figure 4.39. If you pulled an object into the list by accident, you can delete it by right clicking and selecting REMOVE in the context menu.

— Figure 4.39: The weight tag with applied, but not weighted, joint objects.

## MANAGING AND AUTOMATICALLY CREATING WEIGHTINGS

Now it gets more interesting in the TAG part of the WEIGHT tag. There you can find the SET POSE button for setting the start pose of the rig. This saves the current position of the joint objects so you can always go back to the original pose of the rig with the RESET POSE button. This can be helpful if the assigning of inverse kinematics results in unwanted torsions of the character. The saved start pose is also important for the future calculation of the model deformation. CLEAR WEIGHTS deletes all existing weightings of the joints in the list, and REMOVE EMPTY deletes the joints that don't carry any weighting for the object.

AUTO WEIGHT will now get interesting for us since it automatically calculates weightings for the joints in the list. In the best possible case, we could then start immediately with the animation. In practice, though, evaluation and partial correction of the automatic weightings are necessary, but the time saved is still tremendous. Use the AUTO WEIGHT button and watch the display of the

character model in the editor. As shown in Figure 4.40, the character should now be shaded with light colors. The previously black display was an indication that weightings didn't exist yet.

As with the vertex maps, this weighting system is combined with color and brightness values that show the strength of the weightings in the editor. The automatic weighting ensures that every point of the object is assigned to a nearby joint and weighted for that joint. The object now appears to be completely weighted.

## EDITING AND DISPLAYING INDIVIDUAL WEIGHTINGS

To get an overview of the individual weightings of each joint, double click onto the WEIGHT tag in the OBJECT MANAGER or select the WEIGHT tag directly in the CHARACTER menu. In the JOINTS area of the tool dialog you can find a listing of all the joints in the scene. When you click on a joint in this list—this is why it is so important to give the joints meaningful names—you get a colored display of the weight distribution for this joint. In

— Figure 4.40: The character after assigning automatically calculated weightings.

— Figure 4.41: Individual weight display.

Figure 4.41 you can see as an example the automatically created joint weighting at the jaw joint of the character. The unwanted weighting of the bottom jaw and stomach of the character is clearly visible.

### Options of the Weight Tool

The WEIGHT tag offers in its OPTIONS and PAINT settings several options for editing such unwanted weightings. Figure 4.42 shows the corresponding part of the dialog that we will now go through. The majority of these functions are self-explanatory. The STRENGTH sets the intensity of the applied weightings between the extremes 0% and 100%. When AUTO NORMALIZE is active, all subtracted or newly painted weightings of a joint are automatically synchronized with the remaining joint weightings. That way, every point automatically keeps a weight strength of 100%.

The MODE determines whether weightings are applied with every pass of the tool or subtracted from the joint with the erase function. Weightings can be applied absolute or painted with soft edges as well. BLEED increases the already weighted areas of the object and REMAP allows the editing of existing weight

— Figure 4.42: Settings for the painting and editing of the weightings.

values with a curve. This effect is comparable to working with the gradient curve in image editing. PRUNE is equal to a clipping function. Points with weighting less than the strength of the WEIGHT tool in the dialog are reduced to 0% intensity. The two CLAMP options, including their sliders, can be used for the definition of upper and lower limits of the applied and manipulated weightings. The NORMALIZE button is helpful if you haven't used the AUTO NORMALIZE option. With the use of this button, the weightings of all objects affected by the currently selected joint object are normalized. With APPLY ALL, all points of the object receive the value specified by the STRENGTH of the currently selected joint. This of course also changes the weightings of all the other joint objects. When points, edges, or polygons of the object are selected, you can apply to them, with APPLY SELECTED, a weighting based on the STRENGTH setting. With REASSIGN TO SELECTED, all elements not selected receive a weighting of 0%. In the CHARACTER menu you can find the WEIGHT EFFECTOR. It works like a small force field with adjustable falloff radii and is able to include points of the object for the joint to pull. To be affected, this object has to be subordinated under a joint and listed in the OBJECTS list of the WEIGHT tag as well. With the help of this object, the deformation between two joints can be individually

changed to achieve smoother transitions. The object itself is not a deformer in this case, but instead only supplements the influence of the joints on the geometry. This influence can be recalculated into weightings with the BAKE EFFECTORS button. The WEIGHT EFFECTOR can then be removed from the joint. The FROM VERTEX MAP and TO VERTEX MAP functions convert the weighting into a vertex map or transform the vertex map intensities into a joint weighting.

**Paint Settings of the Weight Tool**

The PAINT radius is set in the paint settings of the weight tool, as well as whether VISIBLE ONLY or SELECTED ONLY should be painted. When PROJECTION is active, all points that are located under the tip of the tool in the current viewing angle in the editor viewport are weighted. Otherwise, the tool follows the contours of the surface and makes areas, which are otherwise hidden, accessible for weightings. Also with this activated tool, the risk of accidentally weighting hidden points is reduced.

The STEP function determines how many steps are used to apply or edit weightings. The higher the value, the more detailed the work can be. The FALL-OFF function controls, within the boundaries of the RADIUS value, the falloff of the weighting strength at the edge of the tool. There are several functions available that only make sense if you work with detailed geometries and capture a number of points with one brush stroke. For example, HARDNESS works like a contrast function. Small HARDNESS values cause a softer transition to the outer radius of the tool; high values, on the other hand, cause an almost constant application of weightings up to the edge. In the CURVE settings you can manipulate this falloff curve yourself in a graph and create more unique weight applications, like a weighting just at the edge of the tool tip.

The PRESSURE setting is relevant if you want to use the tool in combination with a graphics tablet. The pressure of the pen changes the

radius of the WEIGHT tool in the RADIUS setting, the intensity of the weight application in STRENGTH, and the falloff curve of the tool in HARDNESS. The NONE setting deactivates this special behavior resulting from the use of a pressure-sensitive graphics tablet.

Now you know everything about the options for the manual application of weightings. In the WEIGHT tool, select the joints, one after the other in the corresponding part of the tool dialog, to evaluate their weightings. When you encounter a section with wrong or unfavorable weightings, like with the jaw joint, activate a 100% STRENGTH in ABS MODE and leave AUTO NORMALIZE active

in the OPTIONS section of the dialog. Then repaint the points, which should be moved when the jaw is rotated. It might help to switch to a line display in the editor to reach the points positioned within the model. Repaint the wrongly weighted points with a STRENGTH of 0% or use the ERASE mode of the tool. Figure 4.43 shows the corrected weighting of the jaw joint.

Faulty weightings are also possible at the upper joints of the arms, since the geometry of the body comes very close to the arms in this spot. Delete any weighting for the lower arm joints at the body of the character, as shown in the before and after images in Figure 4.44.

— Figure 4.43: Correction of the jaw weighting.

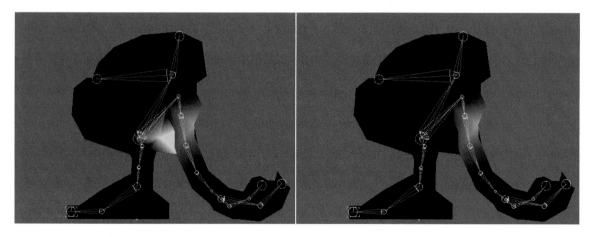

— Figure 4.44: The new weighting of the upper arm joint.

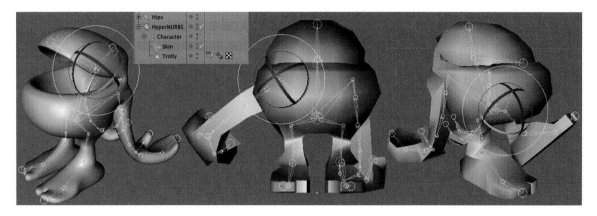

— Figure 4.45: Evaluating the weightings by rotating the joint objects.

## Checking the Weightings and Deformations

As previously explained, contrary to the bone objects, joints are not deformers. Therefore, despite the previously applied weighting, there won't be a deformation when the joints are rotated. We will need to use the so-called SKIN object that is found in the CHARACTER menu. Simply subordinate it under the object to be deformed or under its superordinated object.

Figure 4.45 shows the resulting hierarchy. You can see that the joints don't have to be in hierarchical relation to the objects that are to be animated. When the SKIN object is subordinated, the rotation of single joints should move the geometry of the character. For the first tests it would be best to check critical areas such as the jaw joint, the thigh, and the shoulder. If strange deformations occur, go back to the WEIGHT tool and correct the weightings again until the deformations are correct.

## Activating Inverse Kinematics and Dynamics

The character could now be animated by using forward kinematics. The joints would have to be individually rotated and, in the case of the hip joint, moved as well. In places where the character is more often in contact with other objects, the use of inverse kinematics makes more sense. This is generally the case with the feet and legs. In the OBJECT MANAGER, hold (Ctrl) and select, one after the other, the four joints of the leg. They are marked by colored points in Figure 4.46. The joint of the knee can be skipped over.

In the CHARACTER menu, while still holding the (Ctrl) key, select IK CHAIN. It applies IK tags to the currently selected objects and automatically creates three external help objects for the foot. Figure 4.46 shows these additional objects on the right side. These are generic Null objects that apply a magnetic force through the IK tags to the joints. That way, the joint position can be controlled from outside the joint hierarchy.

— Figure 4.46: Creating handlers for the legs.

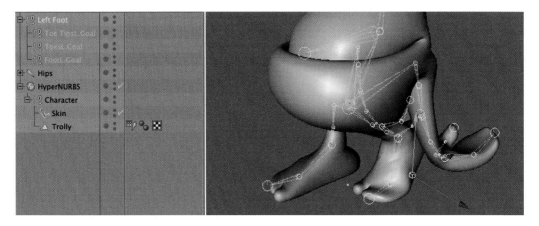

— Figure 4.47: Using external handlers.

To make it easier to use these external handlers during an animation, create a Null object and place it under the sole of the foot for which you just created the IK. Null objects can be found in the OBJECTS menu of CINEMA 4D. Then subordinate the three external handlers under the new Null object, as shown in Figure 4.47. When you now move this group of handlers backward along the Z axis, the foot should move backward as well and automatically lift the heel while the front part and the toes remain on the ground. As you can see, quite complex movements can be achieved by a simple movement of the handler objects. Do the same with the joints of the other leg.

### ORIENTING JOINT OBJECTS

The uniform orientation of the joint objects in a continuous chain is not as critical as with bone objects, but helps nonetheless. While the orientation to the following joint was activated during the creation of the joints, their rotation around the Z axis can vary, as a quick look at Figure 4.48 proves. As you can see by the arrows, the Y axes of the arm joints are uniformly oriented up to a point. However, in the area of the hands there is a −180° rotation. This could cause unwanted rotations in a future animation, so align these joints with the JOINT ALIGN tool in the CHARACTER menu.

This tool can orient selected joints toward objects. We will utilize this for aligning the Y axis of the joints. Create a new Null object that we can use as the target object for the Y axes. Place it above the hand of the currently selected joint chain. An appropriate positioning can be seen on the right of Figure 4.48. The Z axis is automatically aligned in the direction of the bones.

The figure also shows the necessary settings in the dialog of the tool. The Z AXIS of the joints should still point in the DIRECTION of the next BONE. In UP AXIS we define the Y axis of the joints and orient them, with the UP DIRECTION selection of AIM, toward the new Null object. With a click on the ALIGN button, all joint axes are updated without changing the position of the joints.

### USING MOCCA IK

Besides the IK tag, for the inverse kinematics of the legs there is also the MOCCA IK tag. It offers additional possibilities for overlaying inverse kinematics with dynamic effects such as drag or gravity. We will now use this tag

— Figure 4.48: Automatically orienting joint objects.

at the arms of the character. Select all joints of an arm from the shoulder down to the wrist and apply the tag by right clicking and selecting CHARACTER>MOCCA IK.

Contrary to the previously used IK tags, the MOCCA IK tags have to be restricted with an ANCHOR. It defines the uppermost object of an inverse kinematics chain. Select the MOCCA IK tag at the shoulder joint and activate the ANCHOR option in the TAG settings of the ATTRIBUTE MANAGER, as seen on the right in Figure 4.49. This automatically turns on the options for the dynamic behavior of the joints or bone objects that follow in the hierarchy. My settings can also be seen in the figure.

SPEED is a multiplier for the calculation of dynamic effects. Higher values cause faster movements and lower values cause the opposite. DRAG is a kind of resistance against impulses. A drag set too high can, in extreme cases, stop the dynamic effects altogether. GRAVITY, on the other hand, pulls all objects downward along the Y axis when used with a

negative value. A value of −9.81 represents the average value of earth's gravity. Since we can't assign mass to the bones, you should use the DRAG and GRAVITY values to create the desired behavior of movement. DRAG controls the passing of rotations from one bone to another. High values slow down the passing of changes through the bone chain, causing the individual bones to try to stay in their current position longer. In this way, high drag values can be used to simulate big, heavy masses.

Select the MOCCA IK tag of the wrist joint and take a look at its CONSTRAINT dialog. External reference objects can be assigned or created within this dialog. The choices are the TARGET object that magnetically affects the position of the joint and an UP VECTOR object that is used to point one of the axes of the joint or bone toward it. The use of the APPLY button behind the TARGET field generates a new Null object that can be used to move the entire joint chain between the ANCHOR shoulder and the wrist.

— Figure 4.49: Assigning MOCCA IK tags.

As Figure 4.50 shows, I renamed these external Null objects HANDL and HANDR, respectively. The joint chain of the other arm is treated in the same way.

### Aligning the Up Vector

We have already uniformly aligned the joints of the arms. In order to keep it that way during an animation and to avoid unwanted rotations, we will use an external object to roughly orient one axis of the joint to it. This results in restricted mobility for the X and Y axis of a joint. This alignment is called UP VECTOR.

For the assignment of an UP VECTOR, do the same as with the TARGET object. First, select the MOCCA IK tag behind the first joint, under the anchor of the corresponding arm, and use the ADD button behind the UP VECTOR field to generate a new Null object. This Null object is then placed above the

— Figure 4.50: Creating and assigning an external target object.

— Figure 4.51: Aligning the Up Vector.

hand. If you still have the Null object that we created for the alignment of the joints, then use that one instead. Simply pull this object into the UP VECTOR field, which makes the use of the ADD button unnecessary.

Then select all following MOCCA IK tags in the OBJECT MANAGER with a frame selection and, in their dialogs, pull the new Null object into the UP VECTOR field as well. Figure 4.51 shows the last few steps.

Since the joints might have been rotated, you should deactivate the SKIN object for a moment by simply clicking on the green checkmark behind it in the OBJECT MANAGER. The geometry of the character then automatically jumps back to the state in which it was modeled. In case their position changed, use the two external handlers at the wrists to place the joint chains in the center of the arms. Then click on SET POSE in the WEIGHT tag of the character to save the new angles and positions of the joints.

Activate the SKIN object again by clicking on the now red cross in the OBJECT MANAGER. The character should remain unchanged. Figure 4.52 shows these last steps. On the left side you can see the supporting display of lines for the Up Vectors and the yellow connecting line that automatically spans between the anchor and the last link of a MOCCA IK chain.

## CONVERTING JOINTS TO BONES

We are now at a point where we could start with the animation. But since I would like to demonstrate a possible exchange of the animation with an external program that doesn't know joints, we will first convert the current joint rig to a bone setup. All weightings and IK tags remain the same.

Select the root joint and then choose CHARACTER > CONVERSION > CONVERT TO BONES. A new bone hierarchy is generated, displayed

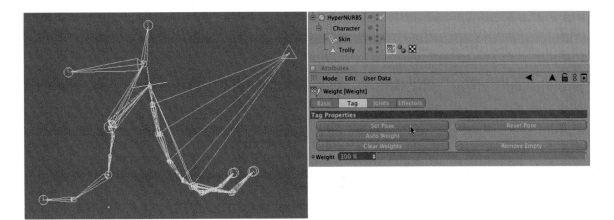

— Figure 4.52: Visual depiction of the constraints.

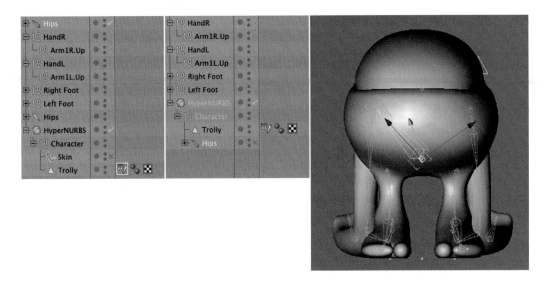

— Figure 4.53: Converted joint rig.

on the left in Figure 4.53, which consists of already fixed bones, as indicated by the checkmark. In order to exchange the joint hierarchy with the bones, you first have to delete the SKIN object. It is not needed anymore, since bone objects themselves are deformers. Then delete the entire group of joint objects, but keep the external help objects that were automatically assigned to the new bone objects during the conversion. Because deformers always have to be subordinated, these bones now belong in the group with the model of the character. To prevent

unwanted distortions do the following. First, select the uppermost bone object and then select SOFT IK/BONES>RESET BONES in the CHARACTER menu. The question about the subordinated object has to be confirmed with OK. The bones lose their deforming properties for now and can be pulled into the Null object group of the character. Figure 4.53 shows these steps on the left side. On the right you can see how else the joint objects differ from the bone objects, because the structure changed at the locations where the rig branches out. This change of location

doesn't influence the deformation of the character, but you can take the time to align the bones again the way you think they need to be. For example, you could pull the bones of the upper part of the head and the bones of the arms out of the hierarchy, align the stomach bone to the imaginary spline, and then subordinate the head and arm bones again.

After the bones are realigned, fix the bones to their current location. Again, select the uppermost bone and this time select CHARACTER>SOFT IK/BONES>FIX BONES. Also here, confirm with an OK that the subordinated bones should be fixed as well. This completes the conversion from a joint rig to a bone rig and we can start with the animation. Our character could use some color and textures, though. Therefore, we will use this opportunity to take a look at the BodyPaint 3D module of CINEMA 4D.

## TEXTURING OBJECTS WITH BODYPAINT 3D

Many surfaces can be textured with shaders or, for example, with a plane or spherical projection of images. In some cases these methods don't go far enough, like when a surface is supposed to be changed in a certain way by painting on it, or when an image structure should follow a curve on the object without being distorted. In such cases the creation and unwrapping of so-called UV coordinates is necessary beforehand. These coordinates cover objects like a second skin and determine the projection of the material onto the surface. Imagine that these coordinates are like the unfolding of the entire surface onto one plane. Of course, it is much easier to project the texture that way than onto the curved surface.

Even though BodyPaint is completely integrated into CINEMA 4D, it is not immediately apparent. When you switch into one of the BodyPaint 3D layouts with WINDOW>LAYOUT, all managers and tools of BodyPaint 3D become visible. In this menu there is the BP UV EDIT layout, which is optimized for working on the UV coordinates, and the BP 3D PAINT layout, which is meant to be used for the painting and editing of textures.

### Creating a New Texture

In the first step you should create a new material in the MATERIAL MANAGER for our comic character. In the COLOR channel of this new material in the texture area, click on the small triangle and select CREATE NEW TEXTURE from the drop-down menu. Then a dialog opens, as shown in Figure 4.54, in which you can define the name, size, and background color of the desired texture. After closing the dialog with OK, assign the material to the character and then change to the BP 3D PAINT layout.

In the MATERIAL MANAGER you will now find our material in a slightly different format. Every material can contain a variety of textures in all possible channels. Before we edit the textures, we have to tell BodyPaint 3D which of them will be manipulated in order to optimize the memory. Behind every material there is a red cross that can be activated by clicking on it, which turns the symbol into a pen. Now the textures within this material

— Figure 4.54: Creating a new texture.

can be edited in BodyPaint 3D. In the small displays of the textures in the materials, you will notice the abbreviation of the channels containing the textures—in our case it's a C since the texture is used in the color channel. Just like in Photoshop, there is also a toggle switch for changing between foreground and background color. You can see these elements on the left of Figure 4.55.

As in the common graphics programs, in BodyPaint 3D you can build textures with different layers and allow these layers to interact with each other. All of this is done in the layers section, seen in the middle of Figure 4.55. There you can create new layers or combine them with the FUNCTIONS menu, shown on the right in the same figure. These layers can also be multiplied with each other or used for other color changes.

The majority of the more important paint tools can be found as icons on the left side of the layout, as shown in Figure 4.56. There are many familiar tools, such as a brush, stamp, eraser, and tools for text. The settings for the selected tool can be found in the ATTRIBUTE MANAGER. Figure 4.56 shows as an example the settings for the brush and its corresponding color settings. By using diverse parameters, the size, opacity, and shape can be adjusted. The use of bit-maps is also possible. A large number of brush presets are included and can be seen after clicking and holding the mouse button on top of the preview image of the brush, in the top left of the ATTRIBUTE MANAGER.

## Unfolding the UV Coordinates of the Character

Before we start the painting of a complex surface, we have to prepare the UV coordinates. With basic shapes like the cylinder, sphere, cube, and the spline-generated NURBS objects, this isn't necessary since these objects are already generated with UV coordinates. However, as soon as changes are applied to these objects, such as extrusions or manually generated faces, the existing UV coordinates won't fit anymore because they are not automatically updated by all tools.

— Figure 4.55: Edit textures in layers.

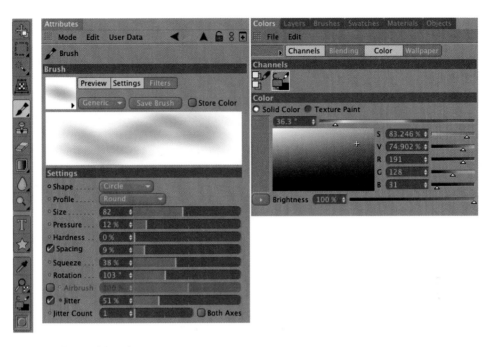

— Figure 4.56: Color and brush settings.

To edit the UV coordinates, first switch to BP UV EDIT. In the icon palette at the upper edge you will find some familiar icons, such as the ones used to switch to point, polygon, or USE EDGE TOOL mode. But there are new, similar-looking icons as well, consisting of a texture symbol as well as one for points and one for a polygon. With these icons you can switch to the editing mode of the UV coordinates, which can be edited as UV polygons as well as UV points.

We should do this step by step, in order for the UV polygons of the character to unfold as flat as possible. It is helpful that the selection of polygons can, at the same time, be used as a UV polygon selection. Start by selecting the polygons of the lower part of the body, as well as the visible outer segments of the lower jaw, as shown in Figure 4.57. The familiar selection methods are available as icons in the upper icon palette.

Switch to USE UV POLYGON EDIT TOOL mode and open the dialog of UV COMMANDS in the UV MAPPING group. This section of the BodyPaint 3D layout is shown on the bottom

of Figure 4.57. There you can find a number of standard commands for mirroring, combining, and maximizing the selected UV polygons. It is important to know that the value range of the UV coordinates spans only between 0 and 1. Deviant values are possible as well, as long as tiling is active in the material. Then the UV polygons will receive a part of the neighboring tile.

### Interactive Mapping

This value range of the original tile of every texture, the coordinate range between 0 and 1 in the X and Y direction, is depicted as a highlighted square. You can find this texture view in the BP 3D EDIT layout directly to the right of the editor viewports. Later, when placing and scaling the UV polygons, you should make sure that all faces are located within this highlighted square. However, we are not that far yet and first have to unfold the UV polygons. We will use the START INTERACTIVE MAPPING button in the UV COMMANDS. This mode allows us to restrict one of

— Figure 4.57: Interactively texturing selected polygons.

the standard projections, such as spherical, cubic or flat mapping, to the currently selected polygons and to calculate the unwrapping of the UV polygons. This sounds more complicated than it actually is.

In the ATTRIBUTE MANAGER you can now see the familiar dialog of a TEXTURE TAG, in which you should select an appropriate projection mode for the selected polygons. Base this decision on the geometrical shape of the selection. Despite the changes to our character's head, which is also the area of our polygon selection, it still resembles a sphere. Select the PROJECTION type in the ATTRIBUTE MANAGER. Adjust the projection preview in the editor viewport using the scale, move, and rotate tools, so the unwrapping of the faces is as flat as possible. Figure 4.58 shows a possible placement and rotation of the projection preview in the side viewport.

While working with these settings, the texture view helps since you can see the resulting unwrapping of the UV polygons in this window, parallel to the rotation of the texture projection. Figure 4.59 shows this unwrapping on the left side. In the event you can't see such a structure, check the SHOW UV MESH entry in the UV MESH menu of the texture view. When you are satisfied with the unwrapping of the UV polygons, end the interactive mode by using the STOP INTERACTIVE MAPPING button in the UV COMMANDS.

In the same texture view there are also the still unedited UV polygons of the now deselected polygons. In order to prevent confusion, pull the currently selected UV polygons to the side, away from the group of other polygons. You can use the normal MOVE tool, as long as the USE UV POLYGON EDIT TOOL mode is active. The shape of our object does not change with this move; UV polygons are responsible exclusively for the textures and not for the shape of objects.

— Figure 4.58: The interactive mapping.

— Figure 4.59: The result of the interactive mapping and the manual unfolding of the UV polygons.

### Individually Moving UV Points

The selected areas are now spherically unwrapped but still overlap a bit. This can be manually fixed since the points of UV polygons can be edited as well. Change to USE UV POINT EDIT TOOL mode and pull apart the points of the projected area of the texture view so that the overlaps disappear. The UV points can be selected by clicking directly on them in the texture view, by selecting them on the object, or by using one of the selection methods in the texture view. Figure 4.59 shows you how the points should be moved. On the right side you can see the half-edited structure of the lower jaw. The right side of these UV polygons wasn't touched and still contains the unwanted overlaps.

Use the same principle with the polygons of the upper part of the head, as shown in Figure 4.60. The selection includes only the

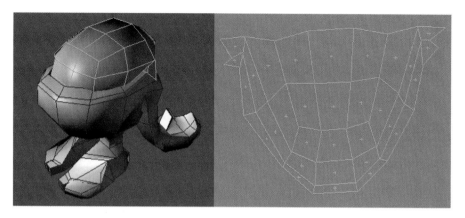

— Figure 4.60: The unfolded area of the head.

faces visible from the outside and ends at about the height of the corner of the mouth. The back of the head, including Trolly's back, will be unfolded in another step. Here, too, I have used interactive mapping with a spherical projection. These UV polygons might have to be edited at point level in the texture view as well.

As an alternative, you could activate Pin Border Points and use the Apply button at UV Mapping>Relax UV. You should still be in Use UV Polygon Edit Tool mode and the UV polygons should be selected. This tool automatically rearranges the UV polygons so overlaps disappear. This rearrangement is based on the area defined by the pinned open edge of the outside of the selected UV polygons. For clarity, you should also move these UV faces to the side or above the other UV polygons in the texture view, so a separate "island" of UV faces is created. Use the same principle for the soles of the feet and the back, which you can unwrap with a flat interactive mapping. The polygons on the inside of the mouth can also be unwrapped this way, as well as those of the gum and the lower mouth cavity.

### Automatic Unfolding

By using the technique of interactive mapping with the correction of the UV points,

every object can be cleanly unfolded. In some cases, though, this can become quite time consuming, especially when the object contains a large number of points or is shaped irregularly. For these instances, there are special unfolding algorithms available that can be found in the Relax UV section. We talked about them before in reference to automatically removing overlapping faces. Additional options allow simultaneous disconnecting of UV polygons for the unfolding of otherwise cylindrically aligned polygons to a flat plane. This is often used for the arms and legs of a character.

Besides the necessary selection of the polygons, the course of the cut for the automatic unfolding has to be specified as well in Use Edge Tool mode. Figure 4.61 shows such a selection for the example of the arm. In our case I made the cut along the side of the shoulder and followed the natural course of the polygons down to and around the finger tips. Generally, such cuts are made in less visible places, since a texture offset might be obvious there.

First we will work the same way as before. Select the polygons of an arm—the edge selection will not be deactivated—and then switch to Use UV Polygon Edit Tool mode. Use the Interactive Mapping with a cylindrical projection, as shown in Figure 4.62, and adjust it to the position of the arm.

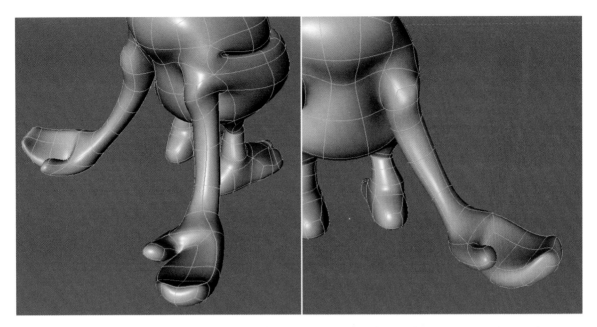

— Figure 4.61: Preparation for the unfolding of the arms and hands.

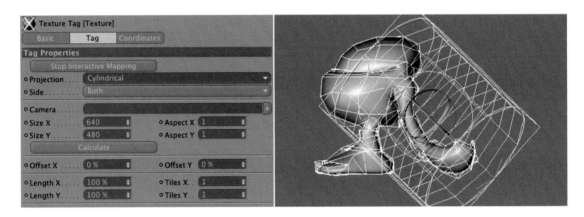

— Figure 4.62: Interactive projection of an arm.

After finishing the interactive mapping, change to the RELAX UV category of the UV MAPPING section. Everything there should be deactivated except for the CUT SELECTED EDGES option. The selected edges will turn to open edges at the selected faces, and the UV coordinates can be unwrapped after clicking on the APPLY button. As an alternative, selection tags could be used, which are pulled into the fields under the options. Besides the edge selection, point selections can also be gener-

ated that are used to fix parts of the surface. The UV coordinates are then unwrapped based on these fixed points.

There are two unfolding methods available: LSCM and the newer ABF. The latter is slower, but better suited for organic objects and the UV faces are straighter. In this case, though, both modes, which can be switched just above the APPLY button, create the same good result. Figure 4.63 shows the outcome. You can see the only

— Figure 4.63: After relaxing and opening the arm polygons.

weak spot, indicated by the small black circle. Bulges on the surface often become very small, which is the case with the thumb of our model. Therefore, you should unwrap it manually and create a new edge selection for it.

The same steps can be used for the legs. After the whole character is unwrapped, in one way or another, the separate UV face islands have to be placed, as optimized as possible, inside the standard tile within the texture view. In order to efficiently use the resolution of the texture, no space should be wasted. Lots of information and workshops for the creation of game characters or models can be found on the Internet. In these resources the focus is mainly on the optimal use of textures for reasons of memory management and performance increase. Figure 4.64 shows an example of my arrangement of these UV faces. Connected islands can easily be selected by clicking on one face and choosing SELECTION GEOMETRY>SELECT CONNECTED. Use the

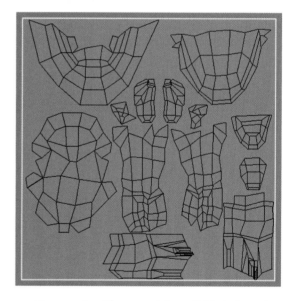

— Figure 4.64: The complete unfolded character.

common tools for moving, rotating, and scaling to move and adjust the islands to the desired spot in the texture view.

### Controlling the UV Unwrapping

The UV polygons are now unwrapped onto a flat plane and a texture can be optimally placed onto them. This doesn't guarantee a distortion-free display of the texture on the object, though, since the straightening of the UV faces doesn't mean that the size ratio of the UV polygons is identical to that of the geometry polygons. This is best checked visually by using an even pattern as the texture. A good texture to use is the CHECKERBOARD shader, found in the SURFACES group. The number of squares can be set in the dialog of the shader. When you use the same number of squares for both the U and V directions, the result is a uniform checkerboard pattern. This shader can then be loaded into the COLOR channel of our character. Figure 4.65 shows this effect on the left side. You can clearly see the areas of the character that have an irregular projection. Especially noticeable is the area of the lower lip, contrary to the region beneath, which has too high of a resolution. Here the UV polygons have to be moved closer together so the lips take up less space. After this correction, the checkerboard pattern looks much more uniform, as displayed on the right of Figure 4.65.

### Subsequent Additions to the Rig

Not always is the concept of a rig or a character planned in such detail that a project can be completed without subsequent modifications or additions. In our case, I think, after looking at the character, that the missing eyes limit our possibilities for expressing emotions in the animation. How can we expand the character and its rig after the fact?

First, we need additional geometries. We will use two simple CUBE primitives that are placed hovering above the head of the character. Put them onto the same hierarchical plane as the character. This is under the Null object, which itself is subordinated under the HyperNURBS. The cubes are then smoothed and lose their distinctive shape. We will counteract that by adding subdivisions. I used two additional segments each in the X, Y, and Z directions of the cubes. Then I converted both cubes with the (C) key and pulled the center points on the top and bottom apart, as shown in Figure 4.66.

Create a new material and add a NEW TEXTURE with white color in the COLOR channel, as shown on the right in Figure 4.66.

— Figure 4.65: Evaluating and correcting UV coordinates.

— Figure 4.66: Adding simple cubes as eyes.

Assign this material to both eyes. The projection of this texture is automatically set to UV mapping. This is not a problem since we work with primitives that are slightly distorted, but otherwise weren't changed.

Then add two bone objects separately, either from the icon palette or with CHARACTER>SOFT IK/BONES. Place these bones lengthwise and inside the eyes as shown highlighted in Figure 4.67. These bones should then be integrated into a proper location within the existing bone hierarchy. A good place would be under the head or spine bone, so the eyes can be moved together with the character. Lastly, the bones have to be fixed so their position and rotation are saved. Therefore, select one of the two new bones and select CHARACTER>SOFT IK/BONES>FIX BONES. Do the same with the second bone object.

### ADDING WEIGHTINGS MANUALLY TO THE BONE OBJECTS

In order to let the bones know what areas of the character they are supposed to influence, they have to receive weightings. There are two methods to accomplish this. With the conversion of the joints and their weightings, we automatically received bone objects with CLAUDE BONET weightings. For the creation of these weightings there is a tool in MOCCA that can be found at CHARACTER>SOFT IK/BONES>CLAUDE BONET.

The use of this tool is quite simple. First, click on the bone object that you want to weight and then paint the points on the object that are supposed to follow the bone with the CLAUDE BONET tool. A colored display on the object gives you feedback about the strength of the weighting. The radius and strength of the weight tool are set in the ATTRIBUTE MANAGER. That way, you can paint the complete eye geometry of an eye, since the eyes should be controlled exclusively by the new bones. Figure 4.68 shows the hierarchy of the new objects and the dialog of the Claude Bonet tool. You can see there as well that I applied additional compositing tags to the eyes. If you don't have MOCCA available, then you can achieve the same effect with VERTEX MAPS. You can paint them with the BRUSH tool from the STRUCTURE menu, with the live selection or by direct assignment to a point selection. Select all points of the left eye and choose SELECTION>SET

— Figure 4.67: Additional bone objects for the eyes.

VERTEX WEIGHT. Give the generated VERTEX MAP a meaningful name in the ATTRIBUTE MANAGER and then create a RESTRICTION tag for the bone located within this eye. It can be found in the OBJECT MANAGER after a right click on the bone object at CINEMA 4D TAGS > RESTRICTION. In the name list of this tag in the ATTRIBUTE MANAGER, enter at the uppermost spot the name of the previously generated vertex map. Now this bone object is weighted and can be used for the character animation.

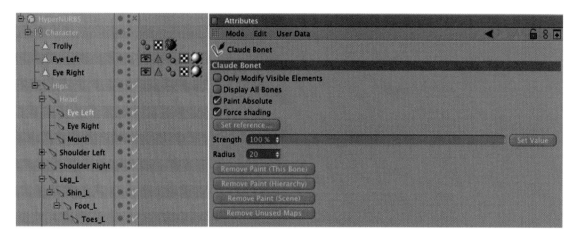

— Figure 4.68: Weighting the new bones.

## Painting Objects Directly in BodyPaint 3D

So far we have only unfolded the UV polygons in BodyPaint 3D and therefore prepared them for the texturing. BodyPaint 3D can also be used for the painting of objects. Change to the BP 3D PAINT layout and activate the new eye material in the MATERIAL MANAGER by clicking away the red cross behind it. Select the brush tool from the icon palette on the left side and set its size and color according to your taste. Then move the mouse pointer

across one of the eyes and paint it directly in the editor viewports. Figure 4.69 shows an example of the painting.

After you are done with the painting, take a look at the side and the back of the eye, as shown on the left of Figure 4.70. The painted structure suddenly appears multiple times. It does so because the UV polygons of a cube primitive are placed on top of each other by default. The texture in front is then automatically projected onto the five other sides of the cube. We can correct this easily in our case. Select all faces that are not supposed to show the eye motif. Change to USE UV POLYGON

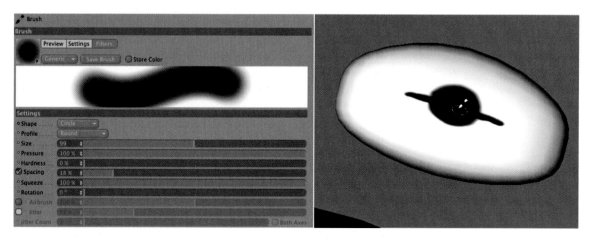

— Figure 4.69: Painting the eye within BodyPaint 3D.

— Figure 4.70: Correcting UV polygons.

EDIT TOOL mode and activate the scale tool. Shrink the selected faces so much that they are placed in the lower left corner of the texture. You can see the corresponding texture view in the middle of Figure 4.70. That way the center of the painted texture remains only at the front faces of the eye. All other faces just show white.

## TEXTURING THE BODY

Finally, we will concentrate on the texturing of the character's body. At the beginning of the workshop we made a material and created a new texture in its COLOR channel. This texture was later replaced by the CHECKER-BOARD shader, to control the unwrapping of the UV polygons. You can get the original white texture back by opening the shader menu within the channels texture area and looking into the BITMAPS entry. There, you can find a list of all textures used within the scene. You should also be able to find and select the texture with the standard name MAT_COLOR_1, which then replaces the CHECKERBOARD shader.

If this texture was not created or got lost, simply create a new texture with a white color in the COLOR channel, using CREATE NEW TEXTURE. As previously done with the eye, use a brush with a black color and paint directly on the character the areas that are meant to have another material applied later. I envisioned the body to be covered with toad-like warts, except the feet and the inside surface of the hands. They will receive a different material and should therefore be marked on the character with the black paint. If you can't paint all areas within the editor viewports, then switch to the texture view and paint there instead, as shown in Figure 4.71. In this texture view you have the advantage of painting directly onto the UV polygons, and you can see their proximity to the other UV islands as well.

When you are happy with the masking of the hands and feet, load this texture into the activated ALPHA channel of the same material. This automatically turns the black painted areas transparent and allows you to see another material underneath. Again, use the BITMAPS entry of the shader menu in the TEXTURE area of the ALPHA channel to load the custom texture.

In the COLOR channel we will now load a prepared toad skin texture. Of course, we could have made the effort to create the texture directly in BodyPaint 3D, but this would go beyond the scope of this workshop. I created this texture by cloning and copying different toad images that I found on the Internet. The coloring can be adjusted

— Figure 4.71: Alpha mask for blending two materials.

within CINEMA 4D using the COLORIZER shader, found in the uppermost level of the shader menu. After the toad skin texture is loaded into this shader, you can exchange the original colors with a custom color gradient and recolor the image. This shader can also be used to turn color images into grayscale or to color grayscale images. Figure 4.72 shows the texture being used and its recoloring in the COLOR channel using the COLORIZER shader. Feel free to be creative with your color choices, or simply use the provided skin texture with its original colors.

I loaded the same skin texture into the BUMP channel of the material and used a negative STRENGTH value, as you can see in Figure 4.73. I would like the warts to be slightly raised. Since the warts are dark in the image, the STRENGTH of the BUMP effect, otherwise based on the brightness of the image, needs to be set to a negative value. Figure 4.73 shows on the right side the use of the painted image in the ALPHA channel.

The highlights can be set any way you want, depending on whether you would like the skin to look dry or wet.

We still need a second material for the hands and feet of the character. The first step is to duplicate the skin material with EDIT>COPY and EDIT>PASTE, and to deactivate the ALPHA and BUMP channels of the duplicated material. Remove the skin texture from the COLOR channel as well—use the CLEAR command in the shader menu—and use the

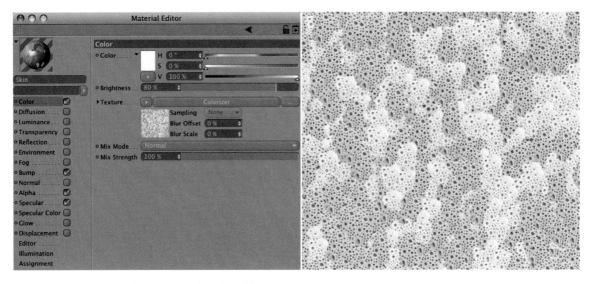

— Figure 4.72: The color texture for the skin.

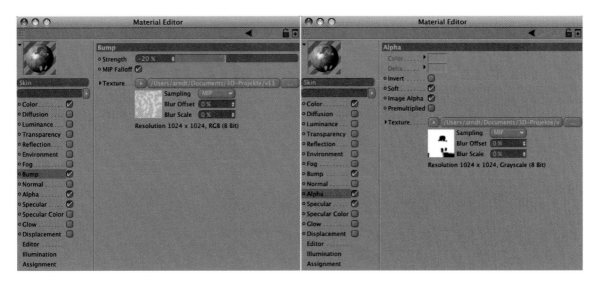

— Figure 4.73: The settings in the Bump and Alpha channel.

color slider there to set an appropriate color tone. In my case, I colored the skin with the COLORIZER so the warts have a reddish tint while the base color of the skin appears rather yellowish. I therefore set a corresponding yellow color and applied this material to the character, too.

Make sure that the yellow material is placed underneath the skin material, which means put it to the left of the skin material in the OBJECT MANAGER. Only in that way can the yellow material be seen through the alpha areas of the skin. Figure 4.74 shows an example of the finished look of the character.

— Figure 4.74: The completed textured character.

## BAKING TEXTURES

The baking of a texture is the reduction of the surface properties into a single bitmap. For example, the entire surface coloring, which has been defined by layering several complex shaders, can be reduced to one bitmap. This makes it easier to pass on the textured model to another software. Of course, it is also helpful for use within CINEMA 4D since it reduces the objects' calculation time. A bitmap can be displayed much faster than one or several shaders that are combined with each other and then rendered. Global illumination, ambient occlusion, and the lighting can be baked as well; even the conversion of material properties is possible. Through baking you can also convert a Bump map into a normal map. For the baking of textures, first create a BAKE TEXTURE tag by right clicking on the textured object in the OBJECT MANAGER. This tag can be found in the CINEMA 4D TAGS list.

Figure 4.75 shows you the parameters available in the tag. In the TAG section of the ATTRIBUTE MANAGER you will find basic settings regarding the file format and file path, as well as settings regarding the size of the texture to be calculated. AUTOMATIC SIZE enables two additional values for the minimum and maximum size that CINEMA 4D uses to calculate the proper resolution. This calculation is based

on the pixel size value, which defines the size of the pixel in square meters. This could be helpful for working with certain measurements on a model, such as modeling a plane with a dimension of 200 x 200 meters. This would result in an area of 40,000 m². When this value is divided by the entry in the pixel size field (the default is 0.5), this turns into 80,000 m². Since the plane is square, we get the number of pixels in both the X and Y direction by taking the square root. Rounded up, this would be 283 x 283 pixels for the baked texture, as long as this value lies within the minimum and maximum size values.

The anti-aliasing settings in the RENDER SETTINGS have no effect on the baking of textures. A comparable effect can be generated with the SUPERSAMPLING setting. This setting is deactivated at a value of 0. Higher values activate and increase the edge smoothing, but this also increases the calculation time. The value for the PIXEL BORDER extends the calculation past the boundaries of the UV polygons by the entered value. If CONTINUE UVS is activated as well, then visible color edges between the UV polygons can be avoided since the color value calculation is then extended past the boundaries of the polygons. The background color is used anywhere in the baked texture where there aren't any UV polygons.

On the OPTIONS page of the tag dialog, displayed on the right of Figure 4.75, activate the properties of the surface that you want to bake as separate textures. The uppermost settings provide you with additional options. With USE POLYGON SELECTION the baking is restricted to just this selection, EVALUATE BUMP takes into consideration effects that depend on normals, and USE CAMERA VECTOR includes the current viewing angle to the object, useful for capturing fresnel effects, for example.

Underneath are the options for the properties to be baked. In our case we are only interested in the COLOR of the surface and the AMBIENT OCCLUSION. The latter needs some time for calculation and, through baking, can save us some render time during the animation.

— Figure 4.75: Settings of the Bake Texture tag.

AMBIENT OCCLUSION receives its settings from the render settings, and therefore doesn't need to be applied as a shader within the material. AMBIENT OCCLUSION doesn't even have to be activated in the render settings.

Every activated option for the baking of a surface property enables some additional options below it. For baking the COLOR you can include the influences of lighting, shadows, diffusion, and luminance. We will leave everything deactivated, though. AMBIENT OCCLUSION could be set to calculate the self shadowing only. In addition, the intensity of the AMBIENT OCCLUSION can be converted to weightings for the points of the object and saved as a vertex map. This map could then be interpreted by the VERTEX MAP shader. However, we don't need that option and will keep it deactivated.

I decided to save the baked texture in Photoshop format and checked the SINGLE

FILE option. After clicking on the BAKE button, we will receive a file in which we can mix the AMBIENT OCCLUSION with the color of the surface. Don't be irritated by the small size of the preview window that shows the progress of the calculation. It shows the result of only one baked channel, but all checked properties are saved. Figure 4.76 shows a possible result. Clearly visible is the darkening by AMBIENT OCCLUSION between the lips, the base of the arms, and of course the mouth cavity.

With the baking of textures, it is very important to check the surface normals. They should uniformly point outward so no irregularities occur during the calculation of AMBIENT OCCLUSION or lighting effects. Load this baked texture into the Color channel of the skin texture and deactivate the Alpha channel of the material. The second, yellow material for the hands and feet can be removed entirely from the character. These colors are now baked

— Figure 4.76: The finished combination of baked Ambient Occlusion and surface color.

within the texture. If you prefer, bake the Bump of the character to a normal map and use it in the NORMAL channel of the material. This makes it easier to later export the character to a game engine. It is important in this case to calculate the normals within the VECTOR space. That way, these normal maps can be interpreted in other programs.

This concludes the modeling, rigging, and texturing, and we can start with the animation.

## Animating the Character

The process for animating a character is generally identical to the animation of a rigid object. The difference is that with a character several objects have to be fixed with keyframes. Basically, it would be enough to animate and set keyframes of the external help objects, but, depending on the complexity of the movements, it might become necessary to animate single bones.

## The Selection Object

Instead of having to manually select each of the objects for setting keyframes, we can use the SELECTION OBJECT. This object saves multiple objects and can be animated with keyframes. First, select all objects that are primarily used for the animation of the character. I selected the external foot handlers, the root bone of the character, and all bone objects of the legs. The latter doesn't need to be added, since they are covered by the external handlers, but I already have the planned export of the character in mind and the use of external handlers and inverse kinematics will not be possible.

After the selection of these objects, choose SELECTION FILTER>CREATE SELECTION OBJECT in the SELECTION menu. The generated object provides a list in the ATTRIBUTE MANAGER, which is shown in Figure 4.77. The listed objects can be selected anytime with the RESTORE SELECTION button. More objects can be added to the list via drag and drop from the OBJECT MANAGER or removed from the list by right clicking on the object and using REMOVE. To be able to find it again when keyframes are set, give the SELECTION OBJECT a meaningful name.

— Figure 4.77: The Selection object.

# The Visual Selector

During the animation we will often have to select and manipulate certain objects, such as the foot handlers or single bones. Since these are always the same objects, we could use some help to accelerate the selection process. The Visual Selector can be used for that purpose. A random background picture can be added to it, and links to objects within the scene can be placed onto this image.

In the first step, render an image that shows the character in a neutral pose so all body parts can be seen. Then assign the VISUAL SELECTOR to any one of the objects in the scene with a right click and by choosing CHARACTER TAGS>VISUAL SELECTOR. In the settings of the tag in the ATTRIBUTE MANAGER you can determine a file path to the background image. You could also drag and drop an image, from your finder or file browser, directly into the empty window of the VISUAL SELECTOR, which opens up after a double click onto its tag.

Figure 4.78 shows an example of using the front view of our character as the background image in the VISUAL SELECTOR. The additional symbols you see there were created by drag and drop of the Null objects from the OBJECT MANAGER directly into the VISUAL SELECTOR. The generated links can then be pulled to the desired spot on the background image. A click on these symbols selects the corresponding object in the OBJECT MANAGER to which it is linked.

Accidentally placed links can be deleted anytime by pulling them out of the VISUAL SELECTOR window. More settings can be found in the TAG part of the VISUAL SELECTOR, as shown in Figure 4.79. There, you can see the links that belong to the symbols. These links can be changed there as well. In the ACTION menu below, a tool can be assigned to each of the hotspots. This tool is then automatically activated by clicking on an icon in the VISUAL SELECTOR. The common tools are move,

— Figure 4.78: Interface of the Visual Selector.

— Figure 4.79: Settings for the links and hot spots of the Visual Selector.

rotate, and scale. In addition, normal commands and functions can be connected with the hotspots when the COMMAND action is active. The desired action is assigned by entering the COMMAND ID.

The ID numbers of all functions and commands can be found at WINDOW>LAYOUT> COMMAND MANAGER. It contains a complete listing of all CINEMA 4D commands that can be sorted with the use of the search field.

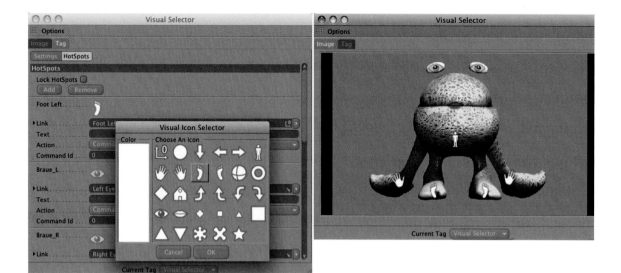

— Figure 4.80: The use of individual hotspots.

A click onto one of the commands in the list shows its ID as well as existing keyboard shortcuts for executing the command. That way you can use individual shortcuts as well.

The look of the hotspot icons is set by the VISUAL SELECTOR and based on the type of linked objects. We have a selection of symbols to choose from, in a list of preset icons which opened after clicking on the icon of a hotspot as shown in Figure 4.80. The coloring of the icons can be altered as well. The right side of the figure shows an example of the individual composition of the applied links.

## Creating a Walk Cycle

With animations of characters, the term WALK CYCLE is often used. It is a complete walk movement of the character that can be turned into a walk or run by automatically repeating it multiple times. That way we have to use only a few keyframes to allow the character to walk a certain distance. Additional movements, like facial expressions or individual arm movements, can then be added to make the animation appear less linear.

The timing is very important during an animation. The wrong approach is to set too many keyframes in the beginning. First comes the length of the animation, then the speed has to be determined. This is also called BLOCKING the animation. The goal is to depict the animation with just a few core poses. The time between the poses should be set in such a way that the correct speed of the character movement is achieved. With a walk movement, this can be set with three poses, where two of these poses are identical. The first pose shows the character, for example, with the left foot forward and the right foot in the back. The second pose shows an opposite step, which means the right foot is now in front and the left foot in the back. Figure 4.81 shows these two poses from different perspectives. The upper row shows the pose from frame 0 of the animation. It is created by moving and rotating the handlers at the feet, and by the moving and rotation of the root bone to indicate a shifting of the character's weight.

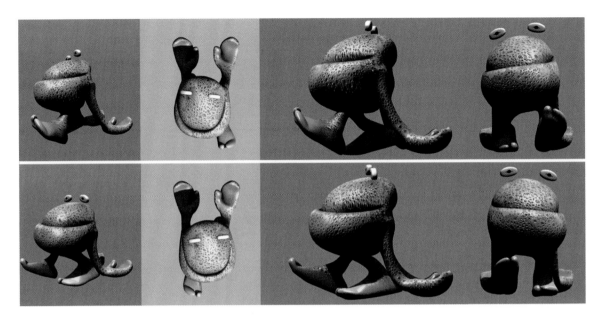

— Figure 4.81: Key poses of the walk cycle.

— Figure 4.82: Selecting the previously created Selection object for the keyframe recording.

When you are happy with the pose, create keyframes for the rotation and movement of the objects saved within the SELECTION OBJECT. Make sure that the SELECTION OBJECT is selected for the keyframe recording, as shown in Figure 4.82. Then move the timeslider to the frame when the character completes one whole step. I determined that to be frame 29. Depending on your desired step speed and the planned frame rate of the animation, time lengths other than the one I used are possible.

## SETTING THE FRAME RATE

I plan to output the animation with a frame rate of 25 frames per second and have already set this in the project settings. You can find them in the EDIT menu of CINEMA 4D under PROJECT SETTINGS. The settings regarding the frame rate should always be checked before the animation is started and adjusted to the desired output media. Belated changes of the frame rate are possible, but create more work because all previously set keyframes would have to be moved or scaled.

At the chosen endpoint of the walk movement, create again keyframes for the SELECTION OBJECT. The time frame is now set for a left/right step of the character and we can move to the center of the time frame. In my animation this would be frame 14. At this frame we need to modify the pose of the character so that it shows the exact mirrored opposite, as can be seen in the lower row of Figure 4.81. After these keyframes are set, the blocking of the step movement is finished. The extreme poses as well as the time frame for a complete cycle are now defined. Figure 4.83 shows how the animation looks in the TIMELINE, which can be found in the WINDOW menu of CINEMA 4D.

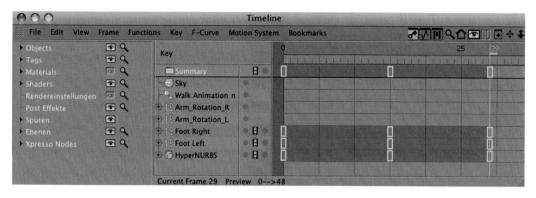

— Figure 4.83: The three key poses of the walk cycle.

## OPTIMIZING THE DISPLAY IN THE TIMELINE

For more clarity in the timeline, I like to turn off all objects, materials, and any additional information that have nothing to do with the animation. Click on the eye symbol in the title bar of the timeline. This causes a list to appear, containing several elements that can be displayed in the timeline, such as the RENDER SETTINGS or the materials. A click on the eye symbol next to these elements turns them invisible in the timeline. This is no loss for us, since we didn't want to animate these elements in the first place, and it gives us more space and a less cluttered look. In addition, you can use the magnifying glass symbol to control which objects or settings can be found by the search function and which ones should be ignored. This can be helpful with complex scenes containing many animated objects. The search function itself is hidden behind the magnifying glass in the title bar of the timeline.

## CYCLICAL PLAYBACK OF THE ANIMATION

In order to check the speed of the step, play the movement of the character in a looped animation. In the ANIMATION menu of CINEMA 4D, set the PLAY MODE to PREVIEW RANGE and CYCLE. Then reduce the preview range by moving the end arrows in the powerslider to an area between frame 0 and frame 28. The necessary steps are shown in Figure 4.84. Frame 29 of the animation looks exactly like the state of the character in frame 0 and can therefore be skipped. Otherwise, there would be a hesitation at the end of a step, since this pose appears twice.

Because so far we are working with only three keyframes, it is still easy to adjust the speed of the steps. Simply select and move the keyframes, at frame 14 and 29 in the main track of the timeline. Once you are pleased with the timing of the steps, move on to the details. You should then concentrate on the rolling motion of the feet and the shift in weight.

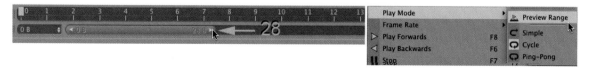

— Figure 4.84: Necessary settings for the cyclic playback of a certain section of the animation.

## FINISHING THE ANIMATION

When the animation is played, you will certainly notice some movement phases that are not the way they should be. Perhaps the toes sink into the imaginary floor, or the movement is simply too monotone. Correct this with additional keyframes for single parts of the character, like for the external handlers. Keyframes don't have to be set for all objects within the SELECTION OBJECT, though. Deactivate this recording mode by selecting ACTIVE OBJECTS in the menu, shown in Figure 4.82. The following keyframe recordings then only pertain to the currently active object. Figure 4.85 gives you a hint of the desired course of the animation. The images in this figure were recorded with a gap of two images in between. The sequence starts on the top left with frame 0 and ends on the top right with the pose from frame 6. The row underneath shows the same poses seen from a side view.

Figure 4.86 continues this image sequence, from frame 8 to frame 14. This completes a whole sequence of switching feet from left to right. The subsequent poses, up to reaching the starting pose, are equal to the sequences shown in the two figures, only they run the opposite way. The random step of two images in these sequences doesn't mean, though, that you have to set keyframes for every second frame. I only selected this time range to show you an almost continuous display of the movement. Most likely you will use fewer keyframes to animate a similar movement.

Don't forget to vary the arm movement as well. Adjust the distance between the hands and the body, based on the pose of the body during the walk, without disconnecting the hands from the virtual floor. These keyframes should be created for the external handlers as well as for the bones that are controlled by them. In this case, these are the bone hierarchies starting at the shoulder. Save them, together with the hand handlers, in a new SELECTION OBJECT so the keyframes for these objects are automatically generated. You should first generate three to

— Figure 4.85: Image sequence of the walk cycle.

— Figure 4.86: The second half of the image sequence.

four keyframes for the external handlers of the arms until their animation looks right. Then jump back to the beginning of the animation and fix the existing animation of the arms with additional keyframes in even steps. You could record rotation keyframes for the arms at every two frames, to capture with keyframes the dynamic behavior controlled by the MOCCA IK.

The reason for not that many keyframes being needed for the legs and the body is that we don't save their poses with keyframes alone, but can also influence the sections in between the keyframes with curves and tangents. Figure 4.87 shows in the upper part my keyframes for a complete walking sequence. Below you can see as an example the display of the stomach bone movement in both the X and Z directions. For this view of the function curves of an animation, you have to change to the corresponding mode, as indicated by the arrow in the figure.

A Y movement, the up and down moving of the stomach, does not occur. The character instead falls slightly forward as soon as the front foot has contact with the floor. At the same time, the lateral shift along the X axis causes a weight shift to the front foot. The maximum of this lateral movement is always reached at the time when the rear foot just starts to depart the floor and begins to move forward. As long as you use the standard SPLINE interpolation for the keyframes, you can control the course of these curves with tangents in the display of the function curves, without having to set additional keyframes.

**Onion Skinning/Ghosting**

During the refinement and evaluation of animations, the constant comparison of the current pose with the previous and following one is important. Therefore, the playback of

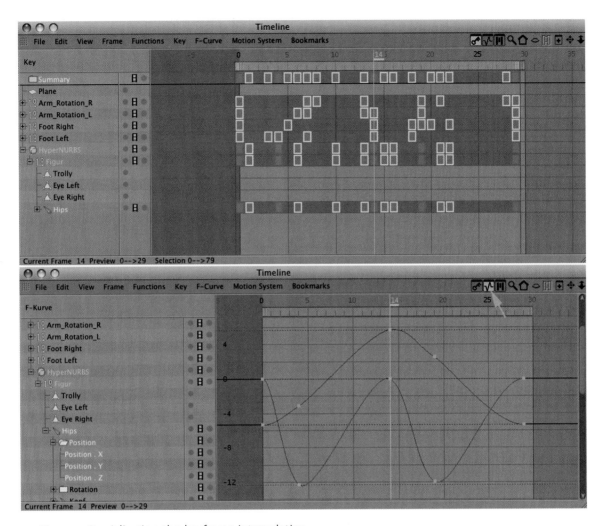

— Figure 4.87: Adjusting the keyframe interpolation.

the animation in real time, in my case with 25 frames per second, is important. This cannot always be achieved, though, when complex animations or high-resolution objects have to be displayed. In these cases, the ONION SKINNING can be a big help since it depicts past and future states of an animated object within one image. Apply a DISPLAY tag to the animated object. This tag can be found in the context menu in the CINEMA 4D TAGS, after a right click on the object in the OBJECT MANAGER.

You can activate this effect in the GHOSTING settings. Several display modes offer different views in the editor. Figure 4.88 shows an example. The movement phases of objects can be shown as a track curve, as single points, or as the whole object surface. With deformations there are certain restrictions, since the animation has to be saved first in a cache with the DISPLAY tag. You can find the corresponding function in the lower part of the dialog. By using the CALCULATE CACHE button, you initiate the saving of the

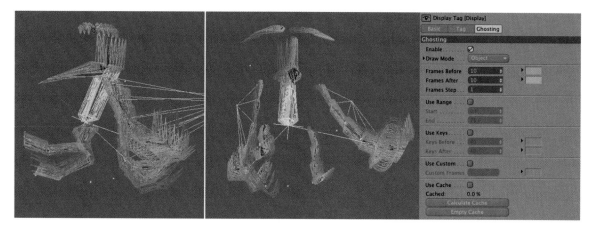

— Figure 4.88: Ghosting effect of the animated bone objects.

animation. Afterward, activate the USE CACHE option to read the cache.

In the case of our bones this is not necessary. Just put the tag onto the uppermost bone of the hierarchy and activate the DRAW MODE called OBJECT. With the FRAMES BEFORE and FRAME AFTER settings you can define the number of images, before and after the current point in time, which should be captured by the ghosting. The FRAMES STEP value defines the manner in which they are counted. A value of two always skips the display of one image in between. When the display in the ONION SKINNING layering is supposed to show only a certain range of images, activate USE RANGE and define the start and end frames.

The ghosting overlay is automatically colored. As a standard, all past movement phases appear blue and the following poses look orange, but these colors can be changed. Also, the poses that were fixed with keyframes can be highlighted with a color; this is achieved by using USE KEYS. This causes a blend of the colors behind the KEYS BEFORE and KEYS AFTER fields. These values define the time frame of the color blending relative to a keyframe. This display mode is only available in OBJECT, AXIS, or POINT mode, though.

Individual image ranges can be defined as well. Activate the USE CUSTOM option, which enables an entry field for numbers, and enter

numbers separated by commas or larger sections, like 10–35. Combinations are also possible, like 10, 15, 20, 30–50. Figure 4.88 shows the ghosting effect with simultaneously deactivated geometries in the editor.

## WORKING WITH MOTION CLIPS

The entire animation is actually captured twice in keyframes, once with the external handlers and again with the keyframes and the bones themselves. Theoretically, this means that we can entirely forego the evaluation of the external elements. In order to check this, select all MOCCA IK tags behind the arm bones and, within the tags, deactivate the USE IK option. Do the same with the IK tags of the legs. Figure 4.89 shows this step. There shouldn't be any differences in the movement when the animation is played, as long as enough keyframes were used to fix the bones.

Only the type of interpolation between the keyframes could still cause small differences in the animation. This is often caused by the so-called overshooting of the function curves at the standard SPLINE interpolation. This sort of interpolation has the advantage that automatically soft blends between the keyframe values are calculated. But this could also cause an overshoot of the interpolation

— Figure 4.89: Deactivating inverse kinematics.

— Figure 4.90: Cutting overshooting interpolation curves.

curve out of the desired value range, for example, when two neighboring keyframes with identical values are used. To avoid this, either deactivate the AUTO TANGENTS option in the keyframes to manually control the tangents, or activate the CLAMP option of the keyframes, as shown in Figure 4.90. This automatically aligns the tangents horizontally at the interpolation curves between identical keyframe values and prevents the overshooting. This completes the animation of one step and we can concentrate on the repetition of the animation and the varying of the walk movement.

For this purpose the new MOTION CLIP and MOTION LAYER can be used. These are links to a keyframe animation similar to an instance of an object. The original animation remains unchanged in the following steps. Such a

MOTION CLIP is advantageous in that we can copy, move, and scale the animation afterward. The most interesting feature of these MOTION CLIPS is the ability to combine several of these clips with each other. Clips can be layered and mixed, as well as cross-faded into one another. The animation system with clips is very similar to working with video clips in a video editing program.

**Creating a Motion Clip**

The creation of a MOTION CLIP is very easy. First, select the uppermost object of the animated hierarchy, or if just one object is animated, select that single object, and then choose ADD MOTION CLIP in the ANIMATION menu of CINEMA 4D. In our case select the uppermost bone of the hierarchy. Then a dialog like the one in Figure 4.91 opens. First give the clip a fitting SOURCE NAME like *Walk Cycle*. This is important so that there won't be confusion later when multiple clips are used. The START and END values define the frame range of the animation of the selected object hierarchy that is supposed to be loaded into the clip. We will enter the same range that we used in the preview range: frame 0 up to frame 28. The CREATE MOTION CLIP option initiates the creation of the motion clip, and BAKE EXPRESSIONS also incorporates the effect of expressions onto the keyframe animation. REMOVE INCLUDED ANIMATION FROM ORIGINAL

— Figure 4.91: Creating a motion clip.

— Figure 4.92: The Motion System tag.

OBJECT would delete, in our case, the keyframes of the bone hierarchy. The animation would then only exist as a MOTION CLIP. The CREATE PICTURES option is a more visual preference since it renders little icons for the first and last image of the clip that display the state of the hierarchy at that moment. These images will then be shown in the MOTION MODE of the TIMELINE.

Which kind of keyframe is added to the MOTION CLIP is defined with the options in the lower part of the dialog. Here, different combinations of POSITION, SCALE, ROTATION, PLA, and PARAMETER keyframes can be activated. The hierarchy window also puts together a preview of the elements that will be added to the MOTION CLIP. Single objects or branches of the hierarchy can be skipped at the creation of the MOTION CLIP by deactivating the little checkmark behind the name. In our case we will leave everything active. You can use the settings in Figure 4.91 as a guide. We will not delete the animation of the original objects and will save POSITION and ROTATION keyframes in the MOTION CLIP.

### The Motion System Tag

A soon as a MOTION CLIP is generated, a MOTION SYSTEM tag is added behind the selected object, as shown in Figure 4.92. The option SHOW GHOST can be used to blend in additional ghost overlays of the animation or to display the summary path in the editor with the SHOW SUMMARY PATH option. The following buttons are used for the creation and managing of additional layers, so-called MOTION LAYERS. These are also automatically generated when several MOVIE CLIPS are created for the same object hierarchy. As a standard, all MOTION CLIPS are loaded into the DEFAULT LAYER. Manually created layers can be mixed in the dialog of the MOTION SYSTEM tag and used in a relative or absolute manner.

### The Motion System of the Timeline

Within the TIMELINE you already know the display modes of keyframes and function curves. An additional icon in the title bar allows the switch to MOTION MODE. There, the additional display of MOTION SOURCES can be activated. The necessary icons are highlighted in Figure 4.93. The modes of the TIMELINE can also be switched in the VIEW menu. When the MOTION CLIPS are activated as well, you see their listing on the left side of the TIMELINE and see their saved hierarchy, as well as the length of the MOVIE CLIP. To

— Figure 4.93: Display of the Motion Clip in the timeline.

the right are the MOTION LAYERS. The percentage value behind the layer name can be animated with the circle in front of it; it controls the opacity and the influence of the layer on the overall animation. On the right is the key area with the visual display of the clips and layers. Figure 4.93 shows these three sections of the complete MOTION MODE. The additional information in the colored section of the MOTION CLIP can be controlled with the MOTION SYSTEM>MOTION VIEW menu in the TIMELINE. There, the start and end times, as well as trimmed sections of time and the looptime, can be turned on. As previously mentioned, the influence of the layers can be animated with percentage values. The generated keyframes, including their interpolation curves, can either be shown in the colored areas of the clips or displayed separately underneath.

A click on the colored part of a MOTION LAYER shows its parameters in the ATTRIBUTE MANAGER. Figure 4.94 shows this dialog. Besides the editable name and the color of the clip, the source of the clip itself can be seen and exchanged via drag and drop. With the LOCKED option, changes to the clip are no longer possible. Besides the set start and

— Figure 4.94: Settings of a Motion Layer.

end times, which are determined when the clip is created, the LOOPS function is especially interesting since it can be used to make the clip perform a number of repetitions. RELATIVE LOOP adjusts the repeats so the values at the beginning and end are equalized. This makes it possible to climb stairs when only the climb to the first step has been animated. Using the relative loop, this animation can then be continued. Several of these clips can be copied and played at different times during the animation.

When the clips are arranged in a manner that creates overlaps, the animation of the clips is blended. The length of the blending is defined with BLEND START and BLEND END. This area can be edited directly in the timeline as well. The blending itself can be defined in the BLENDING menu. The so-called ease curves create a natural-looking transition between the clips. Depending on the EASE IN and EASE OUT settings, this transition starts slowly and then speeds up or does the opposite. The EASY EASE setting creates a slow blending in and out of the clips. This is similar to the normal spline interpolation between keyframes. A separate SPLINE mode is also available that makes it possible to define an individual curve. The curve that runs from top left to bottom right by default causes a linear blending. Control points, which can be added to the curve by clicking on it, allow you to shape a different behavior curve.

Back in the KEYFRAME mode of the TIMELINE, you can see that a copy of the objects in the MOTION CLIP was created. Figure 4.95 shows that. In the OBJECT MANAGER everything stays the same, though; no new objects were created. Depending on the setting of the REMOVE INCLUDED ANIMATION FROM ORIGINAL OBJECT option when the MOTION CLIP is created, the keyframes are either gone from the original objects or still available in addition to the keyframes of the MOTION CLIP.

**Mixing Motion Clips**

The strengths of MOTION CLIPS can only be used to their fullest extent when several separate clips are combined with each other. Therefore, create another clip, but this time only for the head bone and the subordinated bone objects. Depending on your walk cycle animation, this bone might already have some keyframes, which cause the mouth to open and close slightly during walking so this area doesn't appear too static. If you don't have such keyframes, you could create them now. An overlap of bone object keyframes and MOTION CLIP keyframes can be excluded during the recording of new keyframes for the bone hierarchy by using the MUTING symbol behind the MOTION CLIP of the walk cycle. This filmstrip symbol activates or deactivates the evaluation of sequences in the TIMELINE. The term *Mute* is used in CINEMA 4D for this function. An animation can be muted for a period of time that way.

If several keyframes are created for the movement of the head or mouth, select the head bone and choose ANIMATION>ADD MOTION CLIP. This time you can activate REMOVE INCLUDED ANIMATION FROM ORIGINAL

— Figure 4.95: Display of the Motion Clip in keyframe mode.

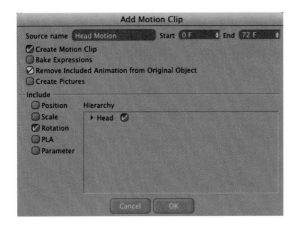

— Figure 4.96: Creating a Motion Clip of the head movement.

OBJECT. We will only need ROTATION keyframes for the MOTION CLIP, since the local positions of the head bone most likely haven't been changed during the animation. Figure 4.96 shows a snapshot of this step.

Since the keyframes of the head animation were deleted at the original bone objects, we can now create a second mouth and head animation. First, switch the new clip for the head hierarchy to mute. After this new head animation is complete, save it as MOTION CLIP and delete the keyframes again at the original. Figure 4.97 shows the result. We now have a clip for the entire animation of

the character bones and two clips with different head animations. The keyframes of the character can now all be deleted, even the keyframes for the arms and legs. These animations are already included in the clips. The mute setting of the MOTION CLIPS can be deactivated again.

Figure 4.98 shows how the mixing of different clips in the TIMELINE could look. At the top you can see the clip of the actual walk cycle. Independent of it, a new group for the head animations was created. This group is automatically created since the head clips pertain to different objects. The upper layer in this group, here named Layer 2, contains the normal animation of the head during the walk. This layer has the same length as the walk cycle clip and can go through the same number of loops to stay synchronized.

The head animation, named Layer 0, contains more extreme mouth and head animations that are supposed to loosen up the monotony of the animation. This animation is slightly longer than a normal step of the character and isn't repeated. Instead, I created a copy of this MOTION LAYER with a (Ctrl) drag and drop directly into the timeline, and slightly moved it. The standard mode Mixing causes a mix of this animation with the layer above, which contains the normal head movement during the walk.

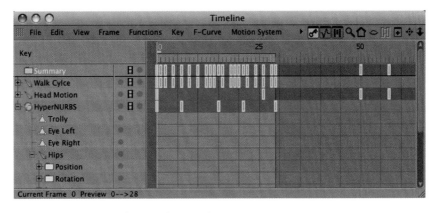

— Figure 4.97: Different Motion Clips in the timeline.

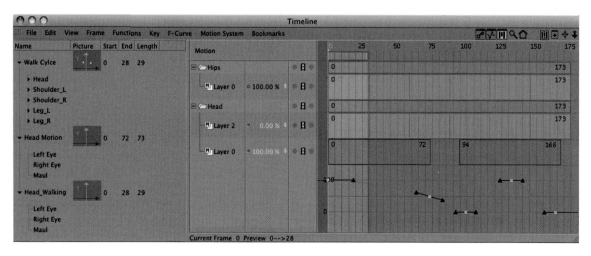

— Figure 4.98: Mixing different clips and layers.

As you can see in the lower part of Figure 4.98, I created an interpolation curve by animating the layer strength, which can be controlled with tangents, like a function curve. The use of the (Ctrl) button, as well as clicking on the keyframe recording circle in front of the layer value, is only necessary with the setting of the first keyframe. Afterward, the simple change of this value generates a keyframe for the strength of the layer.

This is an additional possibility for partly mixing layers and for varying the intensity of their animation. That way you can add many additional animations as clips and layers and create many variations with just a few initial animations. The whole process can be compared to the morphing of objects by mixing different shapes.

Let us take a quick look at the MOTION LAYER of the walk cycle. Click on its colored part in the TIMELINE to show the parameters of this sequence in the ATTRIBUTE MANAGER. In the HIERARCHY section there will be an overview of the objects and animations saved within the clip. Because we took out the animations of the head as separate clips and layers, the corresponding elements can now be deactivated. Open the hierarchy in the source view, as shown in Figure 4.99, and remove

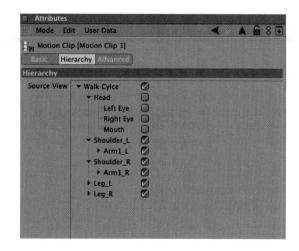

— Figure 4.99: Deactivating single parts of the hierarchy.

the checkmarks behind the bone objects of the head hierarchy. The keyframes of these objects that may still exist in this clip are then simply ignored.

**Influencing the Pivot of the Animation**

You most likely have noticed that we made the character walk on the same spot this whole time. This is easier to deal with than simulating an additional forward movement. It would also

become more difficult, for example, to have the character walk around a curve. In order to change the position of the animated object in 3D space without having to change the existing keyframes, we need to use the PIVOT object.

You can create it by clicking on the colored area of a motion layer in the timeline and switching to the ADVANCED section in the ATTRIBUTE MANAGER. Figure 4.100 shows the dialog on the left. With the CREATE PIVOT or CREATE KEYFRAME PIVOT button, you can create an object that is similar to a Null object. By moving or rotating this PIVOT object, the animation of the motion layer can be moved or oriented differently. This PIVOT object can also be animated with keyframes and therefore could generate a forward movement of the character without having to change the keyframes of the motion clip.

It is not so important whether you create the PIVOT object with or without keyframes. They can always be manually added later. The handling of the PIVOT object is not much different from any other normal object. Only the display in the editor, contrary to the Null object, can be changed. This can be seen on the right of Figure 4.100. With the RADIUS value entered directly on the PIVOT object, its size can be changed.

Besides the variation and addition of animations, the MOTION CLIP can be used for a complete blend of multiple clips. I will add two more motion sequences to the original scene with the walk cycle, a so-called idle animation and a jump. An idle animation contains a minimum of body movements, such as those that are used in video games when the game character doesn't receive input from the player. This could be a simple shift of weight from one foot to the other or a look around. The jump animation expands the motion range of the character, for example, to jump over an obstacle.

Figure 4.101 shows how simply such an idle animation can be structured. The character just bends its knees a bit by moving the root bone slightly downward. This has to be done in the scene where the external help objects and the IK tags are still active.

Your jump animation could look similar to that shown in Figure 4.102—just use your creativity. I put the three different animations directly into the timeline, one after the other. This idle animation lasts, in my scene, from frame 0 to frame 24. At frame 25 the jump starts, and it returns to its start position again at frame 49. The walk cycle is placed between frame 50 and frame 79. Figure 4.103 shows these areas highlighted by their selection.

As before, create different MOTION CLIPS for these three areas. The keyframes of the

— Figure 4.100: The Pivot object.

— Figure 4.101: Simple idle animation.

— Figure 4.102: The jump animation in its motion phases.

— Figure 4.103: The keyframes for the idle, jump, and walk animation in the timeline.

original hierarchy can be left alone. You can simply set them to mute by deactivating the filmstrip behind the root bone in the timeline. In MOTION MODE, arrange the clips to your liking and repeat the walk cycle multiple times. Figure 4.104 shows the status right after creating the three clips.

## Trimming Clips

Make sure that the clips end with the same pose with which they started. If you included the whole frame range of the animation when the clips were created, click on the colored area of each layer, and for END increase the value to 1 in the ATTRIBUTE MANAGER. You can find this value in the TRIM settings of the ADVANCED section. The layer then ends one frame before the motion clip is completed and doesn't show the last keyframe. This could also be done with the START value in

the beginning of the clip. This way you can take from each layer exactly the part you want to use in the animation.

## Automatically Blending Clips

Arrange and mix the motion layers in the way they should be played. You can do this in the same way the second head animation was added. This can be made even easier with the MAKE TRANSITION function in the MOTION SYSTEM menu of the TIMELINE. When you create a connection between two motion layers with this tool, by pulling the mouse directly in the timeline, an EASY EASE blending between the movements is automatically generated.

Figure 4.105 shows this procedure on the left side. The arrow indicates the pulling of the tool from one layer to the next. After the mouse pointer is released, a blending is created, as shown on the right of the same figure. Since

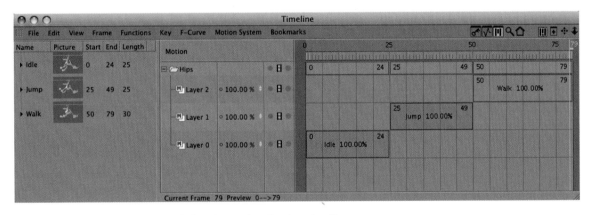

— Figure 4.104: The display of the three clips in the timeline.

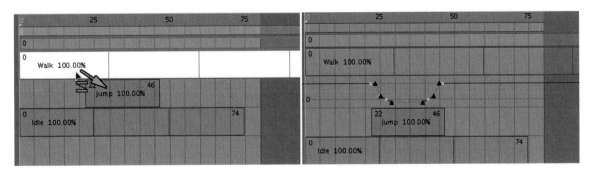

— Figure 4.105: Automatic creation of a transition between the motion layers.

the walk cycle is repeated several times, the tool automatically blends the jump out at the end of its run and again leaves the control of the character to the walk cycle.

Now you are familiar with all the important techniques and functions of the MOTION CLIPS and their layers. This provides you with a powerful tool for the creation of complex animations that can quite easily be changed and varied later. The possibility of animating the PIVOT point separately makes it easy to use motion clips multiple times within a scene and to utilize the created animations in other scenes as well.

## Game Development

Concluding this subject of character animation, I would like to demonstrate the use of animated characters in external game development. We already have all the parts together. The character is modeled and has a bone rig. The textures were simplified by baking them and the desired animations exist as separate blocks. Most game engines are able to exchange all necessary information with the FBX format, which can be read as well as written by CINEMA 4D. For this trip into game development, I used the software Unity 3D (www.unity3d.com). It has the additional advantage of a direct connection to CINEMA 4D with its own plug-in.

This software is currently only available for Apple Macintosh computers, yet has very powerful possibilities. It can be used to save the generated applications for Windows PCs as well as for Apple computers. Additional options contain the development for Nintendo Wii, for the iPhone, or as a browser game. As for the exchange and control of data, there aren't any big differences from other programs. Many of the steps can be transferred to other game engines as well, in case you wish to enter the interesting field of interactive 3D graphics. This is interesting not only for games,

but also for information applications or architecture walkthroughs.

Unity 3D creates, at the start of a new project, a so-called ASSETS folder in which you should save all objects, materials, and animations that are used within the project. These elements automatically appear in the PROJECT window of Unity 3D and can be pulled into the game scene from there. First, we tell Unity 3D that the animation in the scene is supposed to be split into three parts. These can be separated from each other by a number of frames. Here, mainly MOTION CLIPS are generated. As you can see in Figure 4.106, I again skipped the last image of the animation so there is no hesitation at the end of the animation.

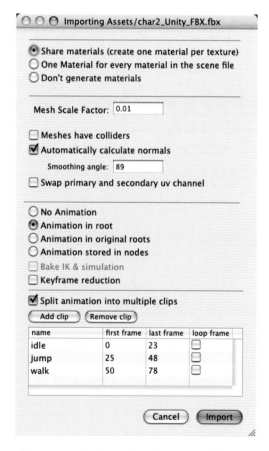

— Figure 4.106: Importing the scene into Unity 3D.

The individually given names of the clips are later used in the script language to gain access to the single animations. First, we determine the standard behavior of the character. Pull the character from the Project window into the Hierarchy view. This is similar to the Object Manager in CINEMA 4D and lists all objects in the scene. The Inspector window works like the Attribute Manager and shows parameters, such as the current position in 3D space or general settings of the selected object. In the Animation section the three loaded clips of our character appear. Figure 4.107 shows this area of the Unity 3D layout on the right. The setting of the Wrap Mode defines the behavior of the clip. In this case I have selected Loop. The animations are then played in an endless loop by default. Play Automatically is selected as well; this causes the automatic playing of the idle animation when the game is started, since it was chosen at Animation as the standard animation.

There's not much more to do, since, without interaction with the keyboard, we can't add interactivity. The game could be compiled and started, but then it would only show the character in the idle animation.

Unity 3D even takes over the settings of the HyperNURBS object and automatically smoothes our character.

The key setting is the render subdivision value of the HyperNURBS. Just remember that we have to use the smallest possible number of polygons. Ideally, the character is already modeled, so no additional subdivisions and smoothings are necessary and the details are simulated by the texture.

The actual control of the game is done with scripts that react to objects and the entries of the player. Such scripts can be written in JavaScript, whose syntax can be learned quickly. Such a script for the control of our character could look like the one shown in Figure 4.108.

There are fixed structures, like functions, that are executed at certain times in the game. Function Start is executed only once at the beginning of the game; Function Update, on the other hand, is used with every redraw of the screen. In Function Start the speed of the animations can be changed to, for example, make the walking appear faster than specified in the keyframes. I left these values at the multiplier 1.0 and instead changed the playback behavior of the jump

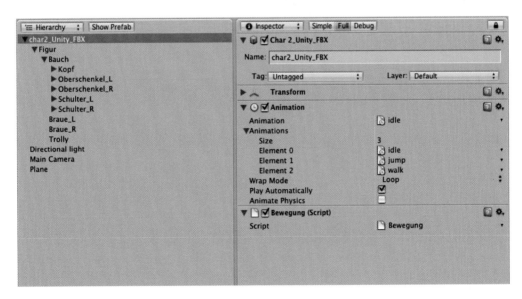

— Figure 4.107: Settings for the animation behavior.

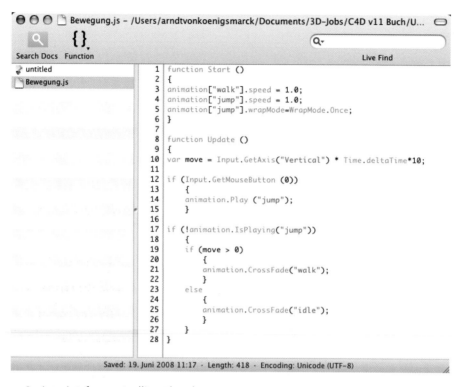

```
    Bewegung.js – /Users/arndtvonkoenigsmarck/Documents/3D-Jobs/C4D v11 Buch/U...

   Search Docs  Function                                                  Live Find

   untitled         1  function Start ()
   Bewegung.js      2  {
                    3  animation["walk"].speed = 1.0;
                    4  animation["jump"].speed = 1.0;
                    5  animation["jump"].wrapMode=WrapMode.Once;
                    6  }
                    7
                    8  function Update ()
                    9  {
                   10  var move = Input.GetAxis("Vertical") * Time.deltaTime*10;
                   11
                   12  if (Input.GetMouseButton (0))
                   13      {
                   14      animation.Play ("jump");
                   15      }
                   16
                   17  if (!animation.IsPlaying("jump"))
                   18      {
                   19      if (move > 0)
                   20          {
                   21          animation.CrossFade("walk");
                   22          }
                   23      else
                   24          {
                   25          animation.CrossFade("idle");
                   26          }
                   27      }
                   28  }

   Saved: 19. Juni 2008 11:17 · Length: 418 · Encoding: Unicode (UTF-8)
```

— Figure 4.108: A script for controlling the character.

animation from a cyclic loop to a single play-back. This allows us to inquire about when the jump has ended, so we can show the idle or walk animation again. First, assign the up and down cursor buttons to the move variable in the UPDATE function. Then the if inquiry asks for the state of the left mouse button. When the mouse button has been used, this will initiate the playback of the jump animation. The inquiry (!ANIMATION. ISPLAYING("JUMP")) executes the following sections of the script only when the jump is finished. Then a value of the move variable executes the walk animation. When this variable is empty, the idle animation will follow instead. The CROSSFADE commands ensure

that a soft blending between the idle and the walk is achieved. For a jump, the soft blending between clips wouldn't look so good. The jump could wind up being blended in the air with the idle or walk animation and would look quite funny.

The basic structure of the script is done, and now we could add some commands for moving the character during its jump or while walking, or add collision detection. This would take us too far from the subject of this chapter, though. The goal of this detour was to show you additional possibilities for character animation and how the new MOTION CLIPS of CINEMA 4D can be utilized in that way. Have fun animating!

# Index